A HISTORY OF
IDEAS AND IMAGES
IN ITALIAN ART

There are two ways of looking at art history. One is to study form and style, that is the merits of individual artists, the formation of schools and national characteristics, and matters of aesthetics. The other way is the one taken by James Hall in this book – a companion to his *Dictionary of Subjects and Symbols in Art* and his *Illustrated Dictionary of Symbols in Eastern and Western Art*. He looks at works of art from the point of view of their subject matter. The questions he asks are 'what' and 'why', rather than 'how'. Seen from this angle, painting and sculpture immediately take on a new dimension.

To explore content and meaning is to discover innumerable connecting links between art and ideas of the age in which it was produced. A fascinating light is shed on people's social customs, beliefs and aspirations. This book tells the story of art in Italy from that standpoint.

There are several threads running through the book: the survival of images from one age to the next, often in quite unexpected ways; the ever-changing attitude of the Christian Church to pagan antiquity and later to humanism; the remarkable persistence until modern times of man's ancient belief in the magical powers of images; and the always vital role of the patron, whether ecclesiastical or lay, in transmitting ideas to the artist.

Besides being read for pleasure the book is also a work of reference. The copious notes, bibliography and three indexes aid the student and everyone wishing to delve deeper. The notes give details of primary sources and critical studies for further reading. The appendix provides a very brief introduction to Greek and Latin alphabets as they appear in inscriptions which will help the reader to identify Byzantine and Western subject matter.

James Hall

A HISTORY OF
IDEAS AND IMAGES
IN ITALIAN ART

John Murray

ALBEMARLE STREET · LONDON

Cover illustration: Allegory of Temperance, detail
from the fresco by Luca Giordano in the Palazzo
Medici-Riccardi, Florence (*photo:* Hall/Mario
Quattroni); and engraving of Temperance from the
Iconologia of Cesare Ripa (*photo:* Hall).

© James Hall 1983

First published in 1983

First published in paperback in 1995
by John Murray (Publishers) Ltd.,
50 Albemarle Street, London W1X 4BD

Reprinted 1997

A catalogue record for this book is available from
the British Library

ISBN 0-7195-5555-8

Printed and bound in Great Britain by
Butler and Tanner Ltd. Frome and London

Contents

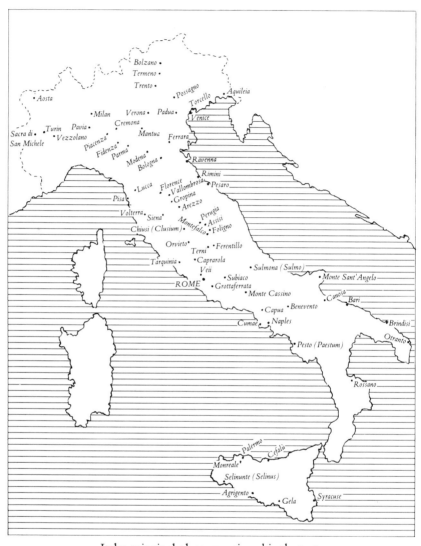

Italy: principal places mentioned in the text.

Acknowledgements

DURING THE SIX YEARS it has taken to write this book I have become indebted to many people for their help. I am grateful to Dr Charles Avery, Mr Alistair Smith and Mr Alan Wardman for advice and criticism on specific matters, and to Mgr Charles Burns of the Vatican Archives. I wish to thank Hester Whitlock Blundell for reading the proofs. I should like to thank also Prof. Alessandro Vaciago and his colleagues at the Italian Institute in London for putting me in touch with many institutions of the Church and State in Italy who provided me with illustrations. I recall with pleasure the generous help I received everywhere in Italy and the useful discussions that often developed out of my inquiries. I should like to mention in particular the staff at the Villa Giulia in Rome, the Ducal Palace and the Procurators of St Mark's in Venice, and the Soprintendenza at Ravenna. Among individuals whom I should like to thank for their kindness are Father Umberto Fasola of the Pontifical Commission for Sacred Archaeology, Sister Maria Francesca of the Benedictine Sisters of Priscilla, Dr Anna Rastrelli of the Archaeological Museum, Florence, and Father Luciano of the Basilian monastery at Grottaferrata. I wish to thank also Mr Ian Jackson for his excellent drawings. All the illustrations are individually acknowledged in the List of Illustrations on pages 380–88.

Finally, a thank-you, most of all, to Stella for sharing in so much of the work in all its stages.

[The figures in square brackets in the text refer to illustrations]

Introduction

THIS BOOK DEALS with some of the important discoveries that have
been made, mostly in the present century, in one particular field of art
history. They concern the content and meaning of works of art. From the
second half of the nineteenth century scholars in Europe and later in
America, beginning with men like Didron in France and Warburg in
Germany, devoted themselves increasingly to studying the visual arts with
the object of identifying subject-matter, and then of relating their findings to
the culture and society of the age in which the art was produced. From that
standpoint, that is to say, its iconography, art can be regarded as belonging to
the history of ideas and, certainly in the case of ancient art, as an aspect of
archaeology.

The aim of this book is not to explore fresh avenues. It is to present to the
general reader, and in particular to the student, a selection of the research
already done, much of it hitherto available only in specialist publications, so
that it forms a coherent history. Its scope is confined to the art of Italy.
Though it can be read as a continuous narrative it is also intended as a tool for
the student who will find the notes and references at the end (p. 351) provide
a guide to the source material, primary and secondary, on which the book is
based. In many ways it is a companion volume to the same author's *Dic-
tionary of Subjects and Symbols in Art*, looking at iconography from a chrono-
logical standpoint.

It is in Italy that art, as a history of ideas, can be followed in an unbroken
story as nowhere else in Europe, not excepting France. Rome was for
centuries the centre of the ancient world (in spite of medieval map-makers
who gave precedence to Jerusalem), and she remained the source of Christ-
ian and classical culture that fertilized the West in the Middle Ages, the
Renaissance and later. The Italian peninsula was one of the crossroads of
Europe. Wars, colonization, foreign trade, religious missions and pilgrim-
age, all at different times brought an influx of new imagery. In this way
Italian craftsmen were made aware of the visual arts of ancient Greece, the
Byzantine and Arab East, as well as the monasteries of Germany and France,
and imitated and absorbed them. Italian art, more than any other, also
reflects the singular dilemma that continually faced the Church from the very
beginning: how, if at all, to come to terms with pagan antiquity.

The task of the artist was to carry out the instructions of his master,

whether pope or emperor, prince or merchant, acting as a kind of spokesman for other people's ideas. This relationship between artist and patron declined in importance as the artist slowly won independence and greater recognition in society, until in the nineteenth century he began to pursue art for its own sake. The change came rather sooner in Italy where the great bestowers of patronage that had traditionally fed and guided the arts – the Church, the aristocracy and the wealthy bourgeois – were beginning to wane in influence as early as the later 1600s. And yet Italian artists who had led Europe for so long ironically failed to find an alternative means of regeneration and by the end of the eighteenth century had lapsed either into sterile academic formulas or a rather feeble romanticism.

This book covers the period beginning with the Etruscans and the first Greek settlers at about the time of the legendary founding of Rome and ends at the beginning of the nineteenth century. The chapters on the whole follow the periods into which art history is conventionally divided and are broken down into subsections for ease of reference. The approach to each period has been to choose a few works rather than many, the ones that are most representative of their subject, and to study them in full rather than attempt exhaustive catalogues. Besides the notes and references there is a bibliographical note listing the main standard works on iconography. There is also an appendix on Greek and Latin inscriptions and a glossary of terms. The general index includes subjects as well as names. Buildings and other monuments are listed under their respective cities. The index of primary sources is arranged in order of authors. The index of artists and subjects included attributes, symbols and similar objects, occasionally ones not mentioned in the text, but appearing in an illustration.

Finally, the illustrations have been chosen not for their qualities as works of art but as representative of the ideas they illustrate. All images, whether masterpieces or humble sketches by men of modest talent, may be relevant to the study of iconography. This book contains examples of both.

THE MEANING OF IMAGES

The word image, in the general sense of 'representation' or 'likeness', might be said to cover the greater part of what we think of as art, especially that which is descended from ancient Greece and Rome. In this book it is used in a more specialized sense to include the purpose for which a work was created (for example as an object of worship or for religious instruction or, sometimes, in the Renaissance, as a literary-philosophical conundrum), and the particular kind of response it evokes in the beholder (such as recognizing it to be a symbol or allegory). The kind of questions we shall ask are what does it represent and why was it fashioned, rather than how is the subject

treated. The French art historian, Henri Foçillon, writing of Romanesque sculpture said, 'Let us study it first as a system of signs before we attempt to interpret it as a system of forms. Every art is language, in two ways – once by its choice of subjects, once by its treatment of them.' He added that the first of these studies, iconography, 'floodlights the life of the spirit.'[1]

Style and iconography should not be thought of as the opposite poles of art studies though they tend to lead us in different directions. For the iconographer an image is an historical document first and if it is also a work of art, so much the better. Its importance to him is not necessarily diminished if it is mediocre art. Contemporary descriptions of works that no longer exist are apt to be more useful to the iconographer than to the student of style. Thus, ancient writers such as Pliny or Pausanias, describing the monuments of their day, may only convey a limited subjective impression of artistic merit, yet they can yield important, objective information about the subject-matter of a work. The study of style involves the search for connecting links between artist and artist, or school and school, where iconography looks for them more between the artist and his patron, all the while exploring contemporary letters, in the widest sense, for clues to meaning.

Before beginning the story of Italian art let us first see what images in general meant to people in past ages and some of the uses to which they were put.

Art and magic

Primitive people created images not for pleasure, which only happened at a relatively advanced stage of civilization, but for an entirely practical purpose which was simply to help make magic work. Magic was the use of special rituals to persuade nature, or the mysterious forces which lay within it, to work for one's benefit in order to promote success in hunting, fertility of the crops and so on, all necessary for livelihood. The rites included imitative actions and dances because imitation of the desired end was more likely to make it happen. Images played a part too because they functioned in a similar way, as imitations or substitutes for the real thing. Paintings and carvings of animals could be subjected to ritual attack, making the chase itself more likely to succeed, or figurines of one's enemies might be deliberately mutilated in order to bring about their death in battle. Man believed also that the powers of nature inhabited natural objects such as rocks and trees which therefore became sacred to him. But nature like man himself has life and motion – plants grow and rivers run – so perhaps the spirits within them resembled man. He began to make idols of these unseen powers and give them human shape, perhaps thereby to exercise more direct control over them and so assure himself of their aid and protection. The images contained the power to influence events, provided the necessary rituals were performed.

Not every community made use of images in its religion. The attitude of

the ancient Hebrews to pagan rites revealed, for those times, a remarkable maturity of outlook. Their religion prohibited idols and taught that there was one god only. He was immanent, pervading the universe, and therefore did not inhabit any local image. He was a protector, like the gods of the pagans, but did not require magic rites in order to guard his followers effectively – except one, the blood of sacrifice. The efforts by their leaders to persuade the Jews to forswear the worship of images is a recurrent theme in Old Testament history and helped them to preserve their national identity during the difficult periods of captivity.

Christianity inherited this tradition and the early Fathers of the Church, like the Hebrew prophets, took special pains to persuade their followers, who were often humble and credulous folk, that the adoration of images which they saw everywhere around them was wrong. It was not that the gods of the heathens were imaginary – they were all too real: they were the disguise adopted by Satan to lead Christians into sin. One early Christian writer, Clement of Alexandria (born c. 150) was clearer-sighted about idols. Addressing the Christians of Alexandria he said, 'The senseless wood and stone and precious gold pay not the smallest regard to the steam, the blood, and the smoke [of the sacrifice]. They are blackened by the cloud of smoke which is meant to honour them, but they heed neither the honour nor the insult.'[2] At the same time, he well understood the power of art to cast a spell over the imagination. 'They say that a maiden once fell in love with an image, and a beautiful youth with a Cnidian statue; but it was their sight that was beguiled by the art ... In your case art has another illusion with which to beguile; for it leads you on, though not to be in love with the statues and paintings, yet to honour and worship them. The painting, you say, is lifelike. Let the art be praised, but let it not beguile man by pretending to be the truth.'[3]

Images and the Christian Church

When Christianity began to make extensive use of art after the edicts of toleration in the fourth century it was with a different end in view. Art in the service of the Church was for instruction, it was to be historical and commemorative, not magical. It illustrated the Bible stories and through them taught the new doctrines. Pope Gregory the Great (c. 540–604) wrote, 'That which the written word is for readers, so are pictures for the uneducated.'[4] But the Church's intentions and the response of the faithful did not always coincide. Gregory's letter was written in reply to the bishop of Marseilles who was troubled by a tendency among his flock to fall down before the images in his church as if they had been pagan idols. This period had seen a revival in the eastern Church of idolatrous attitudes, and they were spreading to the West. The debate about the use of holy icons, which led to their temporary abolition in the East in the eighth century, was conducted by

theologians and concerned itself with matters such as the precise relationship between the icon and its prototype and ultimately whether God was capable of being represented at all. Meanwhile the uneducated, whom such images were intended to instruct, were apt to scrape fragments of paint off them to use as cures for disease, thereby adding weight to the iconoclasts' side of the argument.

The ban on the use of images in places of worship in the eighth and ninth centuries was confined to the eastern Church. In Rome, because of the growing divisions between East and West, it even produced a counter-reaction in their favour. But at other periods outbreaks of iconoclasm occurred in the West as well. In Italy the urge to destroy was always less severe and affected chiefly her heritage of pagan art. The sculpture of Greece and Rome that survives to the present day would be more and would be in a fairer condition, but for the destruction which took place after Christianity became the official religion of the Roman Empire at the close of the fourth century; and who knows what masterpieces were lost when the Dominican friar Savonarola persuaded fifteenth-century artists to throw their profane works on the bonfire.

The transmission of images

The Ecumenical Church Council which met at Nicaea in 787 declared, 'The making of icons is not the invention of painters, but [expresses] the approved legislation of the Catholic Church ... The conception and tradition are [those of the Church Fathers] and not of the painter, for the painter's domain is limited to his art, whereas the disposition manifestly pertains to the Holy Fathers.'[5] The dictates of the Church were followed so far as the choice of subjects and their arrangement within an overall programme of decoration were concerned, though documentary evidence of any such regulations hardly exists for the earlier periods. When however we look more closely at the individual motifs which make up a religious composition we find that the artist is often following traditions of his own in which the Church seems to have had very little say.

The first artists of the Christian religion were called upon to illustrate a new range of subjects for which no conventional imagery had yet been formulated, so they were obliged to draw on an existing vocabulary of visual types. One of the favourite images of Christ in early Christian art depicted him as the shepherd in the parable who left his flock to go after a lost sheep. Having found it, 'he lifts it on to his shoulders and home he goes.'[6] The motif of a herdsman carrying a calf or sheep existed in Archaic Greek art; and later it was used to represent Mercury as the protector of herds and flocks. It could be readily adapted to illustrate the Good Shepherd of the Bible and was used with this meaning in the Roman catacombs and on early Christian sarcophagi (I. 1).

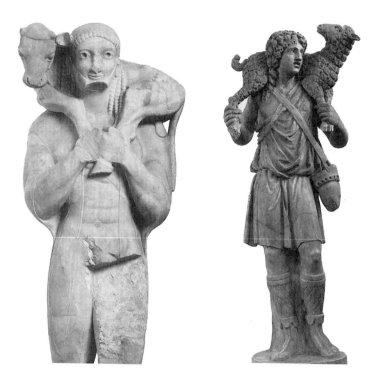

I.1 (*Left*) The Calf bearer. Attic Greek marble. *c.* 570 BC, found on the Acropolis. Acropolis Museum, Athens. (*Right*) The Good Shepherd, probably late 3rd cent. AD, from the catacomb of St Callistus. Vatican Museums.

The habit of repeating an established motif in another context where it acquired a new meaning was not confined to Christian art. Occasionally some particularly useful formula seems almost to acquire a life of its own in the course of being handed on from one age to another, serving a different purpose each time. The winged goddess Victory who is represented on Trajan's column inscribing the emperor's conquests on an oval shield [I. 2] was adapted from a cult statue of the Greek Aphrodite dating from the fourth century BC. The original figure may have been holding a mirror (usual for Aphrodite) which became a shield in the Roman version. In Italian Renaissance and Baroque art the same winged female appears again as the personification of History or Fame writing on a tablet whose shape, not surprisingly, is often oval.

Many of the familiar images of Christian art had their origins in other pre-Christian religions. Sometimes they owed their survival to having been, as it were, carried in on the back of the older cult which Christianity had absorbed. Representations of St Michael weighing the souls of the resurrected at the Last Judgement are first seen in the West in Italian mosaics of the

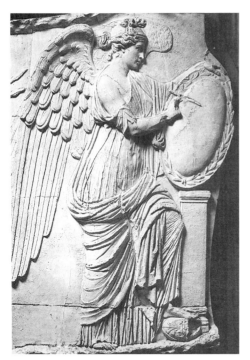
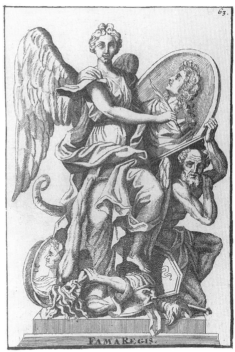

I.2 (*Left*) Winged Victory from Trajan's column, Rome. AD 106–113.
(*Right*) History (or Fame) personified. Engraving by S. Thomassin
(1694) of a statue by Domenico Guidi in Versailles Gardens, in honour
of Louis XIV.

twelfth century. Now, there is no mention in the Bible of the saint himself
carrying out this important duty though ancient literature, including the Old
Testament, contains numerous references to the act of weighing in the
balance in order to determine a person's virtue. How, then, did it become
associated with St Michael? The earliest example of the motif dates from
about 1400 BC and is found in the collections of papyrus leaves, called the
Book of the Dead, which the Egyptians customarily buried with a dead
man, along with other articles that might be useful to him in the afterlife. It
shows the god Anubis weighing the heart of a dead man in the balance
before Osiris who is the judge [I.3]. On Greek vase painting of the sixth
century BC there are examples of a similar kind that show Hermes holding a
balance with a Greek soldier in one scale and a Trojan in the other in order to
determine who is to be the victor. Hermes had various functions, some of
which were connected with the dead and, like Anubis, he was responsible
for conducting their souls to the next world. He eventually became identified
with the Roman god Mercury and, with the expansion of the Empire, his
cult spread through Europe, especially into Gaul. The early Church, in its

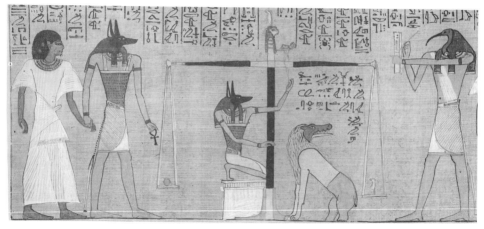

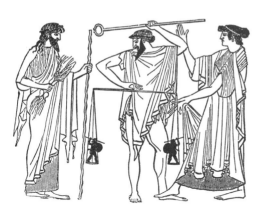

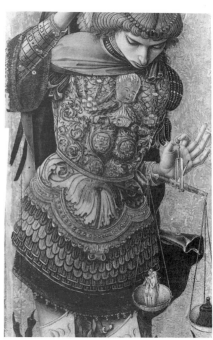

I.3 (*Top*) Detail of the Judgement of Osiris, from a papyrus found at
Thebes. In one scale pan is the heart of the deceased, represented
symbolically as a heart-shaped vase; in the other is a feather, *c.* 1400 BC.
British Museum. (*Left*) Hermes (Mercury) weighing Achilles and
Hector. A scene from the Trojan War (*Iliad* 22: 271–6). On the left is
Zeus holding a staff and thunderbolt; on the right, Athene or Thetis.
From a Greek vase painting, 6th cent. BC. (*Right*) The weighing of
Christian souls. Detail of St Michael from the Demidoff altarpiece, by
Crivelli, 1476. National Gallery, London.

task of converting the heathen, was not averse to taking over old pagan festivals and cults and adapting them to the service of Christianity. In the case of Mercury, his temples were replaced with chapels dedicated to St Michael who acquired at the same time some of the characteristics of the pagan god including his role of conductor of souls and, no doubt, the balance which he used to determine the destination of those who were being weighed. Survivals of this kind are not uncommon and we shall be looking at others later on. By the time they were absorbed into the repertoire of Christian art their former associations with a heathen cult had usually been forgotten.[7]

A different process was at work when a story was invented to explain an existing image whose original meaning had been forgotten. The legend of St George and the dragon was probably formed in this way. The dragon in ancient Near-Eastern religions was a beneficient deity. Because it was widely represented it was readily taken over by the early Church in the East as a symbol of pagan idolatry. It was said that Constantine the Great, to show the people that he was converted to Christianity, 'exhibited for everyone to see upon a panel placed high aloft at the vestibule of the imperial palace a representation in painting of the salutary symbol [the "sacred monogram", p. 81] above his head while the enemy, that hostile beast which had laid siege to God's Church . . . was in the shape of a dragon, falling into the abyss . . . Wherefore the emperor, by means of waxen painting, was showing to everyone, underneath his feet and those of his sons, the dragon pierced by a dart in the middle of his body and cast down into the depths of the sea. [The dragon in eastern religions was associated with the element water.] He was hinting thereby at the invisible enemy of the human race whom he showed to have been precipitated into the depths of perdition by the power of the salutary trophy placed above his head.'[8]

If this account is reliable, the dragon of idolatry entered Christian imagery at a very early date. It became particularly associated with the figures of 'warrior' saints, those who spread the faith in heathen lands, who were therefore represented as dragon-slayers. It was also usual to include in such images a female figure personifying the province or city which the saint had converted to Christianity. She was a descendant of the protective goddess of cities in antiquity, called in Greek Tyche, or in Latin Fortuna. An image of this kind, depicting St George who brought Christianity to Cappadocia, is found in mosaics of the fifth or sixth century at Ravenna. It is not difficult to see how, much later, pictures of this kind came to be interpreted in the imagination of some medieval monk as the story of a knight saving a princess from a dragon, when a similar tale from Greek mythology, about Perseus and Andromeda, would have been familiar to him. The legend of St George was the model for the numerous medieval accounts of a Christian hero's fight with a monster, some of which found their way into art.

Images as sign language

To say that an image 'represents' a person or event from the past is usually true only in a limited sense. Portraiture, in the sense of likeness to an original, though it flourished as an art-form under the Roman Republic and Empire, scarcely existed again until the late Middle Ages. In religious art, recognition of an individual relies partly on the existence of traditional types (St Peter was usually grey-haired with short curly locks and beard, while St Paul was dark-haired and balding). In the Greek Church, too, there were established types for the commoner saints, but persons and scenes were also identified by inscriptions (see Appendix). The western Church relied on the system of attributes, in which an everyday object was associated with the individual, such as the broken wheel of St Catherine or the lion of St Jerome.

Such things had another function, independent of persons, which was to serve as symbols (the dragon of paganism, the lamb or fish for Christ, and so on). A huge vocabulary, animal, vegetable and inanimate, was built up in the Middle Ages, reflecting the attitude of those times which saw the world and everything in it as the symbolic manifestation of the mind of God. Art developed an extensive language of conventional signs but, like any other language, it was capable of being misunderstood. As it evolved later, in the secular allegories of the Renaissance, the intention was sometimes deliberately to mystify. The language of symbols invented by humanist scholars was intended for princes and courtiers. To read its meaning was one of the accomplishments required of a gentleman of the court.

Meaning can exist on more than one level at once. A straight-forward narrative scene is not always just a simple statement in visual terms of a biblical episode or a myth. In Christian art, the picture of an old man, knife in hand, about to kill a youth who lies half prostrate on a primitive altar is a familiar episode from the Old Testament; it represents the patriarch Abraham about to sacrifice his son Isaac. [9] But it was also once meant to remind the spectator that Christianity was the true successor of Judaism, fore-ordained by God, because the Church taught that Abraham's act, which was commanded by God, foreshadowed the sacrifice of Christ on the cross. Similarly, in the art of the Counter-Reformation, the figure of a grey-bearded man weeping, with his hands clasped and eyes raised to heaven, represents the apostle Peter, repenting after he denied Christ three times. [10] But the subject also embodies a doctrinal argument which was current in the later sixteenth century. Catholics taught that Penance was one of the sacraments of the Church, its outward sign being the act of confession before a priest. This was denied by Protestants who recognized only two sacraments, Baptism and Holy Communion. To reinforce its point of view the Roman Church promoted the image of the penitent apostle in places of worship as a symbolic reminder of the sacrament of Penance. [11]

Images, fact or fiction?

The meaning of a picture often becomes clearer if we can put ourselves in the place of a spectator of the artist's own day and try to see it through his eyes. The earth was once a much smaller place. Its centre was the Mediterranean region (*in media terra*, at the middle of the earth). Medieval maps show the earth as a circle with Jerusalem at the centre (and Rome not far away). There were three continents, Europe, Asia and Africa, and their furthermost regions were largely unknown. They were bounded by the ocean which ringed all the earth. We ought not, therefore, to think of the strange creatures of medieval art as 'fabulous' or 'fantastic', as they are sometimes described. To the people of those times they were real enough. They inhabited the distant lands at the earth's perimeter and were known through travellers' tales. Moreover, Jerusalem was not only the centre of the earth, it was the centre of the universe. Around the earth revolved the planets and constellations in their spheres, their movement causing a mysterious celestial harmony. Man was created from the same four elements as the rest of the universe, in fact he was a kind of miniature replica of it, and he was therefore continually subject to its influences. The classical gods and goddesses whom the ancients identified with the heavenly bodies continued in the Middle Ages and Renaissance to be potent symbols of these influences from beyond the earth, and are often represented in this sense. Here are but two examples out of many which show that pictures, sacred and profane, contained, for the people of their own day, a greater factual element than we are now inclined to allow them. The art of the past must be taken on its own terms and not those of our times.

The Etruscans

Early settlers in Italy

THE STORY OF ITALY[1] begins around the eighth and seventh centuries BC. The country was then inhabited by tribes, principally of Indo-European origin, who had come from the north during the Bronze Age and settled in the fertile regions of the peninsula where they lived by cattle-raising and agriculture. Some time in the eighth century, at a place not far from the mouth of the Tiber where it was crossed by a ford, the shepherds and farmers from the surrounding seven hills began grouping themselves into a community for mutual defence. They were mostly Latins but included neighbouring peoples like the Sabines. Because of its favourable position the place became a centre for trade and eventually formed a league with other nearby towns, mainly to promote the worship on Mount Albanus of the god Jupiter who controlled the weather and was therefore important to a farming population. This Jupiter, however, belonged to no colourful Olympian family because the Italic peoples, unlike the Greeks, had in those early days no Hesiod or Homer to provide them with a legendary history or a mythology for their religion.

While these early Romans were establishing themselves by the Tiber, events were unfolding elsewhere in Italy. From about 750 BC and over the next two centuries colonists from the city-states of Greece were founding settlements along the coasts of southern Italy and Sicily, a region that became known as Magna Graecia (Great Greece). They brought the Greek way of life to the Italian mainland. Meanwhile to the north of Rome, in the area between the rivers Tiber and Arno, another race, the Etruscans, were from about the year 700 emerging into the light of history. These three areas, Etruria, Magna Graecia and Rome, were the main elements in the political and cultural evolution that took place in Italy in the following centuries.

Who were the Etruscans?

The Etruscans still mystify us. First, there is the problem of their origins. Were they, as Herodotus thought,[2] Lydians who had emigrated under the pressure of famine from their homeland in Asia Minor in the thirteenth century BC? Some Etruscan customs, religious beliefs and art have unmistakable resemblances to ones in the East. Or were they the remnants of an even more ancient race, native to Italy but having widespread links with

other areas of the Mediterranean, which had somehow managed to survive the successive invasions by the northern Indo-Europeans during the previous millennium? That would not rule out a connection with the Orient either. It seems likely that the Etruscan nation as it was known from the eighth century BC onwards was the conclusion of an historical process that consisted of the laying down of successive strata of races and cultures.[3]

Then there is the question of language. The Etruscans used a form of the Greek alphabet and so their writing can easily be read, yet the language belongs to no known linguistic family, and its meaning has only been partially deciphered. A key has not yet been found. Examples are plentiful but consist, with a few important exceptions, merely of short, often stereotyped inscriptions mostly on funeral monuments. We do know however that, apart from any secular literature, the Etruscans possessed a body of sacred books. But they have not survived, so far as we are aware, and we are dependent for our knowledge of them, as we are about much else concerning the Etruscan way of life, on later Greek and Roman authors. In these circumstances the works of art and articles of craftsmanship that we possess assume even greater importance as historical documents.

Divination in Etruscan religion

Religion appears to have played a dominant part in the lives of the Etruscans. As practised by ancient peoples it was not very often concerned with questions of morality which belonged to a later, more advanced stage of society. It was an attempt to understand the world of nature, believed to be under the control of the gods, and, through them, to influence it in various beneficial ways. By the art of divination, for example, the Etruscan priest attempted to discover the will of the gods so that matters affecting human welfare could be conducted aright. Divination was practised widely by Near-Eastern peoples and took many forms, some of which are familiar to us from the Old Testament: the interpretation of dreams [4] or the calling up of the dead to seek their advice,[5] and so on. The Etruscans were famous for their skill in reading omens in the flight of birds and, even more, in the liver of a sacrificed animal – the art known as haruspication[6] A correct stance was important for the proper performance of this rite. The priest held the liver in the left hand, his left arm resting on his raised left leg, as seen on the engraved mirror from Vulci [1.1].

The mirror

The art of decorating the backs of mirrors flourished in the Etruscan city of Praeneste (modern Palestrina) in the fourth century BC and large numbers have been recovered from burial chambers along with other everyday objects, ornaments and jewellery. The working of precious metals by the Etruscans shows elaborate and minutely detailed craftsmanship, but the engraving of

1.1　Haruspication, or liver-gazing. The inscription reads 'Calchas'. He was the seer who accompanied the Greek armies to Troy. A character from Greek legend is used to illustrate an Etruscan rite. Mirror from Vulci, *c.* 400 BC. Vatican Museums.

mirrors, which were generally of bronze, was kept to comparatively simple forms. Both treatment and subject-matter have much in common with the painting on Greek vases which the Etruscans imported in large quantities in the course of trade. Scenes appropriate to an article of women's toilet, such as the Judgement of Paris, and Helen or Venus with their attendants, occur repeatedly. But the frequency with which the mirror is found among the objects in Etruscan tombs suggests that it also served some purpose connected with death and the afterlife.

BURIAL CUSTOMS

The other main concern of religion was, and still is, to answer the problem of death. Immortality of some kind was believed in by most ancient peoples and took various forms. The soul existed as an independent entity and had to be cared for even during one's lifetime. It departed temporarily from the body

while a man slept and when he died it was free to wander at will. It was somehow present in his shadow, in his portrait or effigy and in his reflection in water or in a mirror, so caution was necessary lest by some accident the soul became permanently separated from the body because then he would die. The Greeks believed that the spirits inhabiting water could draw a man's soul down into the depths and thereby cause his death, perhaps the origin of the story of Narcissus who died gazing at his reflection in a pool. Closely linked to those ideas was the widespread fear that after a person's death his spirit could return to earth to haunt the living, and one of the purposes of funeral rites was to prevent that happening. Articles of daily use were placed in the grave, a cup, knife, clothing, sword and so on which provided for the material needs of the dead. Then the body or its ashes were placed in a chest or urn and sealed in a pit or tomb which was covered with a stone to ensure that the spirit did not escape. The inclusion of a mirror in which the soul might be content to reside was probably another safeguard of the same kind.

The funerary urn

The receptacle for the ashes also served as a dwelling-place for the soul. Burial urns dating from the early Iron Age have been found in parts of Etruria and the neighbouring regions. They are the remains of a very early culture, perhaps the first stratum of what eventually became the Etruscan civilization. It is called Villanovan, from the name of a suburb of Bologna where important discoveries were made. The Villanovans may have come from central Europe. More often than not they cremated their dead, placing the ashes in a large jar which was lowered into a deep pit. The funerary gifts were generally put in another urn and the whole tomb was sealed by one or more stone slabs. The urns were of various kinds. Some were literally dwellings, being a miniature replica of a house. This type, known as a hut-urn, has been excavated in large numbers especially in the area of Rome, and helps us to visualize the appearance of those early settlements on the seven hills [1.2]. Urns were also fashioned in human likeness. In the earliest versions the lid was shaped like a helmet. By the seventh century they were made either with a mask fixed to one side of the urn or, later, with the lid fashioned like a human head, sometimes having handles like arms. They are occasionally discovered placed on a throne in the tomb chamber. This type, known as a canopic jar, was principally made in the region of Clusium (Chiusi) in central Tuscany. They were not, of course, meant to be likenesses of actual persons, but even so they can convey a vivid impression of a spirit still inhabiting the material [1.3]. Later, Roman families kept masks of their ancestors in which their spirit was thought to be preserved, and carried them in funeral processions, a practice that may have derived from the burial customs of the Etruscans (p. 35).

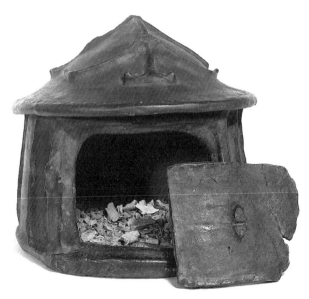

1.2 A Villanovan hut-urn containing the ashes of the
dead. 9th–8th cent. BC. Ashmolean Museum, Oxford.

The tomb

The Etruscan tomb was an underground chamber, the hypogeum.[7] It was
made either of stone with a vaulted roof which was then covered with earth
(the tumulus), or it was carved out of the living rock. The tumulus type
appeared first at the close of the eighth century, the period when Etruscan
records proper begin, and has a marked resemblance to earlier tombs found
in Asia Minor and the Aegean dating from the previous millennium. The
practice of sealing tombs airtight meant that, provided they escaped
subsequent pillage, the contents were kept in a state of perfect preservation
(though once opened they soon deteriorate). Besides depositing everyday
objects for the dead man's use, the Etruscans painted the walls of the chamber
with lively scenes of feasting, games and dancing. These were not just for
decoration nor even reminders of the pleasures that the dead man had enjoyed
in his lifetime. The idea of commemoration which lay behind much Roman
sepulchral art of a later date had no relevance here. These paintings, like the
tomb paintings of the Egyptians, once completed, were meant to be shut
away for ever from human sight. The reason for their existence goes back to a
remoter past when it was the custom at the death of a great man to make a
ritual sacrifice of his slaves, some of his beasts and even his favourite wife.
They were buried with him so that they could continue to serve him in the
afterlife. Moreover, the blood of the victims, somehow transmuted by the

1.3　A canopic jar enthroned, from Dolciano, near Chiusi. 6th cent. BC. Chiusi Museum.

ritual, nourished and sustained his soul, preserving it from extinction. Thus Achilles, at the funeral of his comrade Patroclus, slew sheep, cattle, horses, dogs and twelve Trojan soldiers, the sons of noblemen.[8] As peoples grew less savage, the painted image in the tomb became a magical substitute for this retinue of corpses, though there are indications that the Etruscans reverted to human sacrifice as their civilization went into decline.[9]

The sacred meal

The sacred meal is a recurrent theme in religion, mythology and art. The banquet depicted in Etruscan tombs formed part of the actual funeral rites when the participants, after the sacrifice of a beast, consumed the remaining portions that had not been consecrated to the gods. In the Tomb of the Leopards at Tarquinia [1.4], which dates from the turn of the sixth century BC, we see men and women reclining in pairs. Servants bring jugs of wine and one carries a wine-strainer, no doubt a necessary utensil in those days. The banqueters hold drinking bowls or garlands. Above and below the couches are branches of laurel which were used in purificatory rituals after death (see p. 39). The animals on the pediment are the leopards from which the tomb takes its name. They were regularly trained for hunting from the

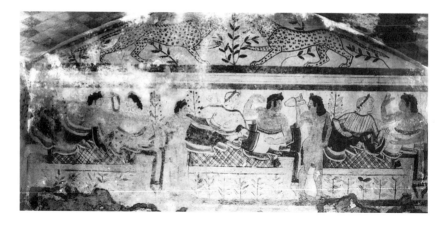

1.4 Banqueting scene, *c.* 500 BC. Tomb of the Leopards, Tarquinia.

days of ancient Egypt down to the Middle Ages and here they represent part of the dead man's possessions. The expectation of a celestial banquet in the afterlife is also implied in this scene. The belief was widespread throughout the ancient world. The devotees of the god of wine, the Greek Dionysus (worshipped also by the Etruscans under the name of Fufluns, and by the Romans as Liber or Bacchus), celebrated their vinous rites on earth in order to ensure their immortality which, they hoped, would consist of a continual round of heavenly intoxication in the company of the gods. The state of ecstasy induced by wine was called 'enthusiasm' by the Greeks, meaning possession by a god. There is plenty of evidence from Etruscan painting that the funeral banquet was an occasion for heavy drinking in the service of Fufluns.

Games and dancing

Games and dancing also feature in Etruscan tomb-painting and were once closely associated with religion. The Latin poet Virgil gives a description of the funeral games held by the Trojan hero Aeneas in honour of his dead father.[10] In Rome, from republican times, the priests of Mars, called Salii (leapers), performed a ceremonial dance in procession round the city and there is some evidence that their origin was Etruscan. Certainly Etruscan dancers were in demand at Roman festivals, in addition to playing an important part in their own rites for the dead. Their lively movements to the accompaniment of the pipes recall the frenzied dances of the Maenads, the female followers of Dionysus, and it is possible that they were celebrating an Etruscan version of the same cult [1.5].

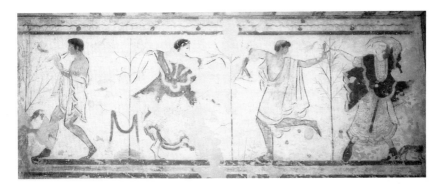

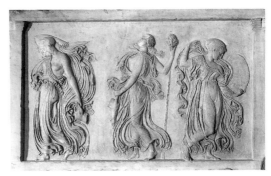

1.5 (*Above*) Funeral dance, 5th cent. BC. Tomb of the Triclinium, Tarquinia. (*Below*) Dancing Maenads. A Graeco-Roman copy of a relief by Scopas (4th cent. BC). Uffizi.

The Underworld

From the beginning of the fourth century BC Etruscan funerary art began to take on a more sinister aspect. This was a time when Etruscan power was beginning to decline in the face of attacks by Gauls, Samnites and Romans. In times of adversity, that is, when deserted by its gods, a society tends to fall back on older superstitions and more primitive rites, and this seems to be reflected in Etruscan art. The afterlife now begins to be pictured not as an eternal banquet but as an underworld kingdom. It corresponded in some respects to the kingdom of Hades in Greek religion. It was ruled, inscriptions tell us, by Eita and Phersipnei (in Greek, Hades and Persephone) and was peopled with demons and monsters. Eita wears a wolf's mask for a helmet and Phersipnei has snakes for hair like the Gorgons. There is a demon of death called Charun (in Greek, Charon), the conductor of souls, who holds a hammer with which he despatches the living. He appears in tomb-paintings and on sarcophagi and urns at this period, together with the scene

of Achilles slaying the twelve Trojans and other episodes of the same kind
from Greek legend. This may indicate a revival of the practice of human
sacrifice at the tomb. Other paintings suggest that certain funeral games
involved a fight to the death between two contestants in which the loser
became a sacrificial victim. This may have been the origin of the Roman
gladiatorial contests. At all events, the attendant who dragged the corpses of
the vanquished from the Roman arena wore a fearsome mask and carried a
symbolic hammer like that of Charun.

Images of the dead

The type of receptacle used for the remains of the dead depended on whether
the body was buried or burned, and was accordingly either a sarcophagus or
some form of cinerary urn. (The word urn includes the rectangular ash-chest
which sometimes resembles a small-scale sarcophagus.) The alternatives,
inhumation or cremation, were often a matter of religious belief: whether the
body or only the spirit was transported to the next world. The Egyptians and
others embalmed the corpse because upon its preservation depended the
future existence of the soul. Among the Romans, who had little sense of the
afterlife, cremation was usual until about the second century AD. The early
Christians buried their dead in anticipation of a not too distant resurrection
of the body. Throughout their history the Etruscans, and the Villanovan
people before them, used both methods, and remains of both have sometimes
been found side by side. However, cremation was far commoner, though this
is difficult to reconcile with the custom of depositing personal belongings in
the tomb. There seems to be here a mingling of beliefs which are not yet fully
understood.

The forms of the early cinerary urns pointed to a belief in some kind of
existence after death; the decoration of the sarcophagus and the ash-chest tells
a similar story. They were made of terracotta or stone and bore reliefs on one
or more of the sides. On the lid was a representation of the dead person,
sometimes with his wife, either in relief or in the round, in a supine or
recumbent position. This type is known as a *gisant*[11][1.6]. When reclining
on one elbow the figure sometimes holds a drinking bowl and resembles the
banqueter seen in tomb-painting. It seems likely that the spirit of the
entombed person was believed to be present in the image, much as it
inhabited the human form of the canopic jar. The prototype from which the
gisant sarcophagus was descended was almost certainly the Egyptian
mummy-case which had the shape of a human head at one end. This
eventually developed into a more sculpted form which may have been
introduced into Etruria by way of Greek workshops in Sicily. In due course
the Romans adopted the *gisant* type from the Etruscans and it became one of
the standard forms of coffin used in the Imperial Age.

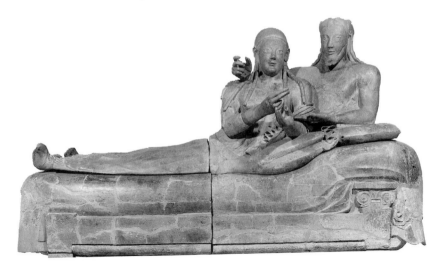

1.6 Lid of a terracotta sarcophagus from Cerveteri. The so-called
'archaic smile' was characteristic of Greek sculpture of the 6th cent. BC
and shows how Etruscan art was influenced by Greece. 550–525 BC.
Villa Giulia, Rome.

The relief sculpture on the side panels of Etruscan sarcophagi and ash-
chests of the fourth and third centuries BC depict the same scenes of
bloodshed and violent death that are found on other types of funerary art of
the period. But a new subject made its appearance. It was one that would
often recur in the history of art, in a variety of contexts and with different
meanings. It showed the figure of a man borne along on a bier, or sometimes
riding in a horse-drawn chariot or other vehicle, and forming part of a
procession. It was both a funeral cortège and at the same time a symbolic
representation of the journey of the soul to the next world. The train of figures
on foot and on horseback is led by musicians playing pipes, trumpets and
sometimes the lyre. Their heads are wreathed in laurel and some of them carry
implements for the sacrifice: an axe, and a dish (the *patera*) for the libation of
wine. Others are holding a palm-branch or a bundle of rods tied together
enclosing an axe (the *fasces*). These were carried in daily life by attendants
before certain persons of authority and are an indication of the dead man's
status. All these features, and others, find their exact counterparts in the
processions which took place in Rome in republican and imperial times, not
just at funerals but those which preceded the games in the circus[12] and,
especially, the triumphal procession for a victorious general (p. 43). Thus the
Romans appear to have inherited, among many other things, the forms of
some of their civic ceremonies from the religious rituals of the Etruscans.

THE ETRUSCAN GODS

Who were the gods of the Etruscans? There were Fufluns, the god of wine, and Eita and Phersipnei, the rulers of the Underworld, who came from Greece. So did Aplu (Apollo) who was widely worshipped by peoples who had contacts with the Greeks, and Hercle (Herakles). Some, like Maris (Mars), were Italic divinities whom the Etruscans adopted. The origin of others, like Satre (Saturn), is not known for sure. The influence of Greece on Etruscan religion is difficult to determine clearly. The original, native gods of Etruria were probably numerous, amorphous spirits, some local, others widely worshipped. One of the most powerful was the sky-god, Tin or Tinia, who made his will known by his thunderbolts. Contact with Greek religion by the Etruscans caused their gods to absorb some of the characteristics of the Olympians, a process sometimes called syncretism. Gods with like functions tended to merge with each other, and formless spirits began to assume human shape. There was a tendency to establish groups, especially of twelve (like the Greek Olympians) and nine.

The existence of a major Etruscan group of three has been inferred from a trio worshipped in early Roman religion. A trinity was a common grouping in ancient cults; in Rome it consisted of Jupiter, Juno and Minerva whose temple stood on the Capitoline hill (p. 33). It had three inner chambers, or *cellae*, one for each deity. The typical Etruscan temple likewise had three chambers, each housing a sacred statue. Nothing remains of these temples today except for their foundations, as they were built not of durable stone, but of timber and brick. Externally they were decorated with terracotta work consisting of reliefs, free-standing statues and heads, much of which has been recovered by excavation. It is, however, possible to visualize the appearance of such temples from burial urns which copy their exterior in miniature.

Thus it was through the Etruscans that the Romans, who originally had no religious imagery of their own, first introduced statues of gods into places of worship. The Etruscan town of Veii had been a great artistic centre, famous for the manufacture of terracottas, from the end of the sixth century BC [1.7]. Vulca of Veii, the only Etruscan artist whose name we know, worked for a time in Rome where he produced cult statues and decorated the temple of Jupiter on the Capitoline hill. To his school has been attributed the celebrated bronze she-wolf which became the emblem of the city [1.8]. In 396 BC Veii was destroyed by the Romans after a long siege and the temple treasures and statues were taken to Rome. 'It was done,' says Livy, 'with the deepest reverence; young soldiers were specially chosen for the task of conveying Queen Juno to Rome; having washed their bodies and dressed themselves in white, they entered her temple in awe, and shrank at first from what seemed the sacrilege of laying hands upon an image, which the Etruscan religion forbade anyone except the holder of certain hereditary

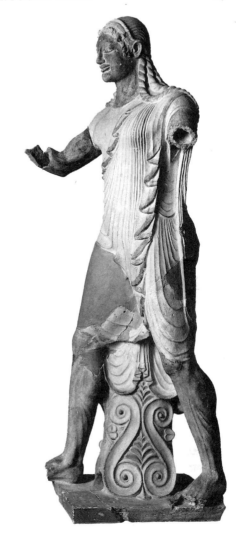

1.7 The famous cult statue, in terracotta, of Aplu (Apollo), from Veii. His lyre is at his feet. The statue, probably the work of Vulca, was part of a group that stood on the roof of a temple. Early 5th cent. BC. Villa Giulia, Rome.

priesthood to touch. Suddenly one of them said, "Juno, do you want to go to Rome?" Whether the question was divinely inspired or merely a young man's joke, who knows? but his companions all declared that the statue nodded its head in reply.'[13]

A nod was the sign of the will of a god. One of the most famous had been made by Zeus, the father of the Greek gods, who said: ' "When I promise with a nod, there can be no deceit, no turning back, no missing of the mark" ... He bowed his sable brows. The ambrosial locks rolled forward from the immortal head of the King, and high Olympus shook.'[14] In the Middle

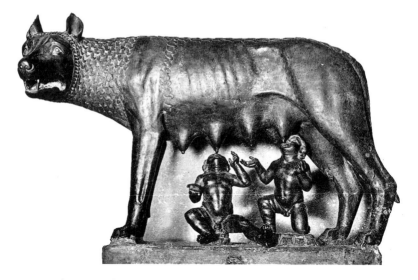

1.8 The Capitoline she-wolf. The figures of the infants Romulus and
Remus were added in the 15th cent. Bronze. Early 5th cent. BC.
Capitoline Museum, Rome.

Ages and later still, popular legends, which have sometimes been represented
in art, told how the figure of Christ on a crucifix would nod to a saint who
knelt before it. This happened to John Gualberto (d. 1073), a Florentine and
the founder of the monastery at Vallombrosa in Tuscany, and many similar
stories were told about images of the Virgin. The Latin for nod is *numen*, and
to the Romans the word carried a great depth of meaning. It was that
mysterious force which existed in nature, besides being present in the images
of the gods. To the Romans, the changing weather and the growth of crops
were examples of *numen*. It was present in groves and streams which were
inhabited by spirits, and in sacred objects. From the earliest times rituals had
been performed to influence this power for one's own benefit, and one good
reason for carrying off the gods of conquered enemies was to acquire their
numen and turn it to one's own advantage.

SUMMARY

Before the rise of Rome the Etruscans were the dominant people in the Italian
peninsula. They were governed by a priestly caste and religion was an
important element in their lives. The Etruscan gods had many affinities with
those of Greece. Etruscan temples, like Greek, contained cult statues of their
divinities and scenes from the Greek myths were common in Etruscan art.
To learn the will of the gods the Etruscans practised various forms of

divination, especially liver-gazing, or haruspication. In common with other ancient peoples they believed a man's spirit survived after death and made elaborate provision for it. They built whole cities of underground tombs, or necropolises, and decorated the walls with scenes of banqueting, dancing, athletic contests, and hunting. The function of this art was magical, not decorative. Relief sculpture on sarcophagi and cinerary urns shows scenes from the Greek myths which seem to have a similar purpose. As Etruscan civilization declined the subject-matter of funerary art took on a more sinister aspect and scenes of violent death became frequent.

Roman culture owed much to the Etruscans: the representation of the gods in human form; the idea of a trinity of gods, and hence the temple with three chambers; the practice of divination, or augury; and many features of their public spectacles and ceremonies. The Roman alphabet was derived from the Etruscan version of Greek (see Appendix).

Ancient Rome

I N THE FOURTH and early third centuries BC the Romans gradually extended their rule over the Italian peninsula, first overcoming the cities of the Etruscan federation. There were setbacks. The Gauls invaded from the north and in 390 BC sacked Rome, except for the citadel on the Capitoline hill which was the home of the city's tutelary gods. It was saved from a stealthy night attack, so the story goes, by the sacred geese of the goddess Juno which began to cackle and raise the alarm.[1] But the Gaulish invasion was overcome and the area of Roman domination widened until, by the end of the fourth century, it extended over the whole of central Italy and Roman armies were threatening the Greek city-states in the south. Naples and neighbouring Greek towns of the region of Campania had already joined the Roman federation but the powerful city of Tarentum remained defiant and called on the Greek King Pyrrhus of Epirus to come to her aid with his mercenary forces. The ensuing series of 'Pyrrhic victories' only depleted his strength and Pyrrhus abandoned his campaigns in Italy after the battle of Beneventum in 275 BC. Five years later, the entire peninsula, except for Cisalpine Gaul in the very north, was united under Roman rule which reduced Etruria and Magna Graecia to the status of provinces.

The influence of Magna Graecia

Little now remains standing of the Greek settlements in the south except the ruins of great Doric temples of the sixth and fifth centuries BC [2.1]. They were usually sited near the shore, on promontories, to serve as landmarks for ships. Today, in their lonely grandeur they mark what were once thriving city-states. Herodotus wrote his history near Sybaris. Aeschylus watched his plays performed in the theatre of Syracuse and died at Gela in Sicily. It was the Sicilian countryside that inspired the pastoral idylls of Theocritus which were the model for one of Virgil's earliest works, the *Eclogues*. In the fifth and fourth centuries the rulers of Syracuse, besides being great war-leaders, were men of culture and welcomed poets and philosophers to their court. At Croton on the mainland, Pythagoras (born *c.* 580 BC), who came from Samos, founded a community of ascetics who followed his religious and philosophical teachings. Apart from his mathematical discoveries, the doctrines of Pythagoras' school dominated Greek thought until the time of Plato. In particular, his ideas about the immortality of the soul were handed

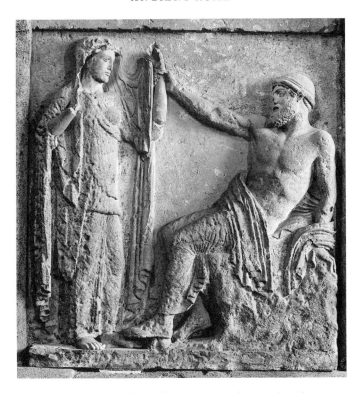

2.1　The exterior of Greek temples was decorated with fine
sculpture in honour of the gods. The scene is the wedding of
Zeus and Hera, divinities whom the Romans identified with
Jupiter and Juno. A metope (frieze panel) from a Doric
temple at Selinunte in Sicily. Mid 5th cent. BC. National
Archaeological Museum, Palermo.

down and in the course of time became part of the religious outlook of
educated Romans of the Imperial Age (p. 56). The Christian concept of
Purgatory had already been foreshadowed by Pythagoras in his doctrines
concerning the soul's purification after death.

There were artistic links between Magna Graecia and Rome even in the
fifth century. In 493 BC, according to the Elder Pliny,[2] two Greek sculptors,
Damophilus and Gorgasus, probably from southern Italy, were called to
Rome to decorate the temple of Ceres with clay images and paintings. The
arrival of Greek artists in Rome was an important event and indicates the
existence of cultural contacts with the south even in the early days of the
Republic. But the influence of Greece was not felt to any great extent until
much later when the campaigns in the south were drawing to a close and

booty, which included sculpture and other works of art, was brought back to Rome. Pliny mentions that a statue of Pythagoras was among those erected beside the Forum at that time.[3] It was done at the command of Apollo through his Delphic oracle, to set up in a place of honour an image of 'the wisest man among the Greeks', and shows that Greek thought was by then penetrating to Rome. The Romans, aware of the magnitude of their military achievements, began to commemorate their leaders and the legendary heroes of their past in stone and bronze, adopting the Greek style of the late classical and Hellenistic periods.

Sicily was rich in Greek works of art until the fall of Syracuse in 212 BC when many of them were carried off by the Romans. Cicero (106 BC–43 BC) gives us an idea of how much was still left in his day. In 70 BC he prosecuted a corrupt governor of Sicily, Gaius Verres, one of whose offences was an uncontrollable passion for collecting works of art. He used bribery, threats, and sometimes violence to achieve his ends. A citizen of Messina was relieved of bronzes and marbles made by Myron, Polyclitus and Praxiteles, who were among the greatest sculptors of Greece's classical period. Others had to hand over articles of gold, silver and tapestry. Nor were sacred figures safe from Verres. He especially coveted an ancient bronze statue of the virgin goddess Diana at Segesta which was deeply revered, particularly by the women of the town. It was, says Cicero, 'of great size and height; but in spite of its dimensions, it well suggested the youthful grace of a maiden, with quiver hung from one shoulder, bow in the left hand, and the right hand holding forth a blazing torch.' It had once been captured by the Carthaginians, 'a removal that was no more than a change of home and worshippers; the reverence formerly felt for it remained.' It was restored to Segesta by Scipio the Younger at the end of the Third Punic War. When Verres wanted to take the statue he found no one who would carry out his orders. Like the soldiers at Veii before the statue of Juno, all shrank from laying hands on a sacred image. Eventually foreign labourers were found to perform the task. [4]

There are other accounts of statues of the gods taken away by the victorious armies. It was done not because of their qualities as works of art but for the sake of their *numen*. A bronze Apollo, said to be by Myron, was removed by the Carthaginians from the temple of Concord at Agrigento, but later restored to its place. (The temple itself is one of the best preserved anywhere in the Greek world because it was used as a Christian church in the Middle Ages.) A more famous Apollo at Gela, of great size, was captured in 405 BC, again by the Carthaginians, and sent to Tyre, their mother-city. When Tyre was besieged by Alexander the Great in 332 BC, the inhabitants, as defeat came nearer, blamed the god for favouring his fellow countrymen, the Greeks, and bound the statue with golden chains. But this had no effect on its powerful *numen* and the city fell. Alexander made

lavish thank-offerings to the statue and named it Apollo Philalexandros because of the love it had shown for the conqueror.

THE GODS OF EARLY ROME

Gods of the hearth

Unlike the gods of the Greeks who became distinct individuals and had picturesque myths, the old native gods of Rome had no colourful background and could hardly be said to have any personality at all. Only at a later stage did they acquire human shape by a slow process of assimilation with foreign deities. At first, Roman religion managed without images. It had the same practical purpose as the ancient magic rituals and was summed up in the phrase *Do ut des* which means approximately, 'I give in order that you shall render something to me in return.' In other words it was a compact made with the god. This took the form of a ceremony, consisting of offering a sacrifice to him in order that he would in return grant a specific request. (If he failed to comply it was because the ritual had not been properly performed.) Private devotions in the home were an important part of Roman religion and the rites were conducted by the *paterfamilias*, the all-powerful head of the household, who was also its priest. Willing obedience to him, called *pietas* (the original meaning of piety), was the prime virtue.

In the Roman house dwelt the Lares and Penates, impersonal spirits that shared the meal-table with the Roman family and in return looked after the store-room. There were other places where the presence of unseen powers was felt. One was the doorway of the house, in Latin *janus*, which was protected by a spirit that eventually rose in status and became a god of that name. Janus was the god of gateways and arches in the city. He had no counterpart in Greece. Since his task involved seeing in two directions at once he eventually came to be represented with two faces [2.2]. A door or a gate is also the scene of departure, the start of a journey or a military expedition, and an event of that kind was marked by a ceremony. In this way Janus became the god of 'beginnings' of various kinds, and gave his name to the first month of the year. Ovid's poem, the *Fasti*, describing the festivals of the Roman calendar, begins with Janus who discourses to the poet about his nature and functions. The *Fasti* were well known in the Renaissance, supplying artists with numerous themes and motifs. Janus reappeared then, especially in allegories of Time.

Another sacred place in the house, full of *numen*, was the hearth. In prehistoric times it is likely that, out of normal prudence, a fire was kept burning continually in the hearth of the chief of a community, the tending of which took on a ritual character. The word for hearth in Greek is *hestia* and is the name by which the spirit protecting it came to be known. The name of

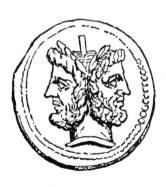

2.2 (*Left*) The Romans believed that coinage was invented by Janus, so
he was one of the most widely represented gods on early pieces of gold and
silver. The reverse of a Roman sextantal *as*, struck about 250 BC. (*Right*)
Two-faced Janus, at the gateway of a human life, offers a handful of fleece
to the three Fates to spin. Luca Giordano. 1682–3. Ceiling (detail) of the
Salone, Palazzo Medici-Riccardi, Florence.

her Roman counterpart was Vesta, and the similarity suggests a common
origin at a very early date. So Vesta was once worshipped not in a temple but
in the house of the head man. His fire may well have been looked after by
unmarried daughters who in time became priestesses of the goddess. Later, in
Rome, they were called Vestal Virgins and were chosen from patrician
families. Their task was to keep the sacred fire, then in the temple of Vesta,
continually alight. We know from the evidence of hut-urns that primitive
Italic dwellings were often circular, and the head man's was probably no
exception. Hence it is likely that the temples of Vesta were, from the first, of
the same shape, and so they remained. That is why they differ from the
typically rectangular Graeco-Roman temple. In the fifteenth century
architects revived the circular ground-plan as the basis of the design of
churches and the influence of the classical temples of Vesta can sometimes be
observed in them [2.3]. In the Middle Ages the Vestal Virgins were
regarded as pagan prefigurations of the Virgin Mary.

Apollo

The first of the Greek gods to arrive in Rome was Apollo. Though he has
survived in art and literature until modern times, symbolizing the spirit of
classical civilization, in the days of ancient Greece and Rome he was a god of
very varied functions and was worshipped in many places. The Romans

2.3 (*Left*) The temple of Vesta in the Roman Forum, as it last appeared.
It was founded in 715 BC and was several times destroyed by fire and
rebuilt, the last time in AD 205. Today only a few columns remain
standing. (*Right*) The classical circular temple was adapted by
Renaissance architects to Christian usage. Bramante's Tempietto,
1502–10, in the cloister of S. Pietro in Montorio, Rome.

would have known of Aplu when they were under Etruscan domination
[1.7], but it was from the Greek city of Cumae, not far from Naples, that he
entered their religion as one of the great gods. There, in a cave, lived a Sibyl;
a priestess of Apollo. She was a prophetess whose words were believed to be
inspired by the god, and therefore to reveal his will, rather like the art of
divination. The prophecies of the Sibyls were collected into nine volumes
which, according to legend, the Sibyl of Cumae offered to sell to Tarquinius
Superbus, the last king of Rome. When he refused because they were too
dear she burned three of the volumes, and then three more. Tarquinius finally
bought the last three for the original price. He deposited them in the Capitol,
the temple of Jupiter, where they were consulted at times of national crisis,
until the building was destroyed by fire in 83 BC. The worship of Apollo was
fostered by the Emperor Augustus, who made a new collection of similar

oracular writings gathered from different parts of the empire. He built a temple to Apollo on the Palatine hill where they were kept beneath a statue of the god. Various additions were made from later Jewish and Christian authors, but the books were eventually destroyed about AD 400. The Christian Church in the later Middle Ages maintained that the coming of Christ could be discerned in the prophecies of the Sibyls, making them a kind of pagan counterpart of the Old Testament prophets. For this reason Sibyls and prophets are sometimes portrayed side by side, as in Michelangelo's painting on the ceiling of the Sistine Chapel in the Vatican [7.22].

The Capitoline trio

If a Greek and a Roman god had similar characteristics, it was natural that a merging of their identities should take place. It was a process that commonly occurred when races and cultures mingled as a result of conquest or trade. It happened to the Capitoline trio. The Capitol was the name of a temple in Rome, and stood on the hill which is named after it. It was dedicated to Jupiter Optimus Maximus, that is, Jupiter the greatest and best, by which was meant not only greatest of all other gods but of all other Jupiters, wherever they might be worshipped. Its foundations date from the end of the sixth century BC, the time when the Romans threw off Etruscan rule and set up a republic, and it was destroyed and rebuilt several times in the course of Roman history. The Etruscans appear also to have worshipped their Jupiter as the head of a trio, and the temple of the Capitol was Etruscan in style. It had three *cellae*, or inner chambers, each housing the statue of a deity: Jupiter in the middle with Juno and Minerva on either side, corresponding to the Etruscan trio, Tin (Jupiter), Uni (Juno), and Menerva [2.4]. Jupiter, the mighty god of the sky who governed the weather and whose thunderbolt was the symbol of his powerful *numen*, controlled the destiny of the Roman state. He was worshipped throughout Italy and military leaders made sacrifices to him before and after their campaigns. His name is a shortened form of *Diovis Pater*, father of the heavens. The word *Diovis*, in English Jove, is related to Zeus, the omnipotent Greek god of the sky, whose functions were similar to those of Jupiter. Second of the trio was Juno, the protectress of women. She came to be regarded as the wife of Jupiter through her identification with the Greek Hera, the wife of Zeus. Both had similar roles, caring for women in marriage and childbirth. The old Roman goddess Minerva, who made up the third of the group, became the daughter of Jupiter, as in Greek mythology Athene was the daughter of Zeus, and in due course she took over the characteristics of her Greek counterpart. The Roman trinity of gods may have owed their origin to the Etruscans but they were greatly enriched through their association with those of the Greeks and the fabric of myth which clothed them. One of the early Roman poets, Ennius

2.4 The temple of Jupiter Capitolinus, Rome, as it probably first appeared at the end of the 6th cent. BC. a) Inner chambers, or cellae.

(239 BC–169 BC), who came from Calabria in the south and knew the works of Greek authors at first hand, created a pantheon of twelve Roman gods after the manner of the twelve Greek Olympians. The myths themselves were retold in Latin in the Augustan Age by Ovid (43 BC–AD 17). His *Metamorphoses*, more than any other single work of antiquity, was responsible for their continuing popularity in later ages.

'Luxuria Asiae'

The closing years of the Republic in the last century before the birth of Christ were marked by the successes of Roman armies abroad. In the east, Roman power extended to Syria and beyond and in the north-west it reached as far as Britain. Meanwhile at home it was a period of strife which led to civil war. But still the arts flourished, patronized by rich aristocratic families for whom Greek culture was ideal. The extent to which Roman art was genuinely original and creative or was simply a reflection of Greek models has often been debated. Perhaps there was a lack of imagination and inventiveness in the Roman character which made men content merely to imitate the works of art of others. At any rate, from the second century BC there was a growing demand for foreign works. It was met by the spoils of war which were brought back in vast quantities from Asia, Egypt and especially from Greece when Roman armies overran the former territories of Alexander the Great in the eastern Mediterranean. This led to the emigration of Greek artists to Rome where, along with native craftsmen, their services were increasingly

2.5 The companions of Odysseus meet the daughter of Antiphates
(*Odyssey*, 10: 103–111). One of the Odyssey Landscapes, wall-paintings
from a Roman house. 1st cent. AD. Vatican Museums.

required. The poet Horace (65 BC–AD 8) wrote, 'Graecia capta ferum
victorem cepit', 'Greece being captured made captive the barbarian
conqueror' (*Epistles*, 11.i.156). Greek literature became the model for Latin
authors and educated citizens understood both languages. Cicero interpreted
the Greek philosophers for Roman readers. Greek sculpture and mosaics
adorned private and public buildings, either brought back from the cities of
Greece and Asia Minor or produced in Rome by Greek craftsmen. Statues
originally created as religious images were now enjoyed for their qualities as
works of art, much in the same spirit that, today, a Renaissance altarpiece
may be admired after its removal to a museum. Private houses were decorated
with wall paintings, often of landscapes and scenes from Greek mythology.
The series of mural paintings depicting scenes from Homer's *Odyssey*,
originally in a house on the Esquiline hill in Rome, belongs to this period
[2.5].

Portraits of statesmen and ancestors

The historic achievements of the Roman Republic had been celebrated in
verse by Ennius (p. 32–3) in an epic poem, the *Annales*, which took eighteen
books to tell the story. The Romans' growing sense of history in the last two

centuries BC gave rise to the development of an art form which is thought of as perhaps their most characteristic. This was the commemorative portrait of a public figure, not idealized or flattering but, in accordance with Roman realism, showing him in his true likeness. Portrait sculpture had been produced in the previous century by Greek artists on the island of Delos, one of the Cyclades, which was a centre of Hellenistic art after it fell into Roman hands. When the fashion spread to Rome it became so popular that it was not confined to public monuments but was also in demand by wealthy families for their own homes. This was the continuation of an ancient native Roman tradition of venerating the family's ancestors, an aspect of their private worship that had its roots in man's earliest religious stirrings. It had been the practice among the old aristocratic families of Rome to display wax masks of their forebears in the main hall, or *atrium*, of the house. The Elder Pliny[5] and the Greek historian Polybius (*c.* 202 BC–120 BC), who lived in Rome, describe how these masks were taken down and worn at funeral processions in the Forum by persons accompanying the bier. They were dressed in the robes and carried the insignia appropriate to the status of the dead person. Thus at his death a man not only went to join his ancestors, they accompanied him to the grave. As Polybius observed, 'Who would not be inspired to see the likeness of these men, so renowned for their valour, all as though they were alive and breathing'[6] [2.6].

Statues of soldiers and statesmen of the Republic increased in such numbers that at one time the Senate ordered many of them to be removed.[7] Portraits were copied on the obverse of coins which, being also inscribed with a name and sometimes a date, are often a useful means of identification. Commemoration in stone continued to furnish a visual record of the emperors, their families and their favourites, to the end of the Imperial Age.

ART IN THE SERVICE OF THE STATE

The reforms of Augustus

The end of the civil war, which was also the end of republican government, came about with the defeat of the forces of Antony and Cleopatra by Octavian at the sea battle of Actium in 31 BC. Octavian, the great-nephew of Julius Ceasar, was from now on in effective control of the entire Roman world. A few years later he was granted the honorific title of Augustus by the Senate. As head of state he was called Princeps. A period of peace and order followed in which he carried out many reforms. The wealth that had poured into Rome from foreign conquest had accustomed the nobility to a life of luxury and self-indulgence in which public and private morality declined and corruption became general. Worship of the state gods was reduced to mere formality. People looked for excitement and mystery in religion, and

2.6 The Warrior of Capestrano (detail). A unique statue, believed to represent funeral attire. The face is masked, the figure is in ceremonial dress and is bearing insignia. Mid 6th cent. BC. Villa Giulia, Rome.

turned to foreign cults, especially those of the different kinds of mother goddess such as the primitive rites of Cybele and Ma from Asia Minor, or the more ceremonious ones of the Egyptian Isis. Among the educated the traditional beliefs were neglected in favour of the rival Greek philosophies of Stoicism and Epicureanism which both held a strong appeal for the Roman temperament.

Augustus set about revitalizing religion. The old virtue of *pietas* was revived, calling for duty to one's family and to the State which itself now became an object of veneration. When the office of head of the college of priests, the *pontifex maximus*, fell vacant, Augustus appointed himself to it as his great-uncle Julius Ceasar had done, thereby putting himself in charge of organized religion. He ordered the building of temples in the city, restored certain priestly functions, and in particular promoted the status of the Vestals who now participated in numerous public festivals. Augustus was a man of education and an author, and he encouraged art and letters, guiding them into patriotic paths. Art now served the State, especially in the form of relief sculpture which narrated the story of Rome's legendary beginnings, the

campaigns of her armies, and even political and religious concepts. The idea that the Princeps himself was divine began to be expressed in monumental art.

The legendary history of Rome

One of the aims of Augustus was to foster the idea that the former golden age of Rome's greatness was about to return. Poets and historians, encouraged by him, rewrote the old legends to show how the might of Rome had been created by the ancient kings and war leaders, their exploits always guided by the gods. Virgil tells the story of the Trojan prince Aeneas, the son of Venus and the mortal Anchises, and how he survived the sack of Troy and the trials of his journey to Latium under the divine protection of his mother. 'At last he succeeded in founding his city, and installing the gods of his race in the Latin land: and that was the origin of the Latin nation, the Lords of Alba, and the proud battlements of Rome.'[8] His son, Ascanius, the first of the Alban kings, was also called Iulus, and the Julian clan to which Julius Caesar belonged claimed descent from him. The Roman historian Livy, the friend of Augustus, tells how the last of the Alban line, Numitor, was nearly usurped by his brother. The usurper had Numitor's daughter, Rhea Silvia, appointed a priestess of Vesta. This was a skilful move designed to prevent the birth of any rival to the succession because Vestals were required by law to maintain absolute virginity. 'But,' says Livy, 'I must believe, it was already written in the book of fate that this great city of ours should arise, and the first steps be taken to the founding of the mightiest empire the world has known – next to God's. The Vestal Virgin was raped and gave birth to twin boys. Mars, she declared, was their father.'[9] They were Romulus and Remus who founded a new city by the Tiber.

So Venus and Mars not only played a part in the creation of Rome, where they had their own religious rites among those of the other gods, they were the very ancestors of the emperors. What better title to divinity? In the Imperial Age the figure of Aeneas appeared in public places on reliefs and as free-standing sculpture, along with other heroes, real and legendary, to remind the Romans of their glorious past [2.8].

Aspects of the State religion

Augustus had brought peace to Rome and to commemorate it he ordered in 13 BC the founding of an altar, which was dedicated in 9 BC. It was constructed on an elaborate scale, the altar itself being surrounded by a wall and approached by two flights of steps. An altar was, essentially, a table for the purpose of making a sacrificial offering to a god, and it was therefore a focus for ritual. The deity to whom the Altar of Peace, the *Ara Pacis Augustae*, was consecrated was Peace herself. She was thought of, not as a vague abstraction, but as a personified goddess who could be represented in

(e) (a)

2.7 The imperial procession. Reliefs on the outer wall of the Altar of
Peace, 9 BC. Via di Ripetta, Rome. (*Continued opposite*)

human form. This imaginative use of the human figure to represent a non-
visual idea was learned from the Greeks for whom religion was essentially
anthropomorphic, and it was readily adopted by Roman artists. Later, in
Christian art, it was the normal way of representing the virtues and vices, and
it remains an artistic convention down to the present day. Rome had many
such divinities, some particularly associated with the Princeps and hence
with the State, and altars were erected to them. As well as Pax (Peace) there
was Salus (Health) who guarded the well-being of the Princeps, and
Providentia who kept him from physical danger. Pietas had to keep
relationships harmonious within his household. In art they were generally
distinguished by some characteristic object, or attribute.

THE EMPEROR'S SACRIFICE: The reliefs on the Altar of Peace (today
reconstructed near the Ponte Cavour in Rome)[12] present Augustus in two
lights: as the man who was a statesman and priest, and as a being who was
descended from the gods. One series of panels on the outer wall represents a
long procession, which took place on the occasion of the altar's foundation in
13 BC. At its head are lictors, followed by Augustus, then the imperial
family, senators and others [2.7]. The figure in the centre with his head veiled
is probably Agrippa (a), the general and friend of Augustus who became his
son-in-law. His toga is draped over his head and indicates that he was to
officiate at the coming sacrifice. It would prevent any accidental distraction
during the ceremony that would nullify its effect. To the left, an attendant,

(*b*) (*c*) (*d*)

the *victimarius*, carries an axe to despatch the victims. The curious cap (*galerus*) worn by the figures next to him identifies them as *flamens*, priests of a specially sanctified rank. The child is probably Agrippa's son Gaius (*b*), and the woman with her hand on his head is Agrippa's wife, Julia (*c*). Next to them in the foreground is Livia (*d*), the wife of Augustus. The Princeps himself is on the extreme left, also with veiled head (*e*). Many in the procession wear laurel wreaths, which in Roman times were won for victory in battle and were also worn at all kinds of religious ceremonies. Long before then the Greeks believed that the laurel was a protection against the plague, and so it became associated generally with rites intended to ward off evil or misfortune.[10]

A series of smaller reliefs on the altar itself shows another procession, which took place at the annual sacrifice. It is led by Vestals who are followed by three sacrificial victims, a ram, an ox and a heifer (probably to be offered to Juno, Jupiter and Pax respectively).

THE SACRIFICE OF AENEAS: On the right of the steps leading up to the principal entrance to the altar is a panel representing another sacrifice [2.8]. The ceremony is about to be performed by Aeneas, the legendary father of the race, and alludes to the divine ancestry of Augustus. His garment too is draped over his head. The victim is a sow which, according to Virgil, Aeneas found beside the banks of the Tiber.[11] Attendants bring other offerings: cakes and fruit, and wine in a jug. To the right of Aeneas is part of another figure who may represent Achates, his companion, or a divinity, perhaps Honos (Honour) or Bonus Eventus (Good Fortune). The little

2.8 Aeneas' sacrifice of a sow. Relief on the Altar of Peace. 9 BC.
Rome.

figurines inside the temple probably represent the household gods which
Aeneas' father took with him on their flight from Troy.

ALLEGORY OF PEACE: On the far side of the enclosure wall is an allegory
of the blessings brought by Peace [2.9]. In the centre is a seated female figure
of matronly aspect with two infants on her lap. It could be that she represents
Rhea Silvia with Romulus and Remus, but it is more likely that she is
intended as Mother Earth (Tellus Mater) or just possibly the personification
of Italy herself. She is surrounded by various emblems of prosperity and
abundance that flow from peace. The group became a well-established motif
much later in European art as the personification of Charity. The figures on
either side may be water spirits. The one on the left, with an overturned urn at
her feet, would then represent the rivers; the other, with the waves of the sea,
the ocean. Alternatively, they may represent the Genii of Air (borne up on a
swan's back) and Water (on the back of a sea creature). The draperies
billowing over their heads and framing them were a very old Greek
convention for representing the spirits of the breezes, the Aurae, and occur
frequently on Roman sarcophagi to denote a Nereid, or sea-nymph [2.18].

2.9 Allegory of Peace. Relief on the Altar of Peace. 9 BC. Rome.

The motif was revived in the Renaissance and is seen often in pictures of
marine subjects from mythology. Poussin uses it in the 'The Triumph of
Neptune.'[13]

The commemoration of history

The Romans used relief sculpture to make a permanent record of their
military victories (and occasionally their defeats). In AD 113, a century after
the erection of the Altar of Peace, Trajan's column was completed. It
commemorated two campaigns of a very able soldier, the Emperor Trajan
(reigned AD 98–117), against the Dacians, the inhabitants of the region
beyond the Danube. The reliefs consist of a series of scenes arranged in a
continuous band which rises spirally, twenty-three times round the column
from bottom to top. The treatment is factual and realistic, suitable for an
historical narrative, and there is little in the way of allegorical figures. Why
was such an unsuitable monument used to display them? It is nearly one
hundred feet high, so that the upper scenes are invisible to anyone on the
ground. The figure standing on the top of the column provides a clue. Today
it represents St Peter but originally it was a statue of Trajan. In primitive
religion the pillar had a practical function which was, quite simply, to hold
up the sky because it was believed that without some form of support the
heavens would fall. The 'firmament' of the Old Testament served a similar
purpose and was a kind of solid vault in which the stars were set. Later,

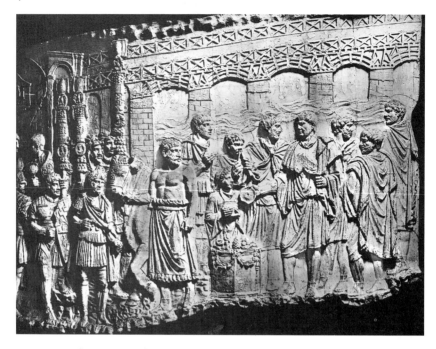

2.10 The sacrifice of Trajan. Relief from Trajan's column, Roman Forum.
AD 113.

when the sky came to be thought of as a deity, Zeus or Jupiter, it was natural
to imagine his abode on the top of a pillar. There is evidence from coins that
such monuments, surmounted by the figure of a god, existed in Greece and
Italy almost until the Christian era. The pathway to heaven was suggested by
a spiral band. As the idea of the divinity of the emperors took shape, the
statue of the earthly ruler replaced that of the god. As for Trajan, he was
eventually usurped by the first bishop of Rome.

The votive offering

The relief from Trajan's column [2.10] shows an incident from the second of
the two Dacian wars which began in AD 105. The place is Viminacium, on
the Danube (modern Kostolatz, east of Belgrade) where the Greek architect
Apollodorus had built a great bridge across the river for the Roman army.
The details of its construction can be seen clearly, and may well have been
copied from drawings made by a war artist on the spot. In the foreground the
emperor stands beside a low garlanded altar on which a fire burns, ready for a
sacrifice. He is in the act of pouring a libation from a flat dish, or *patera*.
Behind the altar a musician plays a double flute – like veiling the head, it
helped to prevent the person making the sacrifice from hearing any ill-

omened sound which would render the rite ineffective. The smaller figure in front of him is an attendant who holds an incense box. The brawny figure on the left is the *victimarius* who holds the head of a steer which is about to be sacrificed. The emperor's sacrifice is illustrated eight times on Trajan's column, and each time it marks some important occasion. Prayers and offerings were made before commencing a battle or other dangerous enterprise and again in thanksgiving at its conclusion. The power of the god was sought not only for the success of the troops but for the personal safety of the general who led them. It was not unusual to take a vow (*votum*) at the beginning of such an undertaking, by which the votary bound himself to make a specific offering to the god at the conclusion, in return for his aid – an example of 'Do ut des' which was at the heart of Roman religion. (The word religion itself was probably once connected with the Latin *religare* meaning to bind.) The subsequent payment was usually, but not necessarily, a formal sacrifice on the altar. The Roman dictator Camillus before leading the assault on Veii in 396 BC had prayed to Apollo, 'Led by you and inspired by your holy breath, I go forward to the destruction of Veii, and I vow to you a tenth part of the spoils.' He continued, 'Queen Juno, to you I pray that you may leave this town where now you dwell and follow our victorious arms into our city of Rome, your future home, which will receive you in a temple worthy of your greatness.'[14] Camillus' prayers were heard. Juno, as we noted, even gave visible sign of her assent.

Votive offerings were also made privately by individuals. It was the custom to dedicate to a god an image of the person or object for which protection was desired (for much the same reason that primitive man made drawings and models of the animals he hunted). The image thereby acquired magical power to influence events through the intervention of the god. In ancient Greece the use of votive offerings, often roughly fashioned in clay or bronze, preceded even the making of cult idols, and it is sometimes difficult to distinguish one from the other. They were much used to ward off sickness or as thanksgiving for a cure. The Etruscans and Latins of the fourth century BC made them of clay in the shape of the affected part of the body – a hand, foot, arm, leg and so on. It was the same sentiment that led to the revival in the Middle Ages of the votive offering, generally a specially-commissioned painting of the Madonna whose intercession was being invoked. As in ancient Rome, it was pledged either in expectation of some future favour, such as protection from the plague, or in thanks for one already granted, such as victory in war or the votary's release from prison [7.11].

The Roman triumph

Trajan was victorious in both the Dacian wars, and each time he returned to Rome he was accorded a 'triumph' by the Senate. This was a great procession in honour of a victor, who was called triumphator. It was led by

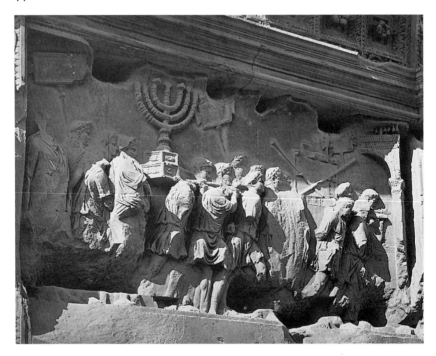

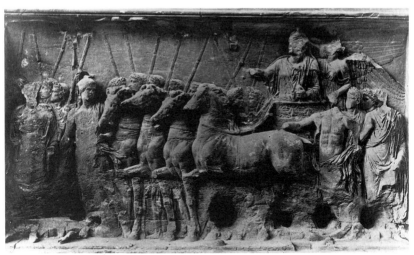

2.11 The triumphal procession of the Emperor Titus after the capture of
Jerusalem. (*Above*) Booty from the Temple. (*Below*) The triumphator in
his chariot. After AD 81. Reliefs on the Arch of Titus, Roman Forum.

members of the Senate, followed by musicians, the spoils and trophies of the war borne aloft on litters, white steers for sacrifice, prisoners, magistrates and finally the victorious general riding in a gilded chariot drawn by four white horses. The streets were decorated and the procession passed beneath garlanded archways that had been specially erected for the occasion. It proceeded to the temple of Jupiter on the Capitoline hill where the triumphator offered sacrifices and thereby absolved himself from the *vota* he had entered into before the campaign.[15]

In AD 71 a triumph took place which is represented in two reliefs on the Arch of Titus in the Roman Forum [2.11]. In the previous year the Emperor Titus had taken the Jewish garrison at Jerusalem after a five-month siege. The city was destroyed and the treasures of the Herodian temple, or such as remained, were taken as booty. The upper illustration shows the famous golden *menorah*, a seven-branched lamp-stand,[16] which is taking eight men to carry it. It is a familiar motif in synagogues to this day and occurs frequently in Christian art as a symbol of Judaism or in scenes depicting Solomon's temple. On another litter going before the *menorah* are trumpets and the table of the shewbread, also of gold.[17] The lower illustration, now defaced, shows the emperor in his chariot. The figure leading the team of horses personifies the city of Rome. The emperor holds a sceptre and olive branch. The triumphator was normally accompanied in the chariot by a slave whose task was to hold steady his heavy golden crown.[18] Here the figure has been turned into the winged goddess Victory who is in the act of crowning him. Processions through the streets of Italian cities remained a popular form of public spectacle, and in the Middle Ages they were held in celebration of the major feast days of the Church. During the Renaissance monarchs and military leaders revived the forms of the Roman triumph for their personal glorification, and in literature and art of the same period the triumph was used as a vehicle for allegory, religious and profane (p. 235).

We have noted how some features of the triumph had their origin in Etruscan religious ceremonies (p. 21). The same was true of the dress and physical appearance of the triumphator himself. His outer garment was a toga embroidered with golden stars and his body was daubed with a reddish pigment called *minium* or cinnabar. The Etruscans had painted the statues of their gods similarly, and at religious festivals their priest-king, painted red and wearing a starry cloak which symbolized the heavens, presented himself in the likeness of the Etruscan sky-god, Tin. In Rome, where the cult of Tin had merged with that of the Capitoline Jupiter, the statue of the latter was painted and garbed in the same way. So, in the eyes of the Roman spectator, the triumphator in his chariot was transformed into the chief god of Rome.[19]

THE EMPEROR AS GOD

The elevation of a monarch to the status of a god was a not unusual phenomenon in the early civilizations of the Near East. It enhanced the ruler's authority and therefore helped to create a stable society. He was simultaneously chief-priest and king, ministering to the State religion during his lifetime and turning into a god at his death. In Egypt the pharaoh had been worshipped as a god even while he reigned and so, when the country was conquered by Alexander the Great, the people were ready to accept their new rulers, the Ptolemies, as divine persons. Alexander himself had demanded, and received, recognition as a deity during his lifetime. The Romans were less ready to accept such an idea. However it began to take root in the later Republican era, coinciding with a change of belief about the afterlife. Until then the abode of the dead, of family ancestors in particular, had been thought of as situated somewhere under the earth: the place had even been visited by the living – Aeneas, Odysseus and Hercules, among others. Now the idea began to take shape of a heaven among the stars. For the time being it was reserved for great war-leaders and benefactors of the State, who ascended after death to take their well-earned place among the gods.

Cicero describes this paradise for heroes in the *Dream of Scipio*. The Romans thought of the universe as a series of concentric spheres rotating about the earth. Each sphere, a kind of hollow shell, held one of the planets – that is to say, literally held it in position to prevent it falling out of the sky, rather like the firmament. The motion of its turning caused each sphere to give off a musical note, all of them together producing a mysterious celestial harmony. The outermost sphere of all was heaven itself. Cicero's narrator is the younger Scipio Africanus. He dreams that his dead grandfather, the Elder Scipio who defeated Hannibal, appears to him and exhorts him to a life of action devoted to just causes. By this means he will discover the pathway to heaven, where a place is kept for those who have done great service to their country, and where the soul will return after death. This image had more substance than a mere poetic fantasy. It was derived in part from the system of cosmology handed down by the followers of Pythagoras. One of the Greek philosopher's great discoveries was the mathematical basis of music which he (or possibly his disciples) embodied in a theory of the universe where the harmony of the spheres sounded eternally.[20]

A commentary on the *Dream of Scipio* was written by the late Roman philosopher and mythographer Macrobius (*fl.* AD 400), who maintained that the movement of the spheres was due to the Muses and ultimately, therefore, to Apollo. Macrobius in turn was taken up by Renaissance humanists for whom the story exemplified their ideal of 'universal man'. His choice of pathways through life (active, contemplative or sensual) made a popular subject for allegorical paintings.

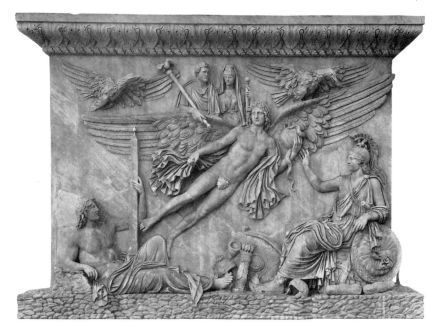

2.12 The apotheosis of Antoninus and Faustina. Relief formerly on the
base of the Antonine Column, AD 161. Now in the Cortile della Pigna,
Vatican.

Apotheosis

The greatest Roman military commander of all, Julius Caesar (102 BC–
44 BC) fostered the idea of his own divinity, having his statue set up
among those of the gods in temples at Rome and in the provinces. After his
assassination an altar was built on the spot where he died, and the next year
Augustus, to restore the honour of his adopted father, had him proclaimed
'Divus Julius' and officially installed as a god. *Divus* was the term applied to
a person who had been granted divine status. The ceremony of deification
was called *consecratio* in Latin, or apotheosis, from the Greek. Augustus was
also deified at his death and it became the rule with succeeding emperors,
even being extended to their wives and favourites. The apotheosis of
emperors was represented on coins, cameos and reliefs and showed the *Divus*
borne upwards to heaven. At the ceremony itself an eagle was released which
carried the emperor's soul to the skies. In art one finds also a peacock (an
ancient eastern symbol of immortality since its flesh was thought to be
indestructible) or other creatures, or a chariot or the figure of Eternity. A relief
of the apotheosis of the Emperor Antoninus Pius who died in AD 161 and his
wife Faustina, shows them carried to heaven on the back of the winged spirit
of Eternity [2.12]. They are represented in the guise of Jupiter and Juno, the

emperor holding a sceptre surmounted by an eagle. On either side, an eagle guards their ascent. Seated on the right is Roma, the personification of the city, and opposite her a reclining figure holding an obelisk, who personifies the Campus Martius (the Field of Mars) where the column of Antoninus originally stood.

The imperial eagle had been introduced to Rome from older religions of the Near East where it was the messenger of the Sun God, carrying the souls of the dead to the upper regions. Even earlier, the eagle was thought to be inhabited by the soul of the king, much as in Egyptian religion the gods appeared to people in the form of birds and animals.[21] A chariot was an alternative vehicle for the soul's ascent. It was drawn by four winged horses and was sometimes fiery, like the car in which the Sun God, according to several religious myths, rose into the heavens every day. The chariot of fire that carried Elijah in a whirlwind to heaven probably had a common ancestry with the one that bore up the souls of the Roman emperors.

The divine ruler

The idea gradually developed in the Imperial Age that the ruler, even while he lived on earth, was not just a human being like other mortals but shared some part of the nature of the gods. In republican times the people had been accustomed to his temporary elevation to the rank of god as triumphator, and his portrayal in art in this role must have helped to give permanence to the idea. Augustus did not encourage the veneration of his person, and his comparatively unobtrusive place in the relief on the Altar of Peace is perhaps evidence of this. Nevertheless, certain imperial virtues were thought to be embodied in him – Pax, Providentia, Pietas and so on – and were objects of official worship. So also was a being known as the Genius of the emperor. This was a man's personal guardian spirit, the kind of entity which Christians later called a guardian angel. Sacrifices were regularly made to the Genius of the emperor. That Augustus was the so-called son (actually the great-nephew) of the deified Julius Caesar gave him an added aura of divinity, and the significance of the relationship *Divi filius*, son of the *Divus*, increased with succeeding emperors. So there were several factors which contributed to the belief that the emperor was a god. Viewed in this light, the refusal of early Christians to make offerings at the altars of the State religion was more than just a denial of paganism, it was a rejection of one man-god in favour of another. From the standpoint of the non-Christian Roman, familiarity with the idea of *Divi filius* may have prepared the ground for his conversion to belief in the Christian Incarnation. Likewise, Augustus was regarded as the saviour of his people. His coming was foretold in the prophecies of the Sibyls and his arrival was to herald the beginning of a new golden age. The Greek word *soter*, meaning saviour, was used to describe him and later emperors, the same word that was later applied to Christ,

whose coming was also foretold and who would bring a reign of peace on earth.

The monarch was identified with other gods besides Jupiter. The reason for deification was not merely to enhance the glory of the ruler but to increase his authority. The quality of *numen*, which the emperor shared with the gods, protected the people from misfortune and brought practical benefits. Coins of the reign of Augustus show him with a caduceus, the staff entwined with snakes that belonged to Mercury. Among his functions Mercury was the god of peace who protected commerce, and therefore furthered the prosperity of the State. Statues of Apollo and the war-god Mars were given the features of the emperors, and their wives were portrayed as Juno or Venus. The image of husband and wife together as Mars and Venus alluded both to a divine ancestry and to the Greek myth which paired them as lovers [2.13].

By the beginning of the second century AD the rites of the official State gods were being displaced in favour of those which venerated the emperor himself. In the year 117 an arch was completed at Benevento commemorating in a series of reliefs the major events, the *res gestae*, of the reign of Trajan. A pair of reliefs on the attic[22] of the arch shows the emperor on his return to Rome being welcomed by two figures who personify the Senate and the People. The second panel represents the Capitoline Jupiter, accompanied by Juno and Minerva – the triad of State gods – at the moment of handing over his thunderbolt, the symbol of his immense power, to Trajan [2.14]. This was a turning point in public monumental art. From now on the Graeco-Roman pantheon yielded its place to the emperor and his court.

Frontality

In order to give the emperor's image a more god-like character, artists began to represent it full face. The traditional way of showing human features on relief sculpture, inherited by the Romans from the Greeks, had been the profile or semi-profile. It was not just a question of the technical problems of carving the frontal view in relief. The use of profile for the figures in a group created a lively sense of communication between them, something that was admirably suited to the narrative subject-matter of much of Greek figurative art which was concerned with the stories of the myths. Placing the principal figure in the centre of the composition and, at the same time, turning him full face towards the spectator, had the effect of withdrawing him from his surroundings. He now stood apart from the other persons who were portrayed in profile. Moreover, he now entered into an immediate and direct relationship with the spectator, often with an awe-inspiring effect. This could be further heightened by making the central figure larger than those around him. This important artistic principle was introduced into Roman imperial art from the religious imagery of the Near-Eastern countries where its effects were fully understood. Its function there was originally apotropaic,

2.13 The living portrayed as
divinities. (*Right*) The Emperor
Commodus (AD 180–92) and his
wife Crispina as Mars and
Venus. The figures, in the
likeness of the imperial couple,
are based on established types of
Greek religious sculpture that had
been handed down from at least
the 4th cent. BC. 2nd cent. AD,
found near Ostia. National
Museum, Rome. (*Below*) Mars
and Venus by Botticelli, later
1480s. An allegory of Love
overcoming Strife. The picture
probably commemorates a
marriage, very likely a member of
the Vespucci family of Florence.
National Gallery, London.

2.14 The Abdication of Jupiter. Relief from the arch
of Trajan, Benevento. AD 114. The god's thunderbolt,
here being ceded to Trajan (who is not shown),
eventually appeared in Christian allegory [8.16].

that is to say, to frighten away evil spirits. It was subsequently carried over
into the Christian art of the eastern empire, and is an essential feature of the
Byzantine hieratic style which presents sacred figures full face to the spectator
(p. 113). Examples of frontality on Roman monuments have unfortunately
suffered much from mutilation in the Christian era at the hands of those who
recognized its purpose. Part of a frieze on the Arch of Constantine at Rome
shows Constantine the Great distributing largesse after his defeat of
Maxentius at the Milvian Bridge in AD 312. He is seated full face, in the
manner used later to represent Christ in Majesty, with his retinue arranged
symmetrically on either side in profile or semi-profile. He is somewhat larger
than they and of considerably greater stature than the populace below who
receive his gifts. A second frieze on the same arch likewise shows him
frontally. [2.15]. The rather awkward arrangement of the team of horses and
the chariot in the triumph of Titus [2.11] may also be due to considerations
of frontality. The horses have made a right-angled turn into a profile position
while the chariot itself still approaches directly towards the spectator so that
the emperor can be shown full face.[23]

2.15 The Emperor Constantine on his rostra in the Forum addressing
the people. Frieze from the Arch of Constantine, Rome. Erected in AD
315.

LIFE AFTER DEATH

Apart from the divinity of the emperor, what did the ordinary Roman citizen
think about his own prospects of survival after death? The evidence is that he
took this aspect of his religion seriously. In their daily affairs educated towns-
people of the Imperial Age gave only perfunctory recognition to the State
gods while country folk continued to be more occupied with nature spirits on
whose goodwill their prosperity depended. The Latin for countryman was
paganus (often with overtones of bumpkin about it), so pagan originally
meant not a non-Christian but one who believed in the old nature worship
which was essentially concerned with the needs of daily life. But death was
another matter. The monuments which the Romans, or those of them who
could afford it, latterly erected over the dead and the coffins in which they
placed the body tell a fascinating story of belief in the existence of the soul and
its destiny in the next world.

Tombstones and burial chests

During the last centuries of the Republic and for a time under the early
emperors it was usual to dispose of a body by cremating it, but from about the
end of the first century AD, from the time of Trajan, burial gradually became
the custom. The typical monument set up over the ashes of the dead was an
upright gravestone, or *stela*, large numbers of which have survived. The
inhumed body, on the other hand, at least if it belonged to a wealthy person,
was placed in a stone sarcophagus, a form of burial which became
increasingly common from the first century and was used by early Christians.

In pre-Roman times the purpose of the gravestone had been not to provide a memorial to the dead but to prevent his spirit escaping. The stone also served as a kind of habitation in which the spirit dwelt. It possessed *numen* of its own which was closely connected with the imagery carved on it. The Greek *kouros* (female *kore*) was a stone of this type, which represented an idealized youth or maiden. It was set up over the grave and was, at least in origin, a means of preserving the soul of the dead person within the stone. The *kouros* dates from the Archaic period which ended about 500 BC, and examples have been found in Greek settlements in southern Italy. It always portrays a young person, regardless of the age of the deceased, which seems to imply a belief that perpetual youth was to be enjoyed in the afterlife. This idea was revived much later in Christian teaching about the Last Judgement. At the Resurrection, according to Saint Augustine, 'All shall rise neither beyond nor under youth, but in that vigour and age to which we know that Christ had arrived.'[24] Christian art traditionally depicts the figures of the resurrected as youthful.

The primitive fear of the dead was in time replaced by a feeling of veneration which gave them a heroic status and the power to influence human events from beyond the grave. When represented on gravestones beside the living, the dead are of much greater stature. This manner of distinguishing divine and living figures by their relative size is seen on Roman imperial reliefs and subsequently pervaded Christian art until the early Renaissance [6.6]. One of the earliest examples known is from Greece [2.16]. It represents the heroic dead enthroned and receiving offerings from worshippers. The frontal aspect of the nearer figure should be noted; also, behind the throne, the snake which was the form that the soul was believed to take after death. The offerings of the living consist of a cock, an egg and a pomegranate, all symbolic of that desired fertility which the dead had the power to promote after receiving their sacrificial dues. The cup is a *kantharos*, a drinking vessel associated with the rites of Dionysus, and suggests that they are celebrating a celestial banquet.

Roman *stelae* are rarely found before the mid first century BC. Generally they bear a frontal portrait of the deceased, usually in a medallion. A man and his wife together signify not a double burial but, as the inscriptions explain, an expression of longing for a reunion in the next world. Their right hands are clasped, as in the formal joining of hands in the Roman marriage ceremony, called *dextrarum junctio*. Scenes of everyday life, the baker at work, the shopkeeper and other tradesmen, are also common and seem to have no special religious significance. The image of a soldier or a hunter in action, a feast or a chariot race, which once typified man's hopes concerning the life to come, signify simply a record of a life that is past. At this period new ideas about the existence of a heaven above the stars and the resurrection of the soul after death began to be introduced to the Romans. They derived, as

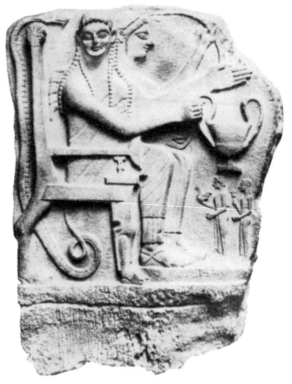

2.16　Ancestors as gods, receiving the adoration of the
(much smaller) living worshippers. Grave *stela* from
Sparta, mid 6th cent. BC. State Museums, Berlin.

we have seen, from Greek and oriental religions which were arriving in the
wake of conquest, and from the works of later Greek philosophers which
were now being interpreted by Roman authors such as Cicero. But the
Romans lacked a tradition of artistic forms which would enable them to
express these new and unfamiliar concepts on their funerary monuments.
They therefore turned to the Greek myths and, by treating them as allegories,
created a beautiful and eloquent visual language, describing man's fate after
death, which adorns later *stelae* and sarcophagi.

Greek myth in Roman religion

Myths were stories invented by people at a time when their understanding of
the universe was still at a childlike stage, to help them make sense of the
world of nature and also to account for certain religious rites whose meaning
and purpose they had long forgotten. The first man was made from rocks that
came magically to life, or he was moulded from clay; animals, birds and

natural objects, when associated with the gods, had fanciful tales woven about them; tribal ancestors were turned into god-like heroes who performed superhuman feats. The Romans had few such myths of their own because the objects of their worship had been immaterial spirits, so they borrowed from the other races with whom they came into contact, especially the Greeks.

But the immoralities of the Greek gods and goddesses were a problem when it came to their use on funeral monuments, and they were a feature of so many myths. Even the ancestors of the Roman people, Mars and Venus, had been caught in an adulterous act of love. Yet that story must be true, a Roman would have said, because Homer, no other, was its source.[25] He had been held in great veneration in Greece and his writings were regarded as a fount of wisdom. Some explanation had to be found for the gods' behaviour. It must be that Homer's stories contained some hidden moral, philosophical or even religious meaning. In the case of Mars and Venus it was perhaps a way of expressing in allegorical form the idea that the power of love was strong enough to overcome man's warlike instincts. Lucretius, the Roman poet who lived in the first century BC, expressed the idea thus:

> Mars doth oft-times fling
> His wearied limbs upon thy lap, his mind
> O'ermastered by the age-old wound of love;
> And lying thus, with shapely neck thrown back
> To gaze upon thy face . . .[26]

To understand an allegory is to perceive a universal truth behind a particular instance. The same applied to understanding a symbol. To a Christian in the Middle ages everything in the visible world about him was a microcosm of God's universe and the most insignificant everyday object was symbolic of a higher truth. The Romans interpreted the Greek myths in a similar way.

Stoicism and the journey of the soul

The myth of Phaethon occurs many times on Roman sarcophagi. He was the son of Helios, the Greek sun-god, who drove his father's chariot across the skies so recklessly that he set fire to the earth, finally crashing in flames, brought down by one of Zeus' thunderbolts.[27] Phaethon is often associated on the same relief with Deucalion. He was the Greek counterpart of Noah who survived a flood brought about by Zeus to punish mankind for its wickedness.[28] These two represented symbolically a new belief, or one that was new to the Romans, taught by the Stoics, that eternity consisted of an unending series of ages which came to an end alternately in a great conflagration or a great flood (called in Greek *ekpyrosis* and *cataclysm*) in which everything was annihilated. Each age was an exact replica of the one

preceding so that man's existence inevitably followed a predetermined pattern.

The founder of Stoicism was the Greek philosopher Zeno who lived about 300 BC. He happened to frequent a public colonnade in Athens which was decorated with paintings by famous artists. It was known as the Painted Porch,[29] in Greek *Stoa Poikile*, hence the name of the school. Stoics taught that God was a rational intelligence and that duty to one's fellow men and restraint of personal feelings were among the principal virtues. These qualities appealed to the Roman temperament and were exemplified in public figures like the younger Cato (95 BC–46 BC), a man of unbending principles. The metaphysical aspects of Stoic belief are presented by Cicero (who delivered a panegyric on Cato at his death) in *De Natura Deorum*, 'On the Nature of the Gods'. The vital force that sustains and moves the universe is the element fire. It permeates nature and quickens all living things. Moreover, 'since all physical motion arises from the cosmic fire and that fire is moved not by external impulse but by its own will, this fire must itself be soul.'[30] It was deduced from this that even the sun and stars were intelligent beings.

Stoicism in the Imperial Age broadened its metaphysical basis. From the Pythagoreans it received the idea that the soul descended from the heavenly spheres and entered the body at birth, reascending again after death. The soul itself was thought of as a kind of fiery particle or, alternatively, as a breath which escaped into the aether when a man expired. During a man's lifetime on earth the soul became heavy as a result of its sojourn in the body, sullied by contact with man's carnal nature, and when the body died it was unable to rise again immediately. It had first to be purified. Aeneas had learned about this from his father in the underworld. 'Some are hung, stretched and helpless, for the winds to blow on them. From others the pervasive wickedness is washed away deep in an enormous gulf, or it is burnt out of them by fire.'[31] The idea of the soul's purification in some manner by the elements was widespread in Near Eastern beliefs. Mazdaism, the ancient religion of Persia, taught of a final conflagration when the human race would pass through a purifying river of fire. This image was taken over by Byzantine artists in representing the Last Judgement, where a fiery river is seen flowing from the feet of Christ down into Hades. Stoic teaching about the purification of the soul entered Christianity in the doctrine of Purgatory. For Stoics, the soul passed through the misty lower regions of the atmosphere, the *inferi*, pursued by hostile demons or blown about by the winds until it rose at last to the Elysian Fields; for Christians it was purified by being consumed in the fire of the love of God until, finally cleansed, it rose to heaven where it was granted the beatific vision.

The concept of the journey of the soul, and the purifying winds that conduct it to its final destination among the musical spheres in the Elysian

2.17 The contest between Apollo and Marsyas, a 'continuous narration' from left to right. Roman sarcophagus, 2nd cent. AD. Louvre. [See also 7.24]

Fields or the Isles of the Blessed, all found allegorical expression on Roman *stelae* and sarcophagi. The winds are represented by the familiar image of the disembodied head, sometimes winged to suggest speed, with cheeks puffed out, its breath issuing trumpet-like from the mouth. They are usually four, one at each corner of the relief. Their names in Greek were Zephyrus (west), Boreas (north), Eurus (east), and Notus (south), and stories grew up about them, especially gentle Zephyrus and cold Boreas.

The contrast between the earthbound and the cleansed, regenerated soul is represented on reliefs by the myth of Apollo and Marsyas [2.17]. Marsyas was an uncouth Satyr who boasted of his prowess on the flute and was challenged to a musical contest by Apollo with his lyre. Marsyas was defeated and paid the penalty of being tied to a pine tree and flayed alive.[32] The sequence of events is illustrated as it happened, moving from left to right. The artist has used a special pictorial convention in which the same figure appears more than once within a single 'picture frame' in order to represent consecutive events.[33] On the extreme left stands the warrior-goddess Athene (the Roman Minerva). She is here because she invented the flute, though she threw it away in a fit of anger, having first cast a harmful spell on it. She wears a helmet and holds a shield. Next to her is Marsyas, with the Satyr's goat-like ears, playing Athene's instrument. The female figure listening attentively with one hand to her ear is one of the Muses who judged the contest. Next is Apollo, laurel-wreathed, performing on a large version of the lyre (the *kithara*). He is then awarded the palm of victory by the Muse at his side. Below her is a river god with his overturned and flowing urn, personifying the River Marsyas in Phrygia, beside the source of which the contest took

place. On the far right is Marsyas once more, tied to a tree and receiving his punishment from Apollo's attendant who has first knelt to sharpen his knife on a stone. The gruesome tale seems an unlikely choice to decorate a tomb without some deeper layer of meaning to justify it. It was believed that the strings of the lyre, when properly tuned, were in accord with the harmony of the spheres, so, through its music one might catch an echo of the heavenly notes. The flute on the other hand excited merely earthly passions, indeed its very shape was unmistakably phallic. The distinction was very ancient. Socrates said, 'We are making no innovation when we prefer Apollo and Apollo's instruments to Marsyas and his instruments.' [34] So to the Romans the figure of Marsyas on a funerary monument symbolized the darkness of the earthly regions, while Apollo stood for the heavenly abode to which the purified soul aspired. Cicero had said, 'Clever men, by imitating these musical effects [the harmony of the spheres] with their stringed instruments and voices, have given themselves the possibility of eventually returning to this place.' [35]

Images of heaven

The place itself, originally reserved for heroes, was the Elysian Fields, or the Isles of the Blessed, also called the Fortunate Isles. Their precise location varied according to the different ideas of ancient cosmographers as to the way the universe was constructed. We have to forget our own notions as to the direction in which heaven and hell may lie. Belief in Father Jupiter as a sky-god did not necessarily imply the existence of a heaven up among the stars. The sky was simply Jupiter's domain, just as the sea was Neptune's or the underworld Pluto's. In fact, the Elysian Fields as described by Virgil in the *Aeneid* [36] were under the earth. On the other hand, Homer locates them at the 'ends' of the earth 'where no snow falls, no strong winds blow and there is never any rain, but day after day the West Wind's tuneful breeze comes in from Ocean to refresh its folk.' [37] This was very like the Christian idea of heaven as it was described in some early patristic writing. [38] The disciples of Pythagoras, in accordance with their belief in the heavenly spheres, placed the Isles of the Blessed in the skies, specifically in the region of the moon. But islands, even celestial ones, imply a voyage for the deceased, and so, on Roman funerary reliefs, we find Nereids (or sea-nymphs) riding on the waves with their sail-like draperies billowing over their heads. Tritons, who were half men, half fish, often with Nereids on their backs, blow on trumpets or horns in order, like the winds, to hasten the soul on its way [2.18]. The heads of Zephyrus and Boreas sometimes appear in the upper corners. Charon, the boatman who ferried the dead across the River Styx in Greek mythology, also sometimes appears. A more direct allusion to a lunar paradise may be inferred from the figure of Selene, the moon goddess, who sometimes descends from her chariot to join her sleeping lover, the shepherd Endymion.

2.18 Sarcophagus with Nereids and Tritons (mermen). The nymph in
the centre holds a *kithara*. 2nd cent. AD. Vatican Museums.

This last image may also be a reference to the reunion of a loving couple in
the afterlife.

Pathways to immortality

The opportunity was not given to everyone to achieve heroic status in their
lifetime, and so more modest accomplishments came to be accepted as an
alternative passport to the hereafter. These corresponded to the more everyday
aspirations of the well-educated Roman. Learning as an end in itself was
virtuous. Striving towards perfect knowledge led to wisdom which, in turn,
opened the road to immortality. Coupled with this went the need for self-
denial. Those who abandoned themselves to the pleasures of the flesh (the
Marsyas types) were denied even the possibility of purgation, and were
condemned after death to return to another cycle of life on earth. Their souls
entered another mortal body, human or animal according to their deserts.
This was the revival of a doctrine that occurs in several ancient schools of
philosophy, called transmigration or, in Greek, metempsychosis. The ideal
type, therefore, was the philosopher who was also an ascetic; his divine
patrons, who presided over learning and the creative arts, were the nine
Muses.

The Muses were originally nymphs of mountain springs who supplied the
creative inspiration of poetry and drama, history and astronomy. Their
temple at Athens was called the Museum. The term 'music' once embraced
the whole field of their activities. In the familiar sense of the word it was,
among the Greeks, the normal accompaniment of verse. Music naturally
linked the Muses to the Pythagorean harmony of the spheres which was
believed to be audible on earth, but only to one who had acquired perfection
in learning and the arts. The Muses form the subject of many reliefs on
Roman sarcophagi. Apollo, their patron, is sometimes present with his lyre,
or the more solid *kithara*, the instrument used by the ancient bard to
accompany his recital of epics. Athena, the goddess of wisdom, may also
appear. Socrates or Homer sometimes declaim before a listening Muse. The

2.19 The nine Muses with their classical attributes. On the lid, a
banqueting scene. Roman sarcophagus, 2nd cent. AD. Louvre.

figure of the deceased himself is sometimes seen reading, writing or playing a
stringed instrument.

The problem of giving separate identities to nine similar female figures
was resolved in the usual manner by providing each with an attribute
appropriate to her calling [2.19]. The illustration shows, from left to right,
Clio (the Muse of history) holding a scroll; Thalia (comedy and pastoral
poetry), a comic mask and shepherd's staff; Erato (lyric and love poetry), a
lyre; Euterpe (lyric poetry and music), a flute; Polymnia (sacred songs), no
attribute but given instead a pensive pose; Calliope (epic poetry), a stylus,
not visible here, and a tablet on which she inscribes the deeds of heroes;
Terpsichore (dancing and song), a *kithara*; Urania (astronomy), a globe and
a staff which perhaps she used as a pointer; Melpomene (tragedy), a tragic
mask, here raised, also sometimes a sword.

On the lid we see a celestial banquet of Satyrs and Maenads, the followers
of Dionysus, somewhat resembling the Etruscan funeral banquet, only a
good deal more informal [1.4]. The state of 'enthusiasm', or possession by the
god, to which such occasions gave rise, was likened to the intellectual
intoxication which the Muses inspired. Socrates had explained it this way:
'The composers of lyrical poetry create those admired songs of theirs in a state
of divine insanity, like the Corybantes, who lose all control over their reason
in the enthusiasm of the sacred dance; and, during this supernatural
possession, are excited by the rhythm and harmony which they communicate
to men. Like the Bacchantes, who, when possessed by the god, draw honey
and milk from the rivers, in which, when they come to their senses, they find
nothing but simple water. For the souls of the poets, as poets tell us, have this
peculiar ministration in the world. They tell us that these souls, flying like

bees from flower to flower, and wandering over the gardens and the meadows, and the honey-flowing fountains of the Muses, return to us laden with the sweetness of melody; and arrayed as they are in the plumes of rapid imagination, they speak truth.'[39] This was the reason for setting the Muses and Bacchantes side by side. The image of the banquet which initiates were allowed to share with the gods lasted into late antiquity until it was overtaken by the Christian concept of the sacred meal.[40]

SUMMARY

The earliest gods of the Romans were impersonal spirits inhabiting woods, rivers and places in the home. They began to acquire human form through Etruscan influence: about 500 BC a statue of Jupiter was made by an Etruscan sculptor for the Capitoline temple in Rome. It was via the Etruscans, too, that Roman gods first acquired the characteristics of the Greek pantheon. An early example of a direct Greek influence was the growth of the cult of Apollo at Rome which owed much to the oracle at the Greek settlement at Cumae on the coast of Campania. (The Sibyls of Apollo later had a role in Christian art.) In the last two centuries of the Republic the Romans began to appreciate Greek sculpture and painting for its own sake when large quantities were brought back to Rome as captured booty. The Greek myths were now used decoratively for wall-painting in private villas. At this period the Romans were developing an art form derived from Greek but which they made very much their own, the life-like portrait bust. Its inspiration may have owed something to the ancient Roman custom of preserving images of family ancestors.

In the Imperial Age art served the State. Under the patronage of Augustus, Rome's legendary history was celebrated in literature and sculpture. Abstract concepts such as Peace, Piety and Providence, on which the well-being of the emperor and the State depended, acquired the status of divinities and were personified in art. The victories of the Roman armies abroad were commemorated in detailed narrative scenes in reliefs on public monuments. The *votum*, or ritual pact with a god, was publicly adhered to by the emperors. The rite of absolution from the vow formed the culmination of the triumphal procession, certain features of which were derived from Etruscan ceremonies. All formed the subject-matter of relief sculpture.

The idea of the emperor as god was first promoted by Julius Caesar. In time, its acceptance became a test of loyalty to the State. The title *Divus* was eventually bestowed on the emperor in his lifetime and it was not unusual to represent emperors and their wives with the 'attributes' of gods and goddesses, especially the emperor as Jupiter. The emperor's image was often displayed frontally to enhance his authority and divinity, a convention that was carried over into Christian art. The apotheosis, or deification, of an

emperor was celebrated after his death. He is represented ascending to heaven perhaps accompanied by his wife.

Evidence for Roman beliefs about life after death is found in funerary reliefs where the Greek myths were used allegorically to describe many aspects of the progress of the soul in the afterlife. Among others, they illustrate the Stoic concepts of the successive ages of the world and the purification of the soul by fire (the latter finding an echo in the Christian doctrine of Purgatory); the journey of the soul to the Isles of the Blessed; and the ideal of the ascetic philosopher as the embodiment of virtue.

The First Centuries
of Christian Art

HOW CHRISTIAN ART BEGAN

CHRISTIANITY IN ITS earliest stage was only one of several sects within the Jewish religion. The first Christians were Jews who followed the rites and teaching of Judaism, but they were unique in one important respect. The Jews, through the writings of their prophets, had come to expect the arrival in the near future of a great leader, a Messiah of David's line, the 'branch from the root of Jesse', who would in a quite literal sense deliver them from their enemies and establish a kingdom of paradise on earth. The object of the first Christian apostolic missions from Jerusalem was to persuade neighbouring Jewish communities that the heralded Messiah had arrived in the person of Jesus. The movement was led by Peter; a second, under Paul, was directed towards the non-Jewish world. The two apostles are often represented together in art as the personifications of the Church's mission in these two fields, Jewish and Gentile (p. 282).

We do not know exactly how or when the first Christian community was established in Rome. According to several very early traditions Peter was its founder and its first head, and it appears that his martyrdom took place there during the persecution of Christians under Nero which followed the great fire in AD 64. Paul, who had come to Rome in the year 60, was executed about the same time. Eusebius, bishop of Caesarea, writing in the first decades of the fourth century, quotes a priest named Gaius who had lived at least a century earlier and had described the place where the apostles' remains had been laid: 'If you will go as far as the Vatican or the Ostian Way, you will find the monuments of those who founded this church.'[1]

The first three centuries of Christianity were punctuated by outbreaks of persecution by the Roman authorities in which numbers of Christians died in circumstances of savage cruelty. But it was also a time of rapid growth for the Church; the orders of clergy were set up, a liturgy was established and questions concerning orthodox doctrine, which sometimes proved to be so thorny, were first tackled. All these aspects of the Church's history at that period had, as we shall see, an impact on its early art.

Opposition to images

At first, Christians appear to have rejected any kind of imagery in connection with their worship or with their burial rites. The Decalogue was binding on Christians as well as Jews, and the second commandment forbade them to 'make a carved image for yourself nor the likeness of anything in the heavens above, or on the earth below, or in the waters under the earth.'[2] Images, especially statuary, were moreover an essential part of pagan worship and for this reason too were condemned by the Church Fathers.

Some of the first Christian images appeared on sacramental cups, lamps and seals and on the walls of the Roman catacombs where everyday objects were used as symbols to express a limited number of simple ideas about the Christian religion. Clement of Alexandria allowed that the seal on the signet-ring of a Christian might depict a dove, a fish, a ship in full sail, a lyre or an anchor. 'For we are not to delineate the faces of idols, we who are forbidden to cleave to them.'[3] The first three are familiar Christian symbols (pp. 86, 73, 84). The lyre was the instrument of Orpheus, the shepherd of classical myth with whom Christ, the Good Shepherd, was identified (p. 65). The music of Orpheus which charmed the animals, was likened to the power of Christ's words which overcame man's baser, animal nature. The anchor stood for the hope of salvation[4] and its somewhat cross-like shape gave it extra significance. Tertullian (c. 160–230), a contemporary of Clement, mentions an image of the Good Shepherd on a eucharistic cup.[5]

The earliest truly representational Christian art in Italy is seen on the walls of underground cemeteries, or catacombs. It is found mainly in Rome, but also in Naples, and is thought to date from about the year 200 onwards. This art, like the sculpture on later Christian sarcophagi, could not by its very nature be regarded as idolatrous though, as we shall see, it contained the seeds of a belief in the power of magic. It was not until the fourth century, when Christians were permitted by law to practise their religion and their art emerged above ground, that the use of images began to be questioned once more.

The purpose of art for early Christians

What purpose did art serve within the new religion? It is usually said that the Church permitted the use of images in order to teach religious history and dogma, especially to the illiterate. But that view was not explicitly formulated until the end of the sixth century by which time Christian art had been in existence for four hundred years. By then the fears of the clergy about idolatry had been fully realized. It was not unusual, for example, to prostrate oneself on the ground before the image of a sacred person, just as the heathen did before his gods. This practice, which was specifically forbidden by the second commandment, was accepted in the Byzantine East and had become

the custom in the western Church as far as Gaul. Serenus, a reforming bishop of Marseilles, took the drastic step of throwing images out of his own church. This provoked the well-known letters from Pope Gregory the Great (p. 4) which drew a distinction between pictures as a means of instructing the unlettered and as objects of adoration. They should be retained for the former purpose but at the same time it was the bishop's duty to take care that 'people sin not in worshipping them', a notable compromise that for centuries served as a guideline for the West.[6] But back in the third century what were the reasons which led Christians to introduce art into their religion?

Before looking at the paintings in the Roman catacombs let us first turn briefly to an eastern outpost of the empire. Excavations at the Roman garrison town of Dura-Europos on the Euphrates have revealed wall paintings in a Christian house and in an adjoining synagogue which date from about the year 230. So by this time there had been some relaxation, even within the Jewish religion, of the prohibition against images. We do not know how widespread the movement was, but it seems reasonable to infer the existence of similar painting in Rome at this period, both among the Jewish community and in houses where Christians met for worship. But none remains. The relationship between the two is not clear but it appears likely that Jewish representational art actually preceded Christian and was in some way the cause of its adoption by the younger, breakaway religion.

The frescoes in the synagogue at Dura depict scenes from the Jewish Scriptures, in particular ones that illustrate the power of the God of the Jews to protect his chosen people and to lead them to the fulfilment of their destiny. Thus we find scenes depicting the crossing of the Red Sea and the return of the Ark of the Covenant to Jerusalem. The hand of God, symbolically controlling the fate of the Israelites, sometimes appears in the heavens above, a motif that occurs later in Christian art where it stands for the First Person of the Trinity [3.19]. In the Christian house at Dura the paintings were on the walls of a room that was used as a baptistery. The central figures represent the Good Shepherd beside Adam and Eve, a combination of images that must be intended as a reference to the Christian doctrine of the Fall and Redemption. There are also scenes from the Old and New Testaments which seem to allude to the rite of baptism and to the resurrection for which baptism was a necessary precondition.

Another instance of the likely influence of Jewish religious art on Christian imagery is seen in the figure of Orpheus. As already noted, the legendary poet and musician had a connection with early Christian belief, and several of the early Fathers drew comparisons between Orpheus and Christ. There had been aspects of the Orphic cult in ancient Greece which foreshadowed Christian teaching, such as the idea of sin and atonement, the purification of the soul, the suffering and death of a god-man, and the

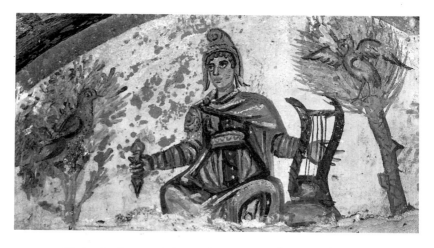

3.1 Christ-Orpheus with lyre and plectrum. He wears a 'Phrygian cap',
usual for Orpheus in late Roman art. It was originally the ritual headgear
of the magi, the priests of Mithras, and they are generally thus represented
in the 'Adoration'. 4th cent. AD. Catacomb of SS. Peter and Marcellinus,
Rome.

Harrowing of Hell. But the image of Christ-Orpheus in early Christian art
seems to be derived from a pre-Christian Jewish literary and pictorial
tradition which had assimilated the pagan god with David. There are
examples in Jewish art at Dura and Gaza. Both were poets and shepherds
and both used the power of music to drive out evil spirits. The early
Christians took over the Jewish image of David-Orpheus, transforming it
into Christ, of whom David was the ancestor. They substituted sheep for the
original wild beasts and, later, a harp for the lyre or pan pipes. There are
examples in several of the catacombs [3.1]. In the catacomb of Domitilla the
figure of Christ-Orpheus holds pan pipes. Although the Christian image
seems to have been confined to Rome and central Italy and died out after
about 400, the idea of David, the 'Orpheus of the Lord', survived in
Byzantine illuminated psalters that were produced between the tenth and
twelfth centuries.[7]

FUNERARY ART: (1) THE CATACOMBS

The earliest frescoes in the Roman catacombs belong to much the same
period as the paintings at Dura. Though they abound in scenes from the Old
and, later on, the New Testament, they do not often appear to illustrate
dogma. Nor are they simply narrative descriptions of stories from the Bible.
The figure of Christ appears rarely, and not at all in the earlier frescoes. There
are no episodes from the Passion. The treatment of the scenes is often merely

schematic, a kind of shorthand, as if the artist had confined himself to sketching only the minimum needed to identify them. Motifs are sometimes even transposed from one scene to another where they do not belong. This suggests that they were probably not intended as a visual text-book of the Bible. The choice of subjects almost certainly indicates another purpose. Like the frescoes in the synagogue at Dura they were meant to demonstrate the power of the deity, but they also did something more. They provided the assurance that the Christians whose tombs they decorated would enjoy salvation and eternal life after death.

Cemeteries were situated outside the walls of a town. The Roman catacombs are found alongside the main roads leading from the city. They consist of networks of underground galleries cut into the soft rock and altogether are many miles in length. Leading off the galleries are small cell-like rooms (*cubicula*) with niches in the walls for the dead [3.2]. Larger niches, arched at the top (*arcosolia*), served as graves for the more honoured. In time, because of overcrowding, niches were also cut in the walls of the galleries which were gradually filled, row upon row. The peculiar character of the catacombs derives from their use as a place where bodies had to be preserved. There were two reasons for this. So far as Christians were concerned (and both Christians and pagans were buried in the catacombs), the deceased were awaiting the Final Judgement when 'many of those who sleep in the dust of the earth will wake'. Also, the remains of the early martyrs, many of whom were buried here, were revered and great importance was attached to their preservation. The paintings covered the walls and ceilings of the cubicles and the *arcosolia*.

The praying figure

The standing figure, portrayed frontally with arms raised and hands spread, recurs constantly in catacomb painting. This was an ancient attitude of prayer, called orant [8], and is seen on Etruscan and Roman monuments. To the Romans it signified Pietas (p. 38) and is found on pagan sarcophagi where it sometimes accompanies the figure of a shepherd bearing a sheep who stood for Humanitas, love of one's fellow men. Christians adopted this attitude while praying and they also sometimes prostrated themselves (*proskynesis*) or knelt and maybe clasped their hands. But in their early art it was the orant that typified prayer, usually implying supplication or thanksgiving, as in the scenes of the three Hebrews in the fiery furnace [3.3] or Daniel in the lions' den. In catacomb painting the figure is most often intended to represent the soul of the deceased after death. It is then generally female, according to the tradition of such personifications. Orant and shepherd figures, like ones that already appeared on pagan sarcophagi, are found on the ceilings of cubicles where they have become symbols of the soul glorifying God and of Christ the Good Shepherd.

The resemblance between the orant pose and the figure of Christ on the cross was not lost on Christians. Tertullian said, 'We not only lift up our hands but even spread them out, modelling them after the Lord's passion.'[9] Later, in the frescoes and mosaics of early Christian and Byzantine churches we find the martyr-saints and the Virgin Mary as orants [3.21]. Here they are suppliants, interceding with God on behalf of the faithful, an important and continuing role of the saints and the Virgin, as we shall see. At the same time

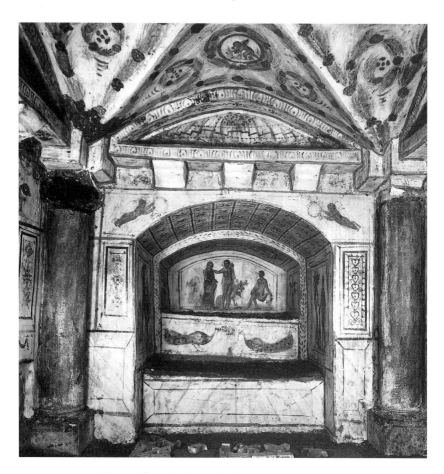

3.2 General view of a *cubiculum* with three *arcosolia*. The wall-paintings depict the exploits of Hercules. On one side is the slaying of the Hydra, on the other, the Garden of the Hesperides. On the back wall Hercules brings Alcestis back from the underworld, an exemplar of salvation, of which there are numerous biblical instances in the catacombs. The peacocks below were pagan and Christian symbols of eternal life. Mid 4th cent. New catacomb of the Via Latina, Rome.

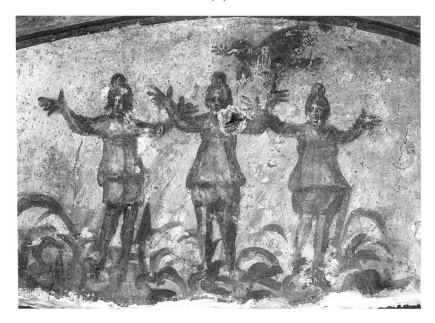

3.3 The three Hebrews in the fiery furnace. Each wears a Phrygian cap
[cf. 3.1]. Catacomb of Priscilla, Rome. Mid 3rd cent.

they served to remind the spectator that the martyr suffered a similar fate to
Christ.

Old Testament scenes and cycles

The Old Testament was the sacred literature of the Jews. Christians, from
the first, insisted on its fundamental unity with their own holy books, the
gospels, and on its continuing relevance to their beliefs. The God of Israel
was one with Christ. His ancient power to protect the Jews, which was
illustrated in the Dura synagogue, was extended equally to the followers of
Jesus, the earliest of whom had in any case been brought up within the
traditions of the Jewish religion.

The first Christian paintings in the catacombs are from the Old
Testament. Certain scenes are repeated again and again, suggesting that they
held some special meaning, or were inspired by a source other than the Bible.
The earliest Christian prayers of which there is any record were said for the
dead. God's salvation was sought for their souls by evoking examples, from
the history of Israel, of his action in delivering the faithful from harm.
Fragments of these old prayers, probably derived originally from Jewish
liturgy, have come down to us and are preserved in the 'Recommendation of
the Soul' (*Commendatio animae*) which is said today in the Catholic Church.

For instance, 'Deliver, O Lord, the soul of thy servant, as thou delivered Noah from the flood,' and similarly Job from his sufferings, Isaac from sacrifice at the hand of Abraham, Daniel from the lions' den and so on. These very instances, a dozen or so in all, correspond to the most frequently depicted scenes in the catacombs.[10] It seems that the paintings, like the spoken words of the prayers, were meant to help the departed soul on its way, except that the images remained to exert a continuing influence after the prayers had ceased. We are reminded of the paintings in the tombs of the Etruscans which served a similar magical purpose.

The idea of a divinely ordained continuity between the Old Testament and the New led eventually to the belief that the great figures of Jewish history somehow foreshadowed Christ. It was an important influence on Christian art in the Middle Ages and later, though it is premature to look for it in the catacombs. Moses, the pre-eminent prototype of Christ, is often represented striking the rock from which water miraculously gushed. Later, this was taken to prefigure the miracles of Christ, in particular the changing of water into wine at Cana, but here it is more likely intended simply as another example of salvation. The same applies to the frequently-appearing figure of Jonah. Though his adventure with the sea-monster was compared by Christ himself to his forthcoming death and resurrection,[11] it was not until the twelfth century that it came to have this meaning in art.

In the fourth century many more subjects from the Old Testament were introduced into the catacombs. The treatment became more elaborate and detailed, giving the frescoes a more narrative character, less easily reconciled with the idea of the soul's salvation. By then Christianity was a lawful religion and the first churches were being built and decorated. Christian art above ground was showing the first signs of an historical sense which was perhaps being reflected also in the paintings in the catacombs. Even so, scenes of dying were still avoided perhaps because, for the Christian, his end was a victory over death.

The New Testament

Catacomb art was, again, very selective in its choice of subjects from the New Testament which suggests that something more than mere visual instruction was intended. In the third century, when gospel illustrations first appeared, we find two scenes which are particularly important in later Christian art, the Annunciation to the Virgin Mary by the archangel Gabriel [12] and the Adoration of the Magi.[13] They were reminders that God had come to earth in the person of Christ, in other words, was incarnate or 'made flesh'.

The Adoration also contained a much more ancient idea, pre-Christian in origin. The act of showing a god to his worshippers, known as theophany, was one of the rites of early religions. The Theophania were originally pagan

religious festivals at Delphi when images of the gods were displayed to the people. At the beginning of the Christian era a number of 'mystery' religions flourished in the Roman Empire in which the ritual of initiation involved the momentary unveiling of the god's image. The action was intended to induce a state of ecstasy, or enthusiasm, in the worshippers. There was a powerful sense of occasion about a theophany and, not surprisingly, it was exploited by the Roman emperors to promote the idea of their own divinity. The birth of an emperor, his accession to the throne, and in particular the giving of an imperial audience were treated ritually as a theophany. Later when Christian attitudes began to reflect the features of emperor-worship (p. 91) certain events in the life of Christ came to be regarded as a theophany or, to use the Christian term, epiphany. The homage of the Persian magi before the infant Christ was thought of as a Christian version of the rite of obeisance before the enthroned emperor. Moreover, since magi were the priests of the god Mithras, whose cult was the most widespread of the mystery religions of the time and the principal rival to Christianity, the scene also symbolized the victory of Christianity over this popular brand of paganism.

From about the end of the third century scenes of Christ's miracles began to appear in the catacombs. At first there seems to have been some reluctance to portray the figure of Christ himself, and some familiar symbol such as the lamb was substituted. The Healing of the Paralytic[14] and the Raising of Lazarus[15] occur regularly, confirming the power of God to save those who believed in him. Another class of subjects depicted the sacramental meal and its elements, the bread, fish and wine. This was a rite central to Christian worship and had a permanent place in its art.

The sacramental meal

So long as they were still liable to persecution, Christians held their assemblies in burial places where, under Roman law, they were safe from being molested. The focus of the meeting was the celebration of the eucharist, the ritual meal which commemorated the actions of Christ at the Last Supper.[16] It was generally preceded, or sometimes followed, by a more informal repast, the *agape*,[17] sacramental in character and shared by all, at which the rich provided for the poor. The intentions of the *agape* were abused by some communities, it fell into disrepute,[18] and was eventually prohibited by the Church. Another form of the *agape*, a feast in honour of the dead, especially the martyrs, was held at the tomb of the deceased.

A form of sacred meal, as we saw earlier, was celebrated by the Etruscans, and was a rite common to many ancient religions. Its purpose was to obtain immortality for the worshipper either by sharing food, that is, the remains of the sacrificial victim, with the god, or, since the god was sometimes held to be present in the animal, actually consuming the deity himself. Christians, though they substituted bread for the traditional victim, believed they were

3.4 The Miracle of the Loaves and Fishes. On the left, Christ the
Lamb touches the baskets with a wand. Mid 4th cent. Catacomb of
Commodilla, Rome. (Compare 3.19, middle, *right*.)

symbolically performing a similar act. In the early Christian era the sacred
meal was still a feature of certain pagan cults. Justin Martyr (*c.* 100–*c.* 165), a
Christian apologist whose works are an important source of information
about the early Church, noted that the followers of Mithras, after their
initiation into the mysteries, took bread and a cup of water ritually.[19]
Tertullian, who drew attention to several similarities between the rites of
Mithraists and Christians, saw in the former's sacred meal a deliberate
imitation of the eucharist, inspired by Satan.[20] There were certainly aspects
of the Christian sacrament that bore traces of outside influences and of an
older ancestry, and art provides some of the evidence. It will be seen that the
form in which the rite was actually practised by the very early Church was
different in some respects from the version with which we are familiar from
St Paul and the gospels.[21]

Eucharistic elements in the early Church

The eucharist is sometimes represented in catacomb art by the Miracle of the
Loaves and Fishes (the Feeding of the Five Thousand). Christ is the only
person present. He stands beside a number of baskets of bread, usually seven
as mentioned by Mark,[22] and touches them with a wand. In the earliest
examples the figure of Christ is replaced by his symbol, the lamb [3.4].
Bread, or cakes, had long been a sanctified food. In Greek and Roman
religion it was eaten ritually as part of the Eleusinian mysteries which
honoured the corn-goddess, Demeter. Bread was important too in Jewish
ritual. The golden table of the shewbread in the temple [2.11] was used for

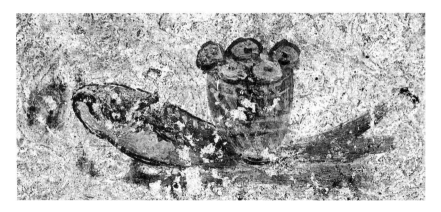

3.5 The eucharistic elements. Besides the fish and bread, wine is
suggested by patches of red on the basket. Early 3rd cent. Catacomb of
St Callistus, Rome.

loaves that were consumed sacramentally by the priests.[23] The feast of
Passover, which was the occasion of the Last Supper, was also called the
'festival of unleavened bread', and was originally connected with the spring
harvest.[24] In some Near-Eastern cults even the basket itself was sacred. The
type which appears in Jewish and Christian art is the *kalathos* [3.4, 3.19] and,
like the cornucopia of the Greeks which it somewhat resembles, was once
associated with the fertility of the fields.

Fish, together with bread and wine, are depicted in the catacombs as a
composite symbol of the eucharist [3.5], probably because the elements of the
original Christian repast included all three. It is likely that this custom was
taken over from an older Jewish ceremonial meal of a similar kind.
Eventually the use of bread and wine alone prevailed. The fish lingered on in
art for a few centuries as a symbol of Christ, but no longer represented one of
the sacrificial elements of his body. Its popularity with Christians was
upheld by the discovery that the Greek word for fish formed an acrostic on
the names of Christ,[25] and by the apt metaphor, used by early writers, of the
faithful as little fishes (*pisciculi*) swimming in the waters of baptism.[26]

Wine had a long history as an adjunct of religion. Worship of the Greek
god Dionysus which was widespread in the Mediterranean and the East was
associated with the cultivation of the grape. The Etruscans knew him as
Fufluns and the Romans as Liber, or Bacchus. The image of a cup or a wine
jar, a cluster of grapes or a vine symbolized the eternal life that his devotees
would enjoy through drinking the 'blood' of the god. An overflowing vase
was the typical emblem of the life-giving fluid in ancient Babylonia and
Syria. Among the Jews the drinking of wine was a ritual, and took the form
of a 'cup of blessing' on the Sabbath and at festivals. It would therefore have

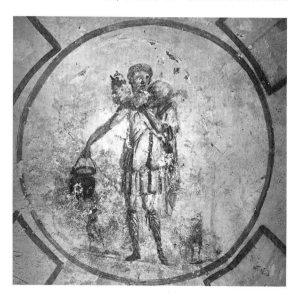

3.6 The Good Shepherd with a milk-pail. Early 3rd cent. Catacomb of St Callistus, Rome.

been familiar to the first Jewish Christians at the time they were establishing their own liturgy.

The cult of wine was only one aspect of a much broader devotion among ancient peoples to sacred liquids that were regarded as a divine source of life. Water, milk and even seminal fluid were all at one time the object of veneration. Milk, which was to become a feature of the cult of the Virgin in the Middle Ages, was for a while adopted by early Christians as a symbol of the sacrament and was used by certain sects at the eucharist instead of wine. The Good Shepherd in the catacomb of St Callistus is holding an earthenware milk-pail (*mulctra*), which is to be understood in this symbolic sense [3.6].

The heavenly banquet

An everlasting banquet in the hereafter was the promised reward of the faithful in pagan religions. In Christian art the scene of a banquet appears in the third century but sometimes in a style so schematic that it is difficult to be sure if it represents the afterlife, a funeral feast, an episode from the gospels such as the Last Supper, or simply the everyday *agape*. Banqueters, when attended at table by the female personification of Peace (Irene) and Love (Agape), would seem to be enjoying a heavenly meal.[27] A typical Christian formula, occurring several times in the catacombs, depicts seven persons seated not at a table but, apparently, at a long, curved, bolster-like object.

The number seven seems to be significant and suggests that it does not represent the Last Supper [3.7]. There is a clear parallel with this scene in the catacombs in a burial chamber dedicated to the god Sabazius. The cult of Sabazius, who was often identified with Dionysus in Greece, became popular in Rome in the second century AD. In his shrine is a series of four frescoes depicting the progress of the soul of a man and a woman to the afterlife. In the last of the series [3.7] the man has finally taken his place at a celestial banquet as one of the 'Seven Pious Priests' of Sabazius. The

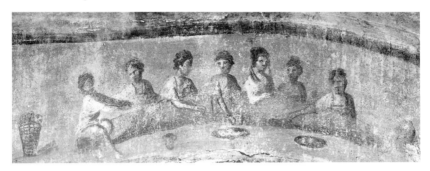

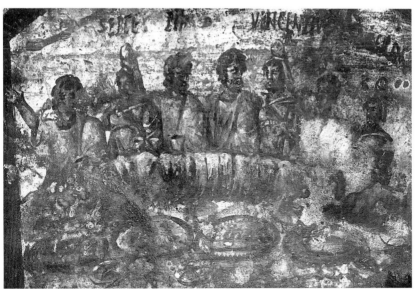

3.7 (*Above*) 'Fractio panis', the breaking of bread – probably a eucharistic celebration, or an *agape*. Beside the seven figures are seven baskets of bread (not all shown) of the same kind as in 3.4. First half of 3rd cent. Catacomb of Priscilla, Rome. (*Below*) Heavenly Banquet of the Seven Pious Priests of Sabazius. 4th cent. Burial chamber attached to the catacomb of Praetextatus, Rome.

3.8 Veneranda led to heaven by the martyr, St
Petronilla. Images of the deceased were rare in funerary
art before the 5th cent. Mid 4th cent. Catacomb of
Domitilla, Rome.

similarity to the Christian repast is unmistakable. These images suggest that
Christian ideas about the hereafter were influenced at this period by pagan
mystery religions. Christians, like Greeks, Etruscans and Romans before
them, seem to have believed that the soul, after death, would participate in a
heavenly banquet, or *agape*.[28]

Martyrs and intercessors

As well as their regular gatherings which centred upon the eucharist, the
early Christians held special meetings to remember those who died for the
faith. The reverence they felt for martyrs was the beginning of the great cult of
saints and their relics that grew up later and is everywhere visible in Christian
art. Many were buried in the catacombs. It was customary to assemble at the
burial place of the martyr for prayer and a ritual meal at which the tomb itself
served both as an altar and a table. The anniversary of the martyr's death,
known as his 'birthday' (*dies natalis*) was specially celebrated. Such rites
probably owed something to more ancient forms of worship which had
existed among the Greeks and Romans. It had been the custom, as we saw,
to offer prayers and sacrifices to one's ancestors, so that, in the course of time,
they acquired heroic status and divinity (page 53). In the Christian era

families continued to pray at the tombs of their own, more recent, dead, but now they called on them to intercede with God on behalf of the living. 'Januaria, be very happy and plead for us,' is a typical inscription of this kind in the Roman catacombs. Eventually these prayers for intercession, through which the believer hoped to obtain his own salvation, were transferred from deceased relatives and addressed to the martyrs.

In the catacomb of Domitilla is a scene of intercession [3.8]. It is one of the earliest images of its kind and is the first to depict a Christian martyr. On the left, the soul of the deceased, named Veneranda, stands with her hands raised in the orant's attitude of supplication. Beside her is the martyr Petronilla, pleading with God on behalf of Veneranda that she may be allowed to enter paradise. One hand rests on the deceased's shoulder, the other is extended towards a cylindrical box holding a number of scrolls. These are the gospels which are the evidence of Veneranda's faith.[29] The role of saints as intercessors was eventually extended to the Virgin Mary and became one of their principal functions in the medieval Church. The image played a vital part in this devotion, providing a focus for the prayers of the living which were addressed to the intercessor so that, through him, God's mercy might be invoked. The theme had a continuous evolution. In the Renaissance it formed part of the composition of the Sacra Conversazione in which a kneeling donor is presented at the throne of the Virgin by his patron saint. The invocatory inscriptions on the walls of the catacombs, like the images to which they were related, were placed there in the belief that they had the same kind of influence as the spoken prayer. Like other catacomb paintings, that influence remained to do its work after the words had ceased.[30]

FUNERARY ART: (2) THE CHRISTIAN SARCOPHAGUS

The new religion began to attract converts from rich families, increasingly so after the granting of toleration in 313. They brought with them the pagan custom of burying their dead in a stone chest. The relief sculpture on sarcophagi was not merely an adornment for those who could afford it, it was intimately related, like the frescoes in the catacombs, to belief in the hereafter. At the same time, by its magical influence, it aided the soul on its journey to paradise. We saw how the idea of the soul's purification and journey to the Isles of the Blessed was expressed symbolically on pagan sarcophagi by using the classical myths. The Christian coffin made use of symbolism in a similar way, expressing the Christian's hope for immortality in scenes from the Old and New Testaments.

The main centres for the production of relief sculpture in the Hellenistic era were Asia Minor (especially Pergamum and Rhodes) and Alexandria, and the art of those schools influenced the workshops that were set up later at

Rome and Ravenna. The style of the Italian products was Greek in inspiration but it is often difficult to determine whether the sculptors were Greeks or were Italian workmen trained by them.

Stone carving is an inflexible medium compared with paint. The painter of the catacombs enjoyed a freedom of expression denied to the sculptor of a sarcophagus and the latter was therefore more inclined to make use of existing formulas when called on to deal with new ideas. For instance, the type of the ascetic philosopher (p. 59) who was represented seated, holding a scroll book (*volumen*), with one of the Muses standing beside him, was used again for Christ, the founder of the 'true philosophy', whose scroll became the gospels. The Muse was sometimes in the orant attitude, so that she became an image of the soul of the deceased. There are many instances of this process, especially in relief sculpture. The sleeping Endymion of Greek legend became the figure of Jonah reclining in the shade of the gourd. The vine motif that originally denoted the rites of Dionysus was turned into a symbol of the Christian eucharist.

The medallion portrait

The medallion portrait, that is, the head and shoulders within a circular frame, was an artistic formula with a long history that was carried over into Christian art, appearing in the catacombs, frequently on sarcophagi, and later in the mosaics of churches. It is also called a *clipeus* (or *imago clipeata*) because the shape resembled the round bronze shield of that name used by the Roman soldier. Pliny describes the ancient custom of decorating a shield with the portrait of one's ancestor and hanging it in a temple or other public place.[31] For the Romans, the portrait had always had a special significance from the days when the masks of ancestors were carried at a funeral procession (p. 35). It summoned up the presence of the dead person and thereby helped to ensure his immortality. The *clipeus* was a feature of Roman tombstones and sarcophagi. The portrait itself represented the deceased's soul whose continuing existence was somehow guaranteed by being perpetuated in stone. The circular surround would be either a simple disk, a shell or a laurel wreath, the latter signifying the victory of the soul over death. The wreath was sometimes surmounted by an eagle, the sun-god's messenger, which bore the soul to heaven. Some of these motifs were retained on Christian monuments, for example the laurel, which now symbolized the Christian victory over death [3.11], and the winged Genii that supported the disk, and were readily turned into Christian angels [4.6, 4.10].

The sarcophagus of Junius Bassus

Junius Bassus was a Roman prefect, a convert to Christianity, who died in 359. His sarcophagus [3.9] is of the columnar type, that is, the relief consists of a colonnade of pillars (in his case two, one above the other). The columnar

(a) (b) (c) (d) (e)

(f) (g) (h) (i) (j)

3.9 (*Above*) The sarcophagus of
Junius Bassus. (*Left*) Christ
handing over the law (*Traditio
legis*) (panel *c*). He is short-
haired, youthful and beardless, a
type derived from classical figure
sculpture and the most usual form
of early image [cf. I.1, 3.10, 3.17,
4.14]. Mid 4th cent. Vatican
Museums.

sarcophagus is first found in Asia Minor. Its distinctive style may have been
copied from the colonnade that formed a wall behind the stage of the open-air
theatre where statuary normally stood. It was first imported to Ravenna from
Constantinople in the later fourth century and began to be produced in Italy
and Gaul at about the same time. It marks the beginnings of eastern influence
on Christian art in the West. The sarcophagus of Junius Bassus has in the
upper register a level entablature joining the columns and in the lower an
alternating gable and arch. Both are typical of the columnar style. The space
between each of the columns forms a niche which contains a miniature
scene, reduced to its bare essentials by the limitations of space.

3.10 Handing over the Law. The apostles approach Christ with veiled hands [cf. 3.17]. Christian sarcophagus, 5th cent. S. Apollinare in Classe, Ravenna.

There are three scenes from the Old Testament inspired by the ancient prayers for the salvation of the soul: the Sacrifice of Isaac (*a*), Job on the dunghill (*f*) and Daniel in the lions' den (*i*). The other Old Testament subject is Adam and Eve and the serpent (*g*). As in the Christian baptistery at Dura (p. 65), it alludes to the doctrine of the Fall and Redemption which taught that Christ by his death on the cross redeemed man from the original sin that he inherited from Adam. To complete the cycle of images one might therefore have expected the scene of the crucifixion, but at this period Christian art generally avoided the subject. Instead, we are given a sequence of earlier events from the Passion that serves the same purpose: the Entry into Jerusalem (*h*), Christ before Pilate (*d*) and Pilate washing his hands (*e*).

In the centre panel in the top row (*c*) is a scene that occurs very frequently on sarcophagi and in mosaics of fifth and sixth-century churches, the *Traditio legis*.[32] Christ is enthroned in heaven and is in the act of 'handing over the Law' to Peter, while Paul stands by [3.9]. He is charging the apostles with their mission to the world. Below the feet of Christ appears the head of Caelus, the classical personification of the heavens, his billowing drapery forming the bowl of the sky. The theme of the *Traditio legis*, which often occurs on sarcophagi [3.10], has no scriptural basis. It was derived from imperial art, where the image of the emperor enthroned on the universe symbolized his world-wide sovereignty. The action of handing over a scroll also occurs on imperial reliefs where the ruler is shown delegating authority or distributing largesse, as for instance on the Arch of Constantine (p. 51). The remaining two scenes (*b* and *j*) allude to the martyrdoms of Peter and Paul, though the actual scenes of their death are avoided. Instead, they are seen receiving judgment after their arrest.[33]

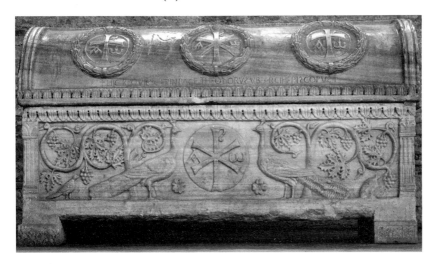

3.11 Christian symbols on the sarcophagus of Theodore, Bishop of
Ravenna. 5th cent. S. Apollinare in Classe, Ravenna.

The sacred monogram

Between the fourth and sixth centuries sarcophagi were imported from
Constantinople into Ravenna and influenced the style and iconography of
those that were being produced in the latter city during that period. Very little
work then originating in Constantinople itself has been preserved because it
was destroyed by the Moslems, but its character can be inferred from
examples that survive elsewhere. In the reign of Constantine the Great
(313–37) the use of monograms for Christ's name was introduced from the
East and became a decorative feature of religious art in Ravenna. The
sarcophagus of Theodore, bishop of that city, dating from the fifth century, is
a good example of the use of non-figurative symbolism [3.11].

The shape of the lid is a half-cylinder. It is typical of Ravenna sarcophagi
of the period which, by various means, imitated architecture in order to
suggest a house for the dead. It is decorated with three medallions formed of
laurel wreaths, a development of the older *clipeus* portrait. The monogram in
the central medallion on the lid, repeated on a plain disk on the façade below
(and with modifications on the lateral medallions on the lid), is a
combination of the Greek letters X and P (*chi, rho*), the first two letters of the
name of Christ. It was widely used as his symbol, at first simply as a short-
hand device in writing. It also appeared on the standards of the Roman
legions in the latter part of Constantine's reign, as we know from
contemporary coins. This strongly suggests that the army fought under a
Christian banner but we cannot be quite sure because the sign appears to
have been used also by non-Christians to denote 'good augury', from the

Greek word *chrestos*[34]. The letters A and ꞷ, incorporated in the same monogram, are *alpha* and *omega*, the first and last letters of the Greek alphabet. They are derived from the Book of Revelation,[35] and stand for the idea of God as the beginning and the end of all things. The Apocalypse, as we shall see, would later contribute a number of important themes to Christian art.

Non-figurative decoration

Typical of Ravenna sarcophagi is the highly decorative use of birds and animals within the scrolls of the vine, motifs that originated in Syria and regions further east and north. Symmetry is much favoured, for example a pair of lions facing each other on either side of a tree, or two peacocks separated by a vase, the latter an old symbol of the Fountain of Life [4.12].

The peacock found its way into western art, having come from as far away as India. There, the tradition existed that to eat its flesh was to receive eternal youth and life. The idea of immortality was seldom absent from its image. In the temple of Artemis at Dura a pair of peacocks face each other and drink wine, the sacred fluid of life, from a vase standing between them. They are a common motif in the pavement mosaics of Antioch, whence they were introduced into the West. They were adopted very widely in Christian art as a symbol of eternal life. Their association with the vine is seen on the Ravenna sarcophagus of Bishop Theodore. The popular belief that the peacock's flesh was incorruptible was tested by St Augustine. In an engaging spirit of inquiry he once took a piece home after a banquet and reported with wonder that it had scarcely deteriorated after a whole year and that 'at no time did it emit any offensive smell'.[36]

CHRISTIAN ART AFTER AD 313

The year 313 was a turning-point in the history of the Church. The previous half-century or so had witnessed some of the most violent attacks yet on Christians so that it came to be known as the Age of Martyrs. In 312 the Emperor Constantine the Great had defeated his rival Maxentius in battle at Saxa Rubra, north of Rome, and assumed overall power in the West. Next year the so-called 'edict of Milan' was issued 'granting to the cult of Christians and to all others full authority to follow whatever worship each man has desired, whereby whatsoever divinity dwells in heaven may be propitious to us and to all who are placed under our authority'. Though Constantine received Christian baptism on his deathbed a quarter of a century later, at this stage of his career his gods were still those of the Roman State. The reliefs on his triumphal arch, erected at Rome in 315, show no trace of Christian symbolism.

From this moment the Christian Church began to grow rapidly while imperial power went into decline. In 330 Constantinople was founded as

capital of the eastern Empire, and, thanks partly to its well-protected situation, survived all threats to its existence until the end of the Middle Ages (p. 106). The West fared worse. In 404 the seat of Empire in Italy was moved from Rome to Ravenna and six years later the Eternal City was sacked by Alaric, king of the barbarian Visigoths. The shock reverberated through the whole of the civilized world. Some blamed the disaster on the rise of the new religion of Christianity which had caused Rome's old tutelary gods to forsake her. 'It was this,' wrote St Augustine, 'which kindled my zeal for the house of God, and prompted me to undertake the defence of the City of God against the charges and misrepresentations of its assailants'.[37] Rome's gods, he said, were no more capable of protecting her than Minerva had been able to defend Troy against the Greeks. Augustine's 'city' was the Christian faith and in the *City of God* he traced its foundations from the beginning of recorded history, as it was told in the Old Testament.

By the end of the fourth century Christianity had been made the sole religion of the State. The Church in the West, while she was converting the barbarian invaders to the faith, gradually assumed the mantle of dying imperial sovereignty. The process was increasingly reflected in Christian art.

The ship of the Church

Freedom to practise their religion had far-reaching consequences for Christians everywhere. Constantine had given Christianity a privileged status among the religions of the Empire, and his architects were now called in on its behalf. Buildings were specially erected as places of communal worship, sometimes on the site of a private house already in use for Christian assemblies, or at a place that possessed some special sanctity. In Palestine, churches were raised to mark the supposed sites of the Nativity and the Crucifixion and other events in the gospels. Pagan temples and imperial edifices were sometimes converted to Christian use, such as the mausoleum erected at Rome by Constantine for his daughter Constantia which was made into a baptistery, S. Costanza, in the fifth century. Another important function of a church was to provide a shrine for a martyr's remains. The art of mosaic, which up to now had been used mainly for pavement decoration, was applied with great effect to the walls of churches where it provided a brilliant visual rendering of the Christian faith.

The characteristic architectural style of the early church in the Roman West was the basilica [3.12]. In pre-Christian times buildings of this type had been used by the Romans as public halls, where the court of justice was held. It consists essentially of a wide, rectangular nave to which is added at one end a semi-circular apse before which the altar stands. The lateral walls of the nave are open colonnades beyond which is a side aisle, or sometimes two, separated by another colonnade. The upper walls of the nave are windowed (the clerestory) and the roof is of timber. Among the oldest

3.12 The early Christian basilica. Besides the apse (c),
other surfaces decorated with paintings or mosaic
were (a) the 'triumphal' arch – the façade surrounding the
apse – and (b) the lateral walls of the central nave below the
clerestory windows.

surviving examples in Rome are S. Sabina (p. 98) and S. Maria Maggiore
(p. 90), both founded in the first half of the fifth century.

Early writers compared the Church, that is, the whole body of Christians,
to a ship, and this was soon firmly established as a Christian metaphor. The
idea of a voyage of the spirit or of the soul's journey after death had been
familiar to the ancient world, Egyptians, Greeks and Romans. Tertullian
gave it a Christian gloss: 'Amid these rocks and bays, amid these shoals and
straits of idolatry, Faith, wafted onwards by the spirit of God, holdeth her
course.'[38] In medieval art, this symbolic vessel has a mast and yard-arm
resembling a cross. The Roman martyr Hippolytus (died c. 235) wrote, 'The
ark of Noah has become a figure of the Church.'[39] Noah himself stood for
Christ and when we meet him in medieval art we can usually assume that he
is to be understood in this sense.

It was customary to apply the same metaphor to the church building, as
we see from the word 'nave' which is from the Latin navis, a ship. The
Apostolic Constitutions, a compilation of liturgical practices put together
between the third and sixth centuries broadened the metaphor: 'When thou
[the bishop] callest an assembly of the church, as one that is the commander
of a great ship, appoint the assemblies to be made with all possible skill,
charging the deacons as mariners, to prepare places for the brethren, as for
passengers, with all due care and decency. And first, let the building be long,
with its head to the east, with its vestries on both sides at the east end, and thus
it will be like a ship. In the middle let the bishop's throne be placed, and on
each side of him let the Presbytery sit down; and let the deacons stand near at
hand, in close and small girt garments, for they are like the mariners and
managers of a ship.' The deacons' duties included keeping a watchful eye on

the passengers that none of them 'whisper nor slumber, nor laugh nor nod.'[40] The ship of the Church, with the apostles as mariners, found a permanent place in Christian art as an allegory of salvation in themes such as Christ stilling the tempest[41] and walking upon the water [42] [6.7].

Christian teaching: the persons of the Trinity

In 325 there was held the first of the periodical assemblies at which bishops from churches throughout the Empire gathered to discuss and pronounce upon matters of faith. The Council of 325 was summoned by Constantine and met at Nicaea in Asia Minor. The main question before it was one that continued to be a matter of debate among theologians for centuries and eventually caused deep divisions between the Churches: how to define Christ's nature, in particular the relationship between its two elements, the human and the divine. The first Council of Nicaea decided that Christ the man was in essence identical with God. For this it used the word 'homoousian' meaning 'of the same substance', and it summed up its conclusions in the Nicene Creed. Arius, a prelate of Alexandria who denied this essential unity between God the Father and Christ, was declared a heretic.

The divine aspect of Christ's nature was expressed by the Greek word 'Logos' meaning 'reason'. Christians called it the 'Word'. The idea it embodied already existed in Greek philosophy where it signified a divine intellect that permeated the universe and was its first cause. The concept was introduced into Christian thought by the author of the fourth gospel who identified Christ with the classical Logos.[43] Like God the Father, the Logos was eternal and already existed 'when all things began.' It was the source of all creation but, uniquely for Christians, it came to earth in the person of Christ. Thus the Word was 'made flesh', or incarnate. Let us look at some of the ways in which artists represented Christ and how they treated the Logos.

The physical appearance of Christ in the early centuries of Christian art varied from one place to another. In the catacombs he was often represented as the Graeco-Roman ideal youth, beardless and with short curly hair. The youthful type, with long hair, is also found on sarcophagi, and was derived from contemporary images of Apollo and Dionysus [3.9]. The bearded Christ, which eventually became the familiar medieval image, may have been influenced by the philosopher type on sarcophagi but is more likely to have been based on the Syrian and Palestinian tradition of representing eastern monarchs. This became the norm in the Byzantine East though early examples of it are rare. It is seen on oil flasks (ampullae) which pilgrims brought back from the Holy Land and which were probably copied from frescoes in churches that no longer exist. It is found also in an illustrated gospel book, the Rabula gospels, made in 586 in Mesopotamia.[44]

In art we recognize Christ by the cross on his nimbus and when we find this figure represented in a context other than a scene from his life on earth we may usually take it that a representation of the Logos is intended. But the term refers more strictly to the figure of Christ in scenes from the Old Testament, in particular the Creation, because it was through the Word that 'all things came to be.' The wall mosaics in the nave of S. Maria Maggiore which were completed under Pope Sixtus III (432–40) depict a cycle of stories about the Old Testament patriarchs. They were based on manuscript illustrations of the Septuagint (page 137) which was Jewish, not Christian, in origin, and have been modified by the mosaicist to suit Christian doctrine. Whereas Jewish art, as we saw at Dura, represented the deity by the hand of God, in the Christian mosaics at Rome it has been replaced by the half-figure of the Logos. Christ the Logos is generally enthroned above the scene of the Creation. He may be seated on an arc, representing heaven or, in the tradition of western art, on a globe.

The Logos with cruciform halo appears several times in the cycle of scenes of the Creation and Fall in the narthex of St Mark's, Venice (early thirteenth century) [4.13]. Here the figure accompanies Adam and Eve on earth and in the scene of the Expulsion thrusts them through the gates of paradise. It has been shown that the artist copied the illustrations in a sixth-century manuscript, the Cotton Genesis, or a work based on it.[45] The Cotton Genesis is in the same Alexandrian tradition of manuscript illumination which began with the Septuagint, and it may be significant that the early Christians of Alexandria, especially Clement, made the Logos a central part of their teaching.

The dove

The problem of representing the First and Third Persons of the Trinity (God the Father and the Holy Spirit), was, basically, their invisibility. Apart from the question whether the deity was a fit subject to represent in human form, artists were therefore obliged to resort to symbols. For the Father they adopted the hand of Yahveh from Jewish imagery, and for the Holy Spirit, for which they had scriptural guidance, the dove.[46] The latter seems surprising, even so, in view of the bird's old association with the cult of Aphrodite. In the scene of the Baptism of Christ it descends above his head while the hand of God the Father appears in heaven. The subject was an early one in Christian art because baptism, together with the eucharist, were the two original sacraments of the Church. In the fifth century the followers of Nestorius, the Patriarch of Constantinople who was deposed for heresy, maintained that the dove symbolized not the Holy Spirit but the Logos. They believed that Christ was born a mere man and became the Son of God only in adulthood, to be precise, at the very moment when the dove descended at his baptism.

The dove, they argued, was therefore the Logos entering the physical body of Christ. From the middle of the fifth century the dove is seen also in the theme of the Annunciation, a time when veneration of the Virgin Mary began to develop (p. 88). In the Middle Ages it was once more involved in controversy. The Nicene Creed had defined the Holy Spirit as 'proceeding from the Father'. Later, the western Church added the words 'and from the Son' (Lat. *filioque*), a distinction which led to schism with the East which believed otherwise. Western medieval art sometimes represents the dove flying from the hands of both the Father and the Son in order to express the 'filioque' doctrine. In medieval art, too, it may be seen at the ear of Christian writers and orators, inspiring their words, and at the scene of Pentecost its rays descend to touch the brow of each apostle. A dove is the regular attribute of Pope Gregory the Great [8.8].

The Trinity as a group

Artists seem to have had difficulty in establishing a satisfactory form for expressing the concept of the Trinity as a whole, and it was not widely represented in early art. There are isolated examples of the hand of God and the dove associated with the figure of Christ or with one of his symbols, usually the lamb or the cross. The mysterious motif of the Empty Throne, combined with the scroll of the gospels or a cross, and the dove, were made into a composite image which appears in Byzantine art from its early period (p. 94).

The best-known early example of the use of human figures to symbolize the Trinity is in the nave mosaics in S. Maria Maggiore [3.13], in the scene from Genesis which depicts Abraham welcoming the three angels at Mamre.[47] The treatment of the Old Testament scenes in these mosaics was, as we noted, based on illustrated manuscripts originally produced by the Jewish community in Alexandria. It was here that the first translation of their Scriptures was made into Greek in the third and second centuries BC under the Ptolemies, known as the Septuagint, of which illuminated versions once existed. The angels are represented without wings, following the Jewish tradition, and, like Abraham, are dressed in a Greek *chiton* (the striped tunic) and a *himation* (the cloak). These were not the clothes of the poor but usually signified someone of rank, and in art were used for specially sanctified persons. Moses in the Dura frescoes is dressed in this fashion, and it remained the tradition for representing Christ and the apostles in Christian art. Abraham's visitors were regarded by the Church Fathers as a prefiguration of the Trinity. In this mosaic an aureole surrounds the middle figure of the three, which must have been a modification by the artist of the original Jewish manuscript in order to convey the specifically Christian idea of the three aspects of God.

3.13 Abraham and the three angels. A 'continuous
narration' in which Abraham appears three times [cf. 2.17].
In the upper zone he bows in welcome. Lower left, he tells
Sarah to bake cakes; to the right, he places food before the
visitors. Mosaic on the wall of the nave, S. Maria Maggiore,
Rome. Commissioned by Pope Sixtus III (432–40).

The Mother of God

References to the Virgin Mary in the gospels are not numerous and with few
exceptions are confined to the childhood of Christ. In art she appears first, as
we saw, in the third-century catacomb paintings of the Annunciation and
the Adoration of the Magi. Yet out of these somewhat meagre beginnings
there grew a devotion that seemed in later times as if it might even outweigh
that given to Christ himself. How did it come about?

In its efforts to win over pagans, the Church was at times obliged to make
concessions to the old beliefs. Instead of attempting to abolish a cult it was
sometimes more effective to 'Christianize' it. Rather than destroy a temple it
might be converted into a Christian church and perhaps the relics of a saint
installed in it. The cults of early saints show many traces of the local pagan
divinities whom they supplanted. In the early centuries of Christianity the

3.14 Shepherdess with child,
from a pagan sarcophagus. The
kind of image from which the
early Virgin and Child was
derived. 3rd cent. AD
S. Sebastiano, Rome.

worship of various mother goddesses was widespread in the Roman Empire.
The Great Mother of the Gods, originally worshipped in Asia Minor, had
had her cult in Rome since 204 BC where she was called Cybele. Her festival
was celebrated annually in imperial times. Isis, the great Egyptian goddess of
fertility, also had a popular following in Rome, and her temple stood in the
Campus Martius. It was not unusual for a son to be associated with such
female deities. Horus, the son of Isis, was commonly represented being
suckled by her. The Christian Church may well have felt the need to
introduce a mother figure of this type as a way of making converts from pagan
worship of the Mother Goddess.

One cannot be sure when the image of a mother holding a child was first
intended to represent the Virgin Mary and Christ. It is seen on pagan
sarcophagi and *stelae* from the third century and is presented in two or three
well-defined ways. One of the earliest shows the pair in a relationship
reminiscent of the most popular type of Italian Renaissance Madonna and
Child [3.14]. In contrast is the severely frontal treatment within a medallion
[3.15] which became a regular type for the Virgin and Child in Byzantine
mosaics and icons (called the 'Nikopea').

From the third century, Christians had offered prayers to the mother of
Christ but it was not until 431 that her relationship to the Son was officially
defined. In that year the third of the ecumenical Councils met at Ephesus. Its

3.15 Mother and child. A
pagan funerary *stela* that
foreshadows a common Byzantine
type of Virgin and Child (detail).
3rd cent. Archaeological
Museum, Aquileia.

conclusions had important consequences for religious art. It was called in
order to counter the teachings of Nestorius, the Patriarch of Constantinople.
He maintained that Christ was born a man and only became divine in
adulthood. From this it followed that his mother could only have given birth
to a man and not to a god. The Council declared that this was heresy.
Nestorius was condemned, deposed and eventually exiled. The Greek word
'Theotokos', which means 'Bearer (i.e. Mother) of God', was proclaimed at
Ephesus to be her official title. Next year Pope Sixtus III began building in
Rome the basilican church dedicated to the Virgin, S. Maria Maggiore.[48]
The mosaics on the arch, sometimes known as the Ephesian arch after the
Council,[49] depict a series of scenes of the childhood of Christ. They were
inspired not by the gospels, which have little to say on the subject, but by
legendary, non-biblical accounts of the life of the Holy Family, some of
which are known to have existed in the East possibly as early as the second
century. They became current in the West in the fifth century. The
illustration [3.16] depicts the welcoming of the family at the gates of a city by
a prince of Egypt, where they had fled to escape Herod. The city's idols had
tumbled from their pedestals at the arrival of the infant Jesus.[50] In this series
the Virgin is dressed not in the veiled garb of a Roman matron, which was
the later custom, but in the splendid robes of a Byzantine empress, wearing a
diadem, ear-rings and necklace, a mark of the honour in which she was now
held.

 Veneration for the Virgin greatly increased about this time through the
discovery in the Holy Land of a portrait of her with the infant Christ,
supposed to have been painted by St Luke. It was said to have been acquired
by Eudocia, wife of the Emperor Theodosius II (408–50), while she was on
a pilgrimage to the holy places. She sent it to Constantinople where it was

3.16 The infant Jesus with Joseph and Mary and attended by angels
being welcomed by Prince Affrodosius of Sotinen in Egypt. 432–40.
Mosaic from the sanctuary arch, S. Maria Maggiore, Rome.

placed in the church of the Hodegon, specially built for it, and the image
became known as the Hodegetria. The appearance of this famous icon,
probably destroyed in 1453, can be deduced from copies, one of very early
date having been discovered recently in the Pantheon at Rome.[51] The
Virgin holds the Child on her left arm, and both gaze to the front, directly at
the spectator, in the manner of sacred figures in Byzantine art. This type
became one of the most popular images of the Virgin and Child in the
Middle Ages [4.7]. Any object that had a close association with a sacred
person was felt to have acquired some of their virtue and influence. It
possessed a kind of *numen* and was capable of producing magically beneficial
effects when the necessary devotions were offered. The Hodegetria was no
exception and became one of the most revered of early icons, especially so
since belief in the Assumption precluded the possibility of most direct relics
of the Virgin. The image was invoked by military leaders before their
campaigns and displayed on the city's walls to confound the enemy. The
tradition of St Luke as a painter, which was derived from it, spread
throughout the Christian world and he became the patron of artists' guilds.
He is frequently represented in art at his easel with the Virgin and Child as
his sitters.

The influence of the Empire on Christian art
After the edict of toleration the attitude of Christians towards the Roman
State changed. In the days of persecution they had been sustained by the
belief that at any moment Christ would return to earth to overthrow the
oppressive power of the pagan emperors and rule for a thousand years.
Constantine's tolerance of Christianity, his efforts at reconciling rival
elements within the Church, and his active encouragement of the building of

new places of worship, led Christians to think afresh about their relationship with the State. The historian Eusebius of Caesarea regarded the Emperor with special veneration. He saw Constantine's achievement of absolute power as the culmination of a divine plan which had been working itself out since the days of Abraham. According to him the Hebrew patriarch was the prefiguration of Constantine in whom God's original promise to the Jews had finally been fulfilled. Moreover, 'the wonderful sojourn of Jesus among men synchronized with Rome's attainment of the acme of power ... And no one could deny that this is of God's arrangement, if he considered the difficulty of the disciples taking their journey, had the nations been at variance one with another and not mixing together because of varieties of government.'[52] In other words, the very existence of the Roman Empire, Eusebius believed, was part of God's plan to promote the Christian religion.

After the age of Constantine, when the Western empire was gradually collapsing under the pressure of the barbarians, the Church in the West began to assume some of the responsibilities that had formerly belonged to the State. Indeed, Constantine himself had invested bishops with some of the powers of magistrates. Towards the close of the century Ambrose, Bishop of Milan (373–97), made himself master of a succession of western emperors in religious and civil affairs, even, on one occasion, denying communion to Theodosius I in order to force him to make public penance. This well-remembered episode was for later ages the very embodiment of the triumph of ecclesiastical over temporal power and was the subject of numerous paintings that showed St Ambrose on the steps of his church refusing to admit the emperor.[53] By degrees the Church absorbed the language and manners of imperialism, many of which survive to this day. The humble Teacher of Galilee was transformed into an all-powerful ruler, and his empire was the universe. His army was the saints, militant and triumphant, who overcame death in a victory for which they received the traditional palm. Features of court ceremonial, such as the use of candles, were adopted in Church ritual. It was inevitable that these changing attitudes would be reflected in Christian art.

The image of Christ symbolically enthroned, on the sarcophagus of Junius Bassus, was derived from an imperial formula. The throne itself was from very ancient times an emblem of human and divine sovereignty and to represent Christ in this way was a natural development. From the close of the fourth century, when Christianity was declared the official and only religion of the State, we find the theme treated in various ways in Christian art. Apostles and angels surrounding Christ take on the character of court officials attending the emperor. The act of delegating imperial authority by the handing over of a scroll becomes the Christian *Traditio legis* (p. 80). The emperor's insignia of authority, the lance, becomes a cross in the hand of

3.17 Christ as Emperor of the universe with his attendants. Bishop
Ecclesius on the right has a square halo, denoting that he was then living.
546–8. Mosaic in the presbytery of S. Vitale, Ravenna.

Christ. The Saviour is represented in the act of crowning a saint in the way
that the secular ruler bestowed a similar honour on the living.

 Christ is represented as a sovereign in the semi-dome (ceiling) of the apse
of S. Vitale at Ravenna [3.17]. The church was built in the sixth century
soon after the city had been reconquered from the Visigoths and had become
part of the Byzantine Empire. The mosaics in the apse date from 546–8 and
reflect the imperial aspect of the Christian religion. Christ is enthroned on
the globe of the universe holding the scroll of the gospels. He has short hair
and is beardless in the western style of that date. Below the globe is a hill,
symbolizing heaven, from which four rivers flow.[54] Christ is attended by an
angel on either side and all three wear the Greek *chiton* and *himation* (p. 87).
The two outer figures wear the robes of a court dignitary. The one on the
right is Ecclesius, Bishop of Ravenna, who is presented by an angel and
holds a model of the church which, symbolically, he is offering to Christ.
On the left is Vitale, the martyr on whom Christ is about to bestow the
crown. The outstretched hands of each saint are covered by his cloak, a
custom introduced into the West from the Persian court where it was a
gesture of respect to approach the monarch in this way. Veiled hands in the
presence of a sacred figure remained a common motif in medieval and
Renaissance art in scenes such as the Presentation in the Temple and the
Adoration of the Magi. [See also 3.10].

The empty throne

One curious survival of the imperial cult is the empty throne. This mysteriously unoccupied seat might seem a not very significant motif in art, yet it is generally placed in a central, elevated, and therefore specially sanctified position in the decorative scheme, usually with Saints Peter and Paul or other sacred figures around it. Lying on it there is often a scroll-book

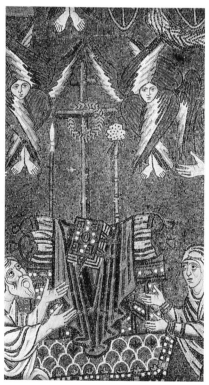

3.18 (*Above*) The Empty Throne with SS. Peter and Paul. 9th cent. Chapel of St Zeno, S. Prassede, Rome. (*Left*) The Empty Throne. The figures may represent Adam and Eve. The back of the throne is formed of the cross, crown of thorns, lance and sponge, the so-called Instruments of the Passion; on the seat is a book, perhaps the gospels or the apocalyptic Book of Life. Detail from the Last Judgement. Early 12th cent. Torcello cathedral. [See also 4.16]

of the gospels and a cross. Its Greek name is *Hetoimasia* which means a throne that has been made ready. Long before the Christian era an empty throne evoked the presence of a god or monarch. Rites were associated with it in the East, especially in India where it was a symbol of sovereignty. Among the Hittites, a throne stood in the shrine of the ancestor to provide a resting place for his spirit. At the sacred meal of the Etruscans it was put at the head of the table so that the god might partake, invisibly, with the other worshippers. In Roman courts of justice it was customary, in the absence of the emperor himself as judge, to substitute some symbol of his authority, either his portrait or an empty throne on which were laid a sceptre and diadem, the imperial insignia. The presence of Constantine at the sessions of the Council of Nicaea, when he was not attending in person, was evoked in the same way. The empty throne had a place too in the cult of emperor-worship. Caligula had one set up on the Capitol, before which senators were obliged to prostrate themselves. The Emperor Commodus who, as we saw, liked to be portrayed as a god (p. 50), was worshipped in the shape of a throne on which lay the club and lion's skin of Hercules, and before which obeisance was made.

For Christians the empty throne made an apt symbol for the Second Coming of Christ, and they did not need to look far in the Scriptures to find suitable references. The Book of Revelation, which foretold the setting up of Christ's kingdom on earth, described a throne in heaven in vivid detail. Though it did not exactly fit the image of the empty throne of the emperors it served well enough as the inspiration for the motif in ecclesiastical art.[55] It is seen for the first time at the top of the sanctuary arch in S. Maria Maggiore. A mosaic dating from the early fifth century in the church of S. Prisca at Santa Maria Capua Vetere (Old Capua) shows a throne with a scroll lying on it, apparently bound with seven seals, which links the image with the Book of Revelation.[56] Above the throne is a dove which suggests that the image as a whole is intended as an allusion to the Trinity. Thus the throne would stand for the invisible Father and the scroll (the gospels) for the Son. Two creatures on either side of the throne are further evidence that the Book of Revelation is the source. They are a winged ox and an eagle, two of the so-called Apocalyptic Beasts. There were four in all: the lion, the ox, the 'creature with a human face', and the eagle in flight, all of which surrounded the throne of God and sang his praises without pause.[57] Early writers made them the symbols of the four evangelists, Mark, Luke, Matthew, and John respectively, and as a group in Christian art they are always to be understood in this sense[58] [3.18].

The Second Coming

That longed-for event, Christ's return to earth for the second time, helped to sustain the faith of early Christians in their trials. It gave rise to a body of

literature, known as apocalyptic,[59] of which the Book of Revelation is the best example. Its origins lay in earlier Jewish writings of a similar kind which foretold the deliverance of Israel from her captors. Parts of the Book of Daniel, dating from the second century BC are apocalyptic in character. Its typical form was allegory and it made use of elaborate and often obscure metaphorical imagery. The 'Revelation of John' (which John, we do not know) was admitted late to the canon of the New Testament and only after much hesitation. But although scholars, especially of the eastern Church, viewed it with suspicion, it had a great impact on the popular mind and was welcomed as a source of comfort and inspiration by simple worshippers and those facing martyrdom.

Some idea of its influence can be gathered from the number of separate images to which the work gave rise in the early Christian art of the West. (It was only later that it was illustrated as a whole in extended cycles of scenes, a development in which Italian and Spanish manuscript illuminators led the way.) We have already noted the scroll with seven seals, the apocalyptic beasts, and the Greek letters *alpha* and *omega* (A and ω). The latter appear as part of an epigraph in the catacombs possibly dating from the second century,[60] and are taken from Revelation where God refers to his imminent return: 'Yes, I am coming soon. I am the Alpha and the Omega, the first and the last, the beginning and the end.'[61] The empty throne, too, though of pagan origin, became established as a Christian image through the influence of Revelation.

One of the most widely used symbols in early Christian art was the Lamb of God. Though the image was banned by the Council of Constantinople in 692 and thereafter disappeared from Byzantine art in the East, the Pope in Rome defied the ruling and the Lamb remained in western art as a symbol of the sacrifice of the Cross. In the Latin Mass the 'Agnus Dei' (Lamb of God) was introduced by Pope Sergius I (687–701). The lamb was always the animal used for the victim in the Jewish sacrificial rite, where Graeco-Roman religion used cattle and other beasts. The metaphor of Christ as a lamb was a natural outcome of this and was first expressed in John's gospel.[62] The author of Revelation makes extensive use of the imagery of the lamb, in particular the vision of it enthroned with the Apocalyptic Beasts, and the Twenty-four Elders falling down in adoration. The earliest reference to the scene of the Adoration of the Lamb in Church art is found in the *Dittochaeum* of Prudentius (p. 97) who died early in the fifth century; by the middle of the same century it was being widely represented in western churches. There is evidence that fifth-century mosaics in the original church of St Peter's at Rome depicted Christ and the apocalyptic beasts and, probably also, the twenty-four elders. Sergius I, when restoring the building during his pontificate, substituted the Lamb for the figure of Christ.

Like the four evangelists, the earliest representations of the apostles took

the form of emblems instead of human figures. They were depicted as twelve lambs, generally arranged six on either side of Christ who was himself shown as the Lamb of God or the Good Shepherd. They emerge from the gates of the cities of Bethlehem and Jerusalem on the far left and right. The image typically forms a semi-circular frieze at the foot of the semi-dome of the apse and is found in several early churches in Rome.[63] The central motif sometimes depicts the Lamb of God standing on a hill from which four streams issue. The hill is heaven, the Mount Zion of the Book of Revelation,[64] around which were the hundred and forty-four thousand who were the saved. The streams are the Rivers of Paradise described in Genesis[65] which became accepted symbols of the gospels.[66]

The unity of the Bible

The principal claim made by Christians about the Old Testament was that its prophecies concerning the coming of the Messiah had been fulfilled. It was this which gave the prophets their permanent place in Christian art. In the earliest manuscript books of the gospels they are depicted beside the scene from the New Testament which their prophecy foretold, often holding an open scroll on which their words are inscribed. Only two such gospel books are known to have survived from before the iconoclast era, the Codex Rossanensis in the Rossano cathedral library, and the fragment found at Sinope, now in the Bibliothèque Nationale, Paris. Both were probably produced in Antioch, the first about 500, the second somewhat later. Christian thinking tried to see the whole of the Old and New Testaments as a single, vast and yet consistent historical panorama, the record of God's purpose as it had gradually unfolded. Yet difficulties lay in the path of anyone taking too literal a view of sacred history. Origen (c. 186–c. 254), the most famous of early interpreters of the Bible had resolved the problem by treating the Old Testament as a form of allegory, the historical surface concealing different layers of spiritual meaning. His writings were widely read in both East and West and prepared the ground for the doctrine which was later called typology. St Augustine summed it up this way: 'In the Old Testament the New is latent, in the New the Old is patent.'[67] In other words, Abraham, Moses and other patriarchs were somehow prefigurations of Christ (as Abraham also was of Constantine, according to Eusebius), and their deeds had precise parallels, ordained by God, in the gospels. Thus, Abraham's sacrifice of his son Isaac was directly related to the crucifixion which was God's sacrifice of his Son. The foreshadowing of the two Christian sacraments, baptism and the eucharist, was seen in many an Old Testament reference to water or to a meal.

We cannot be sure when the typological pairing of subjects was first introduced into church decoration. Prudentius (348–c. 405), an author of religious poems and hymns, composed a set of verses, the *Dittochaeum*, which

describe two sets of twenty-four scenes broadly intended as parallels between the Old and New Testaments. The verses, which are also entitled *Tituli Historiarum* ('Lines to be inscribed under scenes from History'), describe a series of church mosaics either known to Prudentius or intended as a potential scheme. However, only in a few instances can any typological connection be discerned between individual pairs, and this was presumably not his intention. St Nilus, Bishop of Ancyra (modern Ankara), about the year 400 recommended a similar scheme in a letter to a governor of Constantinople who had sought his advice concerning a church that he proposed to build. But no monuments have survived to which these writings might refer. St Nilus also recommended that the two Testaments should be depicted facing each other on the lateral walls of the nave of the basilica, an arrangement that may already have existed in the Holy Land in his day.[68] St Paulinus, Bishop of Nola (*c.* 353–431), describes a church decorated in this way.[69] It became part of the traditional plan of church decoration in Italy and elsewhere in the West in the Middle Ages, though the choice and arrangement of the subjects was not always typological.

The first known instance of more closely parallel subjects is on the carved wooden panels of the doors of S. Sabina in Rome. They are roughly contemporary with the mosaics in S. Maria Maggiore. Some of the details suggest that the sculptors were from Palestine or at least were familiar with the iconographic conventions of the East.[70] Though some panels are missing, the underlying scheme is clear: to show the relationship between Moses, Elijah and Christ, that is, between the Law, the prophets and the gospels, as expressed by St Augustine and others. The illustration shows two of the panels [3.19]. On the left are four miracles of Moses in the desert, from top to bottom, the sweetening of the waters of Marah, the miracles of the quails and of manna, and striking water from the rock. The panel beside it, which is intended as a parallel, reads from bottom to top. It shows three of Christ's miracles, the changing of water into wine, the multiplication of loaves and fishes, and the healing of the blind man.

Old Testament subjects were used to teach the unity of scripture even without accompanying parallels from the gospels. There is an example of this in the mosaics of the presbyterium of S. Vitale at Ravenna. The presbyterium, or chancel, is the part of the church reserved for the clergy. Presbyters were the higher rank of ministers from whom bishops were chosen. It is here that the altar stands and is, if anywhere, the place we might expect to find allusions to Christian dogma and the higher mysteries of the faith. In the apse is the figure of Christ enthroned [3.17] and on either side, in the lunettes, are Abel, Abraham, and Melchizedek. When celebrating the eucharist, after the solemn moment of consecrating the bread and wine at the altar, the priest prays that the sacrifice be accepted 'as thou wast pleased to receive the gifts of thy just servant Abel, and the sacrifice of our father

3.19 The Old Testament foreshadowing the New: the miracles of
Moses (*left*) and of Christ (*right*). Moses, in the top and bottom scenes, is
directed by the hand of God emerging from a cloud. Christ uses a wand
to perform his miracles, as in catacomb paintings [cf. 3.4]. Second half of
5th cent. Two panels from the doors of S. Sabina, Rome.

Abraham, and that which Melchizedek thy high priest offered up to thee.'
Abel, whose sacrifice was accepted by the Lord, and Melchizedek, the
priest-king of Jerusalem who wlecomed Abraham with bread and wine, are
represented standing beside an altar on which is a chalice and two loaves
[3.20]. In the lunette opposite are scenes of Abraham sacrificing Isaac and
offering food to the three angels (p. 87). The Old Testament figures are all
depicted making their offerings with their hands stretched out or raised up, in
the manner of the priest elevating the eucharistic elements, at the moment of

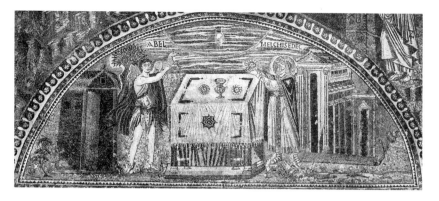

3.20 The offerings of Abel and Melchizedek, foreshadowing the
eucharist. Top centre is the hand of God. 546–8. Mosaic in the presbytery
of S. Vitale, Ravenna.

consecrating them. On the ceiling of the presbyterium, in the centre of the
vault, is the Lamb of God with a halo, the symbol of Christ as a sacrificial
victim. This image, in conjunction with the Old Testament themes on the
walls below, seems intended to convey a single idea, that the death of Christ
was a sacrifice by which mankind was redeemed and which was re-enacted
in the ritual of the Mass. Near the entrance of the presbyterium are images of
Isaiah who prophesied the birth of Christ, and Jeremiah, the prophet of his
death.

Saints, martyrs and relics

The veneration of the saints was a more popular form of Christian devotion
than the official rites that made up the liturgy. The saint shared a common
humanity with the worshipper and was well fitted to play the part of
intermediary between him and the remote awe-inspiring figure of God.
Recognition of a person's sainthood by canonization sometimes came about
simply through popular acclaim, often when a community wished to
honour a local figure. It was also not unusual for some of the beliefs and
superstitions surrounding the spirits and demigods of the old nature religions
to be transferred to the saints.

The ancient belief that an object associated with a deity contained some of
his *numen*, the beneficial power which the devotee could unlock, was main-
tained with undiminished strength in the context of the Christian religion.
It was for this reason that the mortal remains of a saint were preserved.
Any object formerly connected with him, articles of clothing and personal
possessions, or anything that might have felt his touch were treasured because
they were endowed with magical potency. The cult of relics, which began in

the East, had spread throughout the Christian world by the end of the fourth century. In the Byzantine Church it was overtaken in the sixth century by the worship of the icon, an image of a sacred figure which had the same properties as the relic. Icons of Christ or a patron saint were placed over gateways of a city as protection against invaders, or were carried in battle. Travellers could ward off sickness if they carried images of Saints Cosmas and Damian, the twin physicians. Simeon the Stylite was another whose image had magical powers. This Syrian ascetic of the fifth century (d. 459) retired to the top of a pillar for the last thirty-six years of his life and thereby became widely renowned. He appears to have been specially venerated in Rome where, it is said, his images were set up in the porches of workshops to ensure their safety.[71] In the West these idolatrous customs were resisted by the clergy who denied that any power lay in a man-made image. As Gregory the Great wrote to Bishop Serenus of Marseilles (p. 4), 'We commend you indeed for your zeal against anything made with hands being an object of adoration'.[6]

So the West rejected the icon but revered the relic. During the age of persecution the remains of martyrs had, whenever possible, been lovingly preserved, and after the Peace of the Church buildings were specially erected to provide a fitting shrine for them. The design of a martyr's church, or *martyrium*, took different forms but was governed by two main considerations. First, it had to provide a proper resting place for the remains which were placed in or beneath the altar. This tradition originated in the catacombs where the martyr's tomb had served as the altar table. Secondly, the building had to accommodate pilgrims who came, often in large numbers, to make their devotions at the shrine from which they hoped to take away some of the saint's beneficent influence. This mysterious emanation was thought to be present in the very oil that burned in the lamps around the tomb, and the pilgrims would carry some of it home in special *ampullae* (p. 85). *Martyria* sometimes were built with a central dome under which the altar stood, thereby making the relic the focus of the whole edifice. Beneath the dome there radiated four aisles in the form of a cross. At S. Lorenzo in Milan (c. 370) the central altar is surrounded by a circular ambulatory round which the pilgrims made their way. In the outer wall are four apses which were used as chapels, forming a quatrefoil plan. S. Stefano Rotondo at Rome (built in the reign of Pope Simplicius 468–83) is one of the oldest and largest *martyria*. Of the four radiating aisles, once forming a Greek cross, only two now remain. But in Rome and elsewhere in the West, the plan of the martyr's church was more often based on the basilica. It was sometimes situated so that the altar at the east end stood over the catacomb where the martyr was buried. In the medieval church, the crypt, the ambulatory round the chancel and the chapels leading off it, are all features that developed from the early *martyria*.[72]

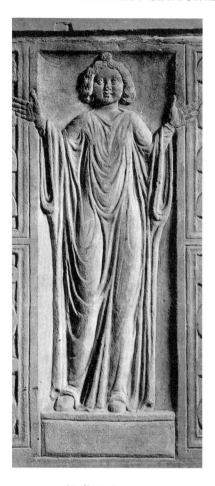

3.21 (*Left*) St Agnes as an orant. Relief from a 4th cent. altar front.
(*Right*) St Agnes dressed as a lady of the court. Mosaic, 625–38. Both in
S. Agnese fuori le Mura, Rome.

A relief on the altar of S. Agnese fuori le Mura at Rome (Via
Nomentana), dating from about the middle of the fourth century, represents
St Agnes to whom the church is dedicated [3.21]. She is one of the most
famous Roman martyrs who, according to legend, died at the age of thirteen.
Her remains, very likely authentic, are buried beneath the altar. She is shown
here as an orant, to suggest her ever-continuing presence in the church. The
original oratory which housed her relics was replaced by a basilica in the
seventh century by which time the cult of saints had greatly increased in
importance. A mosaic in the apse, dating from this later period, shows the

saint, whose real station in life was unknown, dressed, in contrast, in all the splendour of a Byzantine empress and attended by Popes Honorius and Symmachus.

The first list, or calendar, of martyrs was drawn up in the year 354 and contained a mere thirty names of men and women whose place and date of burial were known. Over the next one and a half centuries that number had multiplied some five or six times, which is a measure of the growth of their popularity. For it was essentially a popular and not a priestly cult. The martyr offered protection from the hazards of everyday life through his immediate presence in the icon or relic. He acted as intermediary for the faithful in their prayers to God, and he offered them the promise of immortality because his dying, like Christ's, was a victory over death, celebrated by the people as his *dies natalis*, or birthday.

But the imagery of the saints changed, because it was determined by the clergy, and these much-loved figures gradually withdrew themselves from the common people. With the growth of the cult went their increasing involvement in the formulas of imperial art, as happened in the case of St Agnes [3.21]. The frontal portrait-bust of a saint with its typically wide, staring eyes, framed in a medallion, was a direct reminder of the image of the emperor, as it appeared on his coinage. In their dress the saints now conformed to the style of the court dignitary, regardless of the kind of clothing they might have worn in real life. The procession of saints on the walls of a church recalled the stately approach of courtiers towards the throne for an audience with the emperor, the *aditus*.

The theme of the procession of martyrs, though it is Byzantine in feeling, belongs particularly to the monumental art of Italy. The best-known example is the mosaic frieze on the nave walls of the basilica of S. Apollinare Nuovo at Ravenna, where it forms the lowest of the three horizontal bands of decoration. It dates from about the year 560 when the city had been reconquered from Theodoric the Ostrogoth and had become part of the Byzantine Empire. On the right are twenty-six male saints led by St Martin (to whom the church was formerly dedicated) who approach the enthroned figure of Christ at the east end, each bearing his martyr's crown. On the opposite wall the same number of female saints, preceded by the three magi, approach the enthroned Virgin. A religious procession formed an important part of the cult of relics and took place when the sacred remains were borne into a church and deposited under the altar. The rite was compared by early writers to the imperial *aditus*. At this moment, it was believed, the saint entered the building and took up his occupation, within the altar. The image of the procession of martyrs at Ravenna therefore represents their solemn entry into the church where they took up their abode. We are reminded of the gods of the old religions, each of whom resided in an image within his own local temple.

SUMMARY

Early Christian art had two distinct phases, the first ending in 313 when Constantine granted freedom of worship to Christians. The Jewish prohibition of religious images (not everywhere observed) undoubtedly influenced the young Church. The very first Christian imagery, found on seals, cups and in burial places, consisted simply of symbolic objects like the fish, dove, and anchor. The first true images appeared about the year 200 in the funerary art of the catacombs. The paintings are mostly figurative and comprise single figures and narrative scenes. Among the former are Christ the Good Shepherd and Christ-Orpheus, and a praying figure, the orant, which usually denoted the soul of the deceased. Certain narrative scenes from the Old Testament recur frequently. They are not didactic but are examples of God's power to save. Their function may also have been magical, that is, by their very existence they were believed to promote the soul's salvation. Scenes of Christ's miracles appeared later in the second century. There are echoes of pre-Christian rites in scenes such as the Adoration of the Magi and in banqueting scenes. There is evidence that elements other than bread and wine were at first part of the eucharist. The earliest-known image of a martyr's intercession is found in the catacombs. After 313, biblical scenes took on a more purely narrative character and catacomb painting as a whole declined. It came to an end in the first part of the fifth century.

The first Christian images on sarcophagi date from about the year 230. The subjects cover some of the same ground as the catacomb paintings. The inflexibility of the medium led to the frequent re-use of older pagan motifs in a Christian context. The medallion was still used but now contained non-figurative motifs such as the cross or the sacred monogram. Christian doctrine was often represented, especially the Fall and the Redemption, though the Crucifixion itself – the redemptive act – was still avoided. An early hint of Christian 'imperial imagery' appears in the scene of the *Traditio legis* on the sarcophagus of Junius Bassus (AD 359).

After the year 313, programmes of church building were undertaken throughout the Christian world. Mosaic was much used in their decoration. A popular symbol for the church (the building and the body of members) was a ship, an image that found a permanent place in Christian art. Doctrines laid down by Church councils were expressed in art: the three-fold nature of Christ, the Trinity as a group, the Virgin Mary as the Mother of God. A painting of the Virgin and Child supposedly by St Luke was discovered in the East and widely copied. Apocryphal accounts of the life of the Virgin gave rise to narrative cycles about her in art.

With the decline of the Roman Empire in the West the Church took over civil administration in some regions. Accordingly, Christian art gradually absorbed the imagery of imperialism, especially of the Byzantine court. The

Good Shepherd was replaced by the enthroned sovereign; his attendants, the saints, were now dressed to suit their elevated status. The imperial symbol of the empty throne was widely represented. Christ the Emperor was closely linked to the belief in the return of Christ as Judge (the Second Coming) which drew on the Book of Revelation for its images.

The concept of the Old Testament foreshadowing the New is first represented in the early Christian period. The veneration of martyrs, one of the Christian's very earliest devotions, was greatly expanded after 313 into the much broader cult of saints. Churches were specially built to house their relics and their images were everywhere represented, even the humblest often assuming an imperial aspect.

CHAPTER FOUR

Byzantine Art in Italy

The Byzantine age

WHEN CONSTANTINE THE GREAT established the new capital of the Roman Empire in the East in 330 he chose the ancient Greek city of Byzantium on the shores of the Bosphorus. It was rebuilt with great magnificence and renamed Constantinople. Like Rome it stood on seven hills and its situation gave it a natural protection against invaders. Constantinople became the mother-city of an empire and civilization which lasted with varying fortunes for over a thousand years until it was overthrown by the Turks in 1453.

The East Roman, or Byzantine, Empire, enjoyed two periods of greatness during which the arts prospered (sometimes called their Golden Ages). The first came to a climax under the Emperor Justinian (reigned 527–65). The territories which had been lost to the barbarians to the north in the previous centuries were reconquered by the emperor's armies. The whole of the Italian peninsula was taken back from the Goths by his generals, Belisarius and Narses, restoring communications between Rome and the eastern capital. Narses was made the emperor's viceroy, or exarch, in the West and set up his court at Ravenna. It was the first great age of Byzantine culture. Architecture flourished and with it went hand-in-hand the art of mosaic, used with brilliant effect to decorate the walls of Justinian's churches. At Ravenna the church of S. Vitale (p. 93) represents the peak of this achievement in the West. Byzantine art of this period, as we saw in the last chapter, is an integral part of the broader history of early Christian art.

After the death of Justinian, the power of the eastern empire had everywhere waned. East and West drew further apart, separated politically and because of differences of religious doctrine. When Charlemagne was crowned in Rome in 800 as the first Holy Roman Emperor the rift was complete. At the same time the eastern empire had itself been violently split over the imperial ban on the use of images in worship, which lasted until 843. This controversy also widened the division between East and West.

The second flowering of the Byzantine spirit began with the founding of the Macedonian dynasty in the middle of the ninth century and continued under the Comnenian emperors. The first of the Macedonian emperors was Basil I (reigned 867–86). He and his successors restored the power of the empire, expanding its frontiers and regaining its former possessions in Italy.

The splendour that is traditionally associated with medieval Byzantium belongs to this time and reached its height in the reign of Basil. It was accompanied by a revival of the arts in many different fields, the effects of which were not confined to the metropolis but spread throughout the empire and beyond. The city of Venice, now a rising power with close commercial ties with the East, became a centre of Byzantine culture and influence which was in due course transmitted to other parts of Italy and western Europe. The Macedonians occupied all the south of the peninsula including the toe and heel of Italy, which had remained predominantly Greek in language and outlook. In the south, cities were founded and monasteries built in which the eastern form of Christian worship was practised. Some of the impetus for this movement came from refugees fleeing from the persecutions of the iconoclast emperors. Further north, at Grottaferrata near Rome, a community of Greek monks was established in the eleventh century by Nilus of Calabria where Byzantine artistic traditions continued to flourish.

After the eleventh century the eastern empire once more lost its Italian possessions but by now the influence of Constantinople had become too firmly established to decline immediately. In Sicily the Norman princes who took the island in 1072 supported the eastern Church and founded cathedrals which were filled with magnificent mosaics in the Byzantine manner. But by the end of the fourteenth century Latin monastic Orders had superseded Greek, the Italian language prevailed generally, and western styles of art were in the ascendant.

The attitude of western Europe towards the Byzantine Empire was ambivalent. On the one hand there existed a long-standing political enmity, aggravated by religious schism, which culminated in the sack of Constantinople in 1204 by the crusaders under Baldwin of Flanders. The crusading armies, whose original objectives had been to restore the Holy Land to Christian rule and to make the pilgrim roads safe, on this occasion turned against their fellow Christians and indulged in indiscriminate looting of the city's treasures on a vast scale. At the same time the West looked towards Constantinople as a wondrous, golden city, the source of the finest works of art and the repository of knowledge of a wide range of craft skills such as metalwork, enamelling, textiles and ivory carving.

Greek artists were in demand in the West and had their ateliers in Italy throughout the Middle Ages. When the Benedictine monastery at Monte Casino was rebuilt in the eleventh century the abbot, Desiderius, hired artists from Constantinople to decorate it. The bronze doors of his church were made in the Byzantine capital. They were one of several pairs, copied from eastern originals, that were produced for Italian churches, especially in the south, over the next one hundred years.[1] The school of crafts which grew up around Monte Cassino provided a technical education for Roman craftsmen of later generations. The native Italian painters of Florence and Siena came

under the same kind of influence at the time when these cities were rising powers. The subject-matter as well as the forms of eastern ecclesiastical art are clearly seen in the works of Sienese artists such as Duccio and can sometimes also be detected in the more independent vigorous style of the early Florentine painters.[2]

THE EASTERN BACKGROUND

The sacred monarch

The Empire in the East carried on many of the old traditions of Roman civilization and government but it developed along different lines in two important respects. From the start its rulers were Christian and the religion was adopted at all levels of society. Secondly, with the passing centuries it absorbed more and more eastern influences, Greek and Syrian in particular.

The emperor was both head of State and head of the Church. This was unlike western Europe where the temporal and ecclesiastical powers were always separate, and king and Pope, even after the founding of the Holy Roman Empire, were frequently at odds. The Byzantine emperor was also the high-priest of the state religion and held his office by divine right which had been embodied in law by Justinian. This was adapting to a Christian context the very old idea of the sacred monarch who had ruled the ancient kingdoms of the Near East, Babylon, Persia and Egypt. In those days the king was also a god, the kind of person with whom the later Roman emperors had identified themselves.

A sense of divinity permeated the entire Byzantine court, surrounding the monarch with solemn ritual and investing the imperial audience with an atmosphere of sanctity. It even reached into the departments of government through which the sovereign exercised his power. The royal chamberlain was known as the Quaestor of the Sacred Palace and the work of the tax assessors was called the Divine Delegation. The Byzantine court was the original inspiration for Christian art, both eastern and western, in its imperial aspect. But although the ideal of Christ as emperor was upheld throughout Christendom its portrayal in western art was no more than a reflection of an unrealized hope. The Church of Rome never enjoyed the same temporal authority as her counterpart in Constantinople.

Eastern Christianity

The religious temper of eastern Christianity was a blend of two elements, the oriental – primarily Syrian – which was mystical and transcendental, and the Greek which saw the universe in definable and measurable terms. The peoples of the ancient Near East had always conceived their gods as abstract and spiritual beings, compared with the immediately recognizable human

figures of the Greek pantheon. The fifth-century Syrian monk known as Dionysius the Areopagite[3] expressed the eastern attitude when he described the deity as 'the divine darkness that is beyond light', in other words, one who was unknowable and beyond the reach of human reason. The opposite Greek view held that man's intelligence could shed much light on the nature of God. It was embodied in the teachings of the Cappadocian Fathers in the fourth century[4] who set out to create for the Christian religion an intellectual theological system having classical philosophy as one of its foundation stones.

In the early centuries of Christianity a number of divergent sects arose in the East, primarily mystical in outlook. The more influential of them began to challenge orthodox doctrine, especially in that familiar area of controversy that attempted to define Christ's nature. The most important group, the Monophysites, regarded him as almost wholly supernatural, which effectively denied the doctrine of the Incarnation. They were condemned by the Council of Chalcedon in 451 which upheld the dual nature of Christ and at the same time laid down guidelines for the future. But the sect survived and a permanent schism was created in the East as a result of which the Coptic Church of Egypt has remained Monophysite to this day. The Council's decision was important for eastern Christian art which otherwise might have taken a turn towards the non-figurative. The revival of similar ideas in the eighth century, denying among other things the doctrine of the Incarnation, was one of the underlying causes of the outbreak of iconoclasm in the Byzantine Empire. The mysticism which was at the root of eastern religious attitudes determined much of the character of Byzantine art.

A deeply-felt religious sentiment pervaded the early Byzantine world and was not confined to the priesthood. Any shopkeeper, according to the Cappadocian Gregory Nazianzen, would as soon argue doctrine with his customer as sell him a loaf of bread. It led some men to withdraw to solitude, abandoning the world and their fellows. The Christian hermits who took to the Egyptian desert, undergoing severe physical privation in order all the better to commune with God, were the forerunners of the first communities of monks. Thus monasticism was born in the East. It was first placed on an organized footing by St Basil (329–79), another of the Cappadocian Fathers, and was later adapted for the West by St Benedict (480–547). In the Middle Ages the monasteries which were organized under the Benedictine Rule became storehouses of learning and one of the main sources of patronage of the arts.

Liturgy and language

Liturgy was the term used by the early Church for its official public worship in the widest sense. In time its meaning was restricted to the central rite of the eucharist, which in the Roman Church is called the Mass. The form of the liturgy developed along different lines in the East. It was originally modelled,

at least in part, on the ceremonial of the Byzantine court, and held a fuller symbolism than the Latin form of the rite. It contained more allusions to the events it commemorated, not only the Last Supper but other episodes in the Passion cycle. Even the parts of the church through which the officiating priest and his deacon proceeded in the course of the ceremony held a symbolic meaning which, as we shall see, identified them with places in the Holy Land associated with the life and death of Christ.

The language of the Byzantine Church was Greek. The Greek tongue had been widely disseminated over the eastern part of the ancient world in the wake of the conquests of Alexander the Great. It was the language in which the New Testament was written and also of the translation of the Old Testament known as the Septuagint (p. 137) which the eastern churches used. The eucharist was at first everywhere celebrated in Greek, though Latin came into use in the West from the third century. It was also translated into native languages in the churches of Antioch and Jerusalem, and in Mesopotamia and Egypt, but remained Greek in Constantinople.

Greek was therefore the language of Byzantine art, which made much use of inscriptions in the decoration of churches. They are the means of identifying persons and scenes (in contrast to the more normal western practice of using attributes) and sometimes quote extensively from biblical texts. Latin is often used instead of Greek in Italian churches, where Byzantine forms have partially merged with Latin, western ones. Sometimes both languages are found side by side, as in Monreale cathedral in Sicily [4.1]. (See Appendix.)

ICONS AND ICONOCLASM

The Byzantine image

The spiritual life of the people in the eastern Church was greatly influenced by the saints of the past. Their example guided the steps of the faithful and they interceded with God when offered the appropriate devotions. God was invisible and unknowable but the saints, with the Virgin Mary at their head, were felt to be always present among the living. Their images contributed powerfully to the sense of their continuing presence in places of worship.

Imagery in the Byzantine church was used as an aid to devotion, not, as in the West, for instruction. Western church art was intended to educate and, in the Middle Ages, mirrored the universe in all its aspects. Byzantine art was much more restricted in range. It adhered to a rigidly limited vocabulary of images laid down by ecclesiastical authority. It evolved into something which, though it might lack originality, was an ideal instrument for propagating dogma and for expressing the liturgy in visual terms. It was capable of distinguishing the aspects of Christ's nature, according to the

4.1 The gospels held in the hand of Christ, the Pantocrator
('Almighty'). 1174–82. Apse of Monreale cathedral, Sicily. The
inscription, with elisions, is in Latin and Greek and reads (left) EGO
SU(M) LUX MU(N)DI..., (right) ΕΓω ΕΙΜΗ(ΕΙΜΙ) ΤΟ ΦωC Τδ
ΚΟCΜδ..., 'I am the light of the world ... (John 8: 12). A Greek
inscription on either side of the halo reads, 'Jesus Christ the Pantocrator' –
(See App.)

manner in which he was depicted. It represented sacred figures as a clearly-
defined hierarchy, descending through Christ, the Virgin, angels, prophets,
apostles and saints, giving each his allotted place in the architectural scheme.
It reflected the annual cycle of religious feasts in its choice of themes and their
arrangement in the church.

People believed in the presence of an innate power within the image
which was somehow derived from the sacred person who was portrayed.
Stories about such powers were widely current in the century and a half
preceding the outbreak of iconoclasm in 726. There are contemporary
accounts of the offering of prayers and acts of prostration before
representations of Christ, the Virgin and the saints in order to obtain favours
in return. Exceptional magic resided in any image that had a direct link with
its subject, such as the numerous portraits of the Virgin supposed to have
been painted from life by St Luke. Especially venerable were images believed
to have been made without any human intervention at all (called
acheiropoietai, 'made without hands'), fashioned solely through the effects of
numen upon some material object. There were numerous legends, for

4.2 An early pagan prototype of the Byzantine sacred figure: Konon and his priests. Probably early 2nd cent. AD. Fresco from the Temple of Bel, Dura-Europos (detail).

example, about an image produced on a cloth as a result of Christ pressing his face against it. The most famous of these is kept in St Peter's, Rome (p. 170).

Artists used various pictorial devices, especially when representing the single figure, to enhance its magical aura. We noticed earlier how the principle of frontality, used in the portrayal of the Roman emperors, was taken over by Christian art. It was always present in Byzantine imagery to some degree, and helped to convey a feeling of the actual presence of a sacred person. It was increasingly used in the later sixth century after the death of Justinian, the period when tales about magical icons were growing in popularity. Frontality was one of Byzantium's inheritances from the East, and probably had its ancestry in the art of ancient Persia or northern Mesopotamia.

The earliest example from the East of an unmistakable progenitor of the Byzantine type of human figure is found on the wall of a temple at Dura. It was dedicated about the year AD 50 to Zeus, the all-important sky-god who controlled the weather and who was known as Bel among Semitic

worshippers in the Near East. The decorative scheme of the temple follows a pattern similar to those of numerous other cult buildings at Dura, including the Christian baptistery. One of the early archaeologists at Dura wrote, 'Their walls covered with bright paintings and their niches for cult statues and cult bas reliefs, look very much like Christian churches – Greek Orthodox and Roman Catholic – of any period.'[5] The main cult image in the Temple of Bel was much greater than life size. It occupied the traditional place in the centre of the back wall of the inner sanctuary, or *naos*. The side walls are covered with paintings, now partly destroyed. They are divided into horizontal zones, and show priests sacrificing and the figure of a donor, named Konon, and his family. The ones that are extant probably date from the second century AD.[6] The figures can be identified by inscriptions in Greek. Konon is on the left, holding offerings for sacrifice. Next to him stand two priests in the act of sprinkling incense on a burning altar [4.2]. To the right, in a lower zone are the family of Konon . Traces of a third, upper zone are faintly visible. The gaze of all is directed to the front so that they communicate not with one another but with the worshipper. The position of the feet is typical of the pictorial art of Dura, with the weight on the left foot and the right toe pointed forward so that it appears to extend outside the frame of the picture, sometimes giving the impression that the figures are floating in the air. These features, together with the elimination of spatial depth in the background and the sharp outlines of the figures, later became firmly established in Byzantine art and lasted for centuries. The 'oriental forerunners of Byzantine painting' was how these figures were described by the archaeologist who first discovered them; they convey the same mysterious sense of a living presence that we feel when looking at their descendants portrayed in the devotional icons of medieval Byzantium.[7]

Frontal treatment was ideal for portraying the single figure in isolation. The artist's difficulties began with the presentation of narrative scenes in which the figures needed to communicate with one another, not with the spectator. The natural solution was the profile, as used by the ancient Greeks, but that would have been contrary to the spirit of Byzantine art. A compromise was reached by depicting the face in three-quarters view, with both eyes visible. The degree of frontality sometimes seems to correspond to the sanctity of the person depicted, Christ, the Virgin and angels being portrayed full face, the apostles three-quarters, while Judas and other evil-doers may even be in profile. We can see how these conventions survived in a mosaic made in the eleventh century, during the second Golden Age, in the top zone of the Last Judgement in the cathedral of Torcello, an island in the Venetian lagoon [4.3]. It depicts the Harrowing of Hell (in Greek, *Anastasis*), Christ's descent into limbo to liberate the souls of the righteous who died before his coming to earth and who were therefore, according to the theologians, without grace. The subject was frequently used in Byzantine art

4.3 The Harrowing of Hell, or Anastasis. The cross with double traverse, the patriarchal cross, dates from at least the 6th cent. Mosaic, early 12th cent. Torcello cathedral.

to represent the doctrine of the Resurrection (which in western art is represented as the scene of Christ rising from the tomb). The Saviour is in the act of raising up Adam. Behind Adam is Eve and next to her stand David and Solomon. On Christ's other side is John the Baptist and behind him are the patriarchs of the Old Testament. The correspondence between size and sanctity, which we noted in the Temple of Bel at Dura, is immediately apparent in the great figures of Christ and the two archangels, Michael and Gabriel, who flank the scene. The scale descends to the tiny anonymous souls who give thanks as they emerge from their tombs on either side. The two archangels preserve a fully frontal aspect while the faces of others are partially turned, as the action demands. Only one is wholly in profile, the small figure of Satan who lies beneath Christ's feet among the broken fragments of the doors of his kingdom, shattered by Christ's entrance. Christ's feet, it will be noted, are in the same position as those of the priests of Konon, painted some nine hundred years earlier. The inscription, in Greek letters, beside Christ's head, reads HANAC, the Anas(tasis) (see Appendix).

Iconoclasm and Rome

In 726 the Byzantine Emperor Leo III, founder of the Isaurian dynasty, issued the first of two edicts prohibiting the use of images in worship. Apart from a temporary restoration, endorsed by the second Council of Nicaea in 787, the ban lasted until 843. It was partly a reflection of the eastern,

Monophysite attitude towards Christianity which regarded the deity as a wholly supernatural being and therefore incapable of representation in any shape. But the ban also had political motives, aimed at undermining the growing influence of the monasteries, which were strongly on the side of image worship. The possession by a monastery of a wonder-working icon was a source of wealth and fame, and young people who might otherwise have served in the army were thereby more inclined to join the ranks of the monks. Moreover, recent military successes of the Moslems against the empire were somehow linked in people's minds with the fact that the religion of Mahomet abhorred images. (This was the reverse of the thinking which had attributed the sack of Rome in 410 to the destruction of the images of her gods.)

The most influential voices raised in favour of images were those of the theologian John of Damascus (c. 676–749?) and Theodore, the abbot of the monastery of Studium at Constantinople (759–826). They argued that Christ, the Logos, was in a sense the visible face of God the Father, and to deny the possibility of representing him was to throw doubt on the very dogma of the Incarnation itself. It was here that Nestorius and other heretics had foundered, so by using this argument the supporters of images were putting themselves firmly on the side of orthodoxy.

The iconoclasts did not reject figurative art as such but only religious images, in particular the icon, the portrait of a sacred person that became an object of adoration and before which the worshipper prostrated himself, as courtiers did before the living emperor. One of the consequences of the ban was a flowering of alternative, acceptable forms of decoration in churches and other public buildings. Minor arts such as ivory carving flourished. Floral and animal motifs derived from Persian and Islamic art, and profane subjects from classical antiquity all became popular. The church of S. Maria of Blachernae at Constantinople was one of those to suffer radical alteration at the hands of the Emperor Constantine V (reigned 741–75). He was the son of Leo the Isaurian and another ardent iconoclast. According to an account written in 806, 'the tyrant scraped down the venerable church of the all-pure Mother of God at the Blachernae, whose walls had previously been decorated with pictures of God's coming down to us, and going on to his various miracles as far as his Ascension and the Descent of the Holy Ghost. Having thus suppressed all of Christ's mysteries, he converted the church into a storehouse of fruit and an aviary: for he covered it with mosaics [representing] trees and all kinds of birds and beasts, and certain swirls of ivy-leaves [enclosing] cranes, crows and peacocks, thus making the church, if I may say so, altogether unadorned.'[8]

Persecution of monks, especially the artists among them, became more and more savage and many fled to the West, some to Rome where they were welcomed as refugees by the papacy. Others went to the south of Italy where

they settled among the Greek communities. Here many of them lived as hermits and created churches and oratories, some of them underground, hollowed out of the living rock which they decorated with mural paintings.

The Latin Church, which finally became estranged from Constantinople in the second half of the eighth century, rejected the very idea of iconoclasm. There was a counter-reaction in Italy in favour of religious images which showed itself in various ways. It became a matter of concern to preserve the 'true' likeness of Christ. Icons of the Saviour began to appear in Italian churches at this period, some brought secretly from the East to save them from destruction. Legends were soon manufactured to explain their miraculous origin as *acheiropoietai*. The eighth-century wooden crucifix in Lucca cathedral, the *Volto Santo*, is a well-known example. It represents Christ in the manner of Syrian Christian art, wearing a long tunic, or *colobium*. His features were said to have been carved by angels while the sculptor was asleep (see also, p. 172).[9]

In Rome itself the cult of images prospered under two Popes, Paschal I (817–24) and Gregory IV (827–44). They commissioned some fine mosaics for Roman churches which were executed by craftsmen among the refugee Greek monks and by Italians to whom they passed on their skills. Paschal especially honoured the Virgin who had always been at the centre of popular devotion in the East. In S. Maria in Domnica he had her portrait placed in the apse, her traditional place in Byzantine church decoration. She is enthroned as the Queen of Heaven and surrounded by angels, while the Pope himself kneels before her in adoration.

Paschal also encouraged the veneration of the saints, whose icons and relics had suffered much at the hands of the iconoclast emperors. The basilican church of S. Prassede which he built and had decorated in the Greek style seems to have been conceived as a deliberate challenge to the image-breakers. The Roman catacombs were searched for the remains of early confessors and martyrs which were brought to S. Prassede and re-interred in a specially built crypt. This was situated beneath the altar, the place that had been hallowed since the beginnings of Christian worship as the place for sacred relics. Chapels were built along the side aisles for the same purpose. One, dedicated to St Zeno, an early bishop of Verona, was done in a purely Byzantine manner and became known, because of its mosaics, as *Hortus Paradisi*, Garden of Paradise [3.18, 4.6]. In the main apse of the basilica is a mosaic with Christ as the central figure. He is in heaven and stands receiving two female saints who are presented to him by SS Peter and Paul. The women are Prassede and her sister Pudentiana, the daughters of a Roman senator, who had been devout Christians in their lifetime, although not martyred. The mosaic follows a similar iconographic pattern to the apse of S. Vitale [3.17]. Peter and Paul, and also Christ, wear the Greek *chiton* and *himation* and the two females hold crowns in their veiled hands. They are

flanked on one side by a figure who probably represents St Zeno and on the other by Paschal who is distinguished by a square halo to signify that he was still living at the time the work was created [cf. Ecclesius in 3.17].

THE MIDDLE BYZANTINE PERIOD: THE SECOND GOLDEN AGE

The ending of the prohibition of religious images in the East was followed a few decades later by the founding of the Macedonian dynasty in 867. The Emperor Basil I, the first of the line, was, like Constantine the Great and Justinian, a great builder. He set about restoring the ravages of the iconoclasts and at the same time initiated a whole new programme of secular and ecclesiastical works. In Constantinople he made additions to the huge complex of buildings that formed the imperial palace, and undertook the construction and decoration of a large number of churches, the foremost of which was the Nea Ekklesia, or New Church. He redecorated Justinian's church of the Holy Apostles, originally founded by Constantine, which became the model for St Mark's, Venice. Virtually nothing now remains of Basil's buildings in the metropolis but their style of architecture and the details of some of their mosaics are known to us from contemporary descriptions. Decoration now began to develop in the direction of a richer and deeper theological content.

The church as a replica of the Holy Land

Christians always looked on their place of worship as more than just a roof under which to meet. The early church, as we saw, was described in metaphors likening it to a ship with the bishop as its master-mariner. Churches were also, in a very real sense, regarded as the abode of the saints. In the age that followed iconoclasm the Byzantine church building became the receptacle for a much more ambitious concept, indeed, not just one, but two or three simultaneously. First, it was a kind of replica of the Holy Land, so that each part of the church became identified with one of the places made sacred by the gospel story. At the same time, the choice of subjects and their position within the building was closely related to the words and actions of the eucharistic liturgy.

The idea was not new. It had already been formulated in an ecclesiastical history attributed to Germanus, Patriarch of Constantinople from 715 to 730 who was a great upholder of religious images, and, like John of Damascus, a forceful opponent of the iconoclast emperor, Leo the Isaurian. Later medieval writers enlarged on the same theme, although they did not always agree about the details. The church was, above all, the image of Christ's Crucifixion, Entombment and Resurrection. To one side of the apse was a

chapel, or sometimes a table, called in the eastern church the 'prothesis', which stood for Golgotha. Here, at the beginning of the Greek rite, the priest and deacon, hidden from the general view by the screen, or 'iconostasis', performed the preliminary oblation, the Preparation of the Eucharist, cutting the wafer and blessing the chalice, an action which symbolized the death of Christ. Next came the procession to the altar, when the priest emerged from the sanctuary carrying the elements, which corresponded to the bearing of Christ's body to the tomb. According to Germanus' *Ecclesiastical History*, 'The Lord's Table is the place where Christ was laid in the sepulchre.' The subsequent giving of communion represented the Resurrection. According to another plan the semi-dome of the apse stood for the cave of the Nativity at Bethlehem, the altar was the table of the Last Supper, and the ciborium (the canopy over the altar) was Golgotha. Accordingly the eucharistic procession became a re-enactment of the Entry into Jerusalem.

All this was not just literary metaphor devised by devout churchmen but the expression of a profound belief that the church in some mystical sense was actually transformed into the setting of the Passion. In the same way that St Agnes, for example, was believed to be really present in her church (p. 102), so 'he who looks with the eye of faith upon the mystic table and the bread of life placed upon it, sees the Word of God in person, become flesh for us and dwelling within us.'[10] It was to this concept that the subjects decorating the church walls added their weight. It gave them a magical significance which was absent from the simple didactic imagery of the western church, and reveals a new meaning in themes such as the Crucifixion and Resurrection and the episodes related to them.[11]

The church as a replica of heaven and earth

From the end of the ninth century, the topographical idea that identified places in the Holy Land with specific parts of the church was absorbed into a more elaborate symbolic scheme, and one that was more closely related to the decoration of the building. The church was now transformed into an image, in microcosm, of the whole universe, heaven and earth, peopled with divine and human figures, each in his allotted place according to his degree of sanctity. This was not the same as the *speculum universale* of the western Church which used decoration as a so-called 'mirror', reflecting the world of nature, history and morals simply in order to teach that they were the works of God. The Byzantine scheme used art in order to state visually the articles of Christian doctrine, but it was done in such a way that the worshipper was made to feel that the images of people and places he saw about him had in some way become identical with their originals. The image was once more acquiring that magical aura which the iconoclasts had been at such pains to denounce.

The forms of Byzantine architecture were well suited to receive an

4.4 (*Left*) Squinch: a curved recess placed diagonally across each of the
four corners of a tower, to convert the square to an octagon on which a
circular drum or dome can be raised. (a) Squinch. (b) Soffit.
(c) Perimeter of dome. (*Right*) Pendentive: a convex triangular surface
springing from each corner of a tower, having the same function as a
squinch. (a) Pendentive. (b) Soffit. (c) Perimeter of dome.

iconographical programme of this kind because of the variety of interior
surfaces, curved and flat, which they offered for decoration. The most typical
feature of the Greek church was the dome, or cupola, the historic solution
adopted in the Near East to the problem of roofing four walls that were built
on a square base. The weight of masonry of the circular dome was supported
at the four corners by either a squinch or a pendentive [4.4]. In the Byzantine
church the dome itself was usually raised on a vertical cylinder, the drum.
The four walls supporting the dome were constructed as open arches leading
to four short transepts, themselves roofed with a vault or a dome. The
transepts formed the arms of a cross which helped to contain the outward
thrust from the centre. Christian preference for the cross-shaped ground-plan
led to the evolution in the tenth century of the characteristic eastern cross-in-
square church. The structure of dome and four transepts was now enclosed
within a square plan, thereby creating four separate areas in the corners.
Access to these corner areas, which were roofed with vaults or smaller domes,
was through arches in the walls of the transepts. In the typical cross-in-square
church the eastern transept, which formed part of the sanctuary area, or naos,
was sometimes lengthened. It terminated in an apse which was usually
flanked by a smaller secondary apse on each side. At the opposite end of the
church was an extension, the narthex, serving as a kind of vestibule, which
was customarily unconsecrated. Originally the narthex was the area to
which catechumens were restricted before baptism, when they were not
permitted to share the mysteries of the eucharist. Thus progress in the church

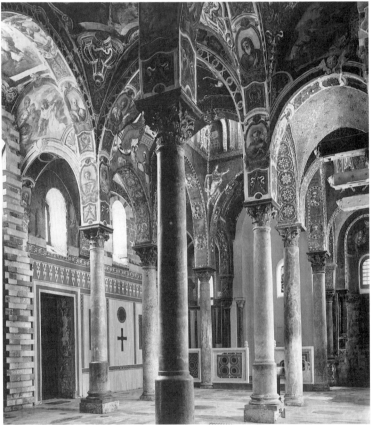

4.5 (*Above*) A cross-in-square church seen from the south-east.
(a) cross. (b) square. (*Below*) Interior of the church of the Martorana,
Palermo, looking towards the north-east. It is built on the cross-in-square
plan. The structure supporting the domes and vaults has been reduced to a
series of pillars which take the weight of the pendentives and arches, giving
a feeling of lightness throughout the interior of the building. Founded 1143.

from west to east was towards increasing sanctity. A derivation of the cross-in-square type, but reduced to its simplest elements, is the chapel of St Zeno in S. Prassede [3.18], Rome, which is built on a square plan with a dome on pendentives. Examples of the cross-in-square church are found in southern Italy, built between the tenth and twelfth centuries. Its fully developed form is seen in the church of the Martorana (founded 1143) at Palermo in Sicily [4.5].[12]

The main principle of the new iconography can be simply stated: the greater the sanctity of the person portrayed, the higher he was placed in the building. The eye of the worshipper was naturally led upwards towards a vision of heaven in the vaults and domes. The highest, celestial zone is the centre of the dome which holds the image of Christ (or one of his symbols), usually half-length in a medallion and surrounded or supported by angels. Great sanctity also attached to the ceiling of the apse (the semi-dome or conch) in which the Virgin is portrayed, either standing in the orant pose or enthroned, usually with the Infant Christ. Not far below Christ and the Virgin come the apostles. The second zone was situated in the pendentives, squinches and upper areas of the vaults and soffits. This was the Holy Land and here are depicted events from the gospels that form the basis of Christian doctrine. The third zone, the lower vaults and walls, represents the terrestrial world, and is occupied by the saints – martyrs, confessors and more notable ecclesiastics. Among the saints the most venerated were the 'warriors' who are usually given places of honour towards the eastern end of the building.

The individual scenes and motifs that made up the new iconography can often be traced back to Near-Eastern sources. For example, the standing angels, which sometimes support the central medallion of Christ at the top of the dome, had an ancient lineage. They are seen in the vault of the ninth-century chapel of St Zeno at Rome, and before that at Ravenna in the presbytery of S. Vitale (546–48), and in the chapel of the bishop's palace (c. 500) in the same city. A still earlier version of the same motif is found in a third-century pagan tomb discovered in Palmyra in Syria where the figures represent Victories which are supporting medallion portraits of the deceased. Figures of the same kind were common in Roman funerary sculpture where they are also seen holding a medallion [4.6]. The female figure had a similar function in the Greek temple where pillars which supported the architrave were sometimes carved in the female form. They were called Caryatids, after the maidens of Caryae in Greece who performed ritual dances. Best known are the Caryatids of the Erechtheum on the Acropolis.

What was new about the decoration of Macedonian churches was the way in which the old motifs and artistic conventions were assembled so that they became a single, interrelated whole which took on a fresh meaning. Thus the mosaics made their own contribution to the overall organic unity of the building.

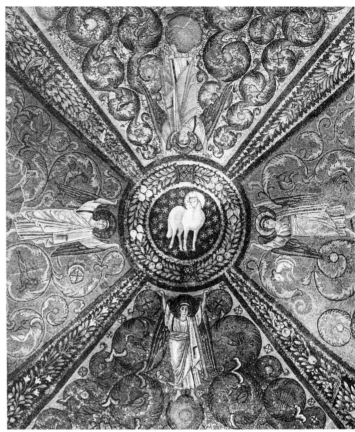

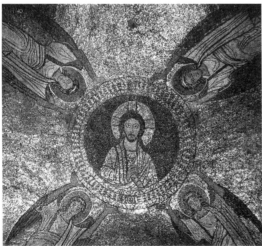

4.6 (*Above left*) Winged
Victory, the pagan prototype of
Christian angels, supporting a
medallion portrait of the
deceased. 3rd-cent. sculptured
tomb, Palmyra, Syria. They
appear frequently on Roman
sarcophagi. (*Above right*) Angels
supporting a medallion with the
Paschal Lamb. Mosaic in the
presbytery vault in S. Vitale,
Ravenna. 546–8. (*Left*) As
above, with the Pantocrator in the
medallion. 9th cent. Chapel of St
Zeno. S. Prassede, Rome.

The first zone: images of heaven

At first the new iconography made do without narrative scenes, confining itself to single figures, full length or busts, separated from one another by smooth surfaces of coloured marble. Little remains today of the monuments of the early Macedonian period and we have to rely on descriptions by contemporary writers. The following is by Photius, the Patriarch of Constantinople (*c.* 810–91), on the decoration of the church of the Virgin of the Pharos in the imperial palace at Constantinople. 'On the very ceiling is painted in coloured mosaic cubes a man-like figure bearing the traits of Christ. You might say he is overseeing the earth, and devising its orderly arrangement and government, so accurately has the painter been inspired to represent, though only in forms and colours, the Creator's care for us. In the concave segments next to the summit of the hemisphere a throng of angels is pictured escorting our common Lord. The apse which rises over the sanctuary glistens with the image of the Virgin, stretching out her stainless arms on our behalf and winning for the emperor safety and exploits against the foes. A choir of apostles and martyrs, yea, of prophets, too, and patriarchs fill and beautify the whole church with their images.'[13].

Heaven, according to the scriptures, was the place to which Christ ascended after he had appeared among the apostles on the Mount of Olives[14]; it was the place from which the Holy Spirit descended on the day of Pentecost upon the brow of each of the apostles, like a tongue of flame, causing them to speak in a variety of foreign languages[15]; heaven was also the throne of God[16], the seat of judgement and, in general, the abode of the Almighty and his angels. These aspects of Christian teaching were all rendered visually in the dome. There was seldom more than one depicted in the same building, at least in the early Macedonian churches of Greece, but in the provinces, in the more elaborately decorated buildings of later date, it was otherwise, as for example in St Mark's, Venice. This church, completed near the end of the eleventh century, has a centralized plan and cross-shaped axes, though it is not strictly the true cross-in-square type. It was modelled on Justinian's church of the Holy Apostles at Constantinople, which was restored by Basil I, and has five domes, one over the central square and one over each of the four arms of the cross. The three domes over the main west-east axis contain mosaics, dating from the late twelfth century, depicting Pentecost, the Ascension, and Christ as Pantocrator. They follow the established conventions of Byzantine iconography, with certain exceptions where western influences have intruded. To judge from descriptions that have come down to us, the subject-matter of the domes of St Mark's was in some respects like the mosaics in the much earlier church of the Holy Apostles.

The Ascension dome shows Christ at the apex within a circular

medallion that is borne upwards by angels. He is seated on the arch of heaven and makes a sign of benediction. Below him, at the circumference of the dome, stands the Virgin who was always presumed to have witnessed the event. She is flanked by two angels. Next to them stand Peter and Paul (though the latter does not belong in this context) and the other apostles who complete the circle. Below, on the drum, in the spaces between the windows are a series of personifications of the Virtues, figures that are commonly found in western church decoration but which normally have no place in Byzantine schemes. In the pendentives are the four evangelists at their writing desks.

In the Pentecost dome the apostles are seated. Rays like spokes of a wheel descend upon their heads. They issue from the central medallion at the top which contains the Hetoimasia, or empty throne (p. 94), a symbol of the godhead and the source of the apostles' inspiration. Below, on the drum, stand sixteen pairs of figures, one between each window, clearly differentiated from one another by their dress. These are Parthians, Medes, Elamites and others, the devout Jews of all races who were astonished to hear their own tongues spoken by the apostles (sometimes called, as in the Greek New Testament, *Phylai* and *Glossai*, 'tribes' and 'languages'). Their more customary place is in the pendentives, but in St Mark's those are occupied by angels. The eastern dome, over the sanctuary, shows Christ as 'Immanuel'[17] with, below, the Virgin and prophets whom the name evokes.

A similar image, the Pantocrator, is the focal point of many schemes of Byzantine monumental art. It is a kind of 'doctrinal portrait'. It depicts Christ with a cruciform halo, either as a bust within a medallion, or, as in St Mark's, the whole figure enthroned. His name usually appears in abbreviated form: IC XC (I(esou)s Ch(risto)s). He holds a scroll or book in the left hand and gives the sign of blessing with the right. The book, if open, bears an inscription. This is not the earthly Christ of the gospels but the 'All-mighty' sovereign (Greek *Pantocrator*). It is the imperial image which Photius described in the church of the Pharos. It also embodies the idea of eternity, of past, present and future, since God is at once Creator, Logos, Ruler, and apocalyptic Judge who will come at the Day of Judgement. The inscription most often associated with the Pantocrator is 'I am the light of the world', probably chosen because it echoes the appellation of the Byzantine emperor who was called 'Lumen Imperii', the 'Light of the Empire'. This icon and its associated imagery is seen in the cathedrals of Sicily at Cefalù and Monreale. They were built by the Norman conquerors in the twelfth century and being essentially basilican in form are therefore without cupolas. In these churches the Pantocrator has of necessity been placed in the next most sanctified place, the ceiling of the apse [4.1], and the Virgin, who would normally occupy this position has, in both churches, been relegated to the next lower zone on the wall.

The Pantocrator is typically attended by archangels and angels. Below them, at the circumference of the dome, or on the drum, are usually found the Old Testament prophets who foretold his coming. Their numbers vary, sometimes eight, more often sixteen, and among them may be Moses, David and Solomon. The accompanying inscriptions, from their writings, generally reflect some aspect of doctrine. The church of the Martorana at Palermo, built on the cross-in-square plan, has the Pantocrator enthroned in the central dome and eight prophets round the drum. The church is dedicated to the Virgin to whom its founder, George of Antioch, was especially devoted. The inscriptions are in Greek, and the scroll of Isaiah carries the well-known text, believed to prophesy the Incarnation: 'Behold, a virgin (*parthenos*) shall conceive, and bear a son'.[18] (ΙΔ δ Η ΠΑΡΘΕΝΟC ΕΝ ΓΑCΤΡΙ ΕΞΕΙ ΚΑΙ ΤΕΞΕΙ VΙΟΝ.)

Next in sanctity to the central dome was the apse because it was situated within the sanctuary area behind the iconostasis. It was the place traditionally reserved for the Virgin, as Bishop Photius confirms. Her role as intercessor, he also noted, went beyond the personal salvation of the individual worshipper to include the safety of the emperor and his victory over his enemies. At the same time, the Virgin had become a symbol of the whole Christian Church and therefore her portrayal as an orant could be said to represent the prayers of all believers. The Virgin is frequently attended by angels and accompanied by the apostles, as in the scene of the Ascension. Besides the orant type she is very often represented as the Hodegetria (p. 91) and then has the Infant on her left arm. This type may be either full-length, as in the apse of Torcello cathedral, or half-length. In the course of the twelfth century the half-length Hodegetria gradually became the predominant type. The older, frontal, rigidly hieratic type began to be treated more informally. The Virgin's head inclined towards the Infant in a manner which foreshadowed the popular type of Madonna and Child which appeared in Sienese painting in the next century [4.7].

The second zone: the festivals of the Church

The reappearance of narrative scenes in Byzantine churches after the iconoclast era seems to have taken place only slowly, and came after the single figure and the medallion portrait. The subjects were, with certain important exceptions, from the Bible, mainly from the gospels. Some were revivals of very old themes, little changed from the early Christian art of the fourth and fifth centuries, such as the Annunciation, Nativity, Baptism of Christ and the Entry into Jerusalem. Others were new, or were represented in a new way. The Crucifixion did not, until the ninth century, assume its typical medieval form, depicting the body of Christ dead and naked on the cross. (Hitherto, he was shown alive, open-eyed and triumphant over death.) The

4.7 (*Left*) The Virgin and Child, full-length Hodegetria type. The inscription reads M(ATH)P Θ(EO)V, Mother of God. 11th cent. Apse of Torcello cathedral. (*Right*) A later Hodegetria, rather more informally posed, including the inscription Η ΟΔΗΓΗΤΡΙΑ. 1140–60. Palatine Chapel, Palermo.

Resurrection, in the form of the Harrowing of Hell, first appeared in the same century.

The western tradition of mural art was to treat biblical scenes as historical cycles. The large flat areas of the typical basilican church lent themselves to this treatment and the subjects tended to be arranged in chronological order along the walls of the nave, as they were described by Prudentius in the *Dittochaeum*. In Byzantine churches, on the other hand, the subjects were arranged in groups, or cycles, according to carefully thought-out theological 'programmes' and their range of subjects was narrower. The cult of the Holy Places led to an emphasis on scenes of Christ's birth and death, special prominence being given to the Crucifixion and Resurrection (the

Harrowing of Hell). Scenes of Christ's ministry, the miracles in particular, had lost the meaning they once had for early Christians as examples of Christ's power to save. Man's salvation was now obtained through the Passion which he celebrated in the eucharist. The miracles, therefore, with the exception of the Raising of Lazarus, which retained its place in the major cycles, were relegated to side aisles of the church or were absent altogether. The principle underlying the choice of subjects of the New Testament cycle was from now on closely connected with Christian rites. Each scene corresponded to one of the major annual festivals of the Church.[19]

Special days, set aside in the calendar for particular devotions, were a feature of older religions. The Romans called them *feriae* or *ludi*. Work ceased and the people took part in processions, games and sacred meals, and made sacrifices to the gods. The Jews consecrated every seventh day to God, and the first Christians observed the Jewish sabbath until the Church substituted Sunday as a specifically Christian feast. The first annual Christian feasts, Easter and Pentecost, were instituted at about the same time. Others were gradually added and by the ninth century they included Christmas, Epiphany, the Presentation in the Temple, the Circumcision and Ascension. It is religious festivals such as these which the principal cycles in Byzantine churches of the eleventh and twelfth centuries are illustrating.

The content of a cycle and the number of scenes in it varied according to the locality. Twelve eventually became the norm, comprising the Annunciation, which celebrated the moment that the Incarnation was held to have taken place; the Nativity; Presentation; Baptism; the Transfiguration, when Christ's divinity was revealed to the disciples; Raising of Lazarus, perhaps retained because it was a 'type' of Christ's Resurrection; Entry into Jerusalem; Crucifixion; Harrowing of Hell; Ascension; Pentecost; and the Death of the Virgin, called the Dormition (in Greek *Koimesis*).[20]

The festival cycle appeared not only in churches. It is found on devotional objects such as the portable icons made of ivory or mosaic which became fashionable in Constantinople about the twelfth century, and on ivory book-covers. Here the scenes are presented in a series of rectangular panels that sometimes frame the image of Christ or the Virgin Mary in the middle. Objects of this kind were carried from place to place and were used for special devotions on each of the holy days represented on them [4.8]. Part of the festival cycle appears on the golden altarpiece, the Pala d'Oro, in St Mark's, Venice [4.9]. This dazzling work is an assemblage of shining gold plaques bearing cloisonné enamels of different periods, some dating from the late tenth or early eleventh century, finally put together in its present form in 1343. The six larger scenes along the top, on either side of St Michael, comprise the second half of the festival cycle (Entry into Jerusalem to Dormition). They are thought to be Venetian spoils, acquired after the sack

4.8 Portable mosaic depicting the festival cycle. Left to right, top
to bottom: Annunciation, Nativity (bottom right, two midwives are
bathing the Infant – a Byzantine motif, rare in the West), Presentation,
Baptism, Transfiguration, Raising of Lazarus.

The other half of the same mosaic: Entry into Jerusalem, Crucifixion, Harrowing of Hell (Anastasis), Ascension, Pentecost, Dormition. 13th cent.(?) Museum of S. Maria del Fiore, Florence.

4.9 Christ's Entry into Jerusalem. The two small figures in
the foreground are laying a cloak. Those at the gate hold palm
branches. The Greek inscription reads – Η ΒΑΙΟΦΟΡΟΣ,
the bearing of palms (see App.). Enamelled gold plaque from
the festival cycle on the Pala d'Oro. 11th–12th cent. St Mark's,
Venice. [cf. 4.11]

of Constantinople in 1204 and taken from an iconostasis which probably
included all twelve. In the centre of the altar is a large enamel of the enthroned
Pantocrator surrounded by the four evangelists. Above him is the
Hetoimasia flanked by angels, and below is the orant Virgin with an
emperor and empress on either side. These and other features recall the
pictorial scheme of the Byzantine church.

In churches, the arrangement of the festival cycle was flexible, depending
on practical considerations such as the design of the building, the natural
shape of the subjects and, to a lesser extent, their order in the calendar. The
deeply curved surface of a squinch or other kind of niche could be used to
good effect to make figures appear to communicate across it from one side to
the other, thereby creating the illusion that they existed in real space, within
the church itself. Even their frontality thus acquired extra significance. Thus

a scene that was composed of two opposing figures, or groups of figures, lent itself to this kind of placing, for example, the Annunciation (the Archangel and the Virgin), the Presentation in the Temple (the Holy Family and Simeon), the Baptism (John the Baptist and the angels with Christ between them in the centre) and the Transfiguration (Moses and Elijah with Christ in the centre). These should all be looked for in the sanctuary area in the four squinches under the dome. The Annunciation is often found in the two spandrels of the sanctuary arch with the angel on the left and the Virgin on the right. The Crucifixion and the Harrowing of Hell are generally situated on flatter surfaces in the transepts, or sometimes in the narthex. They were usually put on west-facing walls so that they confronted the spectator when looking east. A similar consideration affected the composition of the scenes above the sanctuary. As one looks east it is generally the more sacred figures that are directly in view on the curved surfaces.

The earliest churches still standing that display the Byzantine liturgical cycle in its purest form are in Greece and date from the eleventh century – St Luke of Stiris in Phocis, the Nea Moni on the island of Chios and the monastery church at Daphni. In later buildings in the more distant provinces the programme became gradually diluted with the addition of other episodes from the Passion and from the Infancy of Christ which gave the cycle a more historical character. Of the four great Norman churches of Sicily, the Martorana at Palermo conforms most closely to the ideal Byzantine type in architecture as well as decoration, but here the festival scenes, chiefly because of the confined space, are reduced to four, those in which the Virgin appears, since the church is dedicated to her. In the Palatine Chapel two new episodes are added from the Infancy story, Joseph's dream (an angel warns him about Herod) and the Flight into Egypt.[21] The cathedral of Monreale standing above Palermo has a long nave and aisles and the New Testament scenes are accordingly extended far beyond the cycle of subjects based on the festivals. The mosaics were carried out during the reign of the Norman King William II who died in 1189. There are no less than sixty-two scenes, the most extended of any New Testament cycle in Italy. They faithfully follow the traditions of Byzantine iconography, much of it descended from metropolitan forms that go back to the sixth century. The inscriptions however are in Latin. The cycle begins with a less familiar annunciation, the one telling of the birth of John the Baptist to his father Zacharias,[22] which is not normally found in western cycles. Many miracles are included, conspicuous among them the first to be described in the Bible, the changing of water into wine at the Marriage Feast at Cana.[23] Scenes from the Passion and Christ's subsequent 'appearances' include many that remained prominent in eastern and western iconography, such as the Last Supper, the Agony in the Garden, the Betrayal of Judas, the Entombment, and Christ at Emmaus.[24]

The third zone: the saints

While Christians in the West looked for spiritual guidance to the Bible and ecclesiastical institutions such as the papacy, in the East it was more often through the saints that they sought union with God. The sense of the continuing presence of a long-dead martyr or confessor and his power to communicate with the living was greatly enhanced by his image which seems to have exerted the same kind of influence as an ancient cult-object. This reverence for the saints and their associated imagery had grown up as a vital element of Christianity almost from its infancy. Now it became part of the new concept of the church as a microcosm of the universe, where it occupied the third zone of its decoration.

East and West each had many saints of their own, others they shared, particularly those of very early date. Highest in rank were the evangelists and apostles. Next came the martyrs and the Fathers. The latter were priests who had left the impress of a powerful personality on Church history and had usually contributed through their writings to the formation of doctrine. The principal Greek Fathers were the two Cappadocians, Basil the Great (329–79), the founder of the monastic movement, and Gregory of Nazianzus (329–90), identified in inscriptions as the 'theologian', for his discourses on the Trinity; John Chrysostom (c. 347–407), the 'golden mouth', so called for his eloquent sermons, and Athanasius (c. 296–373), a vigorous opponent of Arianism (though no longer regarded as the author of the creed named after him). Chief among the martyrs were soldiers, the 'warrior' saints, many of them insubstantial figures whose origins were merely legendary. They include George, whose cult eventually found its way to Britain, Demetrius of Salonika, and Theodore who also fought a dragon. Next came the healing saints, called Anargyroi – the moneyless – usually six in number, arranged in groups of two or three. Among them are the legendary physicians Cosmas and Damian whose cult came to be associated with the Virgin because of her powers to intercede, in this case for the sick. Among those of lesser rank were the many bishops and monks, some only of local importance, holy women and canonized emperors.

One western saint whose appearance in Byzantine church decoration is perhaps unexpected is Thomas of Canterbury. He is among those standing in the main apse of Monreale cathedral. The image probably dates from the 1180s and is thought to be the earliest representation (he was canonized in 1183) of the man who symbolized the steadfastness of the Church against the threat of temporal power. He was for this reason widely depicted in European art between the twelfth and early sixteenth centuries. The Norman King William II of Sicily was married in 1177 to Joan of England, the daughter of Henry II, and Thomas' image in the church founded by William was no doubt connected with this event. It may also reflect the

king's attitude towards the Pope in Rome, under whose spiritual authority he had firmly placed himself.[25]

The place of greatest sanctity for a saint was in or near the central apse and here the apostles and Church Fathers keep company with the patriarchs of the Old Testament. In the area of the sanctuary are also found the principal martyrs and Anargyroi, on the soffit (the inner surface) of an arch or in the transepts where they may be arranged according to their order in the calendar. Minor saints usually occupy the western part of the building, including the narthex. They form the lowest zone of decoration and, being literally nearest to the worshipper, helped to provide a link between him and the remoter heavenly hierarchy in the upper parts of the church.

The figures of Greek saints, having no individual attributes to distinguish them from one another, are identified by an inscription. There are also differences of dress. The apostles wear the *chiton* and *himation* (p. 87), the warrior saints are in armour, and Fathers and other ecclesiastics have vestments appropriate to their rank in life. Those remembered for their writings hold a closed book or a scroll. Though portraiture in the sense of a likeness to the living person was virtually unknown in the monumental art of this time, some of the more important saints were sharply distinguished from one another and, like the apostles, acquired personal physical traits.

In the middle Byzantine period the old tradition was generally followed of representing the single figure full face, especially when standing. Besides the full-length standing figure, used for apostles and Fathers, the saint may be depicted half-length or as a bust within a medallion. Full-length figures always occupy vertical spaces on the walls, the half-lengths are usually placed so that some architectural feature provides a natural cut-off for the lower part of the body, as in a lunette. The medallion type is usually found in the triangular space between the ribs of a vault or on the soffits, one above the other. The half-length figure and more particularly the bust, were both forms which had long ago acquired their own significance in imperial and religious art. They had a special connotation with kingship, but also with death and immortality. The bust had been the accepted form for representing the emperor on coins and in other kinds of royal portraiture. The bust enclosed within a circular medallion, the *imago clipeata* (p. 78), was particularly associated with the idea of survival after death in pagan and early Christian funerary art. The form was therefore appropriate for conveying the idea of the saint as an immortal being and was widely used in Byzantine mosaics and frescoes of the early and middle periods. An example from the sixth century in the church of S. Vitale, Ravenna, shows medallion portraits of Christ and the apostles on the soffit of an arch [4.10]. The same treatment was used for the very numerous saints in the churches of Sicily and in other regions that came under Byzantine influence.[26]

4.10 Medallion busts of Christ and the apostles. 546–8. Mosaic on the
soffit of the presbytery arch, S. Vitale, Ravenna.

THE DECLINE OF LITURGICAL ART

The diffusion of the Byzantine spirit

It is rare in medieval Italian art to find the Byzantine tradition in a pure,
undiluted form. The flatness and frontality of the Greek style is often
enlivened by a freer, more vigorous modelling which came naturally to Latin
craftsmen, and one tends to find the rigid types of Byzantine iconography
blended with western motifs and themes. The decoration of the Benedictine
church of S. Angelo in Formis near Capua, built in the eleventh century by
Desiderius, the abbot of Monte Cassino, shows this mingling of East and
West. The frescoes were painted by Greek artists and by Italian pupils
trained in their methods. In a lunette over the entrance is a half-length figure
of St Michael and above him an orant Virgin in a medallion supported by
flying angels [cf. 4.6], with an inscription in Greek on the lintel at the
foot. The treatment is wholly Byzantine except for the Latin motif of a crown
on the Virgin's head. In the apse on the other hand is an enthroned Christ
surrounded by the evangelists, who take the form of the four symbolic
creatures (p. 95), which was the Latin way, instead of the figures of Greek art
seated at a writing desk, as on the Pala d'Oro [4.11]. On the walls of the
nave and aisles are subjects from the New and Old Testaments, typically
Byzantine in the content of individual scenes and in the grouping and
gestures of the figures, but together treated as an historical narrative series just
as they were in the basilicas of early Christian Rome.

In the north of Italy the Greek-dominated art of Venice came under the
influence, in the twelfth and thirteenth centuries, of a different artistic style,
barbarian in feeling, which came from across the Alps and produced a
characteristically Venetian combination of Byzantine and Gothic (see
Chapter 5). In the far south, Arabic styles of art mingled with Greek,
particularly in Sicily which had been dominated by the Saracens for two
hundred years before the arrival of the Normans in the eleventh century. The

Normans were receptive to the culture of their predecessors and their churches contain numerous examples of Islamic influence in architecture and in decoration. In the Palatine Chapel the pointed barrel vaults and the nave with its ceiling of intricately carved 'stalactite' forms are wholly Islamic in feeling. The same influence is combined with Byzantine elements in the mosaics covering the walls and ceiling of the so-called Norman Stanza in the Royal Palace at Palermo. The heraldic lions and griffins on the ceiling and the pairs of archers and centaurs on the walls had had a place in Byzantine decoration since the iconoclast era (p. 115), but their origins were Arabic bestiaries and the astronomical works for which Arab scholars were famous [4.12]. A tree with a pair of animals or birds placed symmetrically on either side is a familiar Byzantine formula of this kind, which later spread to the West. The so-called 'sacred tree' is of great antiquity. It was known in ancient Mesopotamia and may originally have been a symbol of primitive man's worship of the tree. In its Christian version, which reached Constantinople from Persia and Syria, the tree is commonly a vine with

4.11 St Luke, the evangelist. On his desk are writing
implements. The book in his hand reads FUIT IN
DIEBUS HERODI(S), 'There was in the days of Herod
...', from the beginning of his gospel. Enamelled gold plaque
from the Pala d'Oro, St Mark's, Venice. Probably Venetian
work of 13th or possibly 14th cent.

4.12 Symmetrical imagery [cf. 5.5]: peacocks at the Fountain of Life;
A hunting scene with stags, huntsmen and their dogs 1160–70. Mosaic
on the wall of the royal apartments, Norman Palace, Palermo.

scrolls of foliage and is flanked by birds, usually doves or peacocks, symbolizing immortality [4.12, also 5.5].

'Liturgical' art failed to achieve the same economy and concentration of expression in Italy as it did further East, not only because of these external influences but because of the West's different attitude to religious imagery, and because the predominant western style of church architecture, the basilica, was basically unsuited to it. Another factor was the gradual substitution of fresco for the more costly mosaic as a consequence of the dwindling resources of the later empire. Fresco was a more flexible medium, tending to spread over larger areas of wall-surface, and lent itself to a more extended, narrative type of illustration.

The Old Testament

The Old Testament contained ample material that was suited to narrative cycles, and Genesis and Exodus alone supplied many themes. The more important were the Days of Creation and the stories of the great Jewish leaders, Abraham, Joshua, Moses and, above all, Joseph. These life-histories in pictures served as instruction for the unlettered and were also meant to be interpreted typologically, that is, as prefigurations of the life of Christ on earth. Some episodes were specially significant, like Abraham's sacrifice of Isaac which stood for Christ's death, seen as a sacrifice,[27] and the visit of the

three angels which represented the Trinity.[28] Many of the scenes and cycles were revivals of ones that decorated the walls of the early Christian churches of Rome and had originally been copied from manuscripts, the same source to which artists turned again in the thirteenth century. The history of Joseph had a prominent place in the illustrations of the Vienna Genesis, the original of which probably dated from the fourth century. The story appears again in the sixth century on the ivory carvings of a famous chair, believed to have been the throne of Archbishop Maximianus of Ravenna. The throne, or cathedra, has thirty-nine panels and includes the life of Christ in twenty-four scenes, and the figures of the Evangelists and the Baptist. It dates from the early sixth century and was made in a Greek workshop, probably in Constantinople.[29] The life of Joseph appears as one of several Old Testament cycles of the thirteenth century in St Mark's, Venice, where it is done in mosaic in the smaller cupolas in the narthex, alongside the Creation and the stories of Abraham and Moses.

These mosaics, carried out over a long period from about 1215 until the end of the century, were modelled on a manuscript. The Creation scenes in particular follow closely the illustrations in the Cotton Genesis (p. 86).[30] This and the Vienna Genesis are the only two illustrated Old Testament manuscripts known to have survived from before the iconoclast era. The Cotton manuscript is a codex and was made in Alexandria in the sixth, or possibly fifth, century. Its archetype was most likely an illuminated Jewish Septuagint, probably in the form of a scroll. Since the original Septuagint dated from before the Christian era, it could have included no specifically Christian motifs. In the Cotton manuscript the illustrations of Jewish history were therefore adapted to the Christian religion, particularly the image of God who, as the Creator, or Logos, was given a cross-sceptre and a cruciform halo. The mosaicist at St Mark's has followed the same conventions, as is shown in the creation of the sun, moon and stars [4.13]. The inscription, which is in Latin, not Greek, reads 'FIA(N)T LUMINARIA I(N) FIR(MA)ME(N)TO C(A)ELI' ('Let there be lights in the vault of heaven').[31] The Creator, standing on the left, is youthful and beardless in the Hellenistic style of Alexandrian illustration. The vault of heaven is represented as a hollow sphere studded with stars, among them the sun and moon. The group of winged figures on the right also features in the Cotton manuscript, and may well have appeared in the Septuagint. They are typically Greek in conception: each personifies a day, this being the fourth day of Creation.

The Last Judgement

In its fully developed version the Last Judgement is a compendium of scenes and motifs which make up a statement of Christian doctrine. When it accompanies the scenes of the festival cycle it forms a kind of culmination to

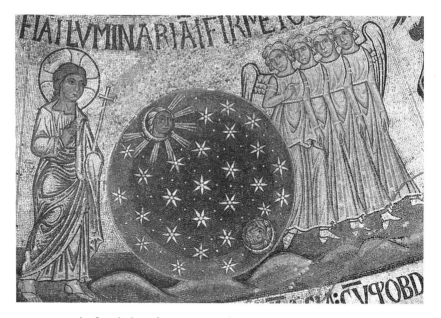

4.13 The fourth day of Creation. 13th cent. Cupola mosaic in the narthex of St Mark's, Venice.

the various aspects of the Incarnation for which they stand. It demands ample space and the resources of mosaic or fresco for its proper presentation. The subject is fairly widely represented in Gothic and late Gothic art of Italy and although Byzantine examples are few they include one that is outstanding, in the cathedral on the island of Torcello in the Venetian lagoon.

Christian belief in the Second Coming of Christ, when he would sit in judgement separating the righteous from the wicked 'as a shepherd separates the sheep from the goats', originally took its authority from the gospels, especially Matthew.[32] The conviction, universally held by early Christians, that his coming was imminent was a source of comfort to them under Roman oppression. The metaphor of Christ as shepherd was everywhere present in their imagery and the Last Judgement in its original form followed the same formula, appearing on Christian sarcophagi in particular. A late example of this type is seen in the church of S. Apollinare Nuovo, Ravenna, where it is treated in mosaic [4.14]. The gradual transformation of the humble shepherd into a triumphant, heavenly emperor which took place in the period following the Peace of the Church can be traced in the writings of such men as Eusebius, Bishop of Caesarea, who elaborated the idea of a God whose throne was the arch of heaven and whose footstool was the earth.[33] The theologian Ephraim 'the Syrian' (c. 306–73), the author of biblical

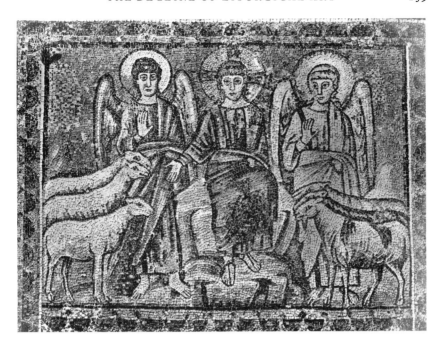

4.14 The separation of the sheep from the goats, an early type of Last
Judgement. Christ the shepherd, who is also the judge, is enthroned
between two angels. Early 6th cent. Mosaic, north wall of S. Apollinare
Nuovo, Ravenna.

commentaries and a prolific composer of hymns and homilies, was fond of
dwelling on the Last Judgement. His colourful notions supplied a number
of the features out of which the great medieval Last Judgements were
composed. According to him, Christ would come clothed in glory as the
King of Kings and attended by a divine hierarchy to the 'throne prepared in
heaven' (i.e. Hetoimasia) where he would judge the living and the dead.

The earliest known example of a Last Judgement to show the series of
tiers, or zones, that later became the norm, is in an illuminated manuscript,
the *Christian Topography*, by a Greek citizen of Alexandria, Cosmas
Indicopleustes ('the Indian navigator') who was writing about 547. He was
a great traveller though it is not known for sure whether he reached India.
The work was an early specimen of what was to become a popular medieval
genre, the explanation of the universe and natural history in terms of
Christian belief. For Cosmas, the earth was not merely flat, but rectangular.
The varied illustrations include geographical features, plants, and animals as
well as biblical scenes chosen to demonstrate typological parallels between
the Old and New Testaments. The style is Alexandrian Greek in its

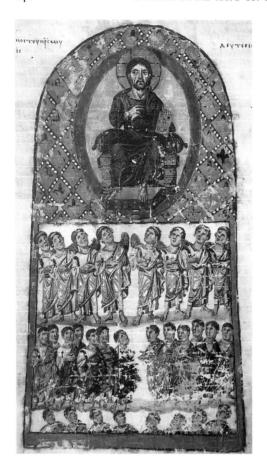

4.15 The Last Judgement,
from *Christian Topography* by
Cosmas Indicopleustes *c.* 547.
From a 9th-cent. copy in the
Vatican Library.

naturalistic treatment of landscape and the nude human figure, and in the use
of personifications for the Sun, the River Jordan and Death. It includes an
illustration of the Last Judgement [4.15]. At the top Christ, the Judge, is
enthroned in heaven holding the gospels. An inscription in Greek on either
side of him reads 'You have my Father's blessing; come, enter ...', and is
taken from the same passage in Matthew that describes the separation of the
sheep from the goats. The horizontal line separating Christ from the figures
below represents the firmament. These lower figures, too, are identified by
inscriptions. First are eight angels wearing *chiton* and *himation*. Next is a row
of 'men on the earth' (the judged?). In the bottom zone are the heads of four
women and four men looking upwards. They are the resurrected. The idea
of judgement, or doom, is clearly conveyed although there are as yet no
indications of heaven or hell.

The eighth and ninth centuries saw the gradual putting together of the

various elements that made up the fully developed Last Judgement. In the eleventh century the subject begins to appear in large-scale monumental art. The time may be significant, reflecting the Church's response to the passing of the year 1000 when, Christians had been taught to believe, the day of Judgement would come. The theme appeared first in the provinces, in Russia, Rumania and Italy. The earliest Italian example, about 1075, is a fresco in Desiderius' church of S. Angelo in Formis at Capua (p. 134) where it covers the whole of the interior west wall.

The great mosaic of the Last Judgement in Torcello cathedral dates from the early years of the following century, though it has been much restored since [4.16]. The source of the various elements was no longer the gospels but apocalyptic writings and extra-canonical works that had always inspired so much ecclesiastical art. It is in five horizontal zones, the top one consisting of the Anastasis (see page 113 and 4.3). In the centre of the second zone Christ sits enthroned on the arch of heaven in a 'glory' supported by cherubim. Unlike the version in the manuscript of Cosmas, his hands are spread to display his wounds (also visible on his feet), a feature which later became typical of Romanesque and Gothic versions. On either side of him the Virgin and Baptist intercede for mankind, the three together making a group known in the Greek Church as the Deësis (Supplication). This often forms a subject in its own right and may have originated in a ninth-century Byzantine court ceremony. In the same zone are seated the apostles, the 'assessors', and behind them a throng of angels and saints. A stream of fire issues from below the feet of Christ, between two wheels, and eventually mingles with the damned in the lower right. This motif is typically Byzantine and recalls the prophet Daniel's apocalyptic vision of the 'Ancient of Days' from whose throne, with its 'wheels blazing fire, a flowing river of fire streamed out.'[34] Below Christ, in the next zone, is the Hetoimasia, another motif not found in western versions, symbolizing the Second Coming. On either side of it kneel figures probably representing Adam and Eve whose sin Christ came to redeem.

Next to the angels guarding Adam and Eve are others sounding their trumpets to awaken the dead to judgement. On the far left and right the land and sea give up their dead as prophesied in the apocalypse of John,[35] but, curiously, being regurgitated from the mouths of wild beasts and sea monsters, rather like the illustrations in the bestiaries. The weighing of souls (Psychostasis) by St Michael takes place in the next lower zone, just above the lunette which contains the half-length orant Virgin. The Psychostasis has no known textual source and is common to both eastern and western Last Judgements. As we saw (p. 7), it may be traced back to the ancient Egyptian Book of the Dead. To the left and right in the bottom registers the virtuous and the damned have arrived at their respective destinations. On the left, at the gate of heaven which is guarded by a cherub, sits St Peter attended

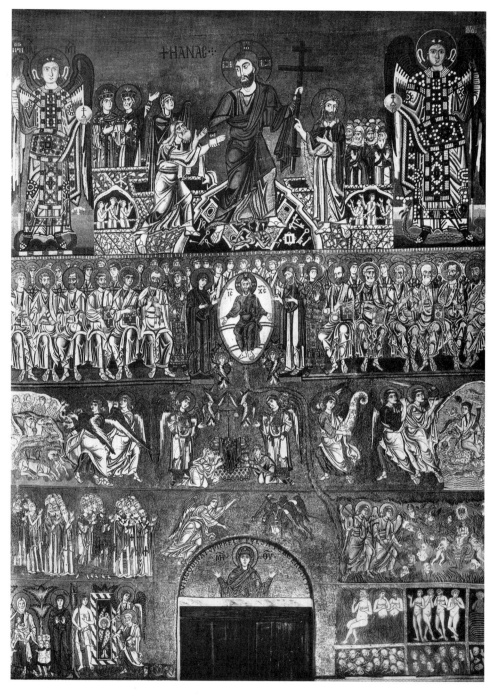

4.16 The fully-developed Byzantine Last Judgement. Early 12th cent.
Mosaic on the west wall of Torcello cathedral.

by an angel. Next to him, holding his cross, is the good thief, Dismas (absent from Western versions), whom Christ promised should be with him in paradise.[36] Beside him is the Virgin, and on the far left Abraham in whose 'bosom' are little figures representing souls. On the other side is hell where the white-haired figure of Hades holds the Antichrist in his grasp, and the unrighteous undergo a variety of torments conjured up by the popular imagination of the times.

SUMMARY

The founding of Constantinople in AD 330 marked the beginning of the Byzantine, or East Roman, Empire. It lasted until 1453 when the city fell to the Turks. The two greatest periods of power and expansion of the empire were accompanied by a flowering of the arts which made a strong impact on Italy. The most important mosaics to have survived from the First Golden Age (its zenith was in the reign of Justinian, 527–65) are at Ravenna and Rome. At this period it is not possible to draw clear dividing lines between eastern and western religious art, either as to style or iconography, because both belong equally to the broad spectrum of early Christian art. The second period lasted from the ninth to about the twelfth century. Again, Byzantine art and architecture flourished in Italy owing to an influx of Greek craftsmen who, originally, were escaping the hostility of the iconoclast emperors (c. 725–842). Pope Paschal I (reigned 817–24) used this opportunity to revive the art of mosaic in Rome.

The Church was powerful in the East because the emperor was its head. Eastern Christianity combined both intellectual (Greek) and mystical (near-eastern) elements. The latter led to a devaluing of the doctrine of the Incarnation and thus to a mistrust of images, one reason for the outbreak of iconoclasm. Byzantine religious images were not didactic, as the West aimed to make them, but were aids to devotion. The repertory of sacred themes and figures was circumscribed by dogma. The normal mode of expression was frontal and hieratic, and was devoid of significant artistic originality. Images of this kind encouraged idolatry and many were believed to work miracles.

After the restoration of images in the East the decoration of church interiors took on a more elaborate theological character. Besides being the abode of departed saints the building was regarded as a kind of replica of the Holy Land so that the eucharistic procession visited the sacred sites in turn. Most importantly, a church was a microcosm of the Christian universe. The cupola and the ceilings of the apse were the zone of heaven, containing images of God and the Virgin. Next, on the pendentives and squinches and other upper surfaces were the events from the gospels which formed the Feasts of the Church (usually twelve). The walls represented the terrestrial world and decreased in sanctity from east to west. Thus the apostles and Fathers

were placed on the walls of the apse, martyrs and other greater saints in the sanctuary area, and lesser saints down the nave. This scheme is followed most closely in eleventh-century churches in Greece; in Italy, as at St Mark's, Venice, or the churches of Norman Sicily, it tends to merge with western or other, regional influences. Narrative cycles of the Old Testament patriarchs, especially Joseph, may accompany the theological programme, and are intended to reflect, typologically, the life of Christ. Some, as at Monreale in Sicily, are greatly extended.

The saints in Byzantine art more often lack attributes and are identified by inscriptions. In the first age in particular they are often represented, bust only, in a medallion, to symbolize their immortality. The tradition of representing the evangelists by their apocalyptic symbols is a western one; in the East they are usually human figures, perhaps writing at a desk.

The subject of the Last Judgement was widely represented in the Middle Ages. It appeared in the first age in Ravenna in the scene of the separation of the sheep from the goats. From the eleventh century it underwent great development in eastern and western monumental art. In Italy, Byzantine influence is marked. At Torcello, to the usual zones is added at the top the Anastasis, or Christ in Limbo. Other eastern motifs, also seen at Torcello, are the Hetoimasia (the empty throne, implying judgement to come); on either side of it, the Virgin and John the Baptist interceding (the Deësis, or supplication); and the river of fire.

The Medieval West: Romanesque

THE OVERRUNNING OF EUROPE by barbarian[1] tribes from the east which took place between the fifth and seventh centuries was a gradual process. The Graeco-Latin culture, disseminated by the Roman Empire, was slowly dissipated and replaced by new and alien art forms. The effect of the Teutonic migrations was felt less in areas bordering the Mediterranean where cities more often escaped destruction and the old traditions were better able to retain their hold. In Italy the invasion of the Lombards,[2] a Germanic people from the north, in the sixth century, marked the beginning of the so-called Dark Ages. In the following century the Saracens overran the south, penetrating as far as Rome. Some centres of civilization survived relatively well, such as Venice and Rome, and Monte Cassino in the south, though elsewhere there was a widespread collapse of the arts due to the severing of traditions of craft techniques. So figurative art managed to continue in Italy thanks to the strength of Mediterranean influences, Byzantine in particular, though there now began to appear, especially in the north, artistic modes of expression of a different kind.

East and West

The art of western Europe in the Middle Ages followed a different course from that of the Byzantine East in both style and iconography. Byzantine art grew out of the classical Graeco-Roman tradition of the eastern Mediterranean which expressed its profoundest ideas through the medium of the human figure; the art of the West had its roots among the people of the north, the migrant tribes whom the Greeks and Romans called barbarians. This tribal art was essentially non-figurative, and tended towards abstract pattern-making. It made use of motifs such as the interlace, the double spiral in the form of an 'S' and a typical almond-shaped leaf (sometimes called a fish-bladder). When the barbarians used animal motifs they forced them into the same decorative forms. Tribal art was small-scale because it was employed primarily for the ornamentation of personal belongings, portable objects such as weapons, brooches and other articles of adornment. It was not concerned with making images of the gods, and when human figures were introduced with the arrival of the Christian Church, there was at first a strong tendency to make them fit the same stylized mould, which led to some strange distortions. In northern Italy under Lombard influence, figurative

sculpture deteriorated into mere surface ornament, with faces no more than crude masks. But the barbarians could also imitate the peoples they conquered. In Ravenna the Mausoleum of Theodoric the Ostrogoth (c. 525) shows the influence of Roman architecture. It is a two-storey rotunda of stone, formerly surrounded by a colonnade, and roofed with a single slab of stone, shaped as a shallow dome.

The reform of art which took place in the ninth century under the Emperor Charlemagne restored the human figure almost to its proper proportions, and was, in its wider aspects, the first move to a return to Roman sources of culture.

The Christian art of the West, unlike Byzantine art, was flexible. It was capable of being reshaped by political and religious change. It was not homogeneous geographically and showed marked variations from one place to another, not least in the different regions of the Italian peninsula. Above all, western Christian art drew on a much wider variety of sources for its imagery than the Byzantine Church ever permitted. Many of them were secular in origin and were seized upon by artists and interpreted with great vigour and imagination. The opportunity to represent scenes of everyday life in the context of religious doctrine, as, for example, in the Labours of the Months, helped to give it a very human, popular appeal. This art, which emanated from the monasteries of Latin Christendom, attempted to mirror the whole Christian universe. It was the opposite of the restricted repertoire of persons and scenes of the Greek Church whose purpose was to reflect ritual and to serve as an aid to devotion. In Italy the eastern and western traditions are seen side by side and often mingle.

The Carolingian revival

After the final disintegration of the Roman Empire little religious art was produced in the West except in the monasteries where it was confined chiefly to the production of illuminated ceremonial books, that is, the gospels, psalters and sacramentaries which were needed for daily worship. These works were modelled on the few surviving early Christian manuscripts that had originated in the Near East and Italy and which, because of their rarity, were regarded almost as holy relics. The classical figurative style of the originals gradually became barbarized and bird, fish and animal motifs were introduced, especially in the embellishment of initial letters and borders.

About the beginning of the sixth century a barbarian tribe of ancient Germania, the Franks, whose homeland was the region of the upper Danube and the Rhine, began a migration westwards. They settled in the northern half of what is now France and established a kingdom there. The conversion of the Franks to Christianity followed the baptism of their king, Clovis I, together with some of his knights, on Christmas Eve, 496, by Rémi, the

Bishop of Reims. The subject is represented in the Gothic cathedral of that city.

The first cultural revival of real consequence in the West was inaugurated by the Frankish king, Charlemagne, or Charles the Great (*c.* 742–814). He greatly extended the kingdom of Francia in a series of successful wars. In 773 Pope Hadrian I appealed to him for help against the Lombards who, having subjugated northern Italy in the sixth century, were now threatening the papal lands further south. Charlemagne overthrew the Lombard king, had himself crowned at the Lombard capital of Pavia, and thereafter styled himself King of the Franks and Lombards.

His coronation in Rome on Christmas Day in the year 800 was of a different kind. This was a symbolic act, intended to mark the beginning of an alliance between the Church and State. It set out to revive the idea of the Roman Empire with a Holy Roman Emperor at its head. For churchmen it was an authentic revival since the old empire had been identified in their minds with Christendom, in contrast to the barbarian invaders who were always thought of as pagans in spite of their conversion. Most important of all, the act of coronation and anointing was a ritual sanctified by the Church which thereby gave its formal blessing to Charles' warlike activities, making him protector of Christianity. Now that the sword had become a legitimate weapon for propagating the faith there gradually emerged that idealized medieval figure, the Christian warrior whose enemy was the heathen Saracen and who, in due course, became the inspiration of poets and artists. Charlemagne's role as defender of the faith is commemorated in a series of frescoes (1123), now in very poor condition, in the church of S. Maria in Cosmedin at Rome. They include scenes of the emperor converting the Saxon by the sword, his summons by an angel to crusade against the Moors in Spain and the subsequent liberation of the tomb of St James of Compostella, the fall of Pamplona, and the (no doubt imaginary) homage paid by Haroun el Raschid, caliph of Bagdad, with whom Charlemagne negotiated to ensure the safety of pilgrims in the Holy Land.

The revival of the arts, sometimes called a renaissance, which began in the reign of Charlemagne was not a broad cultural movement but a deliberate course of action promoted by the emperor himself. It lasted until 877 when, on the death of Charles the Bald, the dynasty ended. The Carolingian revival took much from Italy but gave back relatively little. Its objectives, in keeping with the ideals of the Holy Roman Empire, were to reform the liturgy and to restore and reinterpret as much as possible of the culture of Latin antiquity. To this end Charlemagne gathered together the best scholars from different parts of Europe and set up a kind of academy at his palace at Aix-la-Chapelle. However, it was not to the classical age of Augustus that Charlemagne's scholars turned, but to that of the first Christian emperors. The authors whom they chose for their Commentaries

were first and foremost the four Latin Fathers of the Church, Augustine, Jerome, Ambrose and Gregory the Great. In the arts, their models were not those of the Rome of the pagan emperors but the architecture, mosaics and manuscripts of Christian Italy. The design of the chapel of Charlemagne's palace at Aix-la-Chapelle, his northern capital, attempted to reproduce, so far as his builders were capable, the sixth-century church of S. Vitale at Ravenna.

Wall-painting seems to have flourished in the churches of Charlemagne's empire, though little now remains and our knowledge of it depends mainly on contemporary descriptions which refer to elaborate historical and biblical cycles.[3] Its subject-matter appears to have foreshadowed the monumental painting and sculpture of the eleventh and twelfth centuries, the age now called Romanesque, reflecting the liberal decrees of the Church Councils of Carolingian times which allowed artists greater latitude in the creation of religious images. Monumental sculpture scarcely featured in the Carolingian revival though relief carving flourished on a miniature scale in the production of ivories. The existence of a Carolingian school of metalworkers in northern Italy, or alternatively of Italian craftsmen trained in France, has been inferred from the fine altar in S. Ambrogio in Milan.[4] It is decorated with reliefs on all four sides in gold or gilded silver, inspired in large part by Carolingian ivories and miniatures. Besides the image of Christ enthroned, surrounded by the symbols of the evangelists and apostles, and biblical episodes, there are twelve panels depicting scenes from the life of St Ambrose, Bishop of Milan, who died in 397.

Among the greatest treasures of Carolingian art are the illuminated manuscripts produced by the scriptoria, or writing-rooms, of the monasteries. The most lavish illustration was reserved for royal patrons in works such as gospel books, commissioned by the court, which include whole-page illustrations using a wide palette of colours. Gospel books and evangeliaries (books of selected passages from the gospels used at divine service) generally contain the 'canon tables' (p. 165) and portraits of each evangelist at a writing desk, usually accompanied by his symbol (p. 95). They may also include a dedicatory portrait of the patron. A work on a more modest scale, but none the less renowned, is the psalter of Utrecht (820–30) produced by the School of Reims, in which the psalms and a number of other liturgical texts are illustrated by a wealth of miniature sketches. They are done in monochrome in a rapid, naturalistic style with much detail. They depict landscape, architecture, flora and fauna, medieval trades and occupations, and much else besides.

The influence of the school of Reims was the most widespread and enduring of all in the Carolingian age. It turned to the earlier and purer sources of the antique and reinstated many of the classical images which had featured in early Christian art but which had since been lost. In the Utrecht

5.1 Atlas supporting the universe. At the top, the Lord enthroned in a mandorla, flanked by angels. Below him, the army of the faithful. The illustration to Psalm 99 from the Utrecht Psalter, 816–35. University Library, Utrecht.

Psalter are found once more personifications of abstract concepts and places, and the classical deities of Graeco-Roman art where they mingle with sacred figures. They would eventually find their place again in Romanesque and Gothic. Atlas, the giant of Greek mythology, is depicted supporting the universe on his head and hands [5.1], a motif which recurs later in Italian Romanesque sculpture, where it is used to form the base of a throne or pulpit.[5]

The Ottonian revival

At the beginning of the tenth century northern Italy was subjected to a series of devastating raids by Hungarian tribes led by the Magyars, who penetrated as far as Campania. In the regions they conquered there was great destruction of works of art and artistic activity was brought to a halt. The invaders were

overthrown by the king of the Germans, Otto I (912–73), who made himself master of the greater part of Italy and was crowned Holy Roman Emperor by the Pope in 962. His son married a princess of the Byzantine imperial family and their offspring, Otto III (980–1002) was educated by Greek and Latin tutors who brought him up in both the Byzantine and Carolingian cultural traditions.

The revival of the arts which took place under the patronage of the Ottonian emperors therefore reflected the styles of both East and West. In relief sculpture its typical products were ivory carvings, used for book-covers or made into triptychs, representing the familiar Byzantine versions of Christ and the Madonna, and themes such as the Dëesis (p. 141), the Crucifixion and Dormition of the Virgin. Ottonian sculptors also developed life-size wood-carving in the round for altar-pieces. The monastery at Reichenau, on Lake Constance, became a centre for the production of illuminated manuscripts which showed the influence of both Eastern and Carolingian models. On the other hand the traditional subject-matter of manuscript illustration sometimes exhibited new and unfamiliar features that owed nothing to either Byzantine or Carolingian sources. A well-known evangeliary produced in the monastery of St Emmeran at Regensburg in Bavaria depicts a crucifixion with some wholly original figures replacing the usual *dramatis personae*, such as personifications of Life and Death and figures representing Light and Darkness together with other curious motifs.[6] Portable works of this kind from Germany supplied some of the inspiration for the revival of sculpture in the north of Italy at the beginning of the twelfth century. But the field of craftsmanship which contributed most to the Ottonian revival was bronze-casting. Its main centre was at Hildesheim where a workshop was founded by Bishop Bernward, one of the tutors of Otto III, which was active until the thirteenth century. One of the best-known examples of its output are the bronze doors (completed in 1015), now at Hildesheim cathedral, which represent the Old and New Testaments in a typological relationship. Their style has the same freedom and absence of solemnity that enliven the illustrations of the Utrecht Psalter. Also in Hildesheim cathedral is a bronze column depicting scenes from the life of Christ, arranged spirally in a series of frames which consciously imitate the historiated columns of the Roman emperors.

ROMANESQUE IN ITALY

Romanesque is the name given to the great period of activity in architecture and the arts of sculpture and wall-painting which extended over most of western Europe in the eleventh and twelfth centuries. The word is derived from the Roman forms of architecture which were revived, notably the round arch and the barrel vault. It came late to Italy, in the first decades of the

twelfth century, beginning in the cities of the northern plains between the Alps and the Apennines. The movement had its main roots in the monastic reforms instituted in France by the abbots of Cluny which led to a great religious reawakening in the West. The abbey of Cluny in Burgundy was founded in 910 and during the next two-and-a-half centuries, under a series of great abbots, the new Order, which adhered to the Benedictine Rule, set up monasteries throughout Europe, including Italy, that followed the Cluniac regime. The accompanying revival of sculpture which began in the southern half of France made itself felt eventually in parts of Italy.

Romanesque art in Italy, especially in the north, was also influenced by Germanic forms from beyond the Alps. Elsewhere in the peninsula Romanesque merged with existing traditions, giving it a regional character. Byzantine influence was strong in those areas that had remained under the protection of the eastern Empire throughout the period of the invasions. Through the trading ports of Venice, Torcello, Ravello, Salerno and Gaeta there continued to flow the products of artists and craftsmen from the eastern Mediterranean. In the south, the Arabs had conquered Sicily in 827 and gradually extended their rule on the mainland, bringing with them the distinctive architecture and decorative arts of Islam. The arrival in the eleventh century of the Normans who won control over Calabria, Apulia, Campania and Sicily put an end to the local rule of Byzantines, Saracens and Lombards. They were not, however, destructive but succeeded in welding the three cultures into a kind of unity. So Romanesque art developed differently at one end of the peninsula from the other. In the north, Germanic influences, derived from the art of the Ottonian court, predominated. The south produced a remarkable blend of very diverse traditions. Later, under the Emperor Frederick II, the south enjoyed for a while a kind of renaissance in which the forms of classical antiquity were restored and given new life.

The Romanesque church

The design of the Romanesque church evolved gradually as new building techniques were discovered. Its plan varied, sometimes being a rotunda, in imitation of Charlemagne's chapel at Aix-la-Chapelle, but the form most generally adopted was that of the ancient Roman basilica. These great edifices were conceived on an altogether grander scale than the Byzantine cross-in-square building and reflected the increasing wealth of the monasteries in the eleventh century. They also reflected a new religious enthusiasm which was arising in the West. Men embarked with fervour on campaigns against the Saracen in Spain and in the Holy Land. They were inspired in these military adventures by the clergy of Cluny who taught that such wars were the Christian's duty in the service of God. From this time images of warrior saints overcoming symbolic dragons of evil and themes of

knights in combat became increasingly frequent in Christian sculpture and painting.

The religious revival had other aspects. From the early days of Christianity the imminent prospect of the end of the world and the Second Coming of Christ had occupied men's thoughts, and the Cluniac Order, through preaching and writing, sought to prepare their minds for the Final Judgement. To what extent the year 1000 was at the time believed to be a specially significant date, and how much men's actions were thereby influenced, are questions about which scholars are divided.[7] Certainly a new programme of church building followed the crucial year and it may well be that the passing of the millennium without catastrophe to mankind provided some of the incentive for it. Sculpture and wall-painting were now much used to press home the apocalyptic message by depicting the Last Judgement and related themes.

There was another quite practical reason for increasing the size and number of monastic churches. They were needed to accommodate all those who now travelled on pilgrimage. This practice, also fostered by Cluny, grew rapidly in the eleventh century, having as its principal objectives, besides the Holy Land, the shrine of St James at Compostella in Spain, and Rome with all its sacred places. Churches sprang up along the pilgrim roads, and the routes themselves were a means by which new building methods were spread and new religious imagery disseminated.

Italian churches and their decoration

The Romanesque basilica in Italy has its own characteristic features. Instead of a vaulted stone roof we more often find a timbered gable running the length of the nave. The ambulatory, the semi-circular passage behind the sanctuary, is rare. Exteriors developed regional variations. The school of architecture centred on Pisa used arcades, often superimposed, as a decorative feature on the façade. Further north, in Lombardy, the west front is typically decorated with horizontal bands of relief sculpture [5.2]. In this region the main porch is often of the 'baldaquin' type, a projecting arch forming a canopy. The supporting columns often rest on the backs of crouching beasts, usually lions [5.6]. French influence can be seen in the churches of the pilgrim roads in Italy, especially in the design and decoration of the porch. It is constructed as a series of archivolts, receding concentric arches diminishing in size, the inner one framing the door; the semi-circular area above the lintel is of solid masonry (the tympanum), and is sculptured, a regular feature of the Cluniac churches of France [5.2, 5.14, 5.16]. The archivolts themselves also provide surfaces for a rich variety of carving. In the interior of the Italian Romanesque church, it is not so much the fabric of the building that is used for sculpture – excepting some fine examples of historiated capitals – as the separate items of

5.2 The façade of S. Michele Maggiore, Pavia. 1130–55. The portals
have archivolts and sculptured tympana. Beside and above the portals are
Lombardic friezes, bands of relief sculpture. The blind arcade at the top is
stepped to follow the angle of the gable end. From a drawing by
Giovanna Massari.

its 'furniture' such as stone pulpits, choir enclosures, episcopal thrones and paschal candlesticks.

Painting in churches

In the twelfth and thirteenth centuries mural painting was a feature of the interiors of churches. It was created by craftsmen, often of much individuality, who managed to convey a sense of great religious ardour, contrasting sharply with the impersonal work and the atmosphere of contemplative calm of Byzantine mosaics. The subject-matter of Romanesque mural painting adhered more strictly than did sculpture to religious themes. Unlike the Byzantine church, however, the Romanesque building had no sacred topography and the choice of subjects was accordingly wider. Their broad message was the glory of God as it was revealed in the Bible, and of the Virgin and the saints.

In the absence of a cupola the main devotional image in the Romanesque basilica was located in the semi-dome of the apse. It portrayed Christ in Majesty, the Majestas Domini, which corresponded to the Byzantine Pantocrator. Its treatment varies but usually it represents Christ as Judge at the Second Coming and is based on apocalyptic passages from the Bible. It shows him seated on a rainbow, perhaps also framed in a mandorla, and surrounded by the four symbols of the evangelists (Rev. 4:2–10). In churches dedicated to the Virgin she may take over the principal place, enthroned with the Infant Christ, and accompanied by the magi or the holy women. On the wall of the apse, below the semi-dome figure, are usually found the apostles and saints or sometimes scenes from the life of the saint to whom the church is dedicated. The latter scenes are also found in the crypt where his relics may lie. Lowest of all in the apse is sometimes a kind of dado which may be painted to imitate curtains. Here the artist was free to introduce secular motifs, frequently eastern plant and animal forms, perhaps copied from eastern textiles which themselves were used as hangings. In the crypt of Aquilaea cathedral is a painted curtain of this type with a scene of knights on horseback in combat. The sanctuary arch, which in Byzantine churches customarily has the Annunciation on the two spandrels, usually depicts in the Romanesque West the apostles, prophets, or twenty-four 'elders of the apocalypse'. They are grouped on both sides and look inwards towards the crown of the arch which carries the bust of Christ, generally in a medallion, or the Paschal Lamb, or the hand of God. The nave of the basilica was the place for the main biblical narrative cycles. They portray the Fall and Redemption of man with scenes from the Old Testament situated on the north wall, and from the New on the south. On the west wall is the Last Judgement, with Christ the enthroned Judge facing his image in the apse at the other end of the church, his presence pervading the whole building.[8]

THE UNIVERSE AND ITS INHABITANTS

Romanesque sculpture, more than painting, is remarkable for the variety of its imagery. Alongside the traditional repertoire of sacred art is a great medley of human and animal life. On the one hand it depicts man at his everyday occupations, the tasks allotted to him in the divine scheme of creation. But we also find all kinds of strange and curious monsters. Has the artist here been allowed a free rein to indulge his fancy or is there an underlying order and meaning waiting to be discovered? When, for example, we find fantastic creatures, human and animal hybrids, painted on the wall of the apse, one of the most sacred places in a church, in the company of Christ and the apostles[9]; or when they are carved in stone, occupying a central position above the west porch[10], the place often reserved for the Last Judgement, should we not look for some kind of explanation? There are really several questions to be answered. First, what was the source of the image and then, how was it transmitted from its original context into a Christian setting? In the case of Romanesque art the first is often easier to answer than the second; but even that is complicated by the very diversity of the sources, some of which have been traced back not merely to classical antiquity but to the religious images of the ancient civilisations of Mesopotamia. Finally, and most puzzling of all, what purpose, if any, did they serve within a Christian framework? Are they symbols or merely fantasy? The answer, so far as it has been unravelled, leads to no obvious conclusions. Just occasionally, though, we are able to glimpse a coherent and ordered plan.

The Labours of the Months

Let us begin with the straightforward, homely images. Among the scenes of everyday life in twelfth-century sculpture one of the most familiar shows the husbandman at his various labours at different seasons of the year. It is found especially in churches in France, but also in Italy where there are some fine examples in Lombardy, Emilia, and Tuscany.[11] The full cycle consists of twelve scenes, often with individual variations, corresponding to the months. At the church of S. Zeno at Verona, on the main portal, they are as follows: January, a man, warmly clad, beside a blazing fire; February shows him pruning his vine; March is a personification of the wind, a frontal figure blowing on two horns; April offers a bunch of flowers; May is a knight on horseback setting off for the wars; June gathers a basket of fruit in the tree-tops; July, wearing a hat against the sun, cuts corn with a sickle; August is a cooper with a barrel, hammer in hand; September gathers grapes, bears a bunch on his shoulder, and treads them in the vat, all at once; October beats acorns from an oak to feed his pigs below. In November he kills the fatted pigs; December, axe in hand, gathers winter fuel. Typically Italian are the personifications of the March wind, the cooper, and the tendency to depict

scenes of harvesting earlier in the year than in cooler regions further north. The influence of the antique is seen in the portrayal of two-faced Janus for January (p. 29), or, for March, the figure of a youth seated, and drawing a thorn from his foot (both at Parma Cathedral),[12] and the flower-bearer for April.[13] Sometimes each scene is accompanied by its appropriate sign of the zodiac, as at Lucca Cathedral.

The theme has a long ancestry and was known to the Greeks and Romans. The earliest example of a visual calendar is found on a Hellenistic frieze of the second or first century BC, now built into the church of Agios Eleutherios at Athens. It consists of twelve groups of figures, separated by the signs of the zodiac. They represent Greek religious rites and perhaps also personifications of the months. A Latin manuscript calendar of AD 354, known as the Chronograph of Filocalus (it has survived only in late copies), similarly depicts each month by a human figure, each of which indicates by some ritual action the god to whom the month was sacred, or suggests by its dress the season of the year. The cycle occurs widely in Roman pavement mosaics where the figures are accompanied by various attributes to suggest the time of year. Inevitably it found its way into Christian church art and appeared in Byzantine mosaic pavements in the Near East of the sixth century.[14] What was the reason for the reappearance of the theme in the Christian art of the West in the twelfth century? Its association with the signs of the zodiac suggests that it may have retained a connection with astronomy in the intervening period; indeed, one of the earliest-known medieval examples, from the ninth century, of the Labours of the Months occurs in an astronomical text.

The science of astrology-astronomy, indeed man's understanding of the universe as a whole, had changed little in its main outlines since antiquity. In the twelfth century it was much as Cicero described it in the *Dream of Scipio* (p. 46). At the centre was the earth. It was not spherical but a flat disk bounded on all sides by the waters of Oceanus. The seven planets, which included sun and moon, turned in their separate, concentric hollow spheres about the earth. Beyond them was the firmament, the outer limit of the universe, a kind of spherical shell in which the belt of the zodiac and other constellations were fixed. When a sculptor set about transcribing this world-picture into stone he followed the old conventions and illustrated each constellation with the mythological creature after which it was named. This kind of image of the heavens can be seen at Sacra di San Michele (The Feast of St Michael), a former abbey on a hill-top in the Val di Susa which was a stopping-place for pilgrims to Italy. The jambs of a portal, the Porto dello Zodiaco, show on one side the signs of the zodiac, on the other the constellations, which include Orion (an armed warrior), Pegasus (the winged horse), and Centaurus (the centaur, half man, half horse). They were probably copied from an astronomical treatise. Such manuscripts were

themselves copies of earlier works, a process eventually leading back to antiquity, so that the classical types were preserved, sometimes in their original forms, into the Middle Ages.[15] A similar series, related to Sacra di San Michele, can be seen in Piacenza cathedral on the archivolt of the main portal. Here the hand of God appears at the top to signify that the universe is all his creation.

In medieval thought all things in heaven and earth were intimately related to one another. Man himself was formed out of the same four elements as the stars and planets, and was therefore a microcosm of the larger universe. In a similar way the earthly cycle of the seasons reflected the celestial cycle of the year. Man had toiled unceasingly round the year since Adam first took hold of his spade. The image of his labours was therefore both a mirror of the heavens and at the same time showed the way to achieve redemption from the sin of the first man.

Distant peoples

The 'human monster' was quite a different kind of image, and yet it was also intended to represent the real world. The one-legged, the dog-headed, the headless ones with eyes and mouth situated on the breast and others of the same kind which occur widely in Romanesque art should not be dismissed as meaningless grotesques. The Middle Ages regarded monsters not as fabulous creatures but as real inhabitants of the earth, though they lived only in remote, little-known countries near the perimeter like Ethiopia, India and Scythia. They were first described about 400 BC by a Greek, Ctesias, physician to Artaxerxes, the king of Persia, who wrote down the tales he heard from travellers in the East. Pliny borrowed from Ctesias for his *Natural History*[16] and from him they were copied by another Roman, Solinus, in the third century AD. St Augustine described monsters of this kind on a pavement mosaic at Carthage which depicted, among others, the Cyclops, with one eye in the middle of the forehead, Pygmies 'but a cubit high', the Sciapodes with one leg only who 'in hot weather lie down on their back and shade themselves with their feet', and the Cynocephali, humans with the head of a dog. Augustine conceded that anyone, however outlandish his appearance, so long as he was born of man must be descended from Adam.[17]

Later writers agreed with Augustine that such creatures really existed. Bishop Isidore of Seville (c. 560–636), the compiler of an encyclopaedia, the *Etymologiae*, which was a prime source of information for the Middle Ages, repeated much of what Augustine had written, adding, among others, the Panotii (All-ears) of Scythia 'whose ears were so large that they hid the rest of the body'. Monsters, said Isidore, could have come into existence only through the will of God and were therefore not in defiance of nature, they were contrary only to the familiar (*nota*) in nature.[18] They are seen in the

medieval *Mappa mundi*, a pictorial map of the world of which a fine example (*c.* 1300), is preserved in Hereford cathedral. It is circular and shows the three known continents, Europe, Africa and Asia with Jerusalem in the centre. The map-maker, drawing on many sources of information besides the Bible, produced a visual geography of the earth as it was believed to exist in his day, the principal features being indicated by small sketches – cities, mountains, rivers, people and animals. In the outer regions are depicted many of the half-human creatures which are described by Isidore and others, while at the top of the map God is enthroned in judgement over all that he has created.

A wall-painting in the apse of S. Giacomo at Termeno (a village between Trento and Bolzano), dating from about the middle of the thirteenth century depicts, in the semi-dome, Christ in Majesty surrounded by the symbols of the evangelists. The figures below him are arranged in two tiers. In the upper are the apostles, grouped in pairs under arches, and in the lower an assortment of monsters [5.3]. So far as the sacred figures are concerned this arrangement is often found in Romanesque churches throughout the West, and is well suited to the shape of the apse. It may have been derived from very early narrative representations of the Ascension at which the apostles were present, and became gradually stereotyped into a devotional image. What possible place can there be in this scheme for the figures, mostly on the lower half of the wall, where we recognize a Sciapod, a Cynocephalus and various sea-monsters, among others? The crouching, Atlas-like figures on the far left and right may provide the key. They seem to be bearing the upper zone on their shoulders, suggesting that it represents heaven, since this was the role of Atlas. It may be that the lower zone is the earth, a symbolical rendering of its furthest lands and oceans much as they are represented in the *Mappa mundi*.

There is an earlier example of a similar juxtaposition of apostles and monsters in French sculpture which is relevant. In the great Cluniac basilica at Vézelay, over the portal in the narthex, is an image of Christ enthroned among the apostles, rays of light descending on them from his outstretched hands. This is a western version, dating from about 1125–30, of the theme of Pentecost. The sequel to that event was the departure of the apostles to preach in many lands and tongues. Whereas the distant peoples to whom they took their message are represented in Byzantine iconography by normal human figures, such as we saw at St Mark's, Venice, at Vézelay it is Cynocephali, large-eared Panotii, Pygmies and others of the same sort that surround the sacred personages. The lands they were said to inhabit, such as India, Ethiopia, Scythia and Persia, were, according to various legends, the very ones that the apostles visited on their evangelical missions. It may be, therefore, that the paintings at Termeno are not just the expression of an artist's fantastic imagination, but were intended to convey the same idea of a relationship between heaven and earth and of the apostles as God's emissaries to its remotest regions.[19]

5.3 Monsters in a village
church: (*Above*) a Cynocephalus,
a siren with double fish-tails, a
marine rider, and a Sciapod, in
the lower zone of the apse. (*Right*)
Female Atlas-type figure
supporting the upper zone. Mid
13th cent. wall-painting. S.
Giacomo, Termeno.

Animals and Christian morals

Birds and beasts also abound in Romanesque sculpture but not all
churchmen regarded them as fitting subjects for religious decoration. St
Bernard of Clairvaux (1090–1153), the founder of the Cistercian Order and
a vigorous reformer, condemned them, along with all lavish display and
adornment, because they distracted the mind from its proper devotions (and
were a waste of money). 'To what purpose', he asked, 'are those unclean
apes, those fierce lions, those monstrous centaurs, those half-men, those
striped tigers, those fighting knights, those hunters winding their horns?

Many bodies are there seen under one head, or again, many heads to a single body. Here is a four-footed beast with a serpent's tail; there, a fish with a beast's head. Here again the forepart of a horse trails half a goat behind it, or a horned beast bears the hinder quarters of a horse. In short, so many and so marvellous are the varieties of divers shapes on every hand, that we are more tempted to read in the marble than in our books.'[20] This remarkably comprehensive catalogue is sometimes used to support the argument that Romanesque animal images are purely decorative and without symbolic meaning, and yet St Bernard seems to have recognised that there was a message to be 'read in the marble' by the monk in the cloister.

Some of the creatures mentioned by St Bernard would have been familiar to the monk from the pages of the Bestiary, a picture book which in the twelfth and thirteenth centuries was almost as popular as the regular devotional works. It was a serious natural history compiled from many sources. Its forerunner was a Greek work by an anonymous author known as the Physiologus (the 'naturalist') which possibly dates from the second century AD and was widely translated in the Middle Ages. Though its purpose was scientific the Bestiary everywhere reveals the medieval view that since all creation was the work of God, even animals behave in a manner which reflects the message of the gospels. Thus, lion cubs were thought to be born dead and were brought to life only after three days when the male parent breathed on their faces. 'Just so did the Father Omnipotent raise our Lord Jesus Christ from the dead on the third day.' The wolf, because it preys on sheep, symbolized Satan, as did the cunning fox and the basilisk. The latter was part cock and part serpent, and its glance was enough to kill, unless seen through glass. Christ overcame Satan, the basilisk, by enclosing himself in the bosom of a Virgin who was purer than crystal.

People believed that monsters really existed in the animal world, just as they believed in the outlandish human races of Asia and Ethiopia. They were created by God on the fifth day along with the more familiar species and frequently appear in representations of this theme. A fresco in the abbey of S. Pietro near Ferentillo, above Terni, depicts Adam naming the newly-created animals (Gen. 2:19–21). It forms part of the Old Testament cycle on the north wall and probably dates from the second half of the twelfth century. It includes, together with the domestic sheep, goat, horse, ox and so on, a fine griffin and a unicorn.[21] The subject of the fifth day of Creation, variously treated, was often used for the frontispiece of the Bestiary, especially in England.

Many strange creatures found their way into the religious art of Italy and they came by different routes. From the first, they had been a feature of the churches of Cluny which had numerous foundations in Italy and which had a broad influence throughout Europe on the character of monastic sculpture and painting. In France, in churches closest to the mother-house, animals,

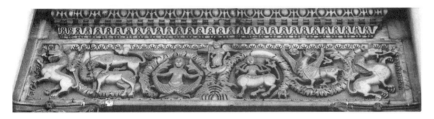

5.4 Exotic beasts decorate the architrave over the west door of
S. Michele, Lucca. Completed 1143.

the distant races, signs of the zodiac and Labours of the Months were
combined to create a symbolic picture of the universe and Christian morals.
But what began there as a coherent iconographic programme seems, in the
course of its diffusion in other countries by itinerant craftsmen, to have lost,
by sheer repetition, some of its force as a symbolic language. Nevertheless,
individual motifs must still have held a moral content for many a literate
spectator in the Middle Ages. The unicorn was identified with Christ in the
Bestiary, especially so because, in myth, it was associated with a virgin.[22]
The griffin's morality was more ambiguous. This four-footed beast with an
eagle's head and wings, whose origin probably lay in travellers' descriptions
of the winged bulls and similar religious images of ancient Assyria and
Persia, was noted for its ferocity and was often the guardian of treasure. It is
often represented holding a human being or, more often, an animal in its
claws, perhaps to symbolize evil destroying good. The centaur, a
combination of man and horse, and the siren, a woman whose lower half is a
bird (both well known in classical antiquity), are often found side by side in
Romanesque carving which points to the Physiologus as the artist's source
because there they are similarly juxtaposed. The story of the near-destruction
of Odysseus by the sirens[23] was used by Jerome[24] and others as a warning to
Christians against the seductive pleasures of the world and hence they are
labelled 'Lamiae', or sorceresses, in the mosaic pavement of Pesaro cathedral.
From the twelfth century the siren acquired one, or sometimes two, fishes tails
instead of the body of a bird and in this form is a very common motif in
France and Italy. The architrave over the west door of S. Michele, Lucca,
shows a fish-siren, a centaur and, on their right, a griffin, among other
oriental creatures [5.4]. Though the church is dedicated to the Christian
dragon-slayer, whose image appears higher up on the same façade, it is
doubtful whether there is any deliberate allusion to him in the carvings of
monsters below. But whatever the intent, the faithful passing underneath
would have been likely to read some such message in the stone. There is, as
we shall see, one unusual example of monsters forming part of an organized
programme of religious symbolism, in the reliefs on the baptistery at Parma
(p. 185).

Fable

The animals of fable, though commonest in the churches of northern Europe, particularly Burgundy, are sometimes seen in northern Italy. The stories of Aesop, handed down by the Roman Phaedrus, were enjoyed by all classes in the Middle Ages, especially in a tenth-century version by an anonymous writer known as Romulus. The essence of fable, that animals behave like human beings with all their wisdom and folly, was close to the morality of the Bestiary. The stories were often used to satirize the vices of the clergy. The ass which attempted to play the lyre is a frequent subject on capitals and façades of the twelfth century. Also popular were the fables of the fox, feigning death and borne on a bier by cocks (Modena cathedral), the fox and the crane (Sant' Orso, Aosta) and, in a satirical vein, the education of the wolf, dressed as a monk (Parma cathedral).

IMAGES FROM THE EAST

Ivories and textiles

The arrival in the West of non-Christian images that had their origins further east, from Syria and Persia in particular, is a process that had occurred before in the early centuries of Christianity. It contributed many motifs to Romanesque sculpture. Objects such as carved ivories, textiles and manuscripts from the East were easily portable and so became accessible to western artists. Secular images, depicting scenes from Graeco-Roman mythology and animal motifs of a typically eastern character, were a feature of ivory caskets and horns (oliphants) made by oriental craftsmen, from the second half of the ninth until the twelfth century. Such secular subject-matter probably reflected changing tastes in the East in the aftermath of the iconoclast era. This was also a time when the West was becoming increasingly acquainted with Persian art, especially as a result of contact with the East during the Crusades. Moreover, the Arabs, who were skilled workers in ivory and adapted many Persian motifs, had an extensive influence in the Mediterranean in the tenth and eleventh centuries.

Textiles, in particular figured silks, had their home in ancient Persia. The craft flourished under the Sassanian kings of Persia (third to seventh centuries AD) and continued under the Arabs, their conquerors, in the seventh century. Oriental silks and tapestries found their way to the West because they were often used to wrap the relics of saints brought back from the Holy Land. The material itself acquired sanctity through contact with the relic and so, too, did the images woven into it. If the piece was large enough it was often later turned into a liturgical vestment, such as a chasuble, dalmatic or cope. Or it was used as a hanging for walls or doorways of a

church or to cover altars and the tombs of saints. Such materials were sometimes believed to acquire a miraculous power, like a relic, by reason of their proximity to the remains of a martyr. There is an account by Gregory of Tours (538–94) of a tapestry that was placed over the tomb of St Martin and afterwards (so it was claimed) was found to have become heavier. It seems likely that the images woven into the material would have acquired some of the potency possessed by the objects themselves.

Designs on oriental textiles can sometimes be traced back to the religious imagery of the earliest civilizations of Mesopotamia. The well-known motif called the Sacred Tree, or the Tree of Life, consisting of a stylized plant with symmetrically confronted animals on either side, is first found on Assyrian clay cylinder seals [5.5]. The tree, or its image, was worshipped in Assyria for its fertility and later, in Persian religion, for its magical curative powers, and is usually shown guarded by lions or griffins. It was a common motif on Sassanian textiles which were copied by Arab weavers for the sake of their decoration. When the motif was transmitted into Christian art the guardian beasts tended to change their species and become those that had a special significance for Christians, such as the dove, peacock or hart, and the tree itself often became a vine. The two-headed eagle found its way into western sculpture in a similar manner. Among many peoples of the ancient Near East the bird was a religious symbol and was associated especially with kingship, as it was among the Greeks and Romans later. Other common medieval motifs that can be traced back to the same source are the pairs of birds with entwined necks, the beast with a single head on two bodies, and the bird of prey or wild animal in the act of attacking another. There is also a Hercules-like figure who clasps a lion in either hand. In his original manifestation this was Gilgamesh, the hero of the Babylonian epic, who tamed the beasts, though he is more likely to have reminded the medieval spectator of the prophet Daniel.

The work of Wiligelmo, the father of the Italian school of Romanesque and the principal sculptor of Modena cathedral in the early twelfth century, owes much of its inspiration, when it is not illustrating sacred history, to illuminated manuscripts, ivories and textiles. The jambs of the main portal at Modena are decorated with curling rinceaux, scroll-like foliage which encloses many curious figures, human and animal, of the kind described above. The followers of Wiligelmo in the north, the Lombard school, made extensive use of the same kind of decoration, and there are notable examples of it in the churches of Pavia, especially S. Michele. In the Tuscan cities of Pisa and Lucca in the twelfth and thirteenth centuries relief sculpture was combined with polychrome stone inlay with brilliant effect. The sculptors' models were silks and ivory caskets of Mohammedan origin, imported into these trading cities from Spain and Sicily, and Byzantine textiles from Constantinople.

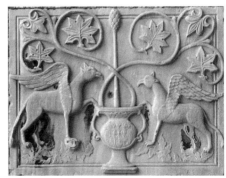

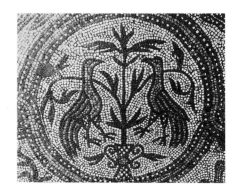

5.5 The Sacred Tree. (*Left to right*) 1) Neo-Assyrian cylinder seal with a king and a griffin on either side. *c.* 850 BC. British Museum. 2) Tree with lions. 9th cent. Transenna in Torcello cathedral. 3) Tree with peacocks. Arab textile from Palermo 1150–1200. Cluny Museum, Paris. 4) Tree with griffins. The pine cone occurs in Assyrian art as a symbol of fertility. 11th cent. Relief at St Mark's, Venice. 5) Tree with doves. 12 cent. pavement mosaic in St Mark's, Venice.

The influence of manuscripts

Some images were transmitted from East to West through manuscript illumination, to reappear in medieval sculpture. Their influence is seen in the lion-columns at S. Zeno, Verona, the cathedrals of Modena, Parma, Fidenza, and elsewhere. This feature is found first in the work of Lombard craftsmen in the north and eventually it spread to other parts of Italy. The porch at S. Zeno is the baldaquin type with two free-standing columns, each resting on the back of a crouching lion [5.6]. We sometimes find, instead of a lion, an elephant, griffin or, more rarely, a winged bull.

There is evidence that columns of this kind were a feature of the royal palaces of ancient Assyria and elsewhere in the East. The original function of lions at gates and doorways was to act as guardians. The columns survived in manuscript illustrations and appear in eleventh-century books of gospels where they decorate the pages devoted to the canon tables. These tables were once always included in books that held all four gospels together. Their purpose was to systematize the four accounts of the life of Christ so that their many differences presented a coherent and continuous narrative. They were invented by Eusebius of Caesarea in the fourth century and consist of a set of tables in which passages common to more than one gospel (or rather, numerical references to them) are arranged side by side in columns. It was the custom from early times in Syrian manuscripts to place the tables within an architectural framework of an arcade, usually decorated with birds and plants and often with scenes from the gospels. The earliest known example of a canon table is in the Rabula gospels, made in 586 (p. 85). The idea of introducing pillars with animals at the base was almost certainly copied by monastic illuminators from actual buildings that were familiar to them in the East and was then handed down by copyists over the centuries [5.7]. The first known examples are in Carolingian manuscripts but it appears that they are representatives of a continuous tradition which goes back to early times. It was these books which supplied the inspiration for builders and sculptors in northern Italy in the twelfth century. Other curiosities like knotted double-columns appear to have been handed down from the same source. They can be seen at Modena, in Trento cathedral (apse), S. Michele, Lucca (on the façade at the corners of the second arcade), S. Pietro, Gropina (pulpit) [5.8] and elsewhere.

Elephants provide the supports for the bishop's throne in the cathedral of Canosa in Apulia. This region was influenced not only by the Lombardic north but by the Islamic art of Sicily and by Persia. The immediate inspiration for the decoration of the throne has been attributed not to a manuscript source but either Mohammedan bronzes or Persian ivory chess sets. But ultimately we have to look still further east. In the Hindu religion the elephant had the same role as the Greek Atlas; it supported the universe,

5.6 Lombard porch with lion columns. 1138. S. Zeno, Verona.

5.7 Canon table with animal-based columns. From an 11th-cent Greek gospel book. National Library of St Mark, Venice.

a function which is clearly echoed here. Indian cosmology, like ones further west, held that unless the whole of creation was solidly supported from below it must collapse. At the base of the universe was a great tortoise on whose back stood eight white elephants supporting a similarly arc-shaped terrestrial world. On earth more elephants upheld the firmament. They are seen in this role, the Caryatids of the universe, in the eighth-century temple of Siva at Eluru, much as they appear in Romanesque sculpture [5.9].[25]

THE PILGRIM ROADS AND THEIR IMAGES

The medieval pilgrim followed a number of well-trodden roads in his journeyings to the holy places of Christianity. They became the channels along which artistic and literary impulses of many kinds flowed. The

5.8 Knotted columns
supporting the pulpit in the
church of S. Pietro, Gropina.
Above, a row of Atlantes appears
to support the pulpit. Under the
reading desk on which the Bible
or evangeliary rested are the
symbols of three of the four
evangelists, the eagle of John, a
human bust (usually an angel) of
Matthew and the lion of Mark.
Late 12th cent.

movement was in both directions. Sacred images in the shrines were copied
by pilgrims and carried back to their native cities where they were sometimes
recreated on a monumental scale. In the other direction, pilgrims and those
who travelled with them, minstrels, jongleurs and others, brought the
religious and secular culture of their own land. Examples can be seen in the
churches and hospices along the pilgrim roads. These buildings, in the
details of their architecture and decoration, often show influences from
outside Italy, especially from France. The pilgrims themselves sometimes
feature in the reliefs as on the façade of the cathedral of Fidenza[26] where we
see a father, pilgrim's staff in hand, mother and child, led by an angel.

Pilgrims to Rome

Pilgrimages were classed as lesser or greater according to whether the journey
lay within the pilgrim's own country or abroad. There were three greater
pilgrimages, to the Holy Land, to Rome and, from the eleventh century, to
the tomb of St James the Greater at Compostella in north-western Spain.[27]
The way to Rome was the only one not seriously threatened by the Saracen.

5.9 (*Above*) Elephants upholding the universe. 8th cent. Temple of Siva, Eluru. (*Right*) Bishop's throne supported by elephants. 1078–89. Canosa cathedral.

Pilgrims from France entered Italy by the Great St Bernard Pass or the Mont Cenis Pass, meeting at Vercelli, east of Turin. The road branched again to cross the Apennines at two points, one over the Cisa Pass between Fidenza and Parma continuing by way of Lucca, the other further south at Forlì by way of Lake Trasimeno, joining up again near Viterbo. From Forlì, pilgrims going to the Holy Land took the Adriatic coast road to Manfredonia or Brindisi where they boarded ship. An alternative port of departure was Venice, which had the further attraction for pilgrims that it possessed the remains of St Mark. The map [5.10] shows the principal towns through which the pilgrims passed.

The approach to Rome took the pilgrim over Monte Mario to the north-west of the city where he had the first sight of his journey's end. It was known as Mons Gaudii, Mount of Joy, the name which, incidentally, gave French soldiers their battle-cry, 'Montjoie!' When Charlemagne first went to Rome in 773 it was said he alighted from his horse at the top of Monte Mario and entered the city on foot like other pilgrims. Abbots of Cluny, who were responsible for the growth of pilgrimage in the eleventh and twelfth centuries, made the journey, and it was an obligation on all bishops, as the successors of St Peter, first bishop of Rome, to do likewise.

There were three main reasons for making a pilgrimage. According to an abbot of Josselin in Brittany, 'The first is of those who seek the holy places for the sake of piety; the second, of penitence, on whom a pilgrimage has been imposed as a penance or who undertake it of their own free will; the third, of those near death, who desire sepulture in holy ground.'[28] These motives were closely allied to the cult of holy relics and the belief that nearness to them was in some way beneficial to the believer. In St Peter's, besides the tomb of the apostle, was another object of this kind, greatly venerated to this day. This was the *sudarium*, or vernicle, of St Veronica, the cloth with which, so it was said, the legendary saint wiped the face of Christ on his way to be crucified thereby causing his image to appear miraculously upon it (p. 311). The cloth was long believed to possess magical properties and replicas of it became the badge of pilgrims to Rome, like the cockle-shell of Compostella and the palm branch of Jerusalem. Chaucer's pardoner, who had been to Rome, had one sewn on his cap.[29]

In front of St John Lateran, another of the pilgrim churches of Rome, stood a bronze statue of the Emperor Marcus Aurelius on horseback (now in the Campidoglio). Christians, however, believed that it represented Constantine, perhaps because he founded the church, and for this reason the statue had been saved from the general destruction of pagan monuments which took place after Christianity became the official religion of the Empire. The prevalence of equestrian figures in the sculpture of Romanesque churches of France, especially in the West, in a few cases identifying Constantine by name, may be due to descriptions brought back by pilgrims

of the monument standing outside St John Lateran which they must have regarded with wonder.[30] Out of this grew the custom, which has lasted almost to the present day, of commemorating great military leaders by showing them mounted on horseback. There are well-known examples by Renaissance artists, notably the statues of the mercenary soldiers Gattamelata at Padua, by Donatello, and Colleoni at Venice, by Verrocchio.

5.10 Principal pilgrim roads of Italy.

Other places of pilgrimage in Italy

There were other centres of pilgrimage in Italy besides Rome. St Mark's, Venice, enshrined the supposed remains of the evangelist, and in S. Martino at Lucca was the Volto Santo, a miraculous wooden crucifix which an angel had taken a hand in carving (p. 116). Pilgrims to Lucca, a staging post on the road to Rome, took away mementos of the Volto Santo in the form of small lead figurines which they sometimes wore as badges. By this means the image travelled widely through northern Europe and was reproduced in churches of France and England, though few now remain.[31] Its meaning underwent one curious transformation. The *colobium*, the ankle-length tunic with a long girdle worn by the bearded Christ which gives the crucifix its distinctive character, is an eastern type and was unfamiliar in the West. This gave rise to the mistaken belief that the figure on the cross represented not the Saviour but a female martyr. Thus, in the way myths and legends are sometimes formed – by the misreading of a sacred image – an imaginary saint came into being. She was a princess of Portugal named Wilgefortis, secretly a Christian and sworn to virginity, whose father forcibly betrothed her to a pagan prince of Sicily. Her prayers for help were answered when she suddenly grew a fine beard causing her betrothed to give her up, whereupon her frustrated father had her crucified. Saint Wilgefortis was for long widely venerated in northern Europe under various names and was known in England as Uncumber. The legend of Saint Veronica would have been formed by the same process. The word Veronica was used first to describe the relic itself and is normally taken to mean 'true image' (*vera icon*). The saint and the legend were probably invented afterwards to explain the existence of the relic.

The church of S. Michele at Monte Sant'Angelo in the Gargano peninsula is built over a grotto that was a famous place of pilgrimage in the Middle Ages and from very early times was a centre of the cult of the archangel. From there it spread to other parts of Europe. Like many other hill-top shrines dedicated to Saint Michael (p. 7) it was originally pagan and was converted to Christian worship in the fifth or sixth century. According to legend the saint appeared first to shepherds and later to the bishop of the neighbouring town of Siponto whom he commanded to build a sanctuary on the spot. The earliest representations of the saint at Monte Sant'Angelo date from the twelfth century but it is thought their form closely resembles a much earlier cult image, a wall-painting known to have been in existence in the same place in the ninth century. It shows a frontal Saint Michael, his lance held in both hands, piercing the mouth of a dragon which twists under his feet. This type, unknown in Byzantine art, is found widely in the south and north of Italy, especially in the churches of the pilgrim roads at Fidenza, Parma (baptistery), Pavia, Lucca (p. 161), and elsewhere. The

image, in its typical form, was widely disseminated through France by pilgrims returning from Italy. A legend similar to that told about Monte Sant'Angelo, of the founding of a shrine after the saint had manifested himself in a vision, is told about Mont St Michel in Normandy and was no doubt transmitted by pilgrims.

EPICS AND ROMANCES

The pilgrim's journey was not without its diversions. Travelling singers and reciters of poetry, dancers and tumblers, the class of entertainer called 'jongleur', performed for his amusement in the market square and cathedral forecourt of the towns through which he passed. On the bronze door of S. Zeno at Verona we see Salome dancing, caught in an acrobatic pose which the sculptor copied from the jongleurs.[32] The heyday of the wandering entertainer was the twelfth and thirteenth centuries. As a storyteller he was also in demand in the houses of the nobility, especially in France, as well as on the pilgrim roads. His songs and verses, which he accompanied on a stringed instrument, told of chivalric deeds and courtly love, themes that reflected a growing refinement among his aristocratic listeners which was something new in the feudal society of that age. The heroic and the romantic tale were two distinct genres and both originated in France. The former, the *chanson de geste*, told of the battles of Christians against Saracens and was typically set in the time of Charlemagne. This is the theme of the earliest and most famous of them all, the *Song of Roland*.

The legends of Roland

Facts about Roland are few. Einhard, one of Charlemagne's biographers, names him as 'Lord of the Marches of Brittany' and mentions him among those who died defending the rearguard of the emperor's army in 778 when it was ambushed in the pass of Roncevaux in the Pyrenees while returning from a victorious campaign against the Moors in Spain. Virtually all the rest is legend but out of it emerged the figure of the heroic knight, one of the Twelve Peers of Charlemagne (akin to the knights of the Round Table), the prototype of the Christian warrior whose task was to defend the true faith against Arab paganism.

Such a man deserved more illustrious beginnings than legend granted to him, for he was said to be the child of an incestuous union between Charlemagne and his sister. (The subject known in painting as the Mass of St Giles represents the emperor confessing this sin). Hence he was given another start in life in two *chansons*, probably intended to counter the old legend, which were written in Franco-Italian in the late twelfth or early thirteenth century, *Berta e Milone* and *Les enfances de Roland*. A series of scenes from these poems appears in sculptured friezes on the cathedral of S.

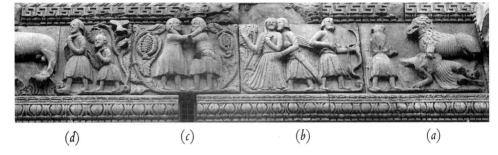

(d) (c) (b) (a)

5.11 Scenes from the childhood of Roland. 1230–40. Frieze on the
façade of S. Donnino, Fidenza.

Donnino at Fidenza. (The original church was said to have been founded by
Charlemagne.) The relief [5.11] reads from right to left and shows (a) the
father of Charlemagne, Pépin the Short, rescuing two youths attacked by a
lion, an act symbolic of his bravery. Next (b) we see Charlemagne's
daughter, Bertha, taking advantage of her father's absence out hunting (on
the right with his bow raised) to dally with her noticeably over-eager lover,
the knight Milone. In the next scene (c) the lovers, who had fled to Italy
when Bertha became pregnant, embrace in a forest. (Bertha's condition is
clearly indicated.) Their child, the little Roland, called in Italian
Orlandino, was born in a grotto near Imola and spent his childhood in Italy.
We see him finally (d) following the steps of his father who had, of necessity,
become a woodcutter in order to support his family. An accompanying frieze
shows Roland at the head of a procession on his way back to France to seek
his destiny.[33]

The exploits of Roland travelled through Italy with the jongleurs. The
story of the epic battle in the pass of Roncevaux in which Roland and his
companions died, told in the *Song of Roland* and in minor related *chansons*, is
widely represented in Romanesque art, especially in France, and is found
also on the Italian pilgrim roads along which the jongleurs passed. On the
campanile of Modena cathedral is a statue of Roland sounding his horn,
summoning Charlemagne to his aid. On the portal of Verona Cathedral he
stands opposite his companion-in-arms Oliver. They make a well-
contrasted pair, Oliver with curly locks and a courtly mien, holding a mace,
Roland wearing a helmet and a coat of mail and holding his sword
Durendal on which the sculptor has incised 'DUR IN DAR DA'. At the
church of S. Zeno in the same city he can be identified as one of the two
confronted knights on horseback in the panels on the façade (bottom left), a
typical image of Roland. In the adjoining panel he slays his opponent who is
the pagan giant Ferragut. In the south of Italy at Matrice, a village on the
pilgrim road between Monte Gargano and Brindisi, on the church of S.

Maria della Strada (west front, right tympanum) he is seen, mortally
wounded, trying to break his sword to prevent it falling into the hands of the
enemy. (He failed, and hid it beneath his body as he died.) A whole series of
scenes from the legend once formed part of a mosaic pavement (1178) in
Brindisi cathedral, but they are now known only from drawings as the
original was destroyed by earthquakes. They included the episode of the
sounding of the horn, over which Roland and Oliver had quarrelled and
were reconciled by Archbishop Turpin, himself a valiant fighter; the death
of Oliver showing his soul issuing from his mouth in the traditional manner;
and the dying Roland in the act of felling the Saracen who tried to steal his
sword. Though formal canonization eluded Roland, Dante placed him in
paradise in the company of biblical and other heroes who had been defenders
of the faith.[34]

Arthurian and other romances

The romance, unlike the *chanson de geste*, drew on the legendary histories of
ancient Greece and Celtic Europe, and dwelt less on heroic deeds than on
the loves of princes and knights and their ladies. The most widely told and
enduring of all was the cycle of poems about Arthur, king of Britain. It was
known in France through the translation by Robert Wace (born *c.* 1100) of
Geoffrey of Monmouth's largely legendary *History of the Kings of Britain* and
from the works of the French poet Chrétien de Troyes (*fl.* 1160–82) who
made use of oral and written sources that are now lost. In Chrétien's verses
the Arthurian legends reflect the ideals of medieval *courtoisie* which gave
them a strong appeal to aristocratic society. They were the beginning of a
literary tradition in France and Germany, and by the second half of the
thirteenth century illustrated books of the romances began to appear in Italy,
including a *Mort Artu* at Bologna, of about 1290. Dante, telling of the tragic
lovers Paolo and Francesca of Rimini, links them with the court of Arthur
by having them read together the story of Lancelot and Queen Guinevere,
the spark which set alight their own illicit love.[35]

The romances were the very stuff of the jongleurs' recitations (unlike the
chansons de geste they were more usually spoken than sung) and, as with the
story of Roland, we find them represented along the pilgrim roads. At
Modena cathedral there is an episode from Arthurian legend, remarkable
because it is the first of its kind anywhere and because it apparently antedates
known literary sources such as Chrétien de Troyes. It appears on the
semicircular frieze on the archivolt of the door called the Porta della
Pescheria, just beside the campanile [5.12]. In the centre is a castle with
towers and in the keep are two prisoners, a man and a woman. But rescue is
at hand for knights on horseback advance from both directions. The
inscriptions tell us that the female prisoner is Arthur's queen, 'Winlogee'
(Guinevere). The foremost knight on the left is 'Artus de Bretania' who

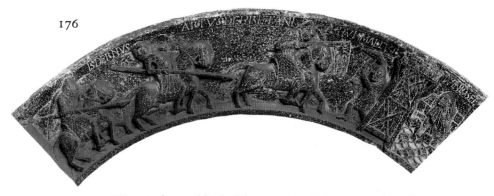

5.12 King Arthur and his knights rescuing Guinevere. Early 12th cent.
Part of the relief above the Porta della Pescheria, Modena cathedral.

confronts one of the defenders, a dwarf. The other defender (not shown) is
'Carrado' (Caradoc) in whose castle the queen is imprisoned. He is attacked
by the knight 'Galvaginus' (Gawain). The scene is similar to an episode in
the romance of Lancelot by Chrétien de Troyes, written half a century later.
(In a later version it is Lancelot who takes on Caradoc, Gawain being a
prisoner in the castle.)

Romances based on stories from classical antiquity, though they were
produced in France in the twelfth century and must have been part of the
jongleurs' repertoire, seem with a few exceptions to have passed by Italian
Romanesque sculpture. They appear, however, in illustrated manuscripts in
southern Italy where fine examples were produced at the court of Naples
from the later thirteenth century which included the stories of Dido and
Aeneas, and Jason and Medea. The best known of the French romances of
this type was the *Roman de Troie* which told of the abduction of Helen by the
Trojan prince Paris and the ensuing siege of Troy by the Greeks. The poem,
written by Benoît de St Maure about 1165, became very popular in Italy and
was the model for illustrated Italian versions later in the following century.
There is an echo of it in a pavement mosaic in Pesaro cathedral which
represents Helen being carried off in a ship to Troy. In an accompanying
inscription Paris is called King of Troy ('Rex Troiae') which is the way he is
styled in the French romance.

One very curious image of a Greek hero, widely disseminated in Europe
from the twelfth to fifteenth centuries and found in Italy along the pilgrim
roads, shows Alexander the Great borne into the sky on his throne (or on a
chariot or in a basket) drawn by two griffins. It is not an apotheosis, though it
resembles one, but an episode from the popular romances of his life which
provided material for the jongleurs. The story of a hero carried to the
'gateway of the gods' by winged creatures occurs in Babylonian myth and
from there found its way into Persian and Byzantine legends in the tenth
century. It was first told of Alexander in a Neapolitan manuscript of the

5.13 The heavenly journey of Alexander the Great. Early 13th cent.(?) S. Donnino, Fidenza.

same period in which the emperor speculated (long ahead of his time), 'how I might fashion a machine that I might ascend the heavens and see if they be the heavens which we behold.'[36] The griffins, having been starved for three days, were yoked with chains and the adventurous airman held two rods baited with meat above their heads and set off. He returned to earth safely, though abruptly. In Christian homilies, unlike the romances, Alexander's exploit epitomized the sin of pride and was compared to Lucifer's attempt against the throne of God. The image can be seen at St Mark's, Venice, in a marble relief brought from the Byzantine East, at S. Donnino, Fidenza [5.13] and at S. Domenico, Narni. It occurs fairly widely in English Romanesque and Gothic churches.[37] On a mosaic pavement at Otranto Alexander appears in the company of other figures who symbolize evil.

SACRED THEMES IN SCULPTURE

The sacred themes of Christian art which predominate in Romanesque wall-paintings seem, in sculpture, often to be forced into second place by the teeming variety and energy of its secular imagery. When the traditional religious repertory – biblical scenes, lives of the Virgin and saints and devotional images – does reassert itself in the decoration of stonework, French influences may again be felt. We find it, therefore, along the pilgrim roads and in a region such as Lombardy where there were major movements of craftsmen to and from Burgundy, Provence and south-west France.

Typology

The juxtaposition of the Old and New Testaments does not occur very frequently. When narrative scenes from both appear together on façades or historiated doors, they are more often intended to illustrate the doctrine of the Fall and Redemption than any precise typological relationship. On the west front of S. Zeno at Verona are two cycles related in this way. On the right of

the doorway a series of panels shows the creation of Adam, Eve and the animals, the Temptation, Expulsion and finally the toil of Adam beside whom Eve nurses the infants Cain and Abel. In a corresponding position on the left of the door are scenes of the infancy of Christ (including the Visitation, which does not occur in Byzantine art), the Baptism, Betrayal and Crucifixion.

There is a clear typological purpose in the Old Testament images in the reliefs on the baptistery at Parma. This building is magnificently decorated with both sculpture and frescoes, the latter in a Byzantine style and of somewhat later date.[38] Painting and sculpture each have their own well-organized scheme of iconography. The sculpture, taken as a whole, reveals a unified plan, unique in Italian Romanesque, which uses a wide variety of separate themes, sacred and profane, to build up a coherent, integrated iconographic programme of the kind usually associated with the decoration of French cathedrals. The dependence of the architecture and sculpture of the baptistery on earlier French models, especially Provençal, is apparent. The work was carried out between 1196 and about 1216 by Benedetto Antelami, probably a native of Lombardy, who may have trained in Provence. The carving on the three portals and related ones inside, together convey the message that Christ is the only salvation for sinful man and that the Church is the means of that salvation. The theme is a familiar one in Christian art but here it is presented with a number of original features.

The tympanum above each of the portals carries relief sculpture, as is normal in French churches of the period but rare in Italy except along the pilgrim roads. Here is placed a key subject whose meaning in each case is amplified by the images on the surrounding archivolt and jambs. On the tympanum over the north portal, once probably the main entrance, is the Adoration of the Magi [5.14]. The Virgin is in the centre, frontal, enthroned and crowned, supporting the Infant on her left knee. She is larger than the figures on either side of her. Besides being the focus of other images on the portal, which amplify the doctrine of Christ's Incarnation, the Virgin is presented in a manner which emphasizes her divine nature, with its echoes of the Byzantine Hodegetria [4.7]. This is probably a reflection of the growth of her cult which was taking place in France in the twelfth century and which spread to Italy. The Parma tympanum is in fact closely modelled on an earlier one in the abbey church of St-Gilles in Languedoc.

The doctrine that Christ's coming to earth was prefigured in the Old Testament is conveyed in the twelve figures on the semicircular archivolt framing the tympanum. They are twelve prophets and each holds a medallion in which is the bust of an apostle. On each side of the portal is a rectangular niche. In one of them stand Solomon and the Queen of Sheba, in the other a pair of figures who are probably David and Ezekiel. The Middle Ages had created an elaborate typology for Solomon and David as

5.14 The Adoration of the Magi (left), and Joseph warned by an angel (right). Above are the prophets and apostles. On the lintel below are scenes from the life of John the Baptist: the baptism of Christ, the feast of Herod and the beheading of the Baptist. 1196–1216. North portal of Parma baptistery.

prefigurations of Christ. The Queen of Sheba's visit to Solomon[39] stood for the coming of the magi, also for the Church, collectively, which came from afar to hear the true wisdom. As for Ezekiel, he was held to have foretold the virginity of Mary, the four evangelists, and the resurrection of the dead. He accompanies the other 'greater prophets,' Isaiah, Jeremiah and Daniel, in earlier twelfth-century reliefs on the cathedrals of Cremona and Ferrara. The juxtaposing of prophets and apostles was a very old typological arrangement and is found first in Italy in fifth-century mosaics in the baptistery of S. Giovanni in Ponte, at Ravenna.[40]

The Tree of Jesse

The upright jambs of the north doorway show, on the left, the twelve sons of Jacob, in pairs, with Jacob at the foot and, at the top, Moses, who was, next to David, the foremost Old Testament type of Christ. On the opposite jamb is the genealogy of Christ in the form known as the Tree of Jesse. Jesse was the father of David from whose line, Isaiah prophesied, the Messiah would come.[41] The metaphor, 'a branch shall spring from his roots' is rendered generally as a literal image of Jesse reclining, with a stylized family

tree growing from his loins. In the branches are the kings of Judah and their descendants, the ancestors of Christ according to Matthew,[42] sometimes with the prophets at their side. At the top is the Virgin and above her Christ surrounded by seven doves symbolizing the seven gifts of the Holy Spirit.[43] The idea of the Jesse Tree may have been devised originally by Abbot Suger of St Denis in Paris where it appeared in a window, no longer extant, in 1144, which was copied, also in stained glass, on the west façade of Chartres cathedral (mid twelfth century). It is widely reproduced, with variations, in French thirteenth-century churches but is rare in Italy. At Parma, Christ and the prophets are omitted, leaving, as the topmost figure, the Virgin whom the doorway as a whole is intended to glorify. There are also Jesse Trees dating from the twelfth and thirteenth centuries on the bronze door of S. Zeno, Verona, the portal of S. Martino, Lucca, and on a carved pulpit in the church of S. Leonardo in Arcetri, Florence. There is a splendid fourteenth-century example, with unusual features, on the façade of Orvieto cathedral (p. 193).

The cult of the Virgin

The main function of the prophets in Christian art is to proclaim the Messiahship of Christ. The doctrine of his Incarnation and of the Virgin as its 'vessel' is expressed by means of the Adoration of the Magi and the series of episodes which precede and follow it. In the Parma baptistery, besides the Adoration, there are others in the interior. First is the Annunciation, when the Incarnation, in the strict sense of the term, took place. It is followed by the Flight into Egypt, and finally the Presentation in the Temple. Joseph's dream of the angel's warning, which belongs to the theme of the Flight, in fact appears on the right of the Adoration relief. The complete sequence of infancy scenes, often with the addition of the Visitation, in which the Virgin has a major role, is found in France in the late eleventh and early twelfth centuries[44] and is intended, as a whole, to illustrate the doctrine of the Word made Flesh.

Though in the Byzantine East the Virgin had long had a special place in the rites of the Church and in popular devotion, her cult in the West was to some extent retarded by the attitude of the monasteries. To them, the feminine element in religion was typified by Eve, the temptress of man, who was another aspect of Luxuria, or Lust, one of the seven deadly sins. But against that there was the growing influence of the Cistercian Order whose founder, St Bernard of Clairvaux (d. 1153), was passionately dedicated to advancing the Virgin's cause. From the middle of the twelfth century the image of the Virgin with the magi was more and more given a place of prominence on the tympanum. There is an early example on Verona cathedral, dating from about 1139. By the end of the century the themes of her death (or Dormition),[45] Assumption and, above all, Coronation by Christ in heaven

are widely represented, largely due to the influence of the Cistercians. At Vezzolano abbey in upper Monferrato, on the tympanum of the main portal, she is enthroned and crowned between angels, while in the nave are reliefs of her Death, Entombment, Assumption and Coronation (*c.* 1189). From now on the Virgin was increasingly an object of veneration in her own right, and became known as the Queen of Heaven. She was also the Bride of Christ, after St Bernard's famous sermons on the Song of Songs in which he interpreted the Old Testament love poems as a mystical allegory according to which the bride of the poems was in reality the Virgin Mary, espoused to God. The earliest example of monumental art inspired by this idea is a mosaic in S. Maria in Trastevere, Rome, in the semi-dome of the central apse (*c.* 1145). It depicts, in a mixture of Byzantine and Latin styles, the Virgin crowned and richly robed, enthroned by the side of Christ. His right hand embraces her shoulder. Mary holds a phylactery bearing a quotation in Latin from the Song of Songs, 'His left hand raises my head, his right arm embraces me.'[46] Christ's left hand, in fact, holds a book which reads, 'Come my chosen one, I shall place thee on my throne.'[47] Just as Christ by his crucifixion redeemed man from the sin of Adam, so Mary, by her virginity, was the redeemer of woman and was known as the Second Eve. Her portrayal in much fifteenth-century painting, especially Sienese, may be understood in this sense [7.11].

A western Last Judgement

Over the west portal of the Parma baptistery, on the tympanum, is a scene of the Last Judgement. Its purpose is to remind those who enter the building that death is not the end but that at any moment they will be summoned before God to stand trial. Because of the confined space of the tympanum the sculptor has been obliged to condense the theme, in contrast to the extended treatment that is possible on interior walls, such as those at Torcello and S. Angelo in Formis. The immediate models for the Parma Judgement are twelfth-century churches in the south of France. In the centre of the semicircular space is Christ enthroned. His hands are raised and his right side is bare to display his wounds. Angels on either side, with veiled hands, carry the cross, crown of thorns, lance and sponge, the Instruments of the Passion. In one corner of the tympanum sits an old man with a scroll who is St John, the supposed author of the Book of Revelation which foretold the day of Judgement. The usual twenty-four assessors are here reduced to the twelve apostles who appear on the surrounding archivolt. Below, on the lintel, the dead are summoned from their graves by two angels with trumpets. All appear to be the same age, in accordance with St Augustine's prediction (p. 53). There is no weighing of souls and no heaven or hell.

The message is clear: man must believe in the doctrine of the Last Day in order to obtain salvation; to have lived a virtuous life is not sufficient. This is

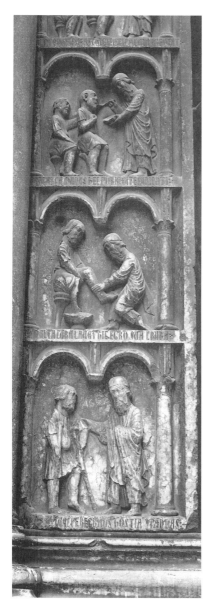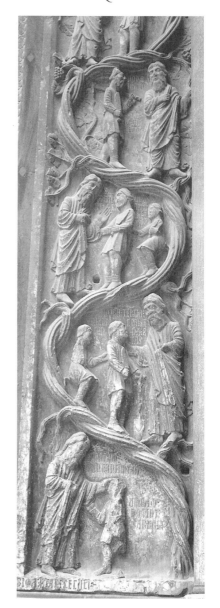

5.15 (*Left*) The Six Works of Mercy (detail). From the bottom up: welcoming the stranger (who is on crutches), tending his injured leg, and feeding him. (*Right*) The Labourers in the Vineyard (detail). The labourer grows older in each scene, beginning with the youngest at the bottom. 1196–1216. Jambs of the west portal, Parma baptistery.

borne out by the six scenes on the left jamb. Each depicts an old, bearded man ministering to other folk in various ways. These apparently secular images in fact illustrate a fairly rare biblical subject, the Six Corporal Works of Mercy [5.15]. They are described in Matthew's gospel where they form the criteria of judgement.[48] In the passage describing the coming of the Son of Man to separate the sheep from the goats which, as we saw previously, was the earliest form of the Last Judgement at Ravenna [4.14], we are told that the righteous will be judged according to their good works. Six are mentioned, the same that are found at Parma: to feed the hungry, give drink to the thirsty, shelter the stranger, clothe the naked, tend the sick and to visit the prisoner.

In the interior, on the tympanum over the west door, in the position corresponding to the Last Judgement outside, is a relief showing King David, crowned and enthroned, playing a harp with dancers and musicians around him. The meaning of this subject is not altogether clear. It is certainly typological and is likely to be related to the exterior relief. It is possible that it is meant to be a prefiguration of God in heaven surrounded by the blessed. This is a normal feature of the Judgement theme and it is absent from the relief on the outside.[49] Alternatively, the image of heaven may be intended in the series of scenes on the jamb of the door opposite the Six Works of Mercy. Here, in six episodes, is the parable of the Labourers in the Vineyard [5.15]. Framed within the winding tendrils of a vine, symbolic of the Christian faith, the landowner hires his labourers at different hours throughout the day, finally paying all the same wage regardless of the hours they worked, beginning with those who started work last. This, Christ himself said, was how the Kingdom of Heaven would be.[50] Yet, if this is the meaning, we have also to explain the inscriptions accompanying each scene. According to them, each is simultaneously a representation of an hour of the day, one of the ages of man, and one of the ages of the world. The first is 'Mane. Infancia. Prima etas seculi' ('Early morning. Infancy. The first age of the world.'), and so on to the last, 'Senectus. Sexta etas.' ('Old age. The sixth age of the world.') It is likely that the series was meant to be understood on more than one level of meaning at once, and that it includes the idea of a metaphorical image of heaven.

The story of Barlaam

We have seen how the north and west portals deal with the Christian faith in its past and future aspects. The south portal contains an allegory for every day. The main image on the tympanum shows a man hiding in the branches of a tree with a fire-breathing dragon at its foot [5.16]. It is an episode from an Indian romance in which a hermit, Barlaam, instructs a king's son, Joasaph or Josaphat, by telling him an allegorical tale. The story was first popularized in the West in the seventh century and in due course the fictitious hermit and

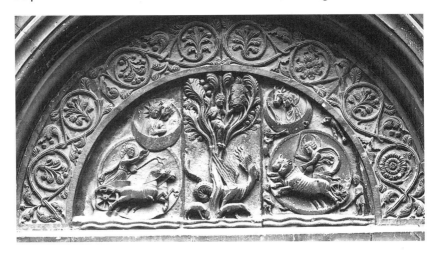

5.16 The legend of Barlaam. 1196–1216. Tympanum on the south portal, Parma baptistery.

his disciple were elevated to the rank of Christian saints. Barlaam's tale concerns the adventures of an eastern 'Everyman' who was pursued by a unicorn and escaped by climbing a tree, having just avoided falling into a deep pit where a dragon lurked. Two mice, one black and one white, gnawed the roots of the tree. Turning from these perils he noticed honey hanging from the branches above and abandoned himself to enjoying it. The story is retold in the *Golden Legend*, which dates from about the same time as the relief.[51] It explains the unicorn as the figure of Death, and the dragon as the mouth of hell. The tree is a man's life which the mice, symbols of night and day, are steadily eating away. The honey represents the pleasures of the world to which he turns, always in vain. On the relief the honey is indicated by a beehive among the foliage, towards which the man is reaching At the foot of the tree, besides the winged dragon, two four-legged creatures are gnawing the trunk. On either side are classical representations of the sun and moon, Sol and Luna, each appearing twice within a disk. The larger of each is driving a chariot across the heavens, a symbol of the passage of time, and here perhaps also implying the brevity of life. The underlying idea seems to be the transience of human life on earth and the inevitability of death, sentiments never far from man's thoughts which were to be revived in seventeenth-century Dutch still-life painting under the name of Vanitas. Although rare in sculpture the Legend of Barlaam occurs frequently in manuscripts, especially Byzantine psalters where it is used to illustrate the verse which goes 'Man is like to vanity; his days are as a shadow that passeth

away,' one of the very passages that inspired the Dutch Vanitas painters.[52] There is a thirteenth-century example in stone at St Mark's, Venice.

The Virtues and Vices

Besides expressing Christian doctrine the sculptures of the Parma baptistery deal with simpler matters of good and evil, represented by numerous examples of angels overcoming a dragon. There is also a remarkable frieze of over seventy panels, extending round almost the entire length of the exterior walls some eight feet above the ground [5.17]. It consists chiefly of the creatures from the Bestiary but also includes a variety of human heads. It is not likely to have been intended simply as decoration yet its meaning is not fully understood. It may be that its purpose was apotropaic, that it was meant to ward off evil, a kind of *cordon sanitaire* to keep away those things that the images represented symbolically. It was sometimes the custom in the Middle Ages to introduce into buildings images of unwanted living things, in particular the familiar household pests, so that the creatures themselves would thereby be prevented from entering, in accordance with the precept 'Similia similibus curentur' – 'let like be cured by like.' Perhaps the animal frieze at Parma was meant to exert a similar kind of magical influence.

The moral life is represented at Parma in four reliefs showing the Virtues as human personifications, two each beside the north and west portals. The three Theological Virtues of St Paul, Faith, Hope and Charity,[53] together with Chastity, are seated and crowned, indicating the position of honour which they held among the Virtues. Each holds a flower in either hand from which emerges another Virtue, making twelve in all. The corresponding Vices, which traditionally accompany the Virtues in French medieval sculpture, are, however, absent.

Underlying all the sculptures of the baptistery is the concept of man's fallen condition and the means of his redemption, as this was understood in the Middle Ages. It provided a broad and not unreasonable basis for bringing together such diverse subjects as the Barlaam legend and more traditional themes representing Christian doctrine.

The idea of giving a corporeal form to man's moral conflict was first expressed in a Christian context by the Spanish poet Prudentius, early in the fifth century. In the *Psychomachia*, or Battle for the Soul, he describes in picturesque detail a series of combats between female personifications of the Virtues and Vices – Faith against Idolatry, Chastity against Lust, Humility against Pride, and so on – in which virtue always triumphs. The poem was popular in the Middle Ages, like the rest of Prudentius' works, and appeared in illustrated editions.[54] It was the inspiration for the medieval image of the victorious female figure treading underfoot a much smaller prostrate human. By the thirteenth century the image of actual combat, derived from Prudentius, was only rarely represented and the Virtues were accompanied

5.17 Part of the Bestiary frieze on the exterior of the Parma baptistery: a
fish-siren, a lion and (*facing page*) two centaur-archers (male and female).
Near-eastern textiles showed archers on horseback turning to shoot in this
manner. 1196—1216.

by little scenes, sometimes in a medallion held in the hand, showing an
example of the vice.

Though they had an important place in French Romanesque and Gothic
sculpture, the Virtues and Vices are rare in Italy before the fourteenth century.
Besides the Virtues at Parma there are two series at St Mark's, Venice, one on
the archivolt of the main portal and one in a mosaic on the drum of the
Ascension cupola (p. 124). Here again the Vices are absent. The Virtues in
the cupola, though they form part of a Byzantine scheme of sacred
topography have no parallel in the East and must have been taken from some
western source, probably Romanesque sculpture. The series on the portal at
St Mark's was copied from the mosaics. Before each of the sixteen windows
of the drum is a Virtue identified by her name in Latin and sometimes by an
attribute. Besides the three Theological Virtues (Fides, Spes, Caritas) are the
four complementary Cardinal Virtues, formulated by Plato.[55] They are
Justitia with a balance and strong box, Fortitudo overcoming a lion,
Temperantia with two vessels (for mixing wine and water) and Prudentia
with two snakes (from Matthew 10:16). Next in rank is Humilitas,
followed by eight of the lesser virtues, Benignitas, Compunctio, Abstinentia,
Misericordia (Mercy), Patientia, Castitas, Modestia and Constantia.[56]

SUMMARY

The art of the barbarian tribes which overran central and northern Europe in
the Dark Ages (*c.* 370—800) was mostly small-scale and non-figurative. The
renewal of figurative art in the West began with the Carolingian renaissance
(768—900) which drew on late-antique forms and imagery. It was followed
by a German artistic revival under the Ottonian emperors (919—1024)

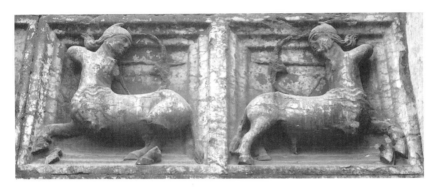

which was influenced partly by contemporary Byzantine models. The way was thus prepared for the development of figurative sculpture and painting which accompanied the great programme of church building inaugurated by the monastic Orders, especially Cluny, all over Europe from the eleventh century. In the earliest Romanesque architecture and sculpture of northern Italy, known as Lombard, Germanic influences are noticeable; churches along the pilgrim roads have features similar to those of Provençal France; in the south, Romanesque merges with Saracenic, especially in architectural details. In both north and south there is also evidence of the direct use by sculptors of antique models.

The typical Romanesque church was the basilica. In northern Italy its characteristic features were the baldaquin (or Lombard) porch and a façade with horizontal bands of reliefs. The arcaded façade is particularly a Pisan style. Pilgrim churches may have portals with decorated archivolts and tympanum of the type found in France.

As to subject-matter, wall-painting adhered mainly to the traditional sacred themes, which were meant for religious instruction. Sculpture on the other hand includes a wealth of secular images intended to demonstrate that the entire universe was part of the divine plan. Thus the Labours of the Months and signs of the Zodiac are everywhere represented, sometimes with the constellations. The animals of the Bestiary and fables were popular subjects because they reflected human morality. Other more exotic, oddly-formed beasts whose function in the context of Christian imagery is not always clear (and indeed thay may often be no more than decorative), were copied from eastern textiles and ivories, and from illuminated manuscripts. Human monsters on the other hand, which occasionally form part of a sacred subject, were apparently believed to exist, though inhabiting only remote regions of the earth.

The travels of the pilgrim helped to transmit images from one place to another. His routes in Italy led to Rome, the Adriatic ports (for the Holy Land), Venice (St Mark), Lucca (the Volto Santo) and Monte Gargano

(St Michael). The stories of the jongleurs who accompanied the pilgrim are often reproduced in sculpture on churches along the roads. *Chansons de geste* were popular and thus we find knights in combat — Christian versus Saracen, scenes from the life of Roland and the Arthurian legend.

The repertory of sacred themes in Italian Romanesque sculpture is wide. Much of it can be traced back to the decoration of churches in southern France, which was inspired by monastic theologians, though generally it lacks the highly-organized iconographic programmes that were often a feature of its prototypes. The glorification of the Virgin in narrative scenes and in devotional images, the Last Judgement, including typically western motifs, and cycles of scenes from the Old and New Testaments, sometimes to be interpreted typologically, are all widely represented. An example of a fully-developed programme of imagery, unique in Italy, is found in the reliefs on the Parma baptistery, some of them clearly indebted to Provençal sculpture. The unknown deviser, just possibly the sculptor himself, has drawn widely on the Bible, Christian tradition, popular legend and other secular subjects to produce an elaborate allegory of man's salvation through the Christian Church.

The Gothic Age

Religious and social change

ART IN THE TWELFTH CENTURY offered a view of the world that was ordered and stable, reflecting monastic dogma and the various aspects of established feudal society. But new forces were at work which, in the coming era, would radically alter traditional attitudes to religion and steadily undermine the power of the old social organization. Moreover they were going to have far-reaching effects on the course of art. The change had several causes.

Daily life in the monasteries, despite its professed ideals, had widely become one of ease and luxury and many of the clergy in the world outside showed the same inclinations. The papacy recognized the need for reform but it was no more than half-hearted. Consequently there began to appear a number of independent sects, better able to satisfy man's religious needs, which turned away from the official religion. Among them were the Waldenses and Albigenses who had many followers in southern France, and the Cathars and Patarini in the cities of northern Italy. Their leaders preached asceticism and a return to the ideals of the primitive Church. Some of the sects instituted their own priesthood which took over the functions of the official clergy. At the same time there was a revival of enthusiasm for the hermit's way of life, in emulation of the early desert Fathers. But the most far-reaching result of the individual's determination to revitalize the Christian faith was the founding of the first two Orders of mendicant friars, the Franciscans, who received the Pope's formal approval in 1210, and the Dominicans in 1216. Francis was inspired by ideals that in many ways resembled those of the independent sects. Dominic's motive was to restore the sects to orthodoxy, though the unfortunate Albigenses whom he had endeavoured at first to convert by peaceful persuasion were eventually massacred at the instigation of the Pope.

The thirteenth century saw the emergence of the universities as independent centres of thought so that learning no longer rested exclusively in the hands of the monasteries. The area of theological debate had been gradually widening in the previous century as individual scholars like Abelard began to examine long-held Christian beliefs, using a new dialectical method of argument.[1] Though he was attacked by men such as St Bernard who condemned the very idea of applying reason to matters of

revelation, horizons continued to broaden. In particular, Aristotle's writings on the natural sciences and philosophy were rediscovered, principally through Arabic sources in Spain and Sicily, and this led scholars to question traditional teaching on such fundamental matters as the Creation and Original Sin which had hitherto been based on the Bible and the writings of the Church Fathers. This growing challenge to orthodox beliefs was faced squarely by the Dominican theologian, Thomas Aquinas (1226–74), a teacher at the university of Paris, who set about creating a whole new edifice of Christian philosophy. By means of the 'scholastic method' of argument and appealing to reason as well as to revelation, Aquinas succeeded in producing a synthesis of classical and Christian thought. He even managed to reconcile Aristotle's view of a universe without beginning or end with the account of creation given in Genesis. Aristotle's concept of a force in nature continually working towards its own good was even demonstrated by Aquinas to be not incompatible with the doctrine of Original Sin. Arab scholars, notably Ibn Rushd, known as Averroës, whose study of Aristotle led to other, more rationalist, conclusions, were officially pronounced to be heretics.

The twelfth and thirteenth centuries saw the rapid growth of commerce in the cities of northern Italy. This was a new economic way of life, based on money as a means of exchange, and from now on the decline of rural feudalism set in. By the fourteenth century, Florence had become the foremost trading power in Europe, her prosperity founded on textile manufacture and banking. Growth of industry led to the creation of new social groups headed by a wealthy and powerful merchant class, the burghers. Below them was a middle class of smaller traders of many kinds, the petty bourgeoisie, whose prosperity depended to a large extent on that of the merchants and bankers. The lowest stratum consisted of manual workers, in Italian *ciompi*, the woolcarders, spinners and weavers, who were generally poor, without property and had few rights.

The Church and the new burgher class that wielded power in the cities readily adapted themselves to each other. Merchants were on the whole pious and customarily set aside a proportion of their profits for religious purposes. The Church, for its part, turned a blind eye to the commercial practice of charging interest, the biblical sin of usury. There was a move by religious leaders to bring together the Church and the upper bourgeoisie. Aquinas declared that the division of society into rich and poor was divinely ordained and therefore each man must accept his station in life because he had been called to it by God. A man was allowed to possess wealth and property, but it laid upon him the obligation to give alms. The Franciscan preacher, Bernardino of Siena (1380–1444), though he consistently attacked the practice of usury, approved the accumulation of private wealth so long as it was righteously earned and put to proper use, notwithstanding the fact that

the founder of the Order to which he belonged had, two centuries earlier, rejected personal possessions of any kind whatever. Indeed those friars, known as Spirituals, who continued to uphold St Francis' ideal of holy poverty gradually found themselves at the centre of controversy as the wealth and possessions of the Order increased. The Church sensed the danger that the Spirituals would become spokesmen for the most deprived class of citizens, the *ciompi*, who might be encouraged to revolt. The matter was settled once and for all by a papal bull in 1323[2] which made it a heresy to maintain that Christ and the apostles had had no possessions of their own, thereby depriving the Spirituals of the main plank of their argument.

Merchants in the same line of business naturally tended to form themselves into associations to promote their common interests. During the thirteenth century in northern Italy these guilds (in Italian *arti*) gradually acquired political influence until the more powerful of them were effectively in control of the government of cities. In reality the control was often in the hands of a few wealthy families within the guilds. In Florence there were seven greater guilds and about twice that number of lesser guilds of smaller craftsmen and tradesmen. The greater guilds included the manufacturers of cloth (*Arte della Lana*), the finishers (*Calimala*) and bankers (*Cambio*). Painters belonged to the guild of doctors and apothecaries, because the sources of their pigments – minerals or organic matter – were ground, like those used for medicine. Sculptors came under the guild of stone masons and carpenters.

A guild was often a considerable patron of art. Formerly, the production of large-scale religious works had come from within the Church, chiefly from the monasteries which had the necessary resources of finance and artistic talent. However from the second half of the thirteenth century, as cities grew, splendid public buildings of many kinds were sponsored by the city corporations. The responsibility for carrying out such projects, both their architecture and decoration, was often allocated to one of the guilds. The guilds' own assembly halls and chapels were likewise decorated, often with elaborate painted altarpieces, generally of the Virgin and the patron saints of the particular guild and city. The wealthiest merchants and bankers commissioned works for their own palaces and for their private chapels in the city churches. The mendicant friars, Franciscans and Dominicans, raised large sums of money from the laity to supplement their own resources in order to build and decorate churches for their own Orders. There were also lay associations, or 'confraternities', attached to the Orders which engaged in both charitable and mutually beneficial activities. They had their own chapels with altarpieces usually dedicated to the Virgin Mary. But civic pride was not the only motive that prompted men to open their purses. The tenor of life remained religious at all levels and the very rich gave money out of devotion to the faith, though no doubt often in the hope that it would help to purchase their own salvation.[3]

THE GOTHIC AGE IN ITALIAN ART

Gothic art in its early stages was a development of Romanesque. It first began to acquire its own distinctive features in northern France in the second half of the twelfth century. In Italy, the change in the form and content of art which took place about a hundred years later, though also called Gothic, derived less from northern Europe than from native influences. So far as sculpture was concerned Italian artists made little use, for example, of the rows of standing figures, the symbolic personifications that are such an integral part of the exteriors of French cathedrals. The work of the Italians was, with certain important exceptions, on a smaller scale, on pulpits, tombs and fonts which they decorated with narrative scenes as well as individual figures. Their treatment of figures often reveals direct borrowings from the antique, as in the work of Nicolà Pisano (p. 231). Towards the end of the thirteenth century, painters, led by Giotto, began to break out of the rigid confines in which they had been held for centuries in Italy by Byzantine traditions. They made use of all the technical devices of Hellenistic art which had been preserved in Byzantine mosaics and frescoes, but with more free-dom and understanding, moving towards a more naturalistic style which imparted a powerful feeling of realism to their work. Moreover, in Italy, much more than elsewhere, artists were now emerging as individuals with recognizable personal styles.

The Gothic age, it is sometimes said, achieved a kind of stability between opposing forces. On one side was the new Christian philosophy of the universities which had become the authorized teaching of the Church; on the other was the more popular culture of the laity, which reflected the influence of the urban middle classes and their commercial background. In Italy the Gothic age, which lasted nearly two hundred years and closed in the mid-fifteenth century was a period of change rather than of equilibrium. During this time the content of religious images underwent continual modification as the bourgeois element made itself increasingly felt. The plague which devastated Europe in the fourteenth century halted the trend towards naturalism begun by Giotto, and brought about, if only temporarily, a reversion to a more mystical and supernatural art. At the same time writers and artists in Gothic Italy were becoming more aware of their own classical past which, as we shall see, eventually provided rich new sources of imagery.

The art of Church and guild

The fusion of ecclesiastical and secular bourgeois elements in art, often called the Gothic Synthesis, has at least one outstanding example in Italy in the relief sculpture on the campanile, or bell-tower, of Florence cathedral which was begun in 1334. The nature of the synthesis can be more easily recognized

if we compare this work with another sculptural programme of similar date which is wholly ecclesiastical in outlook, on the façade of Orvieto cathedral. Each has its own programme, that is to say, the images have been chosen and arranged so that they form a coherent unity of separate but related parts which express, symbolically, some theological idea. Each offers a prospect of salvation within a divinely ordained universe. But whereas on the campanile the range of images embraces the familiar, everyday life of Florence, at Orvieto it depends almost entirely on the Bible to convey its message.

The Orvieto reliefs are on the four piers which form the base of the magnificent western façade of the cathedral. The façade as a whole was designed and partly executed by Lorenzo Maitani of Siena and the sculptures were begun in 1310. The programme follows a familiar pattern, illustrating the way of salvation through the person of Christ. He is portrayed in a series of generally well-established roles: Creator (or Logos), Messiah, teacher and Redeemer, founder of the Church and, finally, Judge. The four piers which treat these different aspects of doctrine represent, from left to right, the Genesis story, the Old Testament prophecies of the Messiah's coming, the life of Christ on earth and the Last Judgement.

The second pier which deals with prophecy has some unusual features. It takes the form of an elaborate Jesse Tree and includes those Old Testament figures who either prophesied or foreshadowed typologically the future Messiah. Jesse, the father of David, reclines at the foot, as at Parma, and his descendants, beginning with David and Solomon, spring from his loins. But whereas at Parma the tree culminates with the Virgin because of her special importance in that scheme of iconography, here she is last but one. The highest figure is Christ enthroned. He hands the scroll of the law to Peter, the act of *Traditio legis* by which the Church was founded (p. 80). At the same time, we are meant to see in him the figure of the Messiah, that is, the one whose coming was foretold by the various persons and episodes that appear in the curling branches on either side of the tree. These, as it were, reinforce Isaiah's prophecy which is contained in the image of the tree itself. They consist of narrative scenes from Daniel, Ezekiel and Zachariah; also from other non-prophetic books, where the meaning is typological: the anointing of David[4] who stands for Christ 'the anointed one', the miracle of Gideon's fleece[5] which was an established Old Testament type of the Annunciation, and so on.

It was maintained in the Middle Ages that the Messiah's coming was not only foretold in the Old Testament but could be found in the writings of pagan antiquity as well. The attempt to bring the ancient world into the Christian ambit, which continually recurs in the history of the Church, is seen yet again at Orvieto at the foot of the Jesse Tree. Here, beside the Hebrew prophets, are the Erythraean Sibyl, the poet Virgil and an unidentified person, who appears to be Greek, perhaps Aristotle [6.1]. From

6.1 Prophets of the coming of the Messiah (left to right): an unidentified
Greek, probably Aristotle, the Erythraean Sibyl, and a Hebrew prophet,
c. 1310. Detail from the Jesse Tree on the second pier of the façade of
Orvieto cathedral.

the time of Augustine Christian prophecy was read into the Sibylline books
(p. 31) and Isidore[6] and others after him maintained that their oracular
sayings contained much that referred to Christ.[7] Augustine even discovered
an acrostic on Christ's name in some verses supposedly written by the
Erythraean Sibyl and hence she was regarded in the Middle Ages as the most
inspired of them all.[8] It should perhaps be noted that numerous additions
were made to the Sibylline books early in the Christian era.

The presence of Virgil in the company of the prophets is an allusion to the
famous Fourth Eclogue, written in 40 BC, which foretells, in terms
sometimes surprisingly reminiscent of Isaiah, the birth of an infant boy who
would usher in a golden age of peace. Again it was Augustine who first
interpreted the poem as a pagan prophecy of the coming of the Redeemer and
thereby ensured a place for Virgil in the Middle Ages among the prophets of
Christ.[9] Virgil's debt, if any, to Isaiah has been debated.[10] The most likely
explanation is that he was referring to the forthcoming birth of a child to the
wife of the Emperor Augustus.[11] Thus, the idea of a Messiah, of a nation's
deliverance by a saviour, which was originally conceived by the Jews as a

result of the Babylonian captivity, was greatly broadened when taken over by the Christian Church. It found an echo in the recurrent expectations of a Second Coming during the Middle Ages and something of this outlook can be felt in the sculpture at Orvieto.

The Gothic Mirror of the Universe

The reliefs on the campanile at Florence, probably designed by its architect Giotto and partly executed by Andrea Pisano, were begun a quarter of a century after those at Orvieto and have very little of the latter's Bible-based theology. They speak to us with a new voice. These are the accents not of the older, narrow, monastic order of things but of the newer scholastic outlook, shaped by the universities which embraced all knowledge, secular as well as sacred. Salvation is still the theme, to be obtained, however, not directly through the person of Christ, as at Orvieto, but through the mediation of the Church by its sacraments, administered by the priest. Daily labour, which is atonement for Adam's sin, is the road to virtue. This recipe for social harmony in the rising industrial cities of the Middle Ages is presented in several connected series of images. They consist of hexagonal and lozenge-shaped reliefs arranged in two tiers on all four sides of the tower.[12]

It is no accident that nearly every set of images is seven in number. The Middle Ages attached a mystical significance to numbers which it inherited from the ancient world as far back as Pythagoras. Three was a spiritual number because of the Trinity; four was related to life on earth because there were four elements and four evangelists. Twelve, the product of three and four, was the number of the Church in which divine and earthly met and which the twelve apostles symbolized, and so on. Dante deliberately organized the *Divine Comedy*, both as to the structure of the poem and the world it describes, on the basis of three and multiples of three. Medieval man, like us today, sought through numbers to understand the workings of the universe, though he arrived at rather different conclusions. In particular he expected to find an underlying connection between series of things having like numbers. Seven, which was closely related to the divine plan because it measured the days of Creation, was particularly rich in such concordances. On the campanile are represented the seven Mechanical (or Technical) Arts and their inventors. Next come the seven Planets, seven Virtues, seven Liberal Arts and finally seven Sacraments.[13] The whole cycle commences with seven scenes from the Old Testament beginning with the creation of Adam and Eve and followed immediately by their toil.

Here, in the shorthand language of images, is the whole framework of the moral and intellectual ideas of the high Middle Ages. It was drawn from the encyclopaedias, the great literary compilations that were the typical products of the period, particularly the thirteenth century. What Aquinas achieved for Christian philosophy, others set out to match in the field of universal

knowledge. The most comprehensive and influential of these huge works was by a French Dominican friar, Vincent of Beauvais (c. 1190–1264). He enjoyed the protection of King Louis IX and was given access to the royal library of some twelve hundred manuscripts, earning for himself the nickname *Librorum helluo*, devourer of books. The outcome of his labours was the *Speculum Majus*, the Great Mirror, a vast yet systematic undertaking, only completed after his death, which embraced the whole of knowledge, interpreting it in the light of orthodox Christian doctrine. This was a continuation of the tradition begun by Bishop Isidore in the sixth century. It was the begetter of other similar compilations, notably, in Italy, the *Libro del Tesoro*, the Book of the Treasure, or Thesaurus, and the *Tesoretto*, both by a Florentine layman, Brunetto Latini (c. 1212–94) who was a friend of Dante. These were much shorter popularisations written in Italian, the second in verse, and so were widely read.

The *Speculum* of Vincent of Beauvais and works based upon it proceed from the proposition that there are three evils brought upon us by our first parents, namely sin, ignorance and mortality. For them God has provided three corresponding remedies, virtue, wisdom and practical necessity. At the human level these divine gifts are represented by the Seven Virtues, Seven Liberal Arts, and Seven Mechanical Arts respectively. The cycle of scenes on the campanile, having begun with Adam and Eve who spin and till the soil, shows us the founders of civilization. They are a strange assortment but nevertheless have the sanction of the encyclopaedias.[14] Besides Old Testament representatives they include Hercules, who is portrayed having overcome a monster; the legendary Daedalus, the marvellous craftsman, here shown in winged flight; a legendary Greek king Phoroneus, the first legislator; and a certain son of Noah about whom the Bible is silent but who was known to Brunetto Latini and whom he calls Gionitus, the father of Astronomy. These, as it were, laid the foundations for the Mechanical Arts which are represented in scenes of everyday occupations: weaving, building, navigation, agriculture, hunting and medicine. The seventh is an exception and shows a Roman charioteer, recalling the public spectacles in the ancient hippodrome. Unlike the others, this is a leisure occupation, chosen perhaps from the analogy of the seventh day of Creation. The influence of the woollen guild, which was responsible for the building's construction, can be seen in the representation of the art of weaving. It shows what must then have been a familiar sight in Florence, a woman seated working a loom with a female overseer beside her [6.2]. The latter may, alternatively, represent the goddess Minerva who was patroness of spinners and weavers.

The influence of the planets

The presence of the planets among the reliefs on the campanile reveals another aspect of man's beliefs in the Gothic age. They indicate how much

6.2 A Florentine weaver, shuttle in hand,
seated at her loom. The standing figure represents
an overseer, or perhaps Minerva. Studio of
Andrea Pisano, 1337–42. Relief on the
campanile, Florence cathedral.

the ancient science of astrology continued to have a hold over people's minds, even while they held themselves to be Christians. The idea that heavenly bodies had the power to influence the course of events on earth goes back to the earliest civilizations and was taken over by the Greeks from the Egyptians and Babylonians. After the fall of the Roman Empire it was left to the Arabs to preserve the knowledge of astrology, together with much more of Greek natural science. It only became widely known again in the West after many centuries as a consequence of contact with Arab culture following the Crusades and through the discovery by western scholars in the high Middle Ages of Latin translations of Arabic texts in Spain and Sicily. The Greeks had distinguished the fixed stars, or constellations, from the 'wandering stars,' or planets, and they identified each of the latter with one of their own gods. According to the Greeks and Romans there were seven planets: the Moon (Luna), Mercury, Venus, the Sun (Sol), Mars, Jupiter and Saturn and it is these that we find represented as human personifications on the campanile, albeit sometimes in unfamiliar guises [6.3, 7.7]. The influence of

6.3 Venus as a planetary deity,
in contemporary dress. She holds
in one hand a pair of lovers
embracing. Studio of Andrea
Pisano, 1337–42. Relief on the
campanile, Florence cathedral.

the last three was paramount and their 'conjunction' in the heavens was
regarded as an exceptionally grave portent. When this very pattern of planets
occurred just before the Black Death struck Italy in 1348 the effect was
greatly to reinforce people's belief in astrology. We shall see later how
astrology continued to play an important part in the lives of the men and
women of the Renaissance.

But the planets on the campanile are concerned less immediately with
astrology than with the structure of the Christian universe. We can
understand better why they should have been included here from a passage
by Dante in the *Convito*. He wrote the work in Italian not in Latin, because,
he explains, he means it not for the scholar but for the intelligent layman.

Dante discusses the nature of the heavens which in his day were still regarded much as they were by Aristotle, as a series of revolving, concentric spheres, each holding a planet. The heavens of antiquity were those of the seven planets and an outer eighth which held the fixed stars. To these the Middle Ages added a ninth, the *primum mobile*, the invisible prime mover which supplied the motive power of the universe, and a tenth, the *prima causa*, or motionless empyrean which was the abode of God and his angels. Dante, only slightly modifying this concept, ascribes the movement of the spheres to 'intelligences, whom the common people called angels,' and which the heathen had made into gods and goddesses.[15] In the same allegorical vein he goes on to compare the first seven heavens of the Greeks, in other words those that appear on the campanile, with the seven medieval sciences, or departments of knowledge, the Liberal Arts. Just as the heavens light up the visible world so the Arts illuminate the world of the intellect. The Moon corresponds to Grammar, Mercury to Dialectic, Venus to Rhetoric; the Sun to Arithmetic, Mars to Music, Jupiter to Geometry and Saturn to Astrology. The eighth heaven, the fixed stars, Dante relates to physics and metaphysics, the ninth, the *primum mobile*, to ethics, and the tenth, the empyrean, to theology.[16]

The Liberal Arts

The Seven Liberal Arts which formed the curriculum of secular learning in the Middle Ages were already established as a group in late antiquity. It was subdivided into the Trivium, consisting of grammar, dialectic and rhetoric, and the Quadrivium, made up of arithmetic, geometry, music and astronomy (the last always embracing astrology). An early treatise on the Liberal Arts was compiled by the Roman historian, Cassiodorus (c. 490–c. 585), and Isidore arranged the contents of the *Etymologiae* on the basis of the Trivium and Quadrivium. Thus they were handed down to the Middle Ages. The first person to give human personifications to the seven Arts was not a painter or sculptor but a fifth-century grammarian, Martianus Capella, in a curiously-titled work, the *Marriage of Mercury and Philology*, This was instruction dressed up as allegory in which the Arts were presented as females who formed the retinue of the god, each of them distinguished by appropriate attributes. Grammar had a box of instruments for writing, Arithmetic used her fingers for calculating, Music was attended by Orpheus, Arion and other appropriate persons, and so on. Martianus' work was widely read in the Middle Ages and his allegorical method was imitated, notably by the Cistercian monk, Alanus de Insulis (c. 1128–1201), who made the Liberal Arts the servants of Philosophy, or Wisdom, in a great poem, the *Anticlaudianus*, which was another compendium of all knowledge. The visual possibilities inherent in all this were not lost on artists and the Liberal Arts began to be widely represented on French cathedrals from the

twelfth and thirteenth centuries, especially in those cities that were well known as seats of learning.

The Liberal Arts are only occasionally found in Italian Gothic sculpture of the thirteenth century but thereafter until the sixteenth century they have their place in programmes of the kind that were devised for the campanile at Florence, where they appear each within a lozenge-shaped frame on the east wall. An early example is found in Siena cathedral where they form the pedestal which supports the central column of the pulpit. This was the work of Nicolà Pisano and his assistants, commissioned in 1266, and shows the influence of French models on an artist whose style otherwise owed much to the study of classical Graeco-Roman remains. Nicolà, his son Giovanni, and his pupils carved the ornamental fountain, the Fontana Maggiore, at Perugia, finished in 1278. Here the figures of the Arts accompany the Labours of the Months (together with the signs of the zodiac) and scenes from Genesis and of the founding of Rome in what was intended to be, in summary form, a history of knowledge. The Arts, together with their historical representatives, or founders, form part of the great programme of Dominican theology painted by Andrea da Firenze between 1366 and 1368 in the chapter-house of S. Maria Novella in Florence (p. 210). They appear again as part of an elaborate pictorial scheme in the now-damaged frescoes of the Palazzo Trinci at Foligno, dated about 1420, which include the Planets, heroes of myth and history and personifications of the Hours of the Day and the Ages of Man, an encyclopaedic view of the Christian universe. The Arts are also among the marble reliefs in the church of S. Francesco at Rimini, commissioned about 1450 by the despotic ruler of the city, Sigismondo Malatesta. This is another 'historical' programme using the established formulas, though in this case for a different purpose. It is not God they are intended to glorify but the lord of Rimini himself and his mistress. Its meaning was plain enough to earn him the censure of the Pope.[17]

THE PREACHING ORDERS AND THEIR ART

The Franciscans

Unlike the monk, who withdrew from the world to take up a contemplative way of life, the main activity of the friar, that is, a member of a mendicant Order, was to travel and preach. The friar depended on alms, for neither he nor, originally, his Order were allowed any kind of possessions, either money or goods. The two most influential Orders, the Franciscans and the Dominicans, were, as we have seen, formed as a consequence of sectarian movements which were active in southern France and northern Italy. But their founders were inspired by quite different motives. The aim of St Dominic (1170–1221) was to convert the sects to orthodoxy and the earlier

part of his career was spent in preaching and debate among the Albigenses in the Languedoc with a group of trained followers.

St Francis of Assisi (1182–1226), on the other hand, seems to have been moved by ideals that had something in common with the sects themselves. Like the heretical Peter Waldo of Lyons who became active about 1176, Francis – the son of a well-to-do family of Assisi – gave all he had to the poor and preached a return to an utterly simple way of life, after the example of Christ and the apostles. He insisted on the oneness of the human soul not only with God but with the whole of nature. For him the elements were not lifeless matter but Brother Fire and Sister Water.[18] The story of the sermon to his brothers the birds reflects the same attitude. Francis was a revolutionary because his goal was not personal salvation through the conventional formulas of the sacraments, but spiritual enlightenment. This was the objective of every mystic, Christian or otherwise. It was sought by the ancient mystical religions of the East and by the heretical sects of Francis' day. The first step along the difficult road to enlightenment was to break the power of the 'sensual will' which demanded, among other things, sexual abstinence and the abandonment of all possessions. The three knots in the Franciscan girdle, symbolizing the vows of poverty, chastity and obedience, are reminders of this resolve.

Francis' impassioned sermons called on people to repent, to accept poverty in imitation of 'the poor Christ' and to welcome humility. They quickly brought him a great following both among his own class, the wealthy bourgeoisie who were disillusioned with official religion, and among the masses of the deprived poor. The movement was far from being declared heretical. Papal sanction was granted, after some official opposition, by Pope Innocent III in 1210, and the founder was swiftly canonized only two years after his death. Those acts were not simply in recognition of Francis' saintliness. They were also diplomatic moves by the Church to provide a safety-valve against the possibility of a popular uprising, religious or social, which might become a threat to her authority.

With the death of Francis the character of the Order changed. Those who continued to adhere strictly to his ideal of absolute poverty, later known as Spirituals, found themselves unable to prevent the Order rapidly acquiring wealth. This provided the means for building vast churches designed for preaching, with spacious naves. It is partly thanks to the popularization by the mendicant Orders of the sermon as part of the church service that we owe the existence of so many fine sculptured pulpits from the mid-thirteenth century. The double basilica at Assisi which contains the relics of St Francis was completed in 1253 and has drawn pilgrims in great numbers ever since. The proposal to build it was a source of disagreement between the Minister-General of the Order, Brother Elias, who drew up the plans and solicited alms to pay for it, and others such as Brother Leo who had been a close

companion of Francis and saw it as a betrayal of trust. It is hard to imagine that Francis himself would have approved of the building or its subsequent magnificent decorations.

The earliest known image of St Francis is at Subiaco in a chapel in St Benedict's monastery. It is a mural painting, probably dating from 1228 and is thought to commemorate a visit by the saint in 1218. During the thirteenth century numerous altarpieces were painted in which he is the central devotional figure, surrounded by scenes from his life, which was already acquiring legendary features. In the upper church at Assisi is an important series of twenty-eight frescoes painted about the end of the thirteenth or early fourteenth century, formerly attributed to Giotto, narrating episodes from his life in which miracles play a significant part. Their source was the official biography of the saint, the *Legenda Major* by St Bonaventura (John of Fidanza), written when he was Minister-General of the Order and completed in 1262–3, replacing earlier versions.

In the lower church at Assisi, in the vault over the high altar, are four frescoes by Giotto's studio dating from the early fourteenth century which depict the glorification of St Francis and allegories of the three vows. The vows of poverty, chastity and obedience are binding on all religious Orders but they came to have particular application to the Franciscans, especially in art. Francis' biographers dwell on his constant eagerness to embrace poverty which, according to Bonaventura, 'he was accustomed to call now his mother, now his bride, now his lady.'[19] The allegory of Poverty represents her as the bride of Francis. The idea of a symbolic marriage was familiar to the medieval Christian from the Song of Songs in which the bride and groom were understood to be the Church and Christ. The scene, reminiscent of Giotto's Marriage of the Virgin in the Scrovegni Chapel at Padua, shows Francis placing a ring on the finger of Poverty who is dressed in a patched and tattered gown, while Christ, as the officiating priest, stands between them. Poverty's halo is hexagonal, the usual shape for personifications of the virtues. The three vows appear again in medallions which form part of Giotto's cycle of frescoes in the Bardi Chapel at S. Croce in Florence. In a well-known panel by Sassetta, painted during the years 1437–44, depicting the mystic marriage of St Francis, the vows, personified as young, angelic maidens, stand before the saint who places a ring on the finger of Poverty. The action is 'continuous' for they are represented a second time in the same picture, floating up to heaven. Obedience bears a yoke.[20]

The Franciscan basilica of S. Croce, the Holy Cross, in Florence, was begun about 1294 and is decorated with frescoes and reliefs of the fourteenth and fifteenth centuries, many of which relate to the Order and its founder. The name refers not just to the cross of the crucifixion but to a medieval legend about it which came to have a special association with the Franciscans and which is often depicted in their churches. According to the

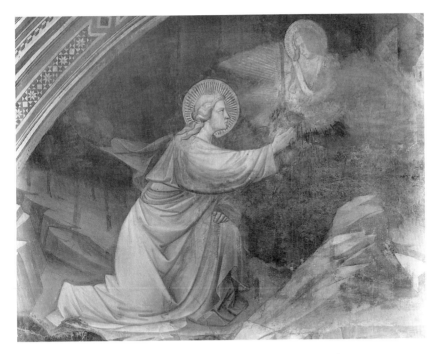

6.4 Seth receives a branch of the Tree of Life from an angel. A scene
from the fresco cycle by Agnolo Gaddi of the Legend of the True Cross.
c. 1380. S. Croce, Florence.

legend, which is really a collection of stories from various sources, the cross
was made from the wood of the Tree of Life from the Garden of Eden.[21]
When Adam died, his son Seth received a branch of the tree from an angel
which he planted on his father's grave [6.4]. Later it passed from hand to
hand, was lost sight of and rediscovered by the Queen of Sheba and buried
by Solomon. By the time of the crucifixion it formed a continuous link
between the Fall and the Redemption. Its history after the crucifixion, told in
the *Golden Legend*,[22] began with its rediscovery in the Holy Land by Helena,
the mother of Constantine. Part of it was carried off by Chosroes II of Persia
after he captured Jerusalem in 614 but was recovered by the Roman Emperor
Heraclius. The supposed relics in various western churches date from the
Crusades or earlier. In the choir of S. Croce the legend is depicted in a series
of frescoes painted about 1380 by Agnolo Gaddi, but the fullest cycle is in
the church of S. Francesco at Arezzo, painted between 1454 and 1466 by
Piero della Francesca, and is one of his major works.[23] A related theme, the
Allegory of the Cross, which was derived from a devotional work, the
Lignum Vitae, the Wood of Life, by St Bonaventura, is also depicted widely

6.5 St Francis receives the
stigmata. The earliest known
example of the subject, painted
nine years after the saint's death.
Bonaventura Berlinghieri, 1235.
Detail from an altarpiece in the
church of S. Francesco, Pescia.

in Franciscan houses. It shows Christ crucified not on a cross but on a tree
from the twelve branches of which hang medallions, as it were fruit. Reading
upwards they illustrate, either pictorially or by quotations from Bonaventura,
the Creation and Fall of Man and the life and death of Christ and his
glorification, in other words the story of the Redemption. There is an
example (recently restored) by Taddeo Gaddi (d. 1366) in the refectory at S.
Croce.

The depth of Francis' feeling about the death of Christ was made plain to
all towards the end of his life by the phenomenon of his stigmatization, the
sudden appearance on his body of marks which corresponded to Christ's
wounds. It was a cause of great wonder to his followers and the happening
itself, which unquestionably took place in what must have been a moment of
profound religious ecstasy, is among the most frequently represented scenes
from his life. He is depicted kneeling in a rocky place before a heavenly vision
which was described by his first biographer, Thomas of Celano, as a man-
like seraph with six wings, fixed to a cross [6.5]. In later examples the vision
changes, in conformity with Bonaventura's amended account in the *Legenda
Major*, and shows the figure of Christ on the cross from whom rays of light
pass into the saint's body. In any assembly of saints, Francis can be readily
distinguished by the five marks.

It was widely believed in the thirteenth century that the new age foretold in
the Book of Revelation was at hand. To a great extent this was due to the
prophecies of a Cistercian monk from Calabria, Joachim of Fiore
(c. 1145–1202), who had announced that 1260 would be the year of its
coming. The Franciscan Spirituals shared the apocalyptic mood of the times.
They maintained that St Francis was the pre-ordained herald of this 'advent'
and that the episode of his stigmatization was but one of many signs that it
was imminent. The 'sacred seals imprinted on him', as the *Legenda Major*

puts it, were identified with the 'seal of the living God' which, according to the Book of Revelation, the angel of the Apocalypse would place on the forehead of the Lord's servants.[24] In 1266, though the supposedly fateful year had passed, it was formally declared by St Bonaventura that, whenever the Last Day should come, this angel would prove to be none other than St Francis himself. There is a cycle of frescoes of the Apocalypse in the upper church at Assisi painted by Cimabue towards the end of the thirteenth century which is evidently a reflection of the official outlook. However, the influence of the Spirituals was then in decline and the subject was rarely represented in Franciscan art thereafter.

In the fourteenth century the process of sanctifying St Francis was taken to even greater lengths. Parallels were sought between the life-stories of the saint and of Christ himself, with the same resourcefulness that was applied to establishing typological relationships between the Old and New Testaments. About 1320 Taddeo Gaddi painted a series of twenty-four panels for a cupboard in the sacristy of S. Croce depicting twelve scenes from the life of Christ and twelve corresponding ones from the legend of St Francis. In 1385 a friar from Pisa, Bartolomeo de' Renonichi, wrote the *Concordances of the Life of the Blessed Francis with the Life of the Lord Jesus* which received the official recognition of the Order and influenced the iconography of narrative scenes and cycles from that time. A series of frescoes by Benozzo Gozzoli, painted in 1451 in the apse of the church of S. Francesco at Montefalco, begins with an imaginary rendering of the saint's birth in a stable with an ox and ass, and ends with the appearance of the stigmata, which corresponds to the crucifixion.

The Dominicans

Unlike Francis of Assisi whose conversion to religion in his early twenties was abrupt and revelatory, Dominic (1170–1221) studied theology as a young man and rose to be a prior of the canons regular. He was born in Spain of a Castilian family. His life, too, had its turning-point when he accompanied a papal mission to the dissident Albigenses in southern France. When the undertaking failed he determined to found an Order for the training of itinerant priests who would promote the Church's orthodox doctrines against those of the sects. By the second half of the thirteenth century the Order of Preachers, as the movement is properly known, had officially adopted the theology of Thomas Aquinas who was himself a Dominican. Thus, whereas the central figure of Franciscan iconography is St Francis, in Dominican art it is more often Aquinas and not the founder who has the principal place.

After the Order was confirmed by the Pope in 1216, Dominic spent much of his life in Italy, travelling and establishing friaries. He died at Bologna where, in the church dedicated to him, his tomb, the Arca di S.

Domenico, is decorated with reliefs of scenes from his life by associates of Nicolà Pisano. Dominican art, until after the end of the Middle Ages, was mostly by Italian artists, several of whom belonged to the Order, and was done for the various Dominican foundations in Italian cities.

Pictures of St Dominic, none of which would have portrayed his actual likeness, show him in the white tunic and black cloak of the Order, usually holding a book and, from the fourteenth century, a lily (for chastity). Cycles of scenes from his life are rare. Besides the reliefs on his tomb there is a triptych painted by Francesco Traini about 1345 for the church of S. Caterina, Pisa,[25] and two fifteenth-century predellas by the Dominican, Fra Angelico[26] of episodes from the saint's life, all of which are taken from a biography dating from about 1290 by Theodoric of Appoldia.[27] Facts were not sacred to the medieval biographer who would freely embellish his account with legend and with borrowings from the lives of others, or simply from his own imagination, when it suited his purpose. Hence the term hagiography has always had overtones of flattery. The most curious legend about Dominic, represented by Traini, concerns his mother's vision, before she conceived him, of giving birth to a whelp which carried a flaming torch in its mouth. The story was probably invented to explain the derivation of the word Dominican which was imagined to be from *Domini canes*, the hounds of the Lord, that is to say, those who hunted down heresy. Dominic is occasionally represented with a small dog by his side having a torch in its mouth. He is shown among the Albigenses standing before a bonfire of their books; his own book, having also been cast into the flames, flies out again unharmed.

There are also borrowings from the legends of St Francis. Dominic is seen supporting the tottering edifice of St John Lateran in Rome, the church of the Popes as bishops of Rome. The story was told of St Francis that the Pope dreamed of this very thing happening on the eve of the saint's request for recognition of his Order. The meeting of Dominic and Francis in Rome on that occasion, related by Theodoric and several times represented in fifteenth-century Italian painting, somewhat in the manner of the Visitation, has no factual basis.

Heresy and inquisitors

Dominican art in the fourteenth century became both didactic and allegorical. St Thomas, echoing Gregory the Great, had stated that images were 'for the instruction of the ignorant but, even more, to instil in our memory the mystery of the Incarnation and the examples of the saints'. Dominican saints certainly played an important part in the art of the Order, and are sometimes joined by persons from the Bible and secular history, not to mention abstract personifications. They form allegories which illustrate the Order's official theology and its principal objective, the rooting out of

heresy. A painting in the church of S. Caterina, Pisa, by a follower of Traini, the Glorification of St Thomas (1363), ingeniously attempts to summarize Dominican doctrine using only human figures and some brief, explanatory inscriptions [6.6]. The figures and their relationships to one another can be identified with passages from St Thomas' *Summa contra Gentiles*. This work sets out to prove the basic tenets of the Christian religion by argument rather than of appealing to revelation, and cites classical as well as biblical sources in support. The central figure in the painting is St Thomas who holds an open volume bearing a quotation from the book of Proverbs with which the *Summa* commences.[28] His inspiration, in the form of rays of light, is received from Christ in heaven above and from figures on either side. These are, at the top, St Paul (with sword) and Moses, next to them the four evangelists each with his identifying symbol and, on a level with St Thomas, Aristotle and Plato (holding the *Ethics* and the *Timaeus* respectively). The rays which issue from Christ descend upon the biblical authors but not upon the two pagan philosophers. The rays which converge upon the head of Thomas symbolize the synthesis of Christian and classical thought. They then pass on from him to two groups of smaller figures on earth below among whom are Dominicans and other friars. At the bottom of this medieval flow-chart lies the Arab philosopher Averroës, the arch-heretic in Dominican eyes, his book face downwards, struck by a ray from the volume in Thomas' lap.

Heresy had two aspects for the Dominicans and both are depicted in their art. First, there were offences against Thomist doctrine which are represented by the often-recurring figure of Averroës (1126–98). Like St Thomas, Averroës was an interpreter of Aristotle but came to different conclusions. The least acceptable was that, though the intellect was immortal, the soul was not. But besides being condemned by Christians, Averroës had already, during his lifetime, suffered a still greater misfortune at the hands of his Moslem co-religionists, being banished from his native Cordova because of his opinions. However, his influence continued to be strongly felt in the thirteenth century, chiefly among the scholastic philosophers of the universities, especially at Paris where St Thomas taught, and among more free-thinking, rationalist intellectuals elsewhere. In Italy, Padua became an important centre of Averroism. Dante placed him among the virtuous pagans in Limbo.[29]

The second kind of heresy was that committed by the Cathars. They were the largest of the dissident sects and were known in southern France as Albigenses, after the town of Albi in the Languedoc (where Toulouse-Lautrec was born). They were very numerous in northern Italy. They appear to have believed, like the early Gnostics, that all matter was inherently evil and that therefore the Creator of the Old Testament must be so himself. It followed from this that there would be no resurrection of the body. Divine

6.6 St Thomas Aquinas with the Christian and classical authors who
were the sources of his doctrine and, on earth below, those who received it.
Follower of Francesco Traini, 1363. S. Caterina, Pisa.

truth was revealed only in the New Testament and it was from the gospels that the Cathars, like St Francis, derived their cult of poverty. A more dangerous threat lay in their claim that God spoke to them directly without the mediation of the Church. Their priests, called 'perfecti', were, in contrast to the official clergy of the time, not only models of purity and self-denial but were usurping the functions of the latter by performing the sacraments themselves. It was people of this kind whom, in 1232, the Inquisition was formed to combat. Inquisitors were chosen chiefly from the friars. One of the most zealous in the thirteenth century was the Dominican Peter Martyr (1205–52), very widely represented in the art of the Order, who became the very symbol of its fight against heresy. In spite of his title he died not, like the early martyrs, defending his beliefs from oppressors, but by the knives of assassins hired by two Venetian noblemen whose property the Inquisition had confiscated. Peter Martyr's attribute in art is a hatchet or knife embedded in his skull, or a sword in his breast.

A kind of pictorial summary of Dominican activities and doctrines can be seen in the frescoes on the ceiling and walls of the chapter-house, later called the Spanish Chapel, of the Order's principal church in Florence, S. Maria Novella. They were painted by Andrea da Firenze between 1366 and 1368. The programme was probably devised, at least in outline if not in all its detail, by a Dominican, Fra Jacopo Passavanti, who was prior of the friary attached to S. Maria Novella and who died in 1357. He was noted for his sermons which dwelt particularly on the theme of repentance. This was also the substance of his main work, the *Specchio della vera Penitenza*, The Mirror of True Penitence, and it is reflected in the imagery of the chapel.

In each of the four bays of the vaulted ceiling is a scene from the gospels. Three of them are of events following the crucifixion that were fundamental to all Christian belief: the Resurrection and Ascension of Christ, and Pentecost. The fourth depicts the disciples in a boat on the occasion when Christ stilled the waves, the scene known as the Navicella, the little boat, [6.7] which is an allegory of man's salvation through the ship of the Church, protected by Christ.[30] The Navicella was a favourite metaphor with Passavanti, the frail craft, tempest-tossed, which would yet reach safe harbour given God's help and the penitent hearts of those on board. It was through repentance, Passavanti reminded his readers, that Mary Magdalene found refuge and salvation, and she is accordingly included in the scene of the Resurrection, kneeling before Christ who has appeared to her beside the empty tomb.[31] A new road to salvation had been opened, Passavanti declared, through the founding of the Dominican Order and it is strikingly depicted in one of the frescoes on the chapel's wall.[32]

Each wall is painted. Opposite the entrance to the chapel is the scene of the Crucifixion which includes, lower down, the Way to Calvary and the Harrowing of Hell (Christ in Limbo). On the wall facing the Crucifixion,

6.7 The 'Navicella', the symbolical ship of the Church. The scene also
represents the episode of Christ walking on the water. There are eleven
apostles on board. Bottom right, Christ reaches out a hand to Peter who is
sinking into the waves. Andrea da Firenze, 1365. Spanish Chapel,
S. Maria Novella, Florence.

surrounding the entrance, is a much damaged fresco depicting six scenes
from the life and death of St Peter Martyr. On each of the side walls is an
allegory of Dominican teaching, the active and contemplative ways of life of
the Order. On the left is the Glorification of St Thomas, a much expanded
version of the one painted by Traini for S. Caterina, Pisa; on the right is the
Way of Salvation, a Dominican rendering of the theme, familiar in literature
and art, of the allegorical journey of the soul.

The Glorification of St Thomas [6.8], sometimes called an apotheosis,
shows him flanked by the biblical authors on whom he had written
commentaries. They are the same that appear at Pisa with the addition, on
the far left, of Job, and David (author of the Psalms) and, on the right, Isaiah
and Solomon (Song of Songs, and Book of Wisdom). Above, in the
heavens, float the Seven Virtues, winged like angels and holding attributes.
On the back of St Thomas' throne, above his head, is a medallion depicting

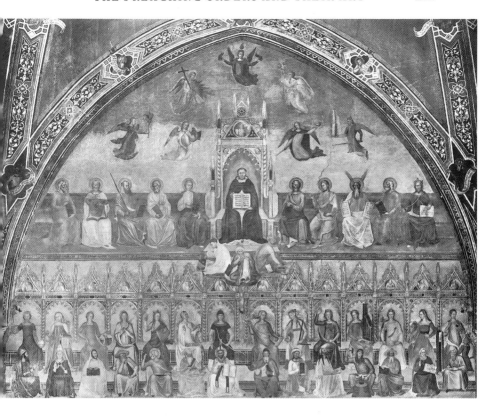

6.8 Christian learning personified. The 'horned' figure, third on
the right, is Moses who was commonly portrayed thus because his face
gave off rays of light when he came down from Sinai. Andrea da Firenze,
1365. Spanish Chapel, S. Maria Novella, Florence.

a bust of Holy Wisdom, or Sapientia. She is something of a curiosity among
the saints, and is better known as the Greek Santa Sophia whose children
were named Faith, Hope and Charity. At the foot of the throne crouch three
heretics, Arius, Averroës (wearing a turban) and Sabellius.[33]

Across the lower half of the wall is a row of fourteen enthroned female
figures, in fact two groups of seven. Each holds an attribute or an inscribed
phylactery. Seated at their feet is another row of fourteen, all men, the
historical representatives of the concepts that the females personify. On the
back of each throne is a medallion containing a figure. The whole assembly
forms yet another summary of the Christian universe. The enthroned figures
on the right are the Liberal Arts,[34] with the Planets in the medallions over
their heads. At their feet are Pythagoras (Arithmetic), Euclid (Geometry),

Ptolemy (Astronomy), and so on. The corresponding scheme on the left seems to represent the Theological Sciences, with Ethics, Dogma, Canon Law and others. In their medallions are the Seven Gifts of the Holy Spirit.[35]

On the facing wall is the fresco of the Road to Salvation. It is an allegory made up of a number of separate narrative scenes, arranged in zones. They illustrate the social order on earth from highest to lowest degree, the place of Dominican teaching within it, and the entry of the souls of the righteous into heaven where a chosen few enjoy the beatific vision of God and his angels. The lowest zone represents life on earth. On the left is a group of people of all ranks, symbolically sheltered by the cathedral of Florence. Though at the time the fresco was painted the building was still in the course of construction, Andrea da Firenze, the painter, was a member of the commission that planned it and was able to render it accurately. The two principal figures in the group are the Pope and Emperor, both enthroned, the former in a slightly more elevated position to indicate his relative status. On either side are ecclesiastical and lay dignitaries arranged in descending order of rank. Among the more humble folk who kneel in the foreground is a pilgrim with three badges on his hat, the vernicle of Rome, the shell of Compostella and a third, indistinct but very likely the palm of Jerusalem. The sheep resting at the feet of the Pope and Emperor are guarded by black and white dogs, the *Domini canes*. To the right, in the same zone, beyond the shelter of the church, the three foremost saints of the Order are seen in action [6.9]. From left to right, St Dominic is urging on more dogs to attack the wolves, symbols of heretics, that are trying to make off with stray sheep; St Peter Martyr preaches to a group of argumentative dissidents; and St Thomas, holds an open volume to which he points, his eloquence having persuaded two Jews to kneel before him. Another figure in oriental robes, perhaps Averroës, tears up a book. But all have not yet been won over, for another in the same group stops his ears. Immediately above them is a company of young people in a flowery garden, seated or dancing to the music of viol and bagpipe, or climbing trees for fruit. What are we to make of them?[36] Perhaps the place is a garden of earthly delights, or paradise, or perhaps the metaphorical 'Catholic garden-plot' mentioned by Dante, which grew all the greener for being watered by St Dominic[37].

Near the garden are a group of penitents, one confessing to a friar, another ushered by St Dominic towards the gate of heaven where St Peter stands, key in hand. Two angels beside the gate are garlanding the head of each diminutive soul as it enters. Among the saints in heaven are Moses, Noah and David, St Paul with sword, St Lawrence with gridiron, and others holding the palm of martyrdom. All gaze upwards towards Christ enthroned at the top of the arch. On his right the Virgin stands, crowned as the Queen of Heaven and holding a lily. The four symbols of the evangelists and the Paschal Lamb are at his feet.

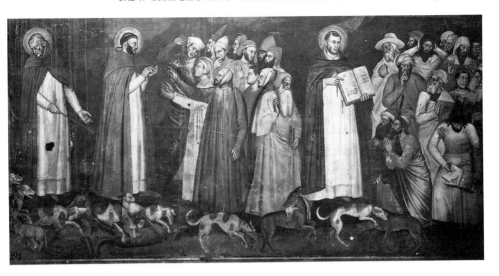

6.9 SS Dominic, Peter Martyr and Thomas Aquinas. In the foreground the 'dogs of the Lord', the *domini canes*, encouraged by Dominic, attack the wolves (heretics) that are carrying off the faithful sheep. Detail of the Way of Salvation, by Andrea da Firenze, 1365. Spanish Chapel, S. Maria Novella, Florence.

NEW IMAGES AND THEIR SOURCES

Retelling the gospels

The basic repertory of narrative religious art, that is, the scenes from the gospels and the lives of the Virgin and saints, began to show more varied subject-matter in Gothic Italy during the thirteenth century. At the same time, artists began to handle the themes more naturalistically, as straightforward story-telling, going beyond the rigid conventions that had characterized Byzantine and much of Romanesque painting and appealing to more everyday emotions. This trend was for a time reversed in the mid fourteenth century in the aftermath of the plague which strongly coloured the religious outlook of the survivors.

The process of popularization was due in part to the appearance of a number of devotional books which provided many new themes. Their authors were often mendicant friars. Best known was *The Golden Legend*, by the Dominican Jacob of Voragine (1230–98), a collection of stories about the lives of the saints and some of the Christian festivals, such as the Assumption of the Virgin[38]. The subjects were arranged for regular reading in the order of their feast days in the calendar. Like all such works it was freely added to from the author's imagination. It was widely read and

translated and greatly broadened the scope of religious art. The *Meditations on the Life of Christ*, once attributed to St Bonaventura, was written about 1300 probably by a Franciscan, Giovanni de Caulibus, also known, after his home town, as Giovanni da San Gimignano.[39] It tells the story of the gospels with simplicity and charm, amplifying it with much homely detail and often adding whole new episodes. It was immediately popular and spread quickly through Europe in many translations. The *Meditations* dwells particularly on the persons surrounding Christ, especially at the Passion, inviting the reader to enter into and meditate upon their feelings. It makes much of the joys and sorrows of Mary and contributed to the rapid growth of her cult which was already taking place at the time it was published. In art, it led to the introduction of several new themes about the Crucifixion, such as the bearing of the cross, the grief of the holy women, the details of the deposition, the sorrowing mother, and the bearing away and burial of the body.

Another somewhat later source of new themes on the life of Christ and the Virgin was the *Revelations* of the Christian mystic, St Bridget (c. 1303–73) who was born near Uppsala in Sweden. They were the records of her visions, said to have been written down without alteration at the time they took place. While Bridget was in Jerusalem in 1372 the Virgin Mary vouchsafed to her many incidents from her life and that of her Son.[40] The emphasis which the *Revelations* put on details of the physical suffering of Christ in the various episodes of the Passion, especially the Crucifixion, made its mark on painting from the end of the fourteenth century. The type of the Nativity which depicts the Virgin in a cave kneeling in prayer before the Infant, which became widely disseminated in European painting, was also derived from St Bridget's description. The Virgin had in fact already been depicted in this devotional pose in a few Italian paintings before the *Revelations* were written and it is likely that the saint's visions were inspired by them.[41]

The Dominican nun, Catherine of Siena, was another case of a devout woman whose imagination was stimulated subconsciously by religious images she had seen previously. St Catherine is depicted in Dominican painting receiving the stigmata which, according to her own description, took the form of rays of light emanating from a heavenly crucifix. The stigmatization of St Francis was generally represented from the late thirteenth century in just this manner, as Catherine would have known well. Neither the rays nor the crucifix are, however, mentioned by Francis' earliest biographers. Catherine, in any case, never learned to read, which may have made her more receptive still to religious images.

The Black Death

The Black Death struck northern Italy in the summer of 1348. The extent of the calamity can be judged from the fact that half, possibly more, of the

citizens of Florence and Siena had died by the same autumn. At the beginning of the *Decameron*, Boccaccio has given us a vivid description of conditions in Florence, attributing the cause either to the influence of the planets or to God in his wrath punishing man's wickedness. The second was the more generally accepted explanation and the remedy, preached by the clergy, was repentance.

The effect of the plague on art was noticeable. The awe it generated was reflected in a return to a more supernatural treatment of religious themes. The figure of Christ the Judge, in scenes of the Last Judgement, often took on a threatening attitude with arm upraised towards the damned (the gesture later used by Michelangelo in the Sistine Chapel). In fifteenth-century painting Christ hurls arrows which, since antiquity, were believed to be carriers of disease. For this reason St Sebastian, the Roman martyr who survived the executioners' arrows (he was subsequently clubbed to death), had from early times been invoked against the plague. He therefore began to appear widely as a devotional image in Florentine painting from the middle of the fourteenth century, and in scenes of his martyrdom from the end of the century.

If there was one who typified triumph over the plague it was the hermit. His survival, no doubt due to his remoteness from contagion, was popularly seen as a victory for the penitent spirit. The first hermits, the fourth-century desert fathers of Egypt from whom the monastic movement evolved, had always remained the ideal of Christian asceticism and their lives formed an important part of the legends of the saints. One collection, written in Italian and widely used by artists, was the *Vita dei Santi Padri*, the Life of the Holy Fathers, by a Dominican, Fra Domenico Cavalca (?1270–1342) who belonged to the friary of S. Caterina at Pisa. It was at Pisa that a cycle of frescoes was painted about 1350 which linked the lives of the hermits with the theme of death and the plague. They were done for the Camposanto, the monumental cemetery, by an unidentified artist, possibly Francesco Traini. They are now in the hall adjoining the cemetery's Amminnati Chapel. One of the frescoes is composed of a number of separate scenes, and illustrates the popular and often engagingly childlike legends about the hermits, as told by Cavalca. It is sometimes called the Thebaid after the ancient city of Thebes in Egypt where, in the nearby desert, the early anchorites took up their abode. We see Paul of Thebes, traditionally the first Christian hermit, meeting Anthony the Great in the wilderness; the temptation of Anthony followed by his dialogue with God; Hilarion on his ass confronting the dragon of Epidaurus; Mary of Egypt, the penitent harlot, receiving communion from Abbot Zosimus; Macarius who, like Saints Francis and Catharine was said to bear the stigmata, debating with the devil who is dressed as a pilgrim, and so on. Lions are often shown as the companions of those who dwelt in the desert: they accompany Macarius and scratch holes in the ground to make graves for Paul and Onuphrius.

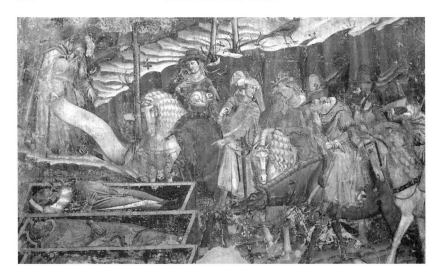

6.10 The legend of the Three Living and the Three Dead, an allegory
of the vanity of human life. Detail from the Triumph of Death by
Francesco Traini. Mid 14th cent. Camposanto, Pisa.

Hermits appear in another fresco, the Triumph of Death, in the same
series. Here they stand for victory over death, in contrast to adjacent scenes of
its victims: decaying corpses of a pope, cardinal, king and queen, for the
plague was no respecter of persons. Each soul, as it issues from the mouths of
the deceased, is snatched up by an angel or demon, while the figure of Death
himself, holding a scythe, swoops from above on black wings. One scene is
based on an eastern legend, The Three Living and the Three Dead. A
company of knights and their ladies, on horseback in a forest, have halted
before three open coffins containing rotting skeletons. A hermit stands to one
side holding a scroll bearing a message in verse that death brings pride and
vanity to naught [6.10]. Nearby, a group of beggars and other unfortunates
implore Death to release them from their misery. To the right is the Garden
of Earthly Joys, resembling the curious scene which Andrea da Firenze
depicted earlier in the Spanish Chapel. There is another rendering of the
Triumph of Death, of which only fragments now remain, in S. Croce,
Florence (refectory). It is attributed to Orcagna and may be of slightly earlier
date than the version at Pisa. One of the fragments depicts beggars calling on
Death, much as they are represented at Pisa.

Heaven and hell

The third fresco in the group at the Camposanto is divided into two parts.
On the left is the Last Judgement, on the right the torments of the damned in

6.11 Christ the Judge, enthroned on a rainbow and displaying his five wounds. His gesture denounces the damned. Mid 14th cent. Detail (redrawn) from the Last Judgement by Francesco Traini, Camposanto, Pisa.

hell. In the Judgement scene the Virgin sits beside Christ the Judge. Each is crowned and enthroned within a mandorla. In this theme the Virgin usually occupies a place lower down with John the Baptist, interceding for sinners (p. 141). Here she is represented as the Queen of Heaven, the Bride of Christ, sitting on his right hand as his equal, while looking down compassionately upon those whom angels are forcing in the direction of hell. Christ raises one hand, threatening the damned, and with the other draws aside his robe to reveal the wound in his side. He seems to be reminding the spectator that those he condemns (among them, yet again, is Averroës with other heretics) have rejected the redemption which his death made possible [6.11]. A further reference to the crucifixion is seen in the angels hovering on either side, carrying some of the Instruments of the Passion: the crown of thorns, lance, sponge, scourges, cross and shroud.

Another group of frescoes on the theme of judgement, heaven and hell, was painted not long afterwards, about 1357, by Nardo di Cione for the Strozzi Chapel in S. Maria Novella, and has features in common with the earlier ones in the Camposanto. The decorative scheme of the chapel, which includes a fine altarpiece by Nardo's brother, Orcagna, is another outline of Thomist doctrine in which the saint appears several times. The fresco of heaven, on one of the side walls, again depicts Christ and the Virgin enthroned side by side, while around and below them are row upon row of the saints. Both Dominic and Francis appear among them, the former occupying the more elevated position. On the opposite wall is hell, conceived in somewhat the same way as at the Camposanto.

The 'Inferno'

In antiquity it was generally believed that there existed an infernal region, that is to say a place under the earth, where the soul departed after death, though that was only one of several possible destinations. The idea that it was a place of punishment was far from universal and references in the Old Testament to Sheol, the Jewish underworld, have no such implication. The Christian concept of hell as a place where the souls of sinners burned in everlasting fire may originally have owed something to the Greek Tartarus, part of Hades' kingdom, where evil-doers suffered a variety of torments. But the principal sources were Matthew's gospel which mentions the 'eternal fire' where the unmerciful would be despatched on Judgement Day[42], and certain references in the Book of Revelation, in particular the bottomless pit into which Satan was thrown.[43] From these meagre beginnings hell gradually acquired over the centuries a rich imagery with additions from eastern religious myths and the writings of Christian mystics.

Images of hell in the fourteenth century sometimes reveal the influence of Dante. (The *Inferno* appeared about 1314.) A division into compartments or tiers usually reflects the different circles of the *Inferno*. Francesco Traini adopts this scheme at Pisa though he places Satan, a terrifying horned figure, not at the bottom of the pit, as in Dante, but in the centre of the composition, and uses the Leviathan motif[44] for an entrance instead of Dante's gateway. Fra Angelico treated the subject similarly for a Last Judgement painted in 1425, placing Satan in the lowest zone.[45] Nardo's fresco of hell in the Strozzi Chapel is based on Dante's topography and reproduces many of its details [6.12].

Dante's plan of the lower regions has nine descending concentric circles. In each circle the souls of sinners receive punishment strictly according to their deserts, the gravity of their offences increasing with depth. Satan himself presides over the ninth and deepest. The scheme mirrors the nine heavens of the medieval universe where the highest heaven, the empyrean, is the abode of God. Dante recognizes two kinds of sin. On the one hand are sins that are the consequence of inborn temperament which are therefore to some degree involuntary, such as gluttony, lust, wrath and avarice. These he regards as lesser evils. In contrast are sins committed by deliberate choice, by an act of free-will, which are therefore offences against God. Among the latter are heresy and treason which are punished in the lowest circles of hell within the flaming walls of the city of Dis.

Nardo's fresco necessarily telescopes Dante's grand design. The first five circles have become three, the extra ones being indicated by diagonal bands of rocks. They are separated from Nether Hell by the wall of Dis, which extends right across the fresco midway between top and bottom. The lower circles are similarly subdivided. Dante's conception of the underworld is in

6.12 The circles of hell (detail), based on Dante's *Inferno*. At the top,
the walls of Dis. Below, Satan devours the traitors. Nardo di Cione,
1350s. Strozzi Chapel, S. Maria Novella, Florence.

some ways like the one described by Virgil into which Aeneas descended in order, like Dante, to talk with the shades of the dead,[46] and many of its features are taken from Latin writers of antiquity. At the top, Nardo depicts the bark of Charon, the ferryman of Hades in Greek mythology, and beside it a walled enclosure and a castle which is Limbo. In the next zone, on the left, is Minos, the judge, who winds his snake-like tail round his body to indicate, according to the number of turns, the circle of hell to which he sentences each sinner. Nearby, the souls of lovers are borne along in pairs on a howling wind, and the gluttonous, savaged by the three-headed dog, Cerberus, wallow in a mire. In the third zone are misers and spendthrifts rolling great rocks, the wrathful fighting one another and, to the right, another boatman, Phlegyas, crossing the river Styx.

Just below is the castellated wall of Dis and on its central tower, overlooking the gate, are the three Furies, or Erinyes, the ancient spirits who avenged crimes committed against kinsmen. Inside the wall, the tombs of heretics, barely visible, are consumed in flames. Nardo's next zone contains the Wood of Suicides where harpies, monstrous birds with women's heads whom Aeneas also encountered,[47] perch in the trees. Beside the wood runs the Phlegethon, a river of boiling blood, here represented as a lake, in which tyrants are immersed, guarded on the banks by centaurs. Further along is the burning desert of blasphemers, usurers and sodomites on whom a fiery rain falls perpetually. They are watched over by Geryon, a sphinx-like monster. We have now reached the two lowest zones, corresponding to the eighth and ninth circles of the *Inferno*, where we can see simoniacs plunged head-downwards into holes in the rocks, seducers scourged by demons and sorcerers whose heads are turned back to front. At the very bottom is the well, with giants all around it. Inside stands Satan, a huge horned figure, devouring three traitors, the worst kind of sinner in Dante's eyes. They are Judas, who betrayed the Church, and Brutus and Cassius who betrayed the Roman State.

The details of this landscape, so many of which come from Greek and Roman mythology, would have been familiar to fourteenth-century Florentines not only through the *Divine Comedy* but from works like the *Aeneid* of Virgil and Ovid's *Metamorphoses* on which Dante drew. The use of pagan images to depict a Christian hell would have seemed appropriate enough to the medieval spectator. Nor was there anything incongruous in the presence of Dante in a Dominican chapel mainly devoted to glorifying St Thomas. Dante had immersed himself in the works of Aquinas and seems to have been much influenced by them. In the *Paradiso* he places St Thomas among the great teachers and historians in the Heaven of the Sun.

Aspects of the Madonna

The iconography of the Virgin Mary began to develop in several quite

different directions in the high Middle Ages. The old hieratic image of the Queen of Heaven, whose origins go back to fifth-century mosaics where she is crowned and robed like a Byzantine empress, and the twelfth-century Bride of Christ of St Bernard, still had a place in monumental painting, as in Traini's Last Judgement at Pisa. At the same time there was a growing tendency, fostered partly by the mendicant Orders, to portray her in a less formal, more human manner. Many new narrative themes began to appear, especially concerning her childhood, parents and marriage to Joseph. New types of devotional images brought the Virgin into a more immediate and personal relationship with the worshipper.

The *Meditations* of Giovanni de Caulibus deal briefly with the childhood of Mary, mentioning her education in the Temple at Jerusalem and her betrothal to Joseph 'in her fourteenth year'. *The Golden Legend*, which drew on the second-century *Book of James*, tells the story of her parents, Joachim and Anne, their meeting at the Golden Gate, Joachim's offering in the Temple and the episode of Joseph's flowering rod, the means by which he was chosen from among her many suitors. All these scenes form part of Giotto's great cycle of frescoes in the Arena Chapel at Padua, painted about 1305. They were commissioned by Enrico Scrovegni who came of a wealthy Paduan family. His father, Reginaldo, had been placed by Dante among the usurers in the seventh circle of hell,[48] and it is likely the commission was intended as an act of atonement by the son for his father's sins. Enrico is depicted on the west wall kneeling as he offers a model of the chapel to three angels.

This was the first time the legend of Joachim and Anne had been depicted in Italian monumental art. It is the story, often recurring in the Old Testament and in folklore, of the barren wife who conceives late in life by a special dispensation from God. The crucial episode is the meeting of the spouses at the Golden Gate of Jerusalem. Their embrace, according to the Franciscans and others before them, was the moment that Anne conceived [6.13]. Mary, it was maintained, was conceived like Christ, 'sine semine viri', without the seed of man, or 'sine macula', immaculately, that is 'without stain'. The Dominicans, on the authority of St Thomas, rejected this. They argued with impeccable logic that, since Christ's death alone redeemed man from Original Sin, to have been conceived before that time 'without concupiscence', as they called it, was an impossibility. But in the long term the Dominican view did not prevail. The doctrine of the Immaculate Conception of Mary in the womb of Anne gradually gained wider acceptance and was finally made an article of faith in 1854. In art the chaste embrace by Mary's parents was superseded in the sixteenth century by the image of her kneeling before God in heaven while around her the Doctors of the Church debate and consult their books. Artists in the Counter-Reformation reverted to the old image of the pregnant Woman of

6.13 Joachim and Anne embracing at the Golden Gate – the moment,
according to Franciscans, when the Virgin Mary was conceived. Giotto,
1305. Scrovegni Chapel, Padua.

the Apocalypse, always identified with the Virgin, who appeared in heaven
'robed with the sun, beneath her feet the moon, and on her head a crown of
twelve stars'.[49] (See p. 321).

The 'humanization' of the Virgin in the thirteenth and fourteenth
centuries was linked to the idea of her as a protectress, because of her power to
intercede for God's mercy and thereby afford protection against evils such as
disease or war. Groups like the Confraternities, the lay charitable bodies
associated with the mendicant Orders, placed themselves under her tutelage,
naming themselves after her, and individuals likewise sought her protection.
A type of devotional image was created to express this relationship, known as
the Virgin of Mercy, the Madonna della Misericordia. It shows her standing
with outspread arms, holding her cloak so that it forms a shelter for kneeling
devotees. Sometimes the cloak acts as a shield against arrows falling from
above, perhaps thrown down by God [6.14].

6.14 The Madonna of Mercy sheltering the faithful under her cloak. A popular theme from the 13th to 16th cents. Here she is protecting the Vespucci, a wealthy Florentine family. The youth whose head appears immediately to the Virgin's right is thought to be Amerigo Vespucci after whom America was named. Domenico Ghirlandaio, 1494. Ognissanti, Florence.

Mary's human aspect is nowhere more clearly seen than in the transformation of the image of the Virgin and Child. It lost the stiff, formal attitudes of the Mother of God derived from the East and became an intimate and personal relationship. A new type emerged at the beginning of the fourteenth century which shows her seated not on a throne but, the very opposite of a queen, on the ground on a cushion or even on the earth itself with the Child in her arms, sometimes suckling it. This was the Madonna of Humility, the virtue extolled by St Francis, and it was due to the Franciscan Spirituals that the image came into being. The word humility, they pointed out, came from the Latin *humus*, meaning earth or ground. Humility was the *radix virtutum*, the root of all virtues which, according to St Thomas, was the essential pre-condition for the existence of the others. It applied particularly to the Virgin because she cared for all, sinners as well as righteous. The type appears first in Sienese painting and spread rapidly during the fourteenth century [6.15]. The act of suckling the Child signified not merely motherhood but symbolized the Virgin's charity and mercy. Even so, her heavenly and royal aspects slowly reinstated themselves. From about the

6.15 The Madonna of Humility. Ascribed to Lorenzo
Veneziano, active (?) 1356–72. National Gallery, London.

middle of the century she is depicted raised above the ground, floating on a
bank of clouds, often with the regal and celestial attributes of the Woman of
the Apocalypse.[50] At about the same time the figure of Anne begins to
appear with the Virgin and Child, as a reminder of the Immaculate
Conception. This trio of figures became popular in Italy in the fifteenth
century and usually showed the Virgin seated on her mother's lap. The cult
of the legendary St Anne as a saint in her own right was never so widespread
in Italy as in France and northern Europe, and it declined everywhere after
the Council of Trent.

 Another devotional theme, complementary to the Madonna of Humility,
which also originated in early fourteenth-century Sienese painting, depicts
her, again sitting on the ground, holding the dead body of Christ in her lap
after it had been taken down from the cross. Called the Pietà or, in Germany
where it became very popular, Vesperbild, it is an extract from the larger
narrative scene of the Lamentation which includes the other mourners but,

by focusing only on the two main figures, increases their emotional impact. Devotees of the Virgin celebrated both her joys and her sorrows. Her joys were expressed through the image of her holding the Infant. Giovanni de Caulibus made her sorrows a subject for meditation at the hours of Vespers and Compline. His words are echoed in images of the Pietà. 'After some little time, when night approached, Joseph begged the Lady to permit him to shroud him in linen cloths and bury him. She strove against this, saying "My friends, do not wish to take my Son so soon; or else bury me with him" ... and she could not cease from weeping and looking at him.'[51]

SUMMARY

In the thirteenth century new forces were at work which began to change the old order. The founding of universities broadened the scope of education which up to then had been in the hands of the monasteries. Christian doctrine once again became the subject of debate: Aristotle's writings on the natural sciences and philosophy, introduced into the West mainly through Arab scholars in Spain, appeared to undermine accepted dogma until Aquinas succeeded in reconciling them. In the cities a wealthy merchant class was rising which gradually took over the powers of the old feudal aristocracy. Merchants formed guilds which became considerable patrons of art, the role previously held by the Church. In their daily lives clergy and monastics had grown lax and the need for reform was recognized. One consequence was the rise of independent religious sects, which were ascetic, mystical and anti-clerical. They were condemned for their heterodoxy. The founding of the first two preaching Orders was also a response to the demand for reform: the Franciscans preached 'holy poverty' and aligned themselves with the poor in the cities, the Dominicans set out to convert the sects.

In fourteenth-century Italy, painters were breaking away from Byzantine conventions and moving towards naturalism, but the process was temporarily halted by the Black Death. There was now a growing bourgeois element in the content of painting and sculpture, which combined with traditional ecclesiastical themes to form what is sometimes called the Gothic Synthesis. The old religious iconography (with some original features) is well represented by the reliefs on Orvieto cathedral. A new approach is seen in the reliefs on Giotto's campanile at Florence. By the use of 'personifications' to denote abstract concepts it succeeded in outlining the whole structure of moral and intellectual thought that had been developed by schoolmen in the universities, and which was derived in large part from the medieval encyclopaedias. This kind of programme, in which the Liberal Arts have an essential place, recurs in Gothic paintings and sculpture with many variations of detail. It formed a kind of summary, or 'mirror', of the Christian universe.

The art of the preaching Orders had a strong narrative bias, its main concern being to commemorate and glorify the lives of the founders and more illustrious members. Legend became mingled with fact in their life cycles, increasingly so as an aura of sanctity grew around them with the passage of time. St Francis, it was eventually claimed, would return to herald the Last Day and he thus features in an apocalyptic cycle in the basilica at Assisi. Episodes in the life of St Dominic were sometimes borrowed from St Francis.

To illustrate their teachings the Orders made use of allegory, as when St Francis weds Lady Poverty. Dominican allegory had a more theological basis. Thomas Aquinas, who belonged to the Order, features prominently in their art as a Doctor of the Church, receiving inspiration from the Bible and Greek philosophy, dispensing his learning to his followers and crushing heretical philosophers, like the Arab Averroës for his unorthodox interpretation of Aristotle. The other kind of heresy that the Dominicans fought was that of the independent sects. The Dominican inquisitor Peter Martyr, who vigorously opposed them, is frequently represented in scenes of his life and death. The most comprehensive rendering of Dominican life and thought is seen in the frescoes of the Spanish Chapel which include an elaborate allegory of the Dominican Way of Salvation.

The appearance of several popular devotional books, like *The Golden Legend*, from the second half of the thirteenth century led to a much wider range of subject-matter in Christian art, especially regarding the lives of the saints, and of Christ and the Virgin. The Black Death (1348) introduced a supernatural element into painting which had strong overtones of guilt and expiation. The hermit symbolized triumph over the plague, that is, the victory of the penitent spirit. The Last Judgement now showed Christ threatening the damned and images of hell were commonplace. Parallel to this, the growing cult of the Virgin as protector, intercessor and a paragon of humility, was reflected in her changing imagery. Her joys and sorrows were typified by the contrasted subjects of the Madonna of Humility and the Pietà. The former hieratic character of the Virgin with the Child now mellowed into an image that was human and maternal. The Marian doctrine of the Immaculate Conception now had its first tentative renderings in painting.

The Renaissance
and the Discovery of Antiquity

I N FOURTEENTH-CENTURY Italy interest was steadily growing among men of letters for the classical past. They searched libraries for manuscripts of the old Latin authors, travelled widely to study ancient monuments, trying with varying success to decipher their inscriptions, and wrote enthusiastically to their friends when they happened to come upon some fragment of antique sculpture. This did not mean that antiquity had been a closed book in the earlier Middle Ages. So far as literature was concerned Virgil and Ovid were always well-known, as were Horace, Cicero, Livy and a number of other Latin authors. What was new was men's attitude to the ancient world. Formerly it had been seen through the eyes of Christian belief and the works of its poets and philosophers were treated as foreshadowing, however dimly, the age of faith. But the idea that pagan and Christian past were all part of one continuous process under a divine plan was receding. In the fourteenth century, first Rome, and then Greece as well, were increasingly recognized as having been civilizations in their own right, with their own intrinsic values. Those who propagated this new outlook came to be known as humanists.

Christians and paganism

How to reconcile the world of classical antiquity with her own teaching was the Church's perennial problem. It was one thing simply to condemn pagan religions as the works of Satan. The poetry and speculative thought of the ancients were another matter. St Jerome (c. 342–420), who translated the Bible into Latin, bitterly reproached himself in a well-known letter for preferring Cicero to the 'rude and rebarbative' style of the prophets.[1] He was depicted, especially in post-Renaissance painting, being scourged by angels for this offence.

The first sustained attempt to reconcile Greek philosophy with Christian belief was made, long before the time of Thomas Aquinas, in the fifth century by St Augustine. In the *City of God* he claimed that 'there are none who come nearer to us than the Platonists,'[2] and elsewhere, 'If they could have had their life over again with us ... they would have become Christians, with the change of a few words and statements.'[3] Indeed, several early Christian writers supposed that Plato had been acquainted with the

Old Testament.[4] We shall see later how Renaissance humanists in the fifteenth century again strove to make a synthesis of Platonic and Christian ideas, and some of the ways this was reflected in art.

The ever-popular myths, with their tales of amorous gods and goddesses, were a problem that divided churchmen. The tendency had always been to treat them as allegories, with moral and spiritual meanings hidden beneath the surface, but this was condemned among others by Augustine, and by Bishop Gregory of Tours in the sixth century who treated them as fables and urged men to turn from them and keep their eyes fixed upon the gospels. But the allegorical view prevailed. One of the earliest and most influential books to treat the myths in this way was the *Mythologies* of Fulgentius, a grammarian who lived in north Africa at the turn of the sixth century and who has been identified by some with a bishop of that name. For Fulgentius, the three goddesses in the story of the Judgement of Paris stand for the active, contemplative and sensuous life (Paris, being a mere cloddish shepherd, chose Venus, who represented the third); the Muses are the nine steps of learning; the three Harpies represent the progress of theft: to covet, to seize and to hide one's gains, and so on. Fulgentius continually refers to the appearance of the gods as they were known in classical art and has ready explanations for their traditional attributes. Thus Mercury, the protector of, among others, tradesmen has 'feathered heels because the feet of businessmen are everywhere in a rush as if winged.'[5] Copies of the *Mythologies* found their way into libraries across Europe in the Middle Ages and, in the Carolingian era (768–*c*. 900) in particular, their way of interpreting the myths was widely imitated. In fourteenth-century Italy the writings of Petrarch and Boccaccio both reveal the influence of Fulgentius. Boccaccio, especially, relies on him heavily in his encyclopaedia of the myths, the *Genealogy of the Gods*, which later became an essential handbook for artists concerned with the representation of pagan divinities.

The *Metamorphoses* of Ovid presented a particular challenge to Christian interpreters. This graceful and wholly amoral retelling of the Greek and Roman myths and legends was widely read in the Middle Ages. There had been several attempts from the eleventh century to bring it into line with Christian teaching. They culminated between 1316 and 1328 in a long poem by an unknown French author, which came to be known as the *Ovid moralisé*, in which the gods were identified with actual persons in the gospels, just as Old Testament figures had always been treated. Actaeon, the hunter who suffered a violent death, was identified with Christ. Phaethon, the headstrong charioteer sent crashing to earth by one of Jupiter's thunderbolts, became Lucifer, the rebel angel who was thrown out of heaven by God, and so on. About 1340, a moralized Ovid in Latin prose was produced by another Frenchman, Pierre Bersuire, a friend of Petrarch. This book, part of a much longer work, was important for its detailed descriptions of the

appearance of the gods and it took its place beside Boccaccio's encyclopaedia as an artist's manual.[6]

As for the classical poets and philosophers themselves, those who had died before the coming of Christ were for that very reason denied any possibility of salvation. They were accordingly given a resting place on the outer margin of hell in the region known as limbo. There they would remain, according to Dante, without hope of future redemption, forever denied the beatific vision. Among them was Dante's guide and companion in the infernal regions, Virgil, who described to the poet how, long ago, he had witnessed Christ's Harrowing of Hell, when Adam and other more fortunate members of his line were carried away to heaven.[7] Pagans, however virtuous, stayed below.[8]

Earlier classical revivals

It was the initiative of a single powerful individual that had brought the Carolingian renaissance into being. The same was true of a revival which took place in Sicily and southern Italy in the first half of the thirteenth century under the Holy Roman Emperor Frederick II (1194–1250). Both men were eager for learning (Charlemagne himself was illiterate) and they gathered about themselves a circle of scholars. Both in their different ways were inspired by the achievements of imperial Rome. But whereas Charlemagne was in the first place a reformer, Frederick was more interested in self-glorification. The Carolingian scholars, besides restoring classical form and images to the visual arts, purified the Latin language and the script in which it was written, and it was thanks to their labours that a large part of Latin literature has survived for posterity. To them the Renaissance humanists owed a considerable debt. Frederick, as it turned out, handed on something rather different which illustrates the diversity of his interests. This was a new style of lyric poetry, created by his court poets, in which Frederick himself also excelled. It was written not in Latin but in vernacular Italian, in imitation of the love songs of the Provençal troubadours. It was the forerunner of Dante's *dolce stil nuovo* (sweet new style) and of the Florentine school of poetry headed by Petrarch.[9] As for Frederick's enthusiasm for antiquity, in particular for the age of Augustus, though it led to a considerable artistic revival based on classical models, it remained, unlike his literary legacy, an isolated phenomenon and little of it was passed on to the Renaissance.

Frederick belonged to the German princely family of Hohenstaufen and ruled over an empire vaster than any since ancient Rome. He was described by his chroniclers as *stupor mundi*, the wonder of the world. Having inherited the Norman kingdom of Sicily, he established his court at Palermo which became a centre of intellectual activities. The art of southern Italy and Sicily was at that time a mixture of many styles. To the remains of Magna Graecia

7.1 A gold augustale, the coin of Frederick II, modelled on the old Roman *solidus*. It shows the emperor crowned with a laurel wreath and wearing a Roman cuirass. On the reverse is the imperial eagle. The inscription, (which continues on the reverse) reads 'CESAR AUG IMP ROM FRIDERICUS'.

had been added elements of Byzantine, Arab, the Romanesque of Lombardic sculptors, and French Gothic probably brought by the Normans. In the midst of this, Frederick founded a school of art devoted to presenting him as an all-powerful Caesar. This was not mere posturing but part of a deliberate policy to counter the temporal power of the Popes, that historic rivalry which gave rise to the Ghibelline (imperial) and Guelf (papal) factions in Italian cities. To protect the town of Capua against attack by papal armies Frederick had a bridgehead built on the river Volturno consisting of an arch of marble on the pattern of a Roman triumphal arch, flanked by towers. It was decorated in the antique style with the figure of the emperor, another personifying the town of Capua, together with two busts of civic dignitaries. The idea of the Roman triumph appealed to Frederick. After defeating the Milanese at Cortenuova in 1237 he called for a triumphal procession through the streets of Rome. Among the spoils of victory was an ancient war chariot which had been a civic emblem in the defeated city. Frederick's likeness, after the manner of the old emperors, appeared on monuments and on coins that he had specially struck [7.1].

Whether the Tuscan sculptor Nicolà Pisano (*fl.* 1258–78) served an apprenticeship in the workshops of the emperor has been debated. He was brought up in the south, in Apulia, and would have been familiar with the new art of the region. Indeed, his work shows a deep understanding of antique forms but it seems to have been acquired, at least in part, at Pisa, the city from which he takes his name. According to Vasari, 'among the marble remains brought home by the Pisan fleet were some ancient sarcophagi now in the Camposanto including a very fine one representing the chase of Meleager, hunting the Caledonian bear. Nicolà ... applied such diligence in imitating that style, and other excellent sculptures on the other antique

sarcophagi that before long he was considered the best sculptor of his time.'[10]

The spirit of Nicolà's art, and of the school that he founded, was, in fact, quite alien to the classical revival in the south. The latter was secular and owed nothing to Christian inspiration, whereas Nicolà took the forms of pagan antiquity and translated them into Christian images, integrating them into the traditional subject-matter. The process which, as we know, goes back to earliest Christian image-making [I. 1] can be clearly seen in his first known work, dated 1260, the set of reliefs on the pulpit of the Pisa baptistery. Here we find a number of features that are clearly derived from an antique sarcophagus in the Camposanto which must have been known to Nicolà, illustrating the Greek legend of Phaedra and Hippolytus. Phaedra herself was the source of Nicolà's Virgin in the scene of the Adoration. There is also a nude figure on the pulpit with the lion's skin and a club which were the attributes of Hercules in Greek and Roman sculpture. Apart from the figure's nudity which was rare in religious art at this time, the artist has given it the classical pose known as *contrapposto* which is also found on the Phaedra sarcophagus. The figure is intended to represent, however, not just the classical hero but the personification of Fortitude, one of the four Cardinal Virtues. Nicolà turned the figure of the drunken god Dionysus, supported by a satyr, into the devout Simeon, attended by an acolyte, in the scene of the Presentation in the Temple [7.2].

The followers of Nicolà, among them his son Giovanni, carried this classicizing idiom to other cities of central Italy. Sometimes they simply carried out his designs, at other times they accompanied him as assistants. Giovanni in his own career (*fl.* 1265–1314) achieved a marvellous and flexible synthesis of antique and Gothic which gave full play to his powerful sense of human drama. His style had a continuing influence in the fourteenth century and helped prepare the ground for early Renaissance sculptors.

What the Middle Ages signally failed to achieve (except to a limited extent in the Carolingian era) was the marriage of classical forms with classical subject-matter. This, the true union, had to wait until the Renaissance. There existed in fact a clear division in medieval art which resulted in classical 'dress' being used for Christian themes while classical themes – the myths, legends and figures of the gods – appeared in contemporary medieval dress.[11] The reason was partly that the representation of antique themes belonged mainly to the field of manuscript illustration where the artist, often of quite modest talents, set out to depict the story in familiar, everyday terms, having only a text to guide him. Religious art had a continuous tradition behind it, each age learning from its predecessor, and it was therefore able more easily to retain the forms of antiquity, once having assimilated them. There was, moreover, no intellectual incentive in the Middle Ages to unite classical form and subject-matter. Artists borrowed

7.2 (*Left*). Hellenistic vase of Dionysus (detail), Camposanto, Pisa.
(*Right*). A detail from the Presentation in the Temple by Nicolà
Pisano, *c.* 1260, showing how the sculptor adapted a classical
model. Pulpit of the baptistery, Pisa.

motifs from ancient urns and sarcophagi simply because they were desirable
models, not because they were exemplars of a great civilization of the past.
The latter was a concept they did not understand until their eyes were opened
by the humanists.

THE RISE OF HUMANISM IN ITALY

The humanism which was born in Italy in the second half of the thirteenth
century had little in common with what we understand by the word today.
For one thing, it was not incompatible with Christian belief; indeed the term
'apostle of humanism' was applied to the man who became Pope Pius II.[12]

The expression originally came from *studia humanitatis* which was used by Cicero to mean, in a general way, a liberal, literary education (and from which we derive the term 'the humanities'). Its use was revived in late fourteenth-century Italy when it began to acquire a more precise meaning. Humanism now denoted a specific course of studies, which included rhetoric, grammar, poetry and history based on classical authors, and this eventually formed a new and distinct scholarly curriculum. The idea of refinement and the pursuit of culture for its own sake which was contained in Cicero's use of the word *humanitas* became very much a part of the attitude of medieval humanists towards their studies.

The two earliest centres of humanism in Italy were Padua, where the university, founded in 1222 by Frederick II, provided a fertile soil, and Verona. Scholars of both cities had access to a fine library. The former was at Pomposa, south of the city, where the Benedictine abbey, founded in the seventh or eighth century, possessed a wealth of Carolingian manuscripts. At Verona, the library of the cathedral chapter was as richly endowed; here, about 1300, were discovered the works of the Roman poet Catullus who had been born in the city.

Enthusiasm for classical literature went hand in hand with antiquarianism, a closely related pursuit. One of the consequences of studying and collecting ancient remains was that it aroused people's pride in their native heritage, particularly when it concerned their own locality. Men were eager to honour a Roman poet or historian if he belonged to their city, and they made often extravagant claims to provide themselves with an illustrious founder. Padua, according to Virgil, had been founded by Antenor, a Trojan hero who, like Aeneas, had headed for Italy after the sack of Troy.[13] It was therefore not perhaps surprising that when the skeleton of a man of great stature was unearthed during excavations in 1283 it was identified with Antenor and given a noble tomb. Padua was the birthplace of the historian Livy. The tradition that he also died there gained support from the discovery (between 1318 and 1324) of a fragment of a tomb inscribed with a name believed (wrongly, as it happened) to be his. However it lent credibility to a further discovery in 1413 of what purported to be Livy's bones. The veneration which was accorded to relics of this kind may be judged from the efforts of Alfonso the Great, King of Naples (1416–58), a patron of humanists, to obtain an arm-bone of Livy. He eventually succeeded and it was received at Naples with great ceremony and rejoicing. This was the kind of treatment normally given only to Christian relics. Mantua, the birthplace of Virgil, honoured him in the thirteenth century with a statue which can be seen today on the outside of the Broletto. Ovid was likewise commemorated in the town of his birth, Sulmo (modern Sulmona). Antiquarians sometimes had difficulty identifying ancient place names, with confusing results. The Rubicon was one, with the consequence that the point at which

Caesar crossed it in 49 BC was marked by a monument on more than one stretch of river.[14]

Another statue of Virgil at Mantua was removed in 1397, amid protests from humanists, because it had become an object of superstitious reverence. This was by no means an isolated phenomenon; indeed the belief that images and relics held magical powers was as strong in the later Middle Ages as in the early Christian centuries and was not confined to Christian cult objects. Virgil, once the pagan prophet of Christianity, was now widely regarded as a magician and miracles were claimed in his name, especially at Naples where his tomb had for long attracted pilgrims. It was a common practice to attempt to foretell the future by opening a volume of his works at random.

The discovery of a piece of classical sculpture might arouse the admiration of humanists but by others it was feared as an idol with latent powers. An ancient statue of Venus, believed to be by Lysippus, was placed on the Fonte Gaia in the main square of Siena (the Campo). After the defeat of the Sienese in battle against Florence in 1357, the statue was blamed. It was pulled down, broken up and the pieces secretly buried in Florentine lands. It is likely, moreover, that a nude statue would have been identified with Eve, the cause of mankind's downfall, in the medieval Christian's mind. As we saw with the Apollo Philalexandros (p. 28) the fate of a city was widely held to depend on some talisman, either objects buried in the foundations or a monument specially erected. The humanists themselves were sometimes no more immune than other citizens from superstitions of this kind. Petrarch believed along with many Christians that pagan gods still existed and that they were demons.

PETRARCH'S INFLUENCE ON ART

In the fourteenth century the leader of the humanist and antiquarian movement was Francesco Petrarca (1304–74). Though Petrarch was born at Arezzo he came of a Florentine family and was claimed by the people of Florence as one of themselves. With Dante and Boccaccio he made up a trio known as the *tre corone fiorentine*, the three crowns of Florence, that is, the poet's crown of laurel. The best-known of Petrarch's works, the poems inspired by the unknown Laura, were written in Italian. They greatly influenced lyric poetry in Tudor and Elizabethan England as well as in Renaissance Italy. Petrarch had always been devoted to the Latin classics. He wrote fluent and elegant Latin modelled on Cicero, and was for long without a rival in the scholarly editing of classical texts. For him, pagan antiquity was a shining light that had been all but extinguished by scholastic teaching in the intervening Dark Ages. Though as a young man he had taken holy orders, the ceremony that meant more to him occurred in 1341 when he was crowned with the poet's laurels on the Capitol in Rome. This

ancient honour which used to be bestowed on victorious generals in imperial Roman days had been revived at Padua university in 1315 to reward a humanist poet and thereafter was much sought after. Dante, though he wished for it and is often represented wearing a laurel wreath over his scholar's cap, in fact died uncrowned.[15] The laurel had from early times been associated with the rites of Apollo so it made a fitting emblem for those inspired by the Muses whose leader was Apollo. In painting, the laurel crown is a common attribute of the god and also of poets and personifications of poetry and related arts. Petrarch appears crowned, among other poets together with Apollo and the Muses in Raphael's Parnassus in the Vatican Stanza (p. 283).

Petrarch visited Rome for the first time in 1337 and was greatly moved by the sight of her ancient ruins. In the following year, no doubt partly inspired by his experience, he began two works in Latin. One was an epic poem in which he deliberately set out to emulate Virgil, called *Africa*, in praise of Scipio Africanus Major, victor in the second Punic War; the other was an historical study in prose, *De Viris Illustribus* ('On famous men'). Both in different ways influenced Renaissance artists. At about the same period Petrarch started on a set of allegorical poems in Italian called the *Trionfi* ('Triumphs') which occupied him on and off until his death.

The Triumph and other themes

The Roman triumph (p. 43) was a celebration that followed a military victory and had been revived by Frederick II for the same purpose. Petrarch's 'Triumphs' celebrate a series of allegorical victories, each succeeding victory overcoming the last. The first is the Triumph of Love who is overcome by Chastity, then Chastity by Death. They are followed in turn by Fame, Time and Eternity. Petrarch was not the first to make a poetic metaphor out of the Triumph; Dante had described the victory of Christianity in terms of a pageant, with Beatrice in the triumphator's car accompanied by the Apocalyptic Beasts, the twenty-four Elders, the Virtues and other symbolic figures [7.3].[16]

In the Triumph of Love Petrarch tells of Cupid riding on a chariot drawn by four white horses. As in a Roman Triumph the victor's captives form part of the procession, but here they are well-known lovers from mythology, the Bible and medieval literature. In the next poem Cupid is among the vanquished and Laura leads a great company of chaste women of history and legend. The Triumph of Death, begun in 1348, the year of the Black Death, just before Traini's painting of the same subject in the Camposanto in Pisa, laments the victims of the plague among whom were Laura and several of Petrarch's friends. The series was completed in 1374, the year of Petrarch's death, with the Triumph of Eternity which expresses his longing to meet Laura again on the Last Day.

7.3 One of Botticelli's drawings for the *Divine Comedy* (probably after
1482): the triumphal car of Beatrice drawn by a griffin, with the
Apocalyptic Beasts (the evangelists) at the four corners. The car is
followed by SS Luke and Paul (the latter with a sword), representing the
Acts and the Pauline Epistles. Next are the four Latin fathers, Augustine,
Gregory the Great, Jerome and Ambrose; finally John the Evangelist as
author of the Book of Revelation. (*Purg.*, Canto 29).

This work, which had come to be regarded in the Renaissance as a kind
of spiritual pilgrimage of the poet, was a source of inspiration for late Gothic
and Renaissance artists in Italy and in northern Europe. The theme of the
Triumph, presented either as a single episode or as a series, appeared in
paintings of every kind – especially on marriage chests (*cassoni*), as well as on
tapestries, ceramics, medals and enamels. It is curious, however, that
although certain conventional pictorial motifs soon established themselves
throughout the series, few of them are found in the poems themselves. For
example, it is only in the Triumph of Love that Petrarch mentions a chariot
yet artists provided all the others with a car and appropriate draught-animals:
unicorns for Chastity, black oxen for Death, elephants for Fame and so on.
If artists had some commentary or handbook to use as a guide, none has come
to light. The great sixteenth-century Flemish tapestries devoted to cycles of
the Triumphs are especially rich in detail. Victor and victim usually appear

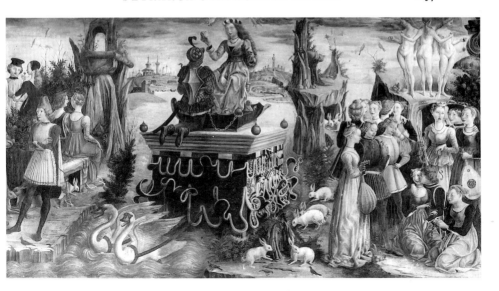

7.4　The month of April, ruled by Venus (detail). Allegory by Francesco del Cossa, c. 1470. Salone dei Mesi, Schifanoia Palace, Ferrara.

each with his own car among a great throng. In the Triumph of Death Chastity dies, stabbed by Atropos, one of the three Fates. Venus lies crushed beneath the hooves of Chastity's unicorns while Cupid sits bound and helpless. Under Death's chariot lie a pope, a knight in armour and a prince. In the ensuing Triumph of Fame it is the turn of the Fates to be overthrown.[17]

The image of the victor on his chariot surrounded by those he holds captive lent itself to astrological cycles. The twelve months were sometimes represented each with its reigning planetary deity enthroned on a car and accompanied by a crowd of figures, the 'children of the planet'. The illustration [7.4] shows a fresco painted about 1470 by Francesco del Cossa for Duke Borso d'Este, one of a series of twelve by various artists in the Salone dei Mesi in the Schifanoia Palace at Ferrara. It represents the month of April and depicts Mars kneeling in chains before Venus, the month over which he ruled having just passed. Mars wears medieval armour and Venus, enthroned on her car, is dressed in the fashion of the day. The goddess' car is drawn by swans. Doves, sacred to her, fly around her head. Her attendants, the Three Graces, stand on a grassy hill. Unlike Venus, they are classically nude. On either side are amorous couples, the courtiers of the Duke who also represent the 'children' of Venus. The evergreen myrtle and the ever-fertile rabbit, both attributes of the goddess of Love, are much in evidence.

The continuing popularity in the Middle Ages and the Renaissance of

street pageants, religious and secular, which often included elaborately decorated cars, undoubtedly helped to establish the theme of the Triumph and the manner in which it was represented. Later, we find it introduced into Christian art in pictures such as the Triumph of Christianity or the Eucharist in which the chariot bears a cross or a chalice instead of a human figure.[See also 7.28.]

Famous Men

Petrarch's *Canzoniere*, though they exist in illustrated editions, did not capture the imagination of artists at all widely, and the poem 'Africa' was used more for information about the appearance of gods than as a source of themes. On the other hand, the series of biographies of Roman generals and statesmen whom Petrarch particularly admired, called *De Viris Illustribus*, produced an immediate artistic commission. In his later years, while still working on it, Petrarch's patron was the ruler of Padua, Francesco Carrara the elder, who ordered a room in his palace to be decorated with the Famous Men and scenes from their lives. It became known as the Sala dei Giganti, as the figures were larger than life-size. Today it forms part of the university buildings. The frescoes were painted between 1367 and 1379, in part possibly by Guariento, the court painter of the Carrara. They were almost completely destroyed by fire around the turn of the fifteenth century and were more than once repainted or restored so that virtually all that remains today of the original work is a portrait of Petrarch himself at his writing-desk. The original composition followed Petrarch closely but was a good deal modified in the course of restoration. However, its appearance can be deduced from illustrations in contemporary manuscripts which were inspired by the frescoes. It seems that although the settings attempted to reproduce ancient Rome, the heroes themselves wore something resembling fourteenth-century dress, following the artistic convention of that time.

The Famous Men of the Sala dei Giganti were not the first of their line. It was already the custom among the rich and powerful to decorate their houses with portraits and deeds of great men of the past, and similar halls continued to be painted during the Renaissance and afterwards. The subjects were drawn from the regular *dramatis personae* of the Bible, history – medieval and ancient – and legend. The hall at Padua was exceptional in being devoted exclusively to the great age of ancient Rome which, Petrarch felt, was worthy to serve as an example for his own times.[18]

Petrarch himself appears as one of a series of nine famous men and women by Andrea del Castagno. The frescoes were painted for the Villa Carducci at Legnaia and are now in the Castagno Museum at Florence (formerly the convent of S. Apollonia). They too are an unusual group. They comprise three trios which consist of heroines of antiquity (Queen Tomyris, the biblical Esther and the Cumaean Sibyl), three *condottieri*, famous in recent

Florentine history as liberators of the city, and the three literary 'crowns of Florence', Dante, Boccaccio and Petrarch. In their original setting the figures were accompanied on another wall by Adam and Eve, and the Virgin and Child. The whole scheme was meant to convey the idea of Original Sin and Redemption, which ultimately made possible the highest achievements of the human spirit exemplified by the three Florentine poets.

THE MARRIAGE OF FORM AND SUBJECT

Artists, as we have seen, returned to the forms of classical antiquity more than once during the Middle Ages, albeit usually in the service of the Christian religion. At the same time they kept alive the persons of the pagan gods themselves, especially in manuscript illustration, though in a style that seldom gave any hint of their ancestry. So the rebirth of antiquity, to which the word Renaissance strictly refers, was evidently not a sudden phenomenon. Indeed, the question has even been asked whether it is correct to speak of a Renaissance at all in view of the difficulty in settling a date for it. But so far as the visual arts are concerned, so long as we take care to confine the term to events which definitely occurred, such as the reintegration of classical forms with classical themes which took place in the later fifteenth century, then we can safely say that the Renaissance undoubtedly happened. We had an early glimpse of it, in pictorial art, in Cossa's treatment of the Three Graces at Ferrara [7.4].

It is curious that the works of the classical poets themselves were un-illustrated in the Middle Ages – there are no images of the gods in extant medieval copies of Virgil or Ovid. They are, however, found in the many commentaries, the medieval works of 'moralization' which were the offspring of late antique writers such as Fulgentius, Martianus Capella (p. 199) and the grammarian Servius, who wrote a lengthy allegorical commentary on Virgil. They appear, too, in the encyclopaedias in the sections devoted to the gods, and in works on astronomy where they represent planets and constellations. In illustrating the latter, artists generally had existing images for guidance and in some cases their ancestry can be traced back to antiquity, though the path is not always clear. In the commentaries and mythographies on the other hand, the artist was more often dependent on the written word before him, so each endeavour was a fresh start, lacking the continuity of tradition and at the mercy of copyists' and translators' inaccuracies.

One of the few comparatively uncorrupted lines of descent, in which the stellar gods retained much of their ancient purity of form, can be traced back to an astronomical work by a Greek poet Aratus who was born about 315 BC. Cicero made a translation of it into Latin, known as the *Aratea*, and so it became widely read in the medieval West. The constellation Gemini

7.5 The constellation Gemini: not the usual Castor and Pollux but, as
on many medieval star-maps, Hercules (with club) and Apollo (with
lyre), from a Carolingian manuscript copy of the *Aratea*. Municipal
Museum, Boulogne-sur-Mer.

[7.5], depicting Hercules and Apollo, is from a Carolingian copy and
shows how remarkably the antique forms have been preserved.

On the other hand, the bishop with mitre, crozier and book [7.6] would
be difficult to recognize as the planet Mercury without his inscription
'Mercurius'. It comes from a fourteenth-century copy of a popular treatise on
astronomy-cum-astrology compiled by a Scottish scholar, Michael Scot
(*c.* 1175–1234), when he was resident astrologer at the court of Frederick II.
Scot, according to Dante, 'knew every trick of the magical arts'.[19]
Michael Scot's sources were illustrated Islamic manuscripts that had been
widely diffused through Sicily and Spain by the Arab conquests. The Arab

7.6 The planet Mercury in the guise of a
bishop. From a 14th-cent. astronomical
treatise, the *Introductorium Magnum*, after
Michael Scot. Staatsbibliothek, Munich.

astronomers had, in turn, acquired their knowledge of the stars from Ptolemy
of Alexandria. This was originally an impeccable source until, over the
centuries, it became intermingled with elements of Babylonian star-worship.
The latter was of great antiquity yet surprisingly it continued to flourish in
certain areas of Mesopotamia in the Middle Ages. Thus the planetary deities
in some medieval Arabic manuscripts were a mixture of Graeco-Roman
and Babylonian types. They were headed by Jupiter who doubled with the
all-powerful eastern god, Marduk. Mercury was assimilated with the learned
and holy Nabu, inventor of writing and patron of Babylonian letters, who
was sometimes represented with book and nimbus. In adapting such images
for the Christian West it was only natural that Michael Scot turned Mercury
into a cleric. The other gods underwent similar transformations. And yet
it seems to have been a different process that turned the planet Jupiter, on
Giotto's campanile in Florence, into a monk with a chalice and crucifix
[7.7]. The source, in this case, was probably a text, not an image – an
Islamic treatise on astrology by an Arab geographer Qazwini who died
about 1283. Like Ptolemy he believed that each planet governed a different
region of the earth. Jupiter ruled over the West, the Christian lands, and
therefore resembled Christians in appearance. He advised devotees of Jupiter
to dress in the style of monks and Christians, with 'a yellow mantle, a girdle
and a cross'.[20]

 At the turn of the fourteenth century when humanism was flourishing
among men of letters there was still little sign of artists turning to classical
treatment of antique themes. It was a time of growing demand for secular
subjects of many kinds. Wealthy patrons, princely and bourgeois, required
the decoration of a variety of household objects, in particular bridal chests

7.7 Jupiter as a planetary deity, dressed as a monk [cf. 6.3]. Studio of Andrea Pisano, 1337–42. Relief on the campanile, Florence cathedral.

(*cassoni*) and the kind of tray known as a *desco da parto* that was given to a mother at childbirth. The long front panel of the *cassone* was well-suited to narrative scenes and was very widely used to depict the sports and pastimes of the rich, episodes from popular *novelle* of the day such as Boccaccio's *Decameron*, Petrarch's *Triumphs* and, increasingly as the fifteenth century progressed, scenes from Greek and Roman myth and history. In painting of this kind the patron wanted to see not a faithful image of the classical past but his own reflection. Love-scenes from the myths, most popular of all themes for decorating bridal chests, show the lovers dressed in the high fashion of the day. Nude figures appear rarely and then only on the inside of the lid. The painter of the *desco da parto* [7.8] shows the three goddesses Venus, Minerva and Juno, undistinguished by any attribute. They have become ladies of the court, wearing a version of the fashionable *houppelande*, an overgarment, first introduced in France in the second half of the fourteenth century.

7.8 Greek myth in contemporary dress: the Judgement of Paris. A 'continuous narration' [cf. 2.17, 3.13]: The goddess of Strife throws the apple of discord among Juno, Minerva and Venus, while the shepherd Paris, guarding his flock, is persuaded by Mercury to judge their beauty. Below, Paris awards the apple to Venus. *Desco da parto* by the Master of the Judgement of Paris, 1430s. Bargello. Florence.

The sources of such themes were seldom the classical authors but more contemporary retellings that were illustrated in modern dress, so the *cassone* painters were merely following a present-day practice. Popular themes from ancient legendary history like the abduction of Helen of Troy by Paris were known not from Ovid or Virgil but through works such as the French *Roman de Troie*, written about 1165 by Benoît de St Maure, which were translated or retold in Italian. Boccaccio's version of Troilus and Cressida, *Il Filostrato*, was taken from the *Roman de Troie*. Classical themes were extracted from Dante and Petrarch, and collections of tales like the *Gesta Romanorum* were mined for suitable subjects.

Artists as collectors
The rebirth of the ancient gods in all their dazzling, pristine splendour, in other words the reintegration of form and subject, which came about in the

second half of the fifteenth century was preceded by a revival of classical styles in architecture and sculpture. Artists, caught up in the wake of the humanist movement, were discovering the fascination of Roman ruins. They began to share the humanists' enthusiasm for collecting antique objects such as marbles, pottery, bronze statuettes, coins and engraved gems or cameos. Their motives, however, were mainly practical. Marbles and statuettes in particular were useful as models, supplementing the pattern books which were a basic tool of every studio. The finest pieces fetched high prices and usually went to wealthy collectors, so artists more often had to be content with objects of lesser value and fragments of sculpture. However, the sculptor Ghiberti (1378–1455) who made two of the bronze doors of the Florence baptistery was noted for his collection of antique sculpture and bronzes which included a piece, supposed to have been an original, from the fifth century BC by Polyclitus of Argos, and was known as the Bed of Polyclitus. It represented Cupid and Psyche. This figure of Psyche was much imitated by Renaissance painters. Donatello (1386–1466), who was apprenticed to Ghiberti and whose bronze of David was probably the first nude to be sculptured in the round since ancient Roman times, was one of the pioneers in reviving the knowledge of human anatomy and devoted himself to the study of antique art. According to Vasari he visited Rome for this purpose with his friend the architect Brunelleschi, in 1430–2, and it was after his return that he created the David. Though, like much of Donatello's work, the figure nominally represents a Christian subject there emanates from it a powerful spirit of pagan antiquity.

The imitation of nature

The aim of painters in the early and mid-fifteenth century was truthfulness to nature rather than a conscious imitation of classical styles. In the search for naturalism they were aided by the anatomical discoveries of sculptors and by the new laws of perspective that had been formulated by Brunelleschi. As with architecture and sculpture it was the Florentine school that led the way in painting. The first to exploit the new science of perspective was Masaccio (1401–28), notably in a fresco of the Trinity in S. Maria Novella. Here the Crucifixion and surrounding figures are disposed symmetrically under a classical, coffered, barrel vault which affords ample scope for perspective treatment. Masaccio certainly borrowed from antiquity but apparently at second hand. His classical vault is more likely to have come from notebooks made by Brunelleschi while he was in Rome, which were known to the painter, than from an actual building.[21] Similarly, the strong echo of the *Venus pudica* in the figure of Eve from another great work of Masaccio, the Expulsion (Brancacci Chapel, S. Maria del Carmine) may have been derived not from a classical sculpture but from a figure by Giovanni Pisano in Pisa cathedral which personifies the Christian virtue of Prudence [7.9].[22]

7.9 Versions of the *Venus pudica*.
(*Top left*) The Medici Venus,
after Cleomenes of Athens. A
1st-cent. BC copy of a 4th-cent.
original. Uffizi. (*Above*) Prudence
by Giovanni Pisano, 1302. Pisa
cathedral pulpit. (*Left*) The
Expulsion of Adam and Eve, by
Masaccio, 1422–6. Brancacci
Chapel, S. Maria del Carmine,
Florence [cf. 8.2]

In the 1460s another Florentine, Antonio Pollaiuolo (1432–98), painted a series of three scenes from the Labours of Hercules showing the hero nude, classically proportioned and with his traditional attributes. Here was an undeniable marriage of form and content, perhaps the first of its kind in the pictorial art of that age. Yet in reality it was primarily an exercise in depicting human anatomy for which Hercules was an obvious choice. Pollaiuolo was an avid student not so much of antique sculpture as of the human body itself and had made himself a master of it. 'He dissected many bodies', wrote Vasari, 'to examine their anatomy, being the first to show how the muscles must be looked for to take their proper place in figures.' Pollaiuolo's contribution to Renaissance art was perhaps more as an anatomist than as a humanist.

Artists and humanism

A humanist treatise addressed to painters had been written in Florence in 1435 though it was many years before its influence was at all widely felt. The author of *De Pictura*, On Painting, was Leone Battista Alberti, a man who combined wide learning with a scientific outlook and a deep devotion to classical studies. He also practised painting, sculpture and architecture. The original Latin edition of *De Pictura* was followed in 1436 by an Italian version dedicated to Brunelleschi. Alberti combined technical instruction, aimed at achieving a faithful imitation of nature, with guidance about subject-matter and the manner in which a subject should be presented. The painter was recommended to study the writers of antiquity for narrative themes, looking particularly for some pregnant moment, a dramatic or emotional incident that lent itself to illustration. Alberti took for granted the artist's freedom to choose for himself, in other words that his employment was no longer confined to the Church and its limited repertory of themes. He encouraged the artist to develop a humanistic outlook and not to rest content with being a mere craftsman. He should therefore study the Liberal Arts. He should 'make himself familiar with poets and orators and other men of letters, for he will not only obtain excellent ornaments from such learned minds, but he will also be assisted in those very inventions which in painting may gain him the greatest praise. The eminent painter Phidias used to say that he had learned from Homer how best to represent the majesty of Jupiter.'[23]

Later humanists were to explore further this question of a relationship between painting and poetry. Alberti, meanwhile, recommended the artist to try his hand at an allegorical subject said to have once been painted by Apelles (fourth century BC) and which was known through a description by the satirical writer Lucian who lived in the second century AD. The theme was Calumny and the scene showed an innocent youth dragged before a judge, who was adorned with ass's ears, by a woman who personified the vice in question. Also depicted were figures representing Ignorance,

Suspicion, Envy, Treachery and Deceit. But all would surely end well for in the rear came Repentance, followed by 'chaste and modest Truth'. The first and most famous rendering of this theme still extant is Botticelli's, done in the 1490s some sixty years after *De Pictura* was published.

Whether Apelles ever painted such a picture in the first place is another matter. Such extensive use of anonymous figures (as opposed to the gods) to personify abstractions was fairly rare before the Christian era. In any case, a description such as Lucian's, one of a whole series he wrote purporting to describe various works of art, was not intended as art-criticism. It was primarily a literary exercise and was part of a writer's training in the subject of rhetoric. Similar series of so-called descriptions were produced by other Greek writers, notably the two Philostratus (Elder and Younger) who were roughly contemporary with Lucian. None of their essays has been positively identified with any known work of art. Nevertheless, the classical 'description', or *ekphrasis*, which had been revived by humanists as early as the fourteenth century, became popular from the early sixteenth century with artists in search of antique themes. Lucian was known to Italian humanists from a Latin translation made early in the fifteenth century. He was used by the Sienese painter Sodoma for the scene of the marriage of Alexander the Great and Roxana which decorates an upper room in the Villa Farnesina at Rome. According to Lucian the original was by the Greek painter Aetion. The writings of Philostratus reappeared in Italy in 1503 in the original Greek which, by that date, was commonly understood in educated society. Their publication was due to the industry of the Venetian printer Aldus Manutius who reprinted much of Greek classical literature. An Italian translation of Philostratus was made about 1510 for Isabella d'Este, Duchess of Mantua, who was an enthusiastic patron of the arts. It was the source of such dream-like idylls as Titian's Andrians and the Feast of Venus, the latter commissioned by Isabella's brother Alfonso.[24] Rubens also painted both subjects, basing himself on Titian.

Humanism and art in Padua

The influence of Alberti, which eventually became so widespread, was slow to take effect at first. It was, after all, over half a century before Botticelli painted the Calumny of Apelles. Indeed, the true spirit of humanism, an understanding in a wider sense of the values of the ancient world, was first manifested among painters not in Florence but in cities further north. In Padua the university had always provided an hospitable climate where religious freedom and breadth of learning went hand in hand. Here Averroism had flourished in its day undisturbed by the Inquisition and, later, humanist studies had their first home in Italy. Eastern influences were felt through the nearness of Venice, more so after the overthrow of the Carrara dynasty of Padua by the Venetians in 1405. The great basilican

church of St Anthony in Padua, known simply as Il Santo, with its Byzantine domes imitating St Mark's in Venice, yet preponderantly Gothic, provided plentiful commissions for artists who were continually drawn to the city, especially from Tuscany. The high altar was furnished with sculptures by Donatello and his assistants between 1445 and 1450 [8.1], and in the Piazza del Santo stands his great equestrian statue of the *condottiere* Gattamelata, done in 1453.

Young Paduan artists in the mid-fifteenth century generally had a lively interest in antiquarian matters, partly due to the influence of the university. Mantegna (1431–1506), who was apprenticed in the city and worked there until about 1460, came under the same influence. He too was a collector of antique sculpture though sometimes a disappointed one. One of his most treasured items was a marble bust of Faustina, wife of Marcus Aurelius, which near the end of his life he was obliged, through poverty, to sell to his patron, Isabella d'Este. Mantegna, whose working life spanned the second half of the fifteenth century and beyond, first became famous for a series of frescoes painted between 1449 and 1454 in the Eremitani church at Padua, depicting scenes from the lives of SS James and Christopher.[25] In them Mantegna adds realism to the events of early Christian history by setting them among authentic Roman architecture of their day and, contrary to prevailing custom, peopling them with Roman soldiers, officials and common folk in the attire of those times [7.10]. Mantegna owed much of his mastery of the human figure to Donatello. His architectural details, such as a classical inscription, a medallion of an emperor, a relief on a frieze or panel representing a chariot race or a pagan sacrifice, reveal a debt to the Venetian painter Jacopo Bellini (*c.* 1400–70/1) (whose daughter he later married). Bellini's sketchbooks are full of items of this kind, together with scenes from the myths, especially Bacchic festivals, indicating his predilection for the classical and pagan world [7.10].[26]

In 1460 Mantegna went to Mantua where he became court painter to the ruling house of Gonzaga. The kind of commissions he carried out on the walls of the ducal palace suited him well. Frescoes of scenes from the life of the Marquis Lodovico II and his wife mingled with portrait busts of the Roman emperors. A series of nine tempera paintings, executed for Lodovico's grandson Gian Francesco, depicted the Triumph of Julius Caesar.[27] All were intended to show how the glories of ancient Rome shed their lustre upon the princes of Mantua.

It was not until late in life, in the early years of the sixteenth century, that Mantegna, directed by Isabella d'Este, wife of Francesco, produced two great works depicting the pagan gods. They were the Parnassus and the painting known as Wisdom overcoming the Vices. They were far from being simple narrative scenes from mythology but used the classical deities as figures of allegory (see p. 267). As we shall see, this was only one of several new

7.10 (*Above*) Antique tombstones, inscriptions and coins from a
sketchbook of Jacopo Bellini (1400–70/1). Louvre. (*Below*) Mantegna's
classical realism in the treatment of a biblical subject – St James the
Greater condemned to death by Herod Agrippa. The inscription (top left)
is copied from Bellini's sketchbook (detail). 1449–54. Formerly in the
Eremitani church, Padua.

approaches to the subject-matter of antiquity which painters and sculptors had been taking during the second half of the fifteenth century, by which time mastery of classical form was becoming a common achievement. These developments often took place at the court of a prince who retained the services not only of artists but also poets, astrologers and humanist scholars who created a fertile environment in which new ideas in art could flourish.

THE PRINCE, HIS ARTISTS AND ASTROLOGERS

Italy in the fifteenth century was divided into a number of independent city-states ruled either by a single all-powerful individual or a small, exclusive group of men. Among the many states in the north the strongest were Venice, Milan and Florence. In the south was the kingdom of Naples and between them, in the centre of the peninsula, were the papal states. The individual ruler usually came to power either as the result of a coup d'état or because he was called in by a failing government to quell internal unrest. Sometimes a mercenary leader, having been hired to defend a city, seized power for himself. Despots such as these needed, above all, to achieve stability for their regime, especially if there was to be any hope of handing it on to their chosen heirs. Whereas the earlier despots had generally ruled by terror, often committing acts of appalling barbarity, in the fifteenth century their actions were governed more by the arts of diplomacy. It is not surprising that such men so often gathered around themselves a circle of scholars and artists whose company they valued. Some, perhaps, began life as ignorant peasants or common soldiers and simply wished to acquire learning. But the court poet generally had more to do than merely provide agreeable verses for his master's pleasure; flattery was also required which praised the prince's virtues and showed him in a favourable light. Artists had a similar function, portraying him as an upholder of religion or likening him to illustrious leaders of antiquity. The skills of painters and sculptors were needed to mount pageants and tournaments, great public spectacles which served to enhance the prince's popularity. The court astrologer was consulted before important decisions of state were taken, thereby, it was supposed, helping to avoid unnecessary risks. In all these ways the members of the prince's circle contributed to the stability of the regime.

A prince who lavished his riches on religious and civic building seldom did so solely out of a disinterested concern for Church and State. So far as the Church was concerned he also hoped by his benefactions to make his peace with God. Though on the battlefield he might be bold in the face of death, the afterlife was another matter. For some, like the early Medici of Florence, bankers whose wealth was derived from usury, donations to the Church,

though they were made in a spirit of genuine piety, were in the nature of the repayment of a debt. Moreover, giving money smoothed the relationship with the priests and perhaps helped to ensure regular absolution. For a man like Cosimo the Elder (1389–1464), although well-informed about architecture and having a high regard for the abilities of a sculptor like Donatello, patronage of the arts was only part of a broad spectrum of financial obligations and, in his case, one in which painting seems to have had only a comparatively small place.[28] At the same time there were others who embraced humanist culture and the arts for their own sake and ungrudgingly dispensed patronage in that cause. Among them were Cosimo's son, Piero (the Gouty) and his grandson Lorenzo the Magnificent (1448–92), himself a not insignificant poet, Federigo da Montefeltro (1422–82), the Duke of Urbino, whose court became a byword for social refinements, and less powerful but still influential figures like Isabella d'Este. It was the munificence of such individuals, added to the traditional patronage of the Church, which produced the overflowing wealth of Renaissance art.

Astrology and religion

The belief that the stars influenced human destiny, reluctantly conceded by Thomas Aquinas, became ever more widespread in Renaissance Italy. It was customary for statesmen and war leaders to have their horoscopes drawn, often in childhood, to discover what pitfalls lay ahead in life. The astrologer chose the hour for them to receive an ambassador, lay a foundation stone or go into battle. Nor were these things confined to the laity: Pope Julius II fixed the date for his coronation by the stars and Paul III, by the same method, would choose the time of day to call a consistory. If the hand of God guided men's deliberations, so did a lot of other unseen powers. The basis for such beliefs lay in the idea that the individual was a kind of universe in miniature, or microcosm. His body was, after all, made up of the same four elements as the rest of created matter. More important still, each limb and organ was governed by a different planet or sign of the zodiac. The movements of the heavens directly influenced all man's activities, from affairs of state to his bodily health. In later times physicians refrained from treating an affected part so long as the moon was in its zodiacal sign and outbreaks of disease such as syphilis were attributed to the conjunction of Mars and Saturn.

It is strange how fatalistic attitudes of this kind managed to exist side by side with Christian belief in freewill. Heavenly bodies – demons, as the Church still thought of them – might determine a person's course of action, yet if the outcome were successful it was to God and not to some pagan spirit that thanks were given. The ancient practice of making a votive offering, of fulfilling one's side of a bargain, the kind of obligation once conveyed by the

saying 'Do ut des', was revived in a different form. If a man was victorious in battle, released from captivity, had recovered from illness or escaped whatever disaster, he showed his gratitude by commissioning a painting which he donated to his church or guild. The subject of such votive paintings was generally the Virgin, perhaps the Madonna of Mercy protecting her grateful devotees under her outspread cloak or, more often, enthroned with the Child and attended by saints. The latter type often includes the donor, kneeling to one side, sometimes being presented to the Virgin by his patron saint. A donor in armour, perhaps with warrior saints, may signify a military victory; the presence of saints such as Sebastian or Roch who were protectors against the plague may indicate sickness cured or averted. The presence of a donor does not, however, of itself signify a votive intent, it may simply be a reflection of the giver's piety. Donors began to appear in thirteenth-century religious painting and from Giotto's time became increasingly a vehicle for portraiture. At first the donor was represented smaller than the sacred figures in accordance with the tradition of relating size to sanctity, but with the growth of naturalism the distinction disappeared. Mantegna's votive painting known as the Madonna of Victories commemorated the victory of Italian forces led by Gian Francesco Gonzaga over the French in 1495 [7.11]. The picture shows the Virgin accompanied by the warrior saints, Michael, George and others. The motion of her right hand and the infant Christ's gesture of benediction draw our attention to the kneeling donor on the left. He is Gian Francesco, painted in his actual likeness.

The attempt to relate astrology to the Christian religion can be seen in more than one monument in fifteenth-century Italy. At that time astrology and astronomy were still virtually synonymous and were regarded as a science as much as a magical art. The idea of physical causality between the universe and man, between macrocosm and microcosm, was accepted by many as a scientific fact, though it was a matter for argument within the Church. At Padua, on the walls of the Palazzo della Ragione, formerly the town hall and known as the Salone or Great Hall, is a vast pictorial programme of over three hundred individual subjects, religious and astrological. They were painted in 1420, or soon after, and replaced earlier ones, possibly by Giotto, that were destroyed by fire. They present the spectator with a kind of summary of the cosmos, comparable in scope to the great cycles in thirteenth and fourteenth century religious art which constituted a 'mirror of the universe'. The astrological subjects are arranged in three horizontal bands round the upper walls. They comprise the planetary gods and their 'children', the signs of the zodiac and corresponding Labours of the Months, and a curious selection of human figures, beasts and birds that represent the constellations of Babylonian and Egyptian astronomy. The latter were known in Italy through manuscripts such as those produced by Michael Scot at the court of Frederick II. The arrangement of the original frescoes was

such that the rays of the sun fell, according to the time of year, on the sign of the zodiac through which it was then passing.

Astrological themes mingle with figures from the Bible and pagan antiquity in a series of frescoes painted towards the end of the century by Pinturicchio in the Vatican apartments of the Borgia Pope, Alexander VI. Roderigo Borgia, the father of Cesare and Lucrezia (and of at least two other

7.11 The Madonna of Victories (detail). The kneeling donor on the left is Gian Francesco Gonzaga. At the base of the throne is the scene of the Temptation, an allusion to the Virgin's title, Second Eve, through whom the sin of the first was redeemed. Mantegna, c. 1495. Louvre.

7.12 Pope Alexander VI among the children of Apollo. Above, the sun god drives his chariot across the heavens. Pinturicchio, 1492–5. Borgia Apartments, Vatican.

families), was elected Pope in 1492 at the age of sixty-two. He was a cultivated man and a Spaniard and therefore well-informed about astrology since it was through Spain that a large part of the West's knowledge of Arabic and Greek star lore had come. As Pope, he rebuilt the university of Rome, known as the Palazzo della Sapienza, and appointed to it teachers of astrology as well as theologians. The paintings that he commissioned for his apartments in the Vatican occupy five interconnecting rooms and are linked to one another by their subject-matter and by the number symbolism which was so dear to the Middle Ages, in this case sevens and twelves.

The series begins with twelve Sibyls and twelve Old Testament prophets who announce, through their accompanying inscriptions, the coming of the Saviour, a sharing of roles which we noticed earlier on the façade of Orvieto cathedral (p. 193). The ceiling is divided into seven compartments each with a planetary deity riding in a triumphal chariot across the heavens and with the 'children' of the planet below. Among the children of Apollo, the Sun-god, Pope Alexander sits enthroned [7.12]. In the next room are twelve prophets paired with the apostles. The theme so far is the unanimity of Christian and pagan thought in foretelling the arrival of Christianity, and its subsequent dissemination throughout the world. The inclusion of the planets was not unfitting since they too foretold the future and it was indeed a star that heralded the Saviour's birth. In the rooms that follow the number seven predominates: the seven Liberal Arts with Astronomy in the chief

place; seven saints who, it has been conjectured, stand for the Theological and Cardinal Virtues; and the Seven Joys of the Virgin. The programme of the frescoes as a whole is yet another summary of universal knowledge, like those devised by earlier churchmen, based on the encyclopaedias. By now, however, at the close of the fifteenth century, the traditional subject-matter has been amended to include the pagan Sibyls and planetary gods – and an element of personal glorification. Besides the appearance of the Pope himself, the principal emblem of the Borgia family – a bull – is everywhere depicted in the various rooms together with mythological scenes in which it plays a part.[29]

Horoscopes

The drawing of a horoscope to determine a person's future according to the configuration of the stars at the moment of his birth (sometimes known as judicial astrology) was probably practised by the Babylonians and was widely used by Greeks and Romans. Ptolemy distinguished between predictions of this kind which concerned the fate of individuals, and more general prognostications concerning war, the plague and the weather. The former particularly aroused the opposition of the early Church because it undermined the principle of freewill. If the time of a birth were significant, St Augustine argued, how could one explain differences in the characters and lives of twins such as Esau and Jacob.[30] Medieval Christianity managed a reconciliation. The Dominican scholar St Albertus Magnus (c. 1206–80), who was the teacher of Thomas Aquinas and was widely read in Arabic literature, allowed that the stars influenced the material world, including the human body, but still maintained that a man's will and his soul were free and answerable only to God. Aquinas reasoned the same way but admitted, if man were subservient to the stars, it was due to his weakness of will: 'The majority of men, in fact, are governed by their passions, which are dependent on bodily appetites; in these the influence of the stars is clearly felt. Few indeed are the wise who are capable of resisting their animal instincts.'[31]

There are decorative schemes in fifteenth-century buildings which are quite simply pictorial horoscopes. Above the main altar in the Old Sacristy of San Lorenzo in Florence is a cupola with paintings of the pagan gods representing the planets and constellations. Their configuration corresponds precisely to the appearance of the heavens on the very day in 1422 when the high altar was consecrated. There is a decoration of the same kind in the cupola of the Pazzi Chapel (1443–6) at S. Croce which reveals a similar purpose.

A horoscope of another kind, containing no religious overtones, can be seen in Rome on a vaulted ceiling in the Villa Farnesina. It was painted at the beginning of the sixteenth century by Baldassare Peruzzi (1481–1536) who also designed the villa itself. The owner was a wealthy banker,

7.13 Perseus slaying Medusa. On the right is Fame, blowing her
trumpet. Peruzzi, *c.* 1511. Villa Farnesina, Rome.

Agostino Chigi, who used the place as a retreat where he kept a mistress and
lavishly entertained men of letters, statesmen, and princes of the Church who
included Pope Leo X. It is said that his banquets were so ostentatious that it
was the custom, when they were held outdoors overlooking the Tiber, to
throw the table silver into the river after each course. However, unknown to
his guests, a net recaptured it safely. Chigi, like many men of his station in life
in that era, firmly believed in astrology.

The walls and ceilings of the Villa Farnesina are filled with scenes from
the classical myths and legends. They include a series depicting the story of
Cupid and Psyche by Raphael and his assistants and Raphael's own lovely
Triumph of Galatea. Peruzzi's ceiling, in the same room as the Galatea,
depicts in one of the topmost panels the scene of Perseus slaying Medusa,
from whose body the winged horse Pegasus sprang [7.13]. Pegasus has here
been transformed into the figure of Fame, blowing her trumpet, a popular
image in the halls of Renaissance lords. The background of a night sky with
prominent stars suggest that Perseus is not just the mythical hero but
represents also the constellation of that name. This is confirmed by a series of
panels lower down in which the signs of the zodiac appear in conjunction
with the figures of the planetary deities. The overall arrangement of planets
and zodiac has been shown to coincide with the actual aspect of the sky on
the date of Chigi's birth in 1466.[32] But, for all his lifelong attachment to the
pagan gods to whom he believed he owed his prosperity, in death Chigi took
care to place himself under the protection of that other power to which the
gods themselves were subject. Above his tomb in the church of S. Maria del
Popolo in Rome is a cupola, painted by Raphael, in which the planets are
again depicted but this time over each there floats an angel while at the
summit, as in a Byzantine church, is an image of the Almighty.

THE GREEK REVIVAL

The fall of Constantinople to the Ottoman Turks in 1453 marked the final extinction of the Byzantine Empire and was followed by their conquest of the whole of Greece. The Turkish advances westwards swelled the numbers of Greek scholars who had already come to settle in Italy. Their presence provided opportunities for new fields of study by Italian humanists. At the same time the works of classical authors, Latin as well as Greek, were now being produced in larger numbers thanks to the newly-discovered craft of printing from movable types which was introduced into Italy by German printers during the second half of the fifteenth century. By the end of the century a knowledge of written and spoken Greek was common among educated people.

Florence had been the main centre of Greek studies in Italy since the turn of the fourteenth century when a Byzantine scholar, Manuel Chrysoloras (c. 1355–1415) taught at the university and attracted pupils from all over Italy. He was the author of the first Greek grammar to be used in the West. The enthusiasm of Cosimo de' Medici the Elder for classical letters led him to set up in 1439 a school for the study of Plato. This Academy, so named after Plato's school of philosophy at Athens, eventually became the centre of an intellectual movement whose influence was felt all over Europe in the field of literature and art, though in the case of art the evidence is sometimes more elusive than we might expect. The Academy was housed in a Medici villa at Careggi, north of Florence, and here in the second half of the fifteenth century there gathered a group of illustrious Renaissance poets and philosophers which included Cosimo's grandson, Lorenzo the Magnificent (1449–92). They formed not so much an institution of learning as a friendly clique of men who shared one another's enthusiasms. They were led by a frail and ascetic scholar, Marsilio Ficino (1433–99), who was the tutor of Lorenzo and to whom Cosimo had made over the villa as a gift.

The Neoplatonists

Ficino was a man of many talents and great industry. He was a humanist scholar, philosopher and priest (he became a canon of Florence cathedral); he was a physician (his father was doctor to the Medici family), and he was an accomplished performer on the lyre. He loved the visual arts, knew the leading Florentine painters of his day and helped to raise the standing of the artist in Renaissance society. Besides his own writings, which were considerable, he made Latin translations of the entire Dialogues of Plato and other Greek Platonist authors. He was a prolific letter-writer.

In his original works Ficino set out to unite the principles of Platonism and Christianity into a single coherent system. Within it he also found room for the classical myths, Cicero, Virgil and Dante, not to mention the natural

sciences and astrology. This vast, all-embracing philosophical edifice was comparable in breadth to the productions of the medieval encyclopaedists though it was far removed from that tradition. Ficino's cast of mind was introspective and mystical, an attitude perhaps fostered by the peaceful setting of the villa and its gardens at Careggi which served as an ideal retreat for an elitist group, away from the social unrest and economic distress of the city. There was a parallel here with the original founder of Neoplatonism, Plotinus (c. 204–270), from whom Ficino derived many of his ideas and whom in some ways he resembled as a person. Plotinus was writing in Rome when the Empire was assailed by wars, outbreaks of plague and financial collapse, yet he gives no hint of any of this in his works. Both men applied themselves to constructing philosophies which looked inward, and which were irrelevant to the issues of their day. They were concerned not with ethical systems which might have had some application to the social problems of the world outside, but with metaphysics – the quest for the soul and for an explanation of the cosmos (the traditional concern of Christian philosophy).

Plotinus was selective in what he took from the great range of Plato's thought, making use mainly of his metaphysical doctrines. Plato conceived of the cosmos divided into a higher and lower region. The higher was a realm of pure spirit which could be only dimly apprehended by man; the lower was the familiar world we know through the senses. He conceived also the existence of universal Forms, which he called Ideas, entities created by God that exist in the upper world. They are known to us through the particular, individual examples we see about us on earth. What knowledge we have of the upper world comes to us by a process of recollection, a faint memory brought by the soul when it descends from above and enters our body at birth. What is the place of the artist in this scheme? Plato takes an everyday object, a bed, to illustrate his argument. It has three aspects: the ideal Form, the object created by the carpenter, and the version produced by the artist. 'Is drawing an attempt to imitate the real as it is,' Socrates asks, 'or the appearance as it appears?' In other words, is the artist attempting to imitate the ideal, God-given Form or merely the earthly copy? 'Does a bed differ from itself when you look at it from the side or from straight in front or from any other point of view, or does it remain the same but appear different?' The answer is self-evident. Because the artist is capable only of imitating appearances – notoriously untrustworthy since they depend on our sense-perceptions – he is condemned as a charlatan and a sorcerer.[33]

Plotinus restored the artist to a place of honour, giving him a role in explaining the universe to man. The essence of his Neoplatonist universe was a trinity. It consisted firstly of an impersonal entity known as the One which somewhat resembled the First Person of the Christian Trinity; next in descending order, the Nous or Mind, a kind of divine intellect that

illuminated the One; and lastly the Soul. The Soul was divided into two parts, one looking inwards towards the Nous, the other outward to the world of nature. The outer world was in some manner a creation of the Soul. Unlike his contemporaries, the Gnostics, who held that all matter was evil, Plotinus regarded the world of the senses as inherently beautiful because the Soul, in fashioning it, was guided by its recollections of the higher, divine realm from which it had come. Hence the symmetries and harmonies we find about us, in nature. 'Consider, even, the case of pictures: those seeing by the bodily sense the production of the art of painting do not see the one thing in the one way only; they are deeply stirred by recognizing in the objects depicted to the eyes the presentation of what lies in the Idea and so are called to recollection of the truth.' The Idea which the artist has captured lying behind the surface appearance is the same as Plato's universal Form.[34]

Plato and Plotinus represent the two sides of an age-old debate between art and philosophy – whether the artist sees only the appearance of things or whether his vision penetrates the surface and reaches the reality. Ficino turned the argument in another direction. He accepted that art was mimetic, that it imitated appearances, and was therefore two removes from the eternal realm of Ideas. 'Just as works of art are images of natural things, so are the latter images of things divine.' But this was no reason for condemning art. The artist, in giving visible shape to his own perceptions, was reflecting not exterior ideas but the inward workings of his own soul. His act of creation, that of a humble artificer, was, on the human level, parallel to divine creation by God, the Architect of the universe. For Ficino this demonstrated how art reflected the operations of the divine mind, thereby providing its metaphysical justification.[35]

Ideal beauty

The doctrine of ideal Forms and their relation to art was closely bound up with the question of ideal beauty. The story told by Pliny[36] about Zeuxis and the maidens of Croton was more than once quoted in this connection. The Greek painter, when making a picture of Helen of Troy, copied different parts of the bodies of a number of young women, taking the best from each because absolute perfection was not to be found in any one person. Alberti had repeated the story mainly to stress the importance of learning from nature, though at the same time he admitted the existence of 'the idea of beauty which the most expert have difficulty in discerning' – and which eludes the ignorant altogether.[37] Raphael, writing in 1514 to Count Baldassare Castiglione about his painting of Galatea, alluded to the same story. 'I should consider myself a great master if it had half the merits you mention in your letter. However, I perceive in your words the love you bear me; and I add that in order to paint a fair one, I should need to see several fair ones, with the proviso that Your Lordship will be with me to select the best.

But as there is a shortage both of good judges and of beautiful women, I am making use of some sort of idea which comes into my mind. Whether this idea has any artistic excellence in itself, I do not know. But I do strive to attain it'.[38] Raphael is here using the word 'idea' not just in the vague sense of 'notion' but with an awareness of its Platonic meaning.

The case of the sculptor, compared to the painter, seems more straightforward since his craft is closer to that of Plato's carpenter. Greek sculpture of the great age of Phidias has always been felt to have a quality of 'ideality',[39] a state of perfection in representing the human figure that exceeds anything to be found in life. Of Phidias' most famous work, the gold and ivory statue of Zeus at Olympia, Plotinus said, 'Phidias fashioned his Zeus in accordance with nothing that sense could apprehend, but he conceived in his soul such an image as Zeus himself would present did he vouchsafe to appear to mortal eyes.'[40] Michelangelo restated the case for sculpture in his own day in terms which echo Neoplatonist thought. For him the act of cutting a block of stone was to release a figure that was somehow confined within it, an impression powerfully conveyed by some of his unfinished works. In his poems he describes the, as yet, unrealized figures as a 'concept' of beauty which is 'imagined or beheld within the heart'.[41] Or again, 'Over many years and through much toil the wise man, seeking the right *concept* in the hard, Alpine stone, arrives when near to death at the living image.'[42] We know that Michelangelo used the word *concetto* as the equivalent of the Platonic Idea. Because of his mastery over his material he was no longer consciously involved in the imitation of nature but in the search for the Idea of Beauty.[43]

The personification of Ideas

Platonic Forms, or Ideas, were not too easy to visualize and writers of Plotinus' time rendered them less indistinct by treating them as personifications. Wisdom, Truth, Beauty and so on came to be imagined as female spirits having human shape, a useful convention that the Church later seized upon for its own purpose. Neoplatonists of the Renaissance went further and expressed the basic concepts of their philosophy by means of the figures of classical myth and legend. The writings of Ficino and his followers are thickly populated with the pagan gods who, incidentally, provided a convenient way for artists to approach their doctrines. But to say that the Neoplatonists made Venus a symbol of Beauty, or Aeneas' wanderings a symbol of the soul's journey, is to misrepresent their thinking. It was not a case of looking for an appropriate symbol to fit an idea, but the other way about.

The Neoplatonist view of the myths was elaborated by a disciple of Ficino, Pico della Mirandola (1463–94) who was widely read in ancient literatures, not only Greek but Jewish, Persian and Chaldean. According to

Pico the myths were the storehouse of a very old and secret wisdom, veiled in allegory which, if it could be deciphered, would reveal the meaning of the universe. Only a select few, the philosophers, were worthy to take up the task. It was this same arcane knowledge that had lain at the heart of the Greek 'mystery' cults, and would be discovered in the religion of the ancient Egyptians if only their sacred inscriptions, the hieroglyphs, could be understood. It was also known to Moses. To have returned from Mount Sinai with only two tablets after communing with God for no less than forty days indicated that much more must have been revealed to him. Jesus seemed to hint at the same thing when asked by the disciples why he spoke to the multitude in parables. 'It has been granted to you to know the secrets of the Kingdom of Heaven; but to those others it has not been granted.'[44] Though religions were kept apart by their different dogmas, beneath the surface they would be found to share identical 'mysteries'. In this way Neoplatonism endeavoured to reconcile the classical myths with Christianity.[45] If we are at first puzzled by an allegorical picture painted in the Renaissance we can be sure that a Neoplatonist would have regarded our response as only proper. That metaphor and symbol should be a disguise for an inner meaning, understood only by initiates, was very much a part of his thinking. The concealment was deliberate.

RENAISSANCE ALLEGORY

Platonic love

The partiality of artists for the figure of Venus is not entirely accounted for by her suitability for depicting the female nude nor the popularity of tales about her amorous adventures. The presence of the goddess of Love in Renaissance art also owes something to the group of men at Careggi, especially when we find her attended by the Three Graces or with her son Cupid. The subject of love, which had always preoccupied the poets of the *dolce stil nuovo*, was elevated by Ficino into a philosophical principle. His doctrine was received enthusiastically by his immediate circle and by others outside it. It caught the popular imagination and inspired a whole new genre of so-called Treatises on Love that were greatly enjoyed by courtly society in Italy in the early sixteenth century. Amor, or Love, according to Ficino, was the oldest of the gods who existed even before the world was created when all was chaos. Love pervaded all the realms of the universe from the highest, which was the abode of the Platonic Forms (and also the angels) down to the terrestrial regions. It was a creative force which emanated from God and which was reciprocated by the individual, forming a kind of continuous spiritual circuit between the divine Mind and those on earth below. In the individual it took the form of a yearning by the soul as it contemplated the vision of cosmic

7.14 Sacred and Profane Love. Titian, *c.* 1514. Borghese Gallery, Rome.

goodness and beauty which lay in the realm of Ideas. Plato called this experience 'mania', or 'divine frenzy'. Plato had also distinguished between two aspects of love, which he described metaphorically as two Venuses, one heavenly, one common (in the sense of belonging, or accessible, to all).[46] From them Ficino developed a dualistic theory of his own. The heavenly and earthly Venuses corresponded to the contemplative and active life. They also stood for the two types of beauty in the universe through which love is generated, the divine ideal and its individual manifestations which the senses recognize. They reflected also the Christian view of love, or Caritas, which was directed both towards God and to one's neighbour.[47]

The twin Venuses appear in a painting by Titian known as Sacred and Profane Love [7.14]. The work was commissioned by a well-known Venetian, Niccolò Aurelio, to celebrate his marriage in 1514 to Laura Bagarotto. It is therefore likely that the two Venuses represent a double portrait of the bride, for the portrayal of the living in the guise of classical deities was very much to Renaissance taste. But there is much more besides. The painting dates from a time when Treatises on Love, derived from Ficino's theory, were at the height of their popularity. Every part of the picture can be fruitfully explored for hidden details which contribute to the overall theme. It is perhaps surprising to discover that the robed figure is earthly Venus and that it is her heavenly counterpart who is nude. But it is only following the principle, common in Renaissance allegory, that absence of adornment is virtuous, as in the case of naked Truth. The goddesses' identification is confirmed by the background details. In the distance, behind nude Venus, is a church and a broken sky revealing the heavens while, in contrast, behind her twin is a castle and lowering clouds. The two landscapes contain respectively sheep and rabbits, both familiar symbols. In the vase held by heavenly Venus burns a flame, perhaps the sacred fire of

7.15 Primavera, or Spring. Botticelli, *c.* 1477. Uffizi.

divine love. Only the relief on the fountain in which Cupid dips his hand seems at first to strike an irrelevant note: a kneeling man scourges another, a woman is hauled away by the hair and a horse is led by its mane. What seems to be implied here is the curbing of the physical passions by chastisement. Purgation was once recognized as a necessary preliminary to prepare the soul for higher things and, as such, formed part of the rites of initiation into the mystery religions. Self-chastisement, indeed, has always had a similiar function in the life of some Christian contemplatives. According to Neoplatonists too, the pleasures of senses were harmful, and consequently had no place in their concept of the earthly Venus. She represented the beauty we perceive about us, through which we are led upward to the Idea of Beauty enshrined in her celestial twin.[48] Because of the latter's proximity to God she begins to merge with the Christian idea of Caritas and even to assume the role of mediator, like the Virgin Mary.

Venus and Botticelli

In Florence in the later fifteenth century were painted two famous pictures with Venus as their central figure. In view of the subject-matter and the time and place in which they were produced we might reasonably look for a Neoplatonist content. Botticelli's Primavera [7.15] was painted probably about 1477. Like the Birth of Venus, which dates from the following decade, it was almost certainly commissioned for a cousin of Lorenzo the Magnificent, his youthful namesake Lorenzo di Pierfrancesco de' Medici

(1463–1503) who was taught by Ficino and other members of the Academy. The Primavera is the first work of the Renaissance to treat the pagan gods on the kind of grand scale previously reserved for religious art. It therefore follows no established tradition and its interpretation is accordingly more difficult. To begin with, it is not a straightforward narrative scene from the myths but an artificial arrangement of various figures singly and in groups and, like the Titian, intended as an allegory. Vasari described it simply as 'Venus whom the Graces bedeck with flowers, denoting Spring.' Beyond this point scholars have tended to go separate ways, indicating that the art of concealment so favoured by Renaissance allegorists, has to some extent succeeded.

There are several possible texts, classical and Renaissance, to which the images can be related. The coming of spring, over which Venus presides, was a popular subject among the Latin poets of antiquity. But there are other possibilities as well, including a poem by one of the Medici circle at Careggi, Angelo Poliziano, called La Giostra, (Joust). This work was popular with Renaissance artists as a source of themes. It was written in honour of Giuliano de' Medici, who was later assassinated in the Pazzi conspiracy in 1478, and because of this it was never completed. Poliziano praises his hero's virtues and prowess; he describes, too, the realm of Venus in terms that are often strongly echoed in Botticelli's picture. The effect of Cupid's darts on Giuliano was to make him fall in love with one of Diana's nymphs, 'la Bella Simonetta.' In real life this lady was married to Marco Vespucci, member of a wealthy Florentine family. It was said that she was Giuliano's mistress, though that is not necessarily proved by the poem which is simply using the conventional metaphors of lyric verse. The legend of Botticelli's own passion for Simonetta and the claim that she was the model for Venus in both the Primavera and the Birth of Venus also seem to be unfounded. She had in any case died of consumption before the latter was painted. Nevertheless, more than one nineteenth-century art critic claimed to detect signs of the wasting disease in the pale flesh tints of the goddess.

The preferred interpretations of the Primavera are ones that reflect the ideas of Ficino and his group though the evidence is not so clear-cut as in the Titian allegory. It is possible that the naked goddess of the Birth of Venus and the robed version in the Primavera represent the Platonic twins. But that is questionable if only because the two pictures were not apparently intended as pendants, and one was in any case painted about ten years after the other. The identity of the figures in the Primavera is nowadays generally agreed. At one level they all fit, not too awkwardly, the idea of an allegory of Spring, though there are indications that this is not the whole explanation. On the far right is Zephyr, the west wind whose mildness makes the earth burgeon. He is pursuing the nymph Chloris who at his touch is transformed into Flora, the goddess of Spring, crowned and garlanded with flowers and strewing

them before her. Ovid described this episode, even to the appearance of Chloris 'whose lips breathe vernal roses,' in his account of the spring festival of the Floralia at Rome.[49] In the centre is Venus, framed in myrtle, while above her a blindfold Cupid draws his bow. Venus's gesture, in the artistic convention of Botticelli's day, signifies welcome, presumably to the spectator who, in this case, would be the young Lorenzo, who commissioned the painting. Next are the attendants of Venus, the Graces, 'those three young sisters' whom Alberti recommended to artists, 'dressed in loose transparent robes, with smiling faces and hands intertwined,' much as Botticelli has depicted them.[50] Ovid included them in Flora's garden where they 'twine garlands and wreaths to bind their heavenly hair.' They are mentioned in the *Giostra* and were a favourite vehicle for allegory among Renaissance Neoplatonists. On the left is Mercury with winged heels, pointing upwards with his caduceus, or wand. Though he was known in antiquity as leader of the Graces his place in an allegory of Spring is less clear. Maybe astrology has the answer, for in the astrological calendar he presides over the month of May, as Venus does over April.

Yet again, there is a link between Mercury and Venus in a passage in Apuleius (*fl.* AD 155). The romance, the *Golden Ass*, includes an account of a mimed show representing the Judgement of Paris in which the descriptions of some of the performers seem to correspond to Botticelli's delicate images. Mercury is 'a handsome boy, naked except for a rich cloak worn over his left shoulder', who, 'explained Jupiter's orders in sign language, then retired gracefully.' The Seasons 'strew the path before Venus with bouquets and loose flowers.' Venus herself dances 'with gentle swaying of her hip and head and hardly perceptible motions of her arms,' and so on.[51] The *Golden Ass* was popular reading in Renaissance Italy from 1469, when it was published in Rome. It harmonized with current 'Platonist' thinking in more than one respect. The story of Cupid and Psyche, told by Apuleius, was regarded as a veiled account of the progress of the soul in its search for, and ultimate union with, divine Beauty. As for Apuleius' main narrative of his hero's adventures, transformations and final initiation into the mystery religion of Isis − all this could hardly have been better suited to Neoplatonist interpretations.

But the possible textual derivations of the Primavera are not yet exhausted and, to the extent that its images are drawn from the common stock of classical poetic themes, the search could be endless. The fact is that the devising of a humanist pictorial programme was a selective process, a piecing together of ideas, texts and images that became a unity only through the creative imagination of the compiler. This is something to which the known documents of the Renaissance unfortunately all too seldom provide a key. So, the fact that Venus is the goddess of Spring by no means excludes the possibility that she also signifies some moral or philosophical concept.

Ficino, in a letter to the young Lorenzo, written about the time the *Primavera* was commissioned, instructed him on the planets as beneficent moral influences, extolling Venus in particular as the personification of *Humanitas*. For Ficino, Humanity was the sum of many virtues, all suffused with divine Beauty. He urged his pupil to embrace a goddess who embodied so many desirable qualities. Perhaps her welcoming gesture was intended as an invitation to the young man.[52]

The growth of allegory

Botticelli's mythological paintings stand at the gateway of a new era. From now on allegory flourished. Yet it was only part of a much wider movement which was quite simply intent on celebrating antiquity. The painter or sculptor, eager to exploit the technical knowledge he had inherited from previous generations, might portray the gods as bearers of some hidden message, but, equally, he was content to take them at their face value and treat their loves, jealousies and battles as straightforward story-telling. Besides the descriptions of classical scenes by Philostratus, Lucian and other ancient authors, the humanist poets of the Renaissance also offered the artist a variety of themes. Poliziano's poem, the *Giostra*, for instance, contains a description of the Palace of Venus which was decorated with carvings and jewelled mosaics representing scenes such as the Birth of Venus, used by Botticelli, and the Triumph of Galatea on which Raphael based his fresco in the Villa Farnesina at Rome. Other variations on the theme of love in the goddess's imaginary abode included the Rape of Europa, Ariadne abandoned by Theseus on the island of Naxos, her rescuer Bacchus, the wine god, with his wild train, and Hercules enslaved by Queen Omphale, all subjects which became popular in Renaissance art.

The ideas of the Florentine Academy continued to be a fruitful source of images in the sixteenth century, and the progress of the soul found visual expression in the most varied scenes from mythology. The soul's striving for union with God was rendered by the story of Cupid and Psyche, or the youth Ganymede who was snatched away to heaven by Jupiter's eagle, or even Leda who was ravished by Jupiter himself in the shape of a swan. The notion of the soul's purification through a rite of initiation, central to the ancient 'mystery' religions, was said by the Neoplatonists to be the inner meaning of the story of the flaying of Marsyas, hence his not infrequent appearance in Renaissance art. The shedding of his skin was in reality man's casting off his outer, sensual self, leaving the purified essence within.

Love versus Chastity

Neoplatonist philosophy was only one of many influences on allegorical art. There was, at the same time, a great deal of moralizing of an altogether

simpler kind. This was partly because artists and their advisers, at least until the middle of the century, still depended to a great extent on the old medieval sources such as Fulgentius and his successors, the 'Moralized Ovid' and Boccaccio's *Genealogia*, all of them encumbered with moralistic explanations.

The eternal conflict between good and evil remained a popular theme, especially when portrayed as an actual combat between particular virtues and vices. In this form it had appeared first in the fourth century *Psychomachia* (Battle for the Soul), by the Spanish poet Prudentius (p. 185) and it pervaded Christian imagery in the Middle Ages. The Renaissance, reluctant to give up a medieval pattern of ideas, took up the theme, though the virtues and vices now assumed the shapes of pagan gods and goddesses and their message tended to reflect courtly rather than clerical values. The humanists who devised these pictorial programmes were, for all their attachment to classical learning, following an essentially medieval tradition. A scholar of Isabella d'Este's circle, Paride da Ceresara, one of her principal advisers, drew up a document of this kind for his mistress to present to the painter Perugino. It is revealing that the guidelines laid down by a secular patron could be just as strict as those that religious artists were obliged to follow.

'My poetic invention,' Isabella wrote, 'which I wish you to paint is the Battle of Love and Chastity, that is to say, Pallas and Diana fighting against Venus and Amor. Pallas must appear to have almost vanquished Amor. After breaking his golden arrow and silver bow and flinging them at her feet she holds the blindfold boy with one hand by the handkerchief which he wears over his eyes, and lifts her lance to strike him with the other. The issue of the conflict between Diana and Venus must appear more doubtful. Venus' crown, garland and veil will only have been slightly damaged, while Diana's raiment will have been singed by the torch of Venus, but neither of the goddesses will have received any wound.' There is more in the same vein, introducing nymphs, satyrs and amoretti and love-scenes from the myths which are to occupy the background. The instructions end: 'If you think there are too many figures you can reduce the number so long as the chief ones remain ... but you are forbidden to introduce anything of your own invention.' So much for the artist as creator. Perugino, a religious painter at heart, was persuaded only with difficulty to take on the commission.[53]

The Battle of Love and Chastity [7.16] hung in one of Isabella's private rooms in the Ducal Palace at Mantua. It was the centrepiece of a set of three paintings, being flanked by Mantegna's two great allegories, the Parnassus which celebrates the triumph of Venus, and Wisdom overcoming the Vices in which Pallas (or Minerva) is the victor. The themes of all three are thus related and when taken as a group illuminate one another, much as religious pictures may form a connected scheme of ideas when juxtaposed. The opposing forces which are equally balanced in Perugino's painting are in

7.16 Allegorical battle between Love and Chastity (detail).
Perugino, 1504. Louvre.

turn victorious in the pictures on either side, and this link suggests that Paride devised the programmes for all three.

The scene of Wisdom's victory [7.17] shows Minerva (who is also Wisdom, or Prudence, and perhaps in this context Isabella herself), with the help of her attendants, driving a horrid brood of Vices, together with their 'mother' Venus, from a grove where they have been disporting themselves in a pool. Recognizable among the Vices are Sloth, Avarice, Lust and Ignorance.[54] In the sky above, three of the four Cardinal Virtues, Justice, Fortitude and Temperance, survey the scene while their sister Prudence goes about her good work below. These four seem to have strayed into a secular allegory from their more customary home in Christian art, where they are the companions of the Theological Virtues and often just as vigorously oppose the Vices in the Battle for the Soul.

Love versus Strife

The Parnassus shows Mantegna in an altogether more light-hearted mood [7.18]. Here we have the lovers Venus and Mars. They stand in a bower of myrtle bushes on a rocky eminence on Mount Parnassus. Nearby, at the mouth of a cave where he has his forge, Vulcan, the husband of Venus, rages impotently at them. Below, the Muses, to whom the mountain is sacred, dance in celebration to the music of Apollo's lyre. To one side stands Mercury, presiding over the scene. Beside him is the winged horse, Pegasus, which he once tamed and which symbolizes Fame.

The affair of Mars and Venus as originally told by Homer was a simple

7.17 Wisdom overcoming the Vices. Mantegna, 1502. Louvre.

case of adultery ingeniously punished by a jealous husband, and was viewed by the poet with a humorous eye. In the hands of Renaissance allegorists it was elevated into something of far greater consequence. It was, for a start, another instance of victor and vanquished, only now it was the goddess of Love who conquered, having overcome the god of War. They are seen together thus in many Renaissance paintings from Francesco Cossa onwards [2.13, 7.4]. Mars is usually in a distressingly unsoldierly state, his armour laid aside, perhaps dozing, or fettered in some way, if only with a love-knot tied by Cupid (possibly an allusion to the unbreakable net which Vulcan threw over the lovers, catching them in the act). Mars, his aggressive instincts refined, has now become a lover as well as a warrior, a dual role which the Renaissance courtier set out to emulate, and for which, incidentally, there was ample precedent in the ideals of medieval chivalry [7.19].

But yet another layer of meaning was claimed by the humanists for, according to one version of the myth, there was an offspring of the union, a

7.18 Parnassus. Mercury's wand, a caduceus, is winged and entwined
with snakes. Behind him, the Castalian spring, sacred to the Muses, falls
among the rocks. Mantegna, 1497. Louvre.

daughter named Harmony. The idea that the opposing forces of Strife and
Love when united gave birth to a third, namely Concord, was already
familiar to writers of antiquity and gave rise to an often-quoted though not
very remarkable saying, 'Harmonia est discordia concors', harmony is
discord reconciled. Renaissance writers liked to toy with this mildly
paradoxical notion and Pico della Mirandola, of Ficino's circle, even
embodied it in a rather ponderous theory of aesthetics: 'Nor do contrariety
and discord between various elements suffice to constitute a creature, but by
due proportion the contrariety must become united and the discord made
concordant; and this may be offered as the true definition of beauty, namely
that it is nothing else than an amicable enmity and a concordant discord.'[55]
So, to the Renaissance, the love of Mars and Venus symbolized, in more
than one way, something praiseworthy rather than the reverse. That alone
would have justified the presence in Mantegna's painting of Pegasus who,
says Fulgentius, 'was born shaped in the form of renown; whereby Pegasus is
said to have wings, because Fame is winged.'[56]

7.19 Mars and Venus, an allegory of Strife overcome
by Love. Cupid on the left binds the lovers with a
knot. Another on the right makes off with Mars'
sword. Veronese, *c.* 1562. Metropolitan Museum of
Art, New York.

THE RENAISSANCE LANGUAGE OF
SYMBOLS

The impulse to mystify, to express one's meaning in a veiled language, was
one of the legacies of the Florentine Neoplatonists. Academies on the
Florentine model sprang up in other Italian cities. Their members formed a
closed circle of literati, and their ideas, far from being profaned by sharing
with the outside world, were sometimes barely intelligible even to one
another. At a more popular level the ability to understand an allegory or

decipher a rebus or conundrum was a desirable accomplishment in the courtier and helped to set him apart from lower ranks of society. The emblem book and the *impresa*, both of which flourished in the sixteenth and seventeenth centuries, catered very much for this taste.

The Neoplatonists maintained that the individual symbol, like the myth, held the key to an ancient, secret lore. Just as symbols used by Christians to represent aspects of God – the hand, the eye, the triangle, the dove, and so on – were seen to contain something of his essential nature, so, they claimed, every pagan symbol, provided it was of respectable antiquity, must have an intrinsic and not merely superficial meaning. The answers to all such riddles, whether to do with symbols or myths, were sought in certain ancient writers, some historical, some purely legendary: Orpheus, Pythagoras, the Persian priest Zoroaster and, in particular, the Egyptian deity Thoth, the divine patron of all wisdom and knowledge. Thoth was more commonly known by his Greek name, Hermes Trismegistus, the thrice-greatest. The Hermetic Books, the mystical writings believed to have been inspired by him and to date from the time of Moses, were actually the work of third-century contemporaries of Plotinus. The legendary authors sometimes appear in Renaissance compendiums as representatives of ancient pagan learning.

Horapollo

It was for long supposed that Egyptian hieroglyphics were symbolic images (and not, as we now know, mainly phonetic signs) in which this esoteric information had been set down. According to Josephus,[57] writing in the first century AD, the Egyptians originally acquired their knowledge from inscriptions, made by Adam before the Fall, on two pillars – one more piece of evidence that pagans ultimately owed everything to the God of the Christians. In the early fifteenth century a genuinely antique find was made which appeared to be additional proof that hieroglyphics really were symbols. In 1419 a Florentine priest returned from the Greek island of Andros with a manuscript by a fourth or fifth-century Alexandrian named Horapollo, called the *Hieroglyphica*, which explained them in just those terms. Some had a familiar ring: the lion signified courage or strength; the goat, male virility; the swan, an aged minstrel because it sings most sweetly when old. The mouse, polluting and spoiling all things by nibbling, stood for 'disappearance', rather like the rodents in the Legend of Barlaam (p. 184) and in some Renaissance allegories where they symbolize the decaying effects of Time. Eternity, on the other hand, was represented by the serpent; and with its tail in its mouth stood for the universe. Hence the serpent became a regular attribute of Father Time, of the god Saturn who personified Time, and of Janus. The vast allegory of human life, painted by Luca Giordano in 1682–3 on the ceiling of the Salone in the Medici-Riccardi palace at Florence (p. 338), represents the birth of man as the figure of Janus offering a

handful of wool to the three Fates to spin. Encircling the group is a huge snake with its tail in its mouth.

The Dream of Poliphilo

Horapollo's book made humanists curious about the ancient Egyptians and was one reason for the great revival of interest in the language of symbols and in things Egyptian generally which occurred in the later fifteenth century. Hieroglyphics, so called, became fashionable. In 1499 the Venetian printer Aldus Manutius published a romance, *The Dream of Poliphilo*, by a Dominican friar Francesco Colonna.[58] It was the familiar story of a lover's search for his mistress – perhaps intended as an allegory of the soul's journey – but it also included descriptions, wholly fanciful, of various ancient ruins and their ornamentation that Poliphilo came across in his wanderings. Besides a temple of Venus decorated, as in the *Joust* of Poliziano, with love scenes from the myths, he discovered reliefs carved with what the author describes as Egyptian hieroglyphics. Some are rebuses, some illustrate mottoes. A favourite was 'Make haste slowly,' – *Festina lente* (or *tarde*), which is illustrated in a variety of ways: a seated matron holds a pair of wings in one hand and a tortoise in the other (her legs, it will be seen, have the opposite meaning to her hands); ants turn into elephants and vice versa; and a dolphin entwines an anchor [7.20]. The latter image in fact had a long history, having been used as a device by the Emperor Augustus and appearing on coins of the reign of Titus, apparently in the same sense as the motto. Aldus used it as his personal mark on title pages. *Festina lente* became a popular maxim among Renaissance humanists, not only Italian, for Erasmus of Rotterdam to whom Aldus had shown one of the coins of Titus, wrote about it at length.[59] Compilers of emblem books, too, invented countless images to express the notion of making haste slowly, often coupling it with the idea of balanced growth, maturity and so on.

Alciati

The first book of emblems was compiled by an Italian, Andrea Alciati who was a jurist by profession. It appeared in 1531. Each emblem consists of an illustration which contains some hidden, symbolic meaning and was accompanied by a few lines of verse which explained in a brief, pithy way the moral underlying the picture. Alciati borrowed many ideas from classical Latin authors, especially the epigrams of Martial, and also made use of Horapollo who had been published by Aldus in 1505. The gods play an important part. Janus, looking both ways, teaches prudence; Bacchus, the evils of liquor; Venus, standing in a pillared hall with one foot on a tortoise, that woman's place is in the house and that she should know when to hold her tongue. A figure dressed in rags, one hand holding a stone, the other sprouting a pair of wings, symbolizes the contrariness of Chance who too

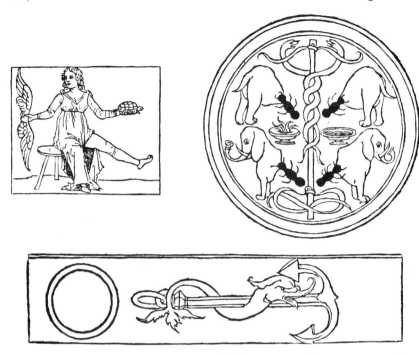

7.20 Three versions of the motto 'Make haste slowly', from *The Dream of Poliphilo* by Francesco Colonna, 1499.

often brings poverty [7.21]. These homely precepts were a long way from the Neoplatonists' use of the myths. They soon became popular and Alciati had many imitators.[60]

The impresa

The *impresa*, too, enjoyed a great vogue in the sixteenth and seventeenth centuries. Like the emblem it was in two parts, an image and a text, but unlike the emblem it was devised for an individual for whom it had a wholly personal application. An *impresa*, usually the invention of the resident humanist in a prince's court, commemorated some special event in his master's life or some noteworthy trait of character. The image was generally some familiar object or living thing and the text merely a short motto, one complementing the other. Such devices are found on medals, on the ceilings of palaces and occasionally in easel paintings. On one of the ceilings of the Ducal Palace at Mantua each coffer is occupied by a crucible filled with gold bars and with a fire burning beneath. Elsewhere the crucible is accompanied by a quotation in Latin from the Psalms: 'Lord, thou hast examined me and knowest me.'[61] The metaphor of the crucible which tests true worth by

7.21 Fortuna (Chance) with a winged hand reaches for the heavens, while the other is weighed down by the stone of 'jealous poverty'. From Alciati's *Emblematum Liber*, 1553 edition.

burning away the dross here alludes to an episode in the career of Gian Francesco Gonzaga, and is an early example of an *impresa*. The Marquis, well-known for his probity, was accused by the Signoria of Venice after his victory against the French in the battle of Taro in 1495, of betraying the Venetian troops, whom he led, by displaying dangerous sympathies with the enemy. The *impresa* reaffirms his patriotism. It was the expulsion of the French armies from Italian soil later that year which is commemorated in Mantegna's Madonna of Victories (p. 252).[62]

Mythographical manuals

The sixteenth century was a period of great activity for humanist compilers of handbooks and dictionaries. They were of two main types. There were manuals of mythology, of which the forerunner was Boccaccio's huge *Genealogy*, which described the gods and the attributes which distinguished them from one another, generally also giving allegorical explanations of the myths. Then there were dictionaries, the descendants of Horapollo, which presented the world of nature as a great catalogue of sacred and profane symbols.

Of the mythological manuals the one that found most favour among artists was the *Images of the Gods* by Vincenzo Cartari, partly no doubt because it was written in Italian and was fully illustrated. But Cartari's gods were not merely, or even mainly, the classical Greek pantheon; they included a whole crowd of strange figures, often weirdly decked out. These belonged to the ancient religions of the Near East and Egypt which had become known in Rome after the expansion of the Empire, and were described by writers of late antiquity. We shall see how, suitably transformed and moralized by Cartari, they entered fresco cycles on the ceilings and walls of sixteenth and seventeenth-century palaces (p. 288, 290).

The dictionaries of symbols, or 'hieroglyphics', as people liked to call

them, drew on many sources besides Horapollo: classical authors, the Bible, the Bestiary and the medieval encyclopaedias, besides borrowing freely from one another. They were all finally superseded by the *Iconologia* of Cesare Ripa which appeared in 1593 and, with illustrations, in 1603. Ripa's work, in Italian, was a dictionary of virtues, vices and other abstractions, running from Abundance to Zeal. They were presented as male and female personifications, the usual anonymous figures but adorned with a variety of symbolic objects to distinguish one from another. Ripa's life was spent at Rome where he held a post at the court of Cardinal Salviati, a well-known humanist and man of letters who had attended the Council of Trent.[63] The company of clerics in which Ripa found himself no doubt affected his views for the *Iconologia* received the Church's official imprimatur. Its influence on artists of the seventeenth century was, as we shall see later, considerable (p. 332ff.).

THE CHURCH AND HUMANISM

The revival of Rome

Humanists of the fourteenth and early fifteenth centuries, when they made their pilgrimage to Rome in search of ancient ruins, found desolation and decay as well. Open warfare between rival families and outbreaks of the plague had caused the collapse of civic government. Moreover, in the fourteenth century the papacy was absent, residing in Avignon in so-called exile, and even after its return it remained weakened and divided by quarrels between Pope and Anti-pope. The city's fortunes began to recover with the healing of the Great Schism under Pope Martin V who reigned from 1417 to 1431. Over the next hundred years prosperity gradually returned to Rome as the papacy won back political supremacy and recovered its lost lands in central Italy. It was led by a series of strong and often ruthless men who were statesmen and warriors first and spiritual leaders only second.

From the mid-fifteenth century the Popes began to spend lavishly on the arts. The best architects, sculptors and painters were engaged to build and decorate churches, palaces and public monuments. Libraries were founded and collections of antiquities were formed. For the Popes, as for secular princes, patronage of the arts was as much a means of self-glorification as a sign of devotion to culture. But two at least pursued art and letters for their own sake. Nicholas V (1447–55) was founder of the Vatican library and had grandiose plans to rebuild the city, including a new St Peter's, though little of the latter had been realized by the time he died. Pius II (1458–64), Aeneas Silvius Piccolomini, was an enthusiastic antiquarian. He had travelled widely in pursuit of the ancient past, keeping a detailed record of his impressions of people and places. In the cathedral library at Siena, which

was built to house his collection of books, is a fresco cycle by Pinturicchio of ten scenes from his life. He is seen as a young papal envoy presenting himself at the court of King James I of Scotland, and receiving the poet's crown of laurel from the Emperor Frederick III.

However much humanists might deplore it, the rebuilding of Rome was not achieved without appalling cost to her imperial remains. The demolition of the old to provide masonry and other building materials for the new had been practised in Rome since the Cosmati workers began producing their stone inlay, around the early twelfth century. Nicholas V plundered the Colosseum for marble, as did the great builder of Roman churches and the Sistine Chapel, Sixtus IV (1471–84). The Borgia Pope Alexander VI (1492–1503), whose building activities included an addition to the Vatican, destroyed parts of the Baths of Diocletian, besides a forum and a temple. Moreover, marble, especially Parian, when burned made excellent lime, so that great numbers of Greek and Roman statues perished to provide builders' plaster and mortar. Rich finds of antique sculpture have been made when lime-kilns of Renaissance Rome have been uncovered. The historic pretext for image-breaking might be religious intolerance, but here was another entirely practical excuse.[64]

Sacred and profane united

The early years of the sixteenth century were a splendid but short-lived Golden Age for Roman art. It came to an abrupt end in 1527 when the city was sacked by the mutinying troops of the Emperor Charles V. Eight days of murder, rape and looting left a large part of the city once more in ruins and artists fled to other towns of Italy. That brief period of glory saw the production of works such as the fresco by Michelangelo on the ceiling of the Sistine chapel and those by Raphael for the papal apartments, the Vatican Stanze.

The status of the artist had risen since the days when he was regarded merely as a craftsman whose job it was to translate into visual terms the dictates of theologians and humanists. Painting, in the eyes of sixteenth-century critics, now belonged among the Liberal Arts and was the sister of poetry. They quoted Horace approvingly, 'Ut pictura poesis,' as is painting, so is poetry. Leonardo indeed claimed that painting was the superior art. The concept of the 'learned painter' was put forward, one who was familiar not only with classical and biblical texts but other useful fields of knowledge and who knew enough of the manners and modes of the past to represent historical personages accurately and with proper regard to their station in life, in a word, with decorum.[65]

THE SISTINE CEILING: Michelangelo did more than anyone to raise the status of the artist in society, not only by expressing decided views on the

matter but, even more, by the mere exercise of his immense and diverse creative powers. As a young man in Florence he came under the twin influences of the revivalist preacher Savonarola and of Neoplatonism, with the result that his works are a unique combination of profound religious sentiment and humanism. Whether Michelangelo himself devised the programme of the Sistine ceiling is an open question, for no document has survived, if one ever existed. The work was ordered by Pope Julius II and Michelangelo later wrote: 'He gave me a new commission to make what I wanted, whatever would please me.' Yet there are indications that, though the broad outlines of the iconographical scheme are Michelangelo's, the more erudite theology which is to be found in some of the details was supplied by a learned adviser, perhaps a follower of Savonarola.[66]

The theme of the ceiling is related to the two lateral walls of the chapel which depict the history of Moses and the life of Christ. St Augustine divided the history of the world into three ages which he called *ante legem, sub lege* and *sub gratia* (before the Law, under the Law and under Grace), the first beginning with the Creation, the second with Moses receiving the tablets on Mount Sinai, the third with the birth of Christ. Thus the ceiling, which depicts the Creation, corresponds to the first age. The walls which were painted in the fifteenth century and had hitherto had a straightforward typological relationship, now took on a new significance, forming the second and third phases of the cycle.

Michelangelo's plan has two distinct directional movements. If the spectator faces either of the lateral walls he sees three superimposed zones which carry the eye upwards. The lowest, in the lunettes and triangular spaces above the windows, depicts man on earth and includes the ancestors of Christ as they are named at the beginning of Matthew's gospel. In this zone, too, belong the spandrels at the corners of the chapel which depict four well-known Old Testament exemplars of salvation, David and Goliath, Judith and Holofernes, the Death of Haman and the Brazen Serpent. The second zone contains those who were endowed with special understanding of the divine, the prophets and Sibyls. They are surrounded by anonymous nude figures who seem to be related to them. The highest zone, with the main narrative scenes, depicts God's acts of creation and the fate of humanity, its fallen condition symbolized by Noah. The frame that encloses each scene is supported by another series of nude youths. Viewed from the east end of the chapel opposite the altar, the cycle of narrative scenes in the upper zone can be seen in sequence (and the right way up). Furthest from the spectator is the Creation in five episodes. They are directly above what was formerly the presbyterium. They are followed by the Fall and Expulsion, in one continuous scene, and finally, nearest, is the sacrifice of Noah, the Flood and Noah's drunkenness.

An overpowering sense of the classical past pervades these religious

images. Some of the nude figures deliberately echo the forms of antique statues though all are transfigured by Michelangelo's vision of ideal Beauty. The Sibyls, it is true, were too well-established in Christian art by this time to be thought of as profane personages though, in this instance, their role is probably not simply the traditional one of the pagan prophets of the Messiah. At the beginning of the Sibylline Books they are described as having been witnesses of the Creation, the Fall and the Flood and it seems likely they are also to be understood in that sense here. But it is the male nudes, or *ignudi*, that particularly call for an explanation. Vasari supposed that they personified the Golden Age that Italy enjoyed in the reign of Julius II, especially as some of the figures hold bunches of oak leaves and acorns which were the Pope's emblem [7.22]. Later critics thought they represented slaves, or Atlantes (supporters of the heavens), or earthly exemplars of ideal Beauty according to Plato's doctrine. We know that originally Michelangelo conceived them as angels because in earlier sketches he gave them wings, and it seems likely he retained the idea of them as some kind of daemon or spirit. There are in fact three kinds of *ignudi*: the youthful pairs that hover closely about the prophets and Sibyls, the pairs of *putti* in the panels on the adjacent pilasters and, up above, the young men surmounting each pilaster. It has been suggested that these categories correspond to the Neoplatonist concept of the three elements that constitute man, that is, respectively, intellect, body and soul. Each prophet or Sibyl is therefore accompanied by the spirits, or Genii, that comprise his, or her, threefold nature. If this was Michelangelo's intention then the ceiling as a whole fulfils the Neoplatonists' aim to unite Christian belief with their own doctrines.[67]

THE STANZA DELLA SEGNATURA: In 1508, the year that Michelangelo began his labours on the Sistine ceiling, Pope Julius II summoned Raphael to Rome to decorate one of his apartments in the Vatican, the Stanza della Segnatura. Like Michelangelo, Raphael seems to have been free to devise his own pictorial programme and he too in his own way made a synthesis of sacred and profane. Raphael had moved in humanist circles before he came to Rome. He had been born in Urbino in 1483 and returned there more than once as a young man to mingle with the polished society of writers, artists and men of affairs who used to gather at the court of the Montefeltro, the Dukes of Urbino. One in particular became Raphael's friend. This was Baldassare Castiglione, the author of *The Book of the Courtier*, published in 1527, a work that became famous throughout Europe. It established for all time the ideal type of the gentleman of the Renaissance court as he might be found at Urbino: the all-rounder who was soldier, sportsman, humanist man of letters and much else, and who also had a proper appreciation of the arts. A certain grace coupled with absence of affectation were, above all, the distinguishing marks of the courtier, qualities that could be said to be

7.22 Part of the Sistine ceiling, viewed from the side. In the centre is the first scene of the Creation, the separation of light from darkness. At each corner of the 'frame' is an *ignudo*, two with bunches of acorns. At the bottom is the prophet Jeremiah, in the likeness of Michelangelo. Opposite (upside down), the Libyan Sibyl. Michelangelo, 1508–12. Sistine Chapel, Vatican.

reflected in Raphael's art. When he arrived in Rome Raphael was ready to mix with intellectuals as their equal.

The frescoes in the Stanza della Segnatura occupy all four walls and ceiling and bring together Christian revelation and secular learning. Raphael uses the customary abstract figures of allegory but, even more, a multitude of actual historical persons. Study of the frescoes has sometimes so involved itself with the problems of identifying the latter that broader aspects of meaning have been neglected. This has led some historians of style to dismiss the iconographical approach altogether: 'When Raphael wanted to make his meaning unmistakable he employed inscriptions, but this happens only rarely and there are even important figures, protagonists of the compositions, for which no explanations are given, since Raphael's own contemporaries did not feel the need for them. The all-important thing was the artistic motive which expressed a physical and spiritual state, and the name of the person was a matter of indifference.'[68] Let us see where Raphael's inscriptions lead us.

On the ceiling are four painted medallions, one above each wall. Each contains an allegorical female figure personifying a branch of knowledge. On each wall below are people from history and myth who are her typical representatives. The personification of Theology presides over a great panorama of sacred figures known as the Disputà; below Philosophy is the School of Athens where Plato and Aristotle occupy the centre of the stage. Below Poetry are Apollo and the Muses on Parnassus, surrounded by writers ancient and modern. Below Justice are two historical scenes of the promulgation of law.

Raphael leaves us in no doubt about the identity of the figures in the medallions as they are accompanied by putti holding inscribed tablets. 'Knowledge of things divine' is Theology, and 'Knowledge of things through their highest causes' is Philosophy who holds two books entitled *Natural* and *Moral*. They are the philosophical systems represented by Plato and Aristotle below, who also hold books. Plato's is the *Timaeus* (which deals with the divine origin of the universe) and Aristotle's is inscribed *Ethics*. Returning to the ceiling, we have Poetry, crowned with laurel and holding a lyre. She is 'Inspired by the divine will,' that ancient and mysterious power, or *numen*, which possessed the Muses. Justice, with her regular attributes of sword and scales, is 'The law that assigns to each his due.'[69]

Raphael's way of presentation was not new. Perugino had produced something like it in the hall of the bankers' guild, the Cambio, at Perugia. He depicted the four Cardinal Virtues, Prudence, Justice, Fortitude and Temperance enthroned in the clouds and, below them, their earthly representatives, twelve famous men of ancient Greece and Rome. Raphael was a pupil of Perugino when this work was carried out and would have

been familiar with it, even if he did not take a hand. But the idea was older still than that. In the Spanish Chapel (p.211), Andrea da Firenze had depicted the personified Arts and Sciences each accompanied by an historical exemplar, and a similar series of figures can be seen in the plan of Giotto's campanile (p. 196). This is not to suggest that Raphael in the Vatican Stanza had simply produced another version of the medieval *Summa*, a synopsis of knowledge seen through the eyes of Christian belief. Though he shows us the sacred and profane worlds side by side, each now exists in its own right and has its own self-sufficient values. This was the fundamental change that humanists from Petrarch onwards had made to the medieval view of the universe.

The decoration of a ceiling often brings together and unifies the different elements of a pictorial programme and the Stanza della Segnatura is no exception. But whereas a Byzantine church, say, or Agostino Chigi's chapel (for which Raphael designed the decoration) shows the Almighty, the highest and most supreme, surveying all, in the vault of the unconsecrated Vatican stanza, Theology is given no more prominence than her three companions. Balance and harmony prevail. The same can be said about the compositions on the walls.

The Disputà (the realm of Theology) is formally organized into two semicircular zones, one above the other. Each has a central devotional image with figures to the left and right forming a continuous arc. In the upper, heavenly zone is the Trinity and on either side are the founders of the Christian Church, terminating at either end with Saints Peter and Paul. They represent its two branches, Jewish and Gentile, or 'Ecclesia ex circumcisione' and 'Ecclesia ex gentibus.' The earthly zone, below, is ranged about the Eucharist and includes many writers. The Latin Fathers are nearest the centre and beyond them other Doctors of the Church mingle with Christian apologists, among them Dante. The movement flows towards the centre. At the extremities, on each side, an anonymous lay figure leans on a parapet, turning his back on the Doctors. It has been suggested that they symbolize two enemies of the Church, heresy and what is sometimes known as indifferentism, the view that differences of doctrine were unimportant. Both seem half-prepared to listen to persuasion though Heresy raps his book impatiently to support his argument [7.23].

On the wall opposite the Disputà is the fresco that has become known as the School of Athens. Here there is a similar balance in the treatment of composition and ideas. In the centre Plato points to the heavens and Aristotle towards the earth. They are at the apex of a half-circle of figures which includes many of the leaders of Greek philosophy beginning, on the left, with Pythagoras. The two onlookers at the edge of the group on the far right are, according to Vasari, in the likeness of Raphael and Perugino.

The same symmetry of ideas occurs in the scenes on the end wall below the

7.23 Detail of the Disputà, lower zone, left. The figure with a book on the left probably represents Heresy. Right, background, in a papal tiara is Gregory the Great and next to him, seated, Jerome, two of the four Latin Fathers. Raphael, 1508–11. Stanza della Segnatura, Vatican.

figure of Justice where two lawmakers, one civil and one ecclesiastical, are depicted. The Emperor Justinian hands over a book containing his digest of Roman jurisprudence, the Pandects; next to him Pope Gregory IX (portrayed in the likeness of Raphael's patron, Julius II) gives a volume of his collection of papal decrees, the Decretals, to a kneeling prelate. In the lunette over the window are the figures of Fortitude, Prudence and Temperance who, with Justice, comprise the four Cardinal Virtues.

In the Parnassus the grouping is more informal. Poets of ancient Greece and Rome mingle with writers of more recent times and of Raphael's own day. In the centre Apollo, surrounded by the Muses, plays a viol.[70] Dante appears for a second time, not far from his other self in the adjoining Disputà. He is the only person, so far as one can be sure, who appears twice among the many who throng the four walls. Raphael seems to be using him to bridge the two worlds of sacred and profane, showing him once in the company of Apollo and once as a witness to the divine vision granted to Christian believers. Above Dante, in the corner of the ceiling, is a mythical scene which is perhaps meant to form a link between his two selves. This is the Flaying of Marsyas, Apollo's punishment of the satyr after defeating him in a musical contest. In the first canto of the Paradiso Dante invokes Apollo's aid for his final task ahead which is to depict in words the beatific vision:

7.24 The Flaying of Marsyas.
On the left, Apollo with his lyre
is crowned with laurel. Raphael,
1508–11. Stanza della Segnatura,
Vatican.

> Breathe in me, breathe, and from my bosom drive
> Music like thine, when thou didst long ago
> The limbs of Marsyas from their scabbard rive.[71]

Dante makes the flaying a metaphor for the birth of poetic inspiration and it
could well be that Raphael was alluding, in his portrayal of the myth, to this
passage which brings together classical ideal and Christian belief [7.24].

Decorum, sacred and secular

By the sixteenth century artists had long since ceased to be wholly dependent
on the Church for their livelihood. Moreover, in Italy at least, personal
patronage had replaced the guild as a source of commissions. This new
freedom was one aspect of the artist's improved position in society, which
also often led to creatively fruitful friendships with men of letters, as in the
case of Raphael and Castiglione. Around the middle of the century two new
influences began to make themselves felt from very different quarters. The
Church once more started to dictate strict rules as to the form and content of
pictures, much as the Dominicans had done in the fourteenth century in their
fight against heretics, only this time art was being enlisted to help combat the
Protestant Reformation (see Chap. 8). The scope of the new decrees, as
defined by the Council of Trent (1545–63), was limited to ensuring that
religious images in churches were free from error and impropriety and did not
become the objects of idolatrous behaviour. The final arbiter in such matters
was the bishop. The Bishop of Bologna, Cardinal Paleotti, following these

broad guidelines, embarked on a five-volume work of amplification which extended far beyond sacred art. It included the almost total condemnation of mythological subjects which were to be allowed only to the scholar in the privacy of his study.[72] Paleotti, however, failed to deter his fellow prelates, some of whom commissioned ambitious programmes using pagan themes, as we shall see.

Side by side with this renewed activity by orthodox churchmen there began to appear from the mid-1500s a number of treatises on art theory by men of more independent outlook. Their values were aesthetic rather than ethical and therefore tended to cut across the boundary of religious and secular art. They had much to say on the subject of decorum in art in all its aspects. Their starting point was Horace's *Art of Poetry* which begins: 'If an artist chose to join a human head to a horse's neck and to cover with many-hued feathers limbs assembled in one from all over the place ... could you, my friends, refrain from bursting out laughing?'[73] Horace's lightly-expressed warning to poets to avoid incongruity when delineating character seemed to be just as applicable to artists. Alberti, in *De Pictura*, had stressed that every part of a body must be appropriate to the person portrayed: the hands of Helen or Iphigenia must not be old and gnarled nor the legs of Ganymede like a porter's. Leonardo, too, advised painters to 'observe decorum, that is to say, the suitability of action, dress, setting and circumstances to the dignity or lowliness of the things which you wish to present. Let a king be dignified in his beard, his mien and his dress; let the place be rich, and let the attendants stand with reverence and admiration, in clothes worthy of and appropriate to the dignity of a royal court.'[74] In the second half of the sixteenth century the theory began to acquire moral overtones. A work lacked decorum if it was wanting in decency or, if a sacred subject, was treated irreverently. Nudity for its own sake was disapproved of in religious art. Michelangelo was accused of just such impropriety in his highly personal vision of the Last Judgement in the Sistine Chapel (completed 1541) though his accusers' motives were sometimes suspect. The flamboyant Pietro Aretino, an art collector and outspoken critic who held a personal grudge against the painter, wrote to him pretending to be shocked and imploring him to restore the work to good repute by 'turning the indecent parts of the damned to flames and those of the blessed to sunbeams; or imitate the modesty of Florence who hides your David's shame beneath some gilded leaves.'[75] In the face of continuing objections of a similar kind Pope Pius IV had Daniele da Volterra paint draperies over some of the figures, earning him the nickname *Il braghettone*, the breeches-maker.

A leading art theorist in the later 1500s was Giovanni Paolo Lomazzo (1538–1600) whose writings continued to be read until the nineteenth century. His two major works provide a survey of the principles underlying

the artistic style of his day, together with a practical course of instruction for artists.[76] Art should no longer model itself directly on nature as it had in the early Renaissance but on the works of the great masters of the recent past. Beauty was first and foremost a concept in the artist's mind, which he ultimately received from God. This echoed the Neoplatonist thinking of Michelangelo, the man whom, above all, artists of the later sixteenth century sought to emulate. Lomazzo's *Treatise on the Art of Painting* (1584) was a comprehensive handbook for training artists to acquire a good manner. The term *maniera*, much used by art theorists of Lomazzo's day, denoted not just 'style' but the accumulation of skills which were exemplifed by artists such as Leonardo, Raphael and Michelangelo, and which had not been discovered until then. The word Mannerist was thus originally applied to artists who set out to imitate the style of those masters.

The last of the seven parts of Lomazzo's *Treatise* deals with iconography. The author, who had been a painter, not a theologian, was far from objecting to the use of the myths. He provides artists with a wealth of detailed information on the attributes and other distinguishing characteristics of sacred and profane figures, especially the latter. Among his sources he acknowledges Cartari's *Imagini*, in spite of its strangely bedecked divinities.

Decorum for Lomazzo meant also the choice of appropriate themes according to the place they were to occupy.[77] In royal palaces and the houses of princes should be depicted famous captains of the past, their battles and triumphs: Scipio against Hannibal, Greeks against Trojans and so on. In tombs and cemeteries and 'other melancholy and funereal places' scenes of death are naturally fitting: the Dormition of the Virgin, Lazarus surrounded by the weeping women, or the deaths of Old Testament patriarchs and others. The decoration of fountains should allude to water: Diana and her nymphs bathing, Narcissus gazing into the pool, Pegasus causing the Castalian spring to flow, or, 'to satisfy devout persons,' Christ walking upon the water, the calling of Peter and Andrew or the changing of water into wine. Gardens required outdoor themes, but only joyful ones: not Mercury lulling the shepherd Argus to sleep (before killing him) but the race of Atalanta and Hippomenes, Meleager's hunt, the banquet of the gods and so on. A bedchamber was the place for love scenes though decorum shuns the coupling of youth with age, so the rape of Proserpine by Pluto was to be avoided; more appropriate were Mars and Venus, Zephyr and Flora and so on.

Lomazzo ignores some long-established principles. Religious themes are chosen not for their symbolism or any typological relationship but simply for aptness to their setting in conformity with the rules of decorum. A scheme of decoration such as the Gothic reliefs on the Great Fountain at Perugia (p. 200) would have been quite foreign to his thinking. Nor is allegory to be read into the myths; for Lomazzo they are no more than fables as told by

Ovid or Homer. Prometheus stealing fire from heaven, Hercules on the Pyre, the Hebrews in the fiery furnace or Moses before the burning bush, sacred or profane no matter, all are equally serviceable when it comes to decorating the chimneypiece of a great hall.

The decoration of the Farnese palaces

Rooms where Pope and cardinals meet to conduct their business should have decorations of the kind we see in the Stanza della Segnatura, says Lomazzo, but he is relatively silent about their private palaces and villas. Here the pagan gods came into their own. In view of their condemnation by Paleotti and, in general, the new spirit of reform in the Catholic Church, the presence of the gods in the homes of high dignitaries of the Church might have called for some explanation. Perhaps that is why they are so often cloaked in moral allegory.

Two notable examples of the myths used in this way can be seen in the houses of the Farnese family whose members included several cardinals and one Pope. It was Alessandro Farnese (1468–1549) who, as Pope Paul III, had called the Council of Trent. At the same time, like others of his family, he was a generous patron of artists. He gave great encouragement to Michelangelo during his work on the Last Judgement and was impatient for it to be finished. One of his grandsons, his namesake, Cardinal Alessandro (1520–89), commissioned elaborate decorations (begun in 1561) from Taddeo and Federico Zuccaro for his summer residence at Caprarola, north-west of Rome. They were mainly secular subjects, as were the later frescoes in the Farnese town house, the great palace in Rome itself.[78] The latter were planned by Odoardo Farnese (1573–1626), a great-nephew of Cardinal Alessandro, who received the hat while still in his teens. The main work was begun by Annibale Carracci soon after he entered the service of the young cardinal in 1595, assisted later by his brother Agostino.

In both palaces rooms are devoted to glorifying the Farnese family with scenes from the lives of ancestors who were statesmen and war leaders besides princes of the Church. Paul III is prominent in both. At Caprarola mythology begins on the ground floor with cycles of scenes representing the Four Seasons and the so-called Nurture of Jupiter. The infant god suckled a goat belonging to the nymph Amalthea and the animal's reward was to be crowned in heaven.[79] *Capra*, a goat, alludes to Caprarola, so this was a neat way of honouring the name. The decorations in the ground and first floor rooms, taken as a whole, illustrate the theme of the active and contemplative life, and were devised by humanists of the Farnese circle. The cardinal's study and bedroom are suitably contemplative, the former depicting Solitude, the latter Night and Sleep, a more decorous theme for a churchman than the active loves of the gods recommended by Lomazzo. Both programmes were drawn up by a scholarly secretary to the Farnese family,

Annibale Caro, and have been preserved in his letters. Solitude is to be shown, in its main outlines, as a contrast between Christianity and other religions and philosophies, the representatives of one coming out of the desert to preach, the others turning their backs on the people. The many individual pictures are to be allocated a descending order of size, the smallest depicting creatures that were supposed to be solitary by nature, among them 'a red/breasted robin, a bird so solitary that one reads that two of them can never be found in the same wood. I cannot find, however, what it looks like, therefore I leave it up to the painter to do it as he pleases.' Caro also admitted ignorance about the appearance of the Hyperboreans and Druids, solitary peoples whom the painter could clothe as he chose. It would surely be impossible to decipher Zuccaro's work without the help of Caro's letter. Who, having identified the figures of the Baptist, Saints Paul, Jerome, Francis and others grouped round Christ, would go on to recognize them as 'solitaries'?[80]

Caro's programme for the bedroom, the Stanza dell'Aurora, is the earlier of the two and is based on mythology.[81] It is concerned with night and dawn, and with sleep, dreams and death. The theme of night has a long history. The Greek poet Hesiod, writing at the end of the eighth century BC, describes the goddess Night holding her children in her arms, the awful brothers Sleep and Death.[82] Homer, too, alludes to them more than once. Pausanias, travelling in Greece in the second century AD, discovered the group. It was wrought in gold and ivory on a famous chest kept in the temple of Hera at Olympia, and was said to have been the one in which Cypselus, a seventh/century ruler of Corinth, was, like Moses, hidden as a baby.[83] The image made its way into funerary symbolism and is mentioned by Renaissance mythographers. Caro needed to look no further than Cartari's *Imagini* which quotes Pausanias (and in later editions provides an illustration [7.25]). But he made some additions of his own: 'Night... with black skin, mantle, hair and wings, the last open for flight. She should hold up her hands with a white baby in one for Sleep and a black one in the other, apparently asleep, for Death, because Night is called the mother of both.'

Zuccaro also depicts the House of Sleep, a myth told by Ovid [7.26].[84] The god of Sleep lies on a couch, around him his empty dreams. He has three sons, Morpheus (below), skilled in imitating human shapes, Icelos (right) who changed himself into beast, bird or serpent, and Phantasos (left) who could resemble earth, rock, water or trees. Caro uses a version from Cartari, adding his own details: the poppies in the god's left hand, the masks that Morpheus is making and the wings and twisted feet of the dreams 'to indicate their unstable and uncertain nature.'

In the Roman palace half a century later the gods depicted by the Carracci are resplendently nude, unlike those of the Zuccaro brothers at Caprarola or the Villa Giulia in Rome where they tend to be chastely draped. Yet the fact remains, this dazzling pageant of mythology was planned as a moral allegory

for a pious young cardinal, Odoardo Farnese. The decorative scheme on the
ceiling of the famous gallery at the back of the palace includes some twenty
love stories from the myths, crowned by the Triumph of Bacchus and
Ariadne. The pictures are 'framed' and supported by *ignudi* recalling
Michelangelo's Sistine ceiling; yet Annibale Carracci, in striving to
recapture the ideals of the High Renaissance, could in no way be called a
Mannerist. His robust handling of the human figure was far from the effete

7.25 Night and her children, Sleep and Death. Her hair is garlanded
with poppies and her dress covered with stars. The floating figure on the
left also personifies Sleep. From *Le imagini degli dei degli antichi*, by Vincenzo
Cartari, 1556.

7.26 The god of Sleep on his couch. Nearby are his
three sons. Above his head flit the figures of dreams.
Drawing by Taddeo Zuccaro for a fresco in the Villa
Farnese, Caprarola (begun 1561). Louvre.

style into which later Mannerism had lapsed. There is evidence from the
artist's sketches that the organization of the programme proceeded to some
extent in step with the work itself, and certainly no preliminary document is
known to exist. Possible literary advisers were Giovanni Battista Agucchi, a
friend of the Carracci and author of a treatise on painting, or the humanist
scholar Fulvio Orsini, the cardinal's librarian. The key to the programme is
to be found in the four corners of the ceiling in each of which is depicted a
pair of wrestling *erotes*, or Cupids. Pausanias saw just such an image carved
in relief in a gymnasium at Elis. He described the figures as 'Love' and 'Love
Reciprocated' fighting for possession of a palm-branch,[85] precisely the way
they are illustrated in Cartari and in one of the corners of the gallery [7.27].
But Renaissance humanists, influenced by Neoplatonist thinking,
interpreted the pair differently. One Cupid was the offspring of Heavenly
Venus, the other of her eathly twin, so the image now symbolized a contest
between Divine and Earthly Love. The four variations on this theme in the
gallery illustrate the progress of their struggle and the loves of the gods
depicted all around them are meant to typify one or the other category of
Love. The central picture of Bacchus and Ariadne, a mortal deified by a
god, draws all the elements together, showing the triumph of the divine

7.27 (*Above*) Love and Love Reciprocated, from Cartari. On the right, the victor quenches his torch. (*Right*) The contest of Divine and Earthly Love. Annibale Carracci, begun 1595. Gallery of the Farnese Palace, Rome.

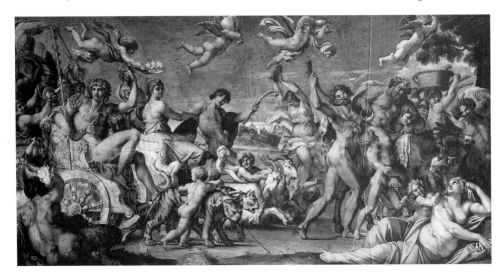

7.28 The Triumph of Bacchus and Ariadne. The procession is led by
drunken Silenus on an ass, borne along by Satyrs and Maenads. The
figure following with a shepherd's crook is, perhaps, Pan. The triumphal
cars are drawn by goats and tigers. Annibale Carracci, 1597–1600.
Gallery of the Farnese Palace, Rome.

[7.28]. But love had three aspects, divine, earthly and the third, abhorred by
the philosophers, that of physical passion, all of which were represented in
Titian's allegory (p. 262). All three seem to be recognizable in Annibale's
Triumph, too, in the figures of the god, the woman reclining on the right and
gazing heavenwards who is Earthly Venus and, opposite her, the satyr.[86]

Odoardo Farnese is honoured in the Roman palace not with the
customary narrative scenes but by means of classical legend. His study, a
room on the first floor known as the Camerino, decorated earlier than the
gallery, contains the Cardinal Virtues and various mythical heroes. A
medallion on the ceiling shows the cardinals's *impresa*, three purple irises with
the motto, in Greek, 'I grow with the help of God.'[87] Among the heroes
Hercules predominates. He had a variety of roles from the time when the
Roman Emperor Commodus was represented with his club and lion's skin.
In the Middle Ages noble families, especially French, would claim Hercules
as an ancestor, and the Church used him to symbolize the Christian virtue of
Fortitude.

In the Camerino this benefactor and righter of wrongs appears in a
number of scenes having a broadly virtuous theme. At their focus, in the
centre of the ceiling is the so-called Choice of Hercules, or Hercules at the
Crossroads [7.29]. It is not a myth but a moral fable from the fifth century BC

7.29 Hercules at the Crossroads. A copy in the Farnese Palace of the original, by Annibale Carracci (1595–7), now in the Pinacoteca Nazionale, Naples.

invented by a Greek sophist, Prodicus of Ceos, and related by more than one classical author.[88] The hero sits pondering between two female figures, each of whom urges him to follow her direction. Virtue points to a narrow, rocky path leading up to a plateau where Pegasus stands, the symbol of Fame. Vice invites him to a dark wood in which bunches of grapes are hanging. Beside her lie musical instruments and playing cards, the attributes of sin, and two masks that symbolize deceit. Beside Virtue, a poet with an open book in hand waits to record the hero's deeds. In the fable Hercules chooses the better way. Annibale's treatment of the subject became the model for later artists. It was often used as a vehicle for portraiture, to demonstrate the virtuous nature of a prince or an eldest son, though in the case of Odoardo no actual likeness has been attempted. An image of Pegasus on Parnassus, the home of the Muses, also appears on an *impresa* of Cardinal Alessandro so the picture's message may perhaps be read as an exhortation to the young Odoardo to follow the example of his illustrious great-uncle – not least in his patronage of the arts.[89]

SUMMARY

HUMANISM: The study of antiquity, both its literature and the remains of its monuments, produced a new attitude towards the ancient world. It was now recognized as having its own intrinsic values that were outside and independent of the Christian world-view. This was contrary to the Church's teaching from Augustine to Aquinas. The new approach began at the universities of Padua and Verona where teachers of classical studies became known as humanists. Antiquarianism, the study and collecting of ancient remains, was also pursued enthusiastically, both for its own sake and for the light that inscriptions could shed on the ancient world. There had been earlier classical revivals that affected the arts, notably at the court of the Holy Roman Emperor Frederick II (1194–1250). But when artists made use of classical models it was still mainly in the service of Christian subject-matter. The leader of the Italian humanist movement was Petrarch (1304–74) who received the poet's crown of laurels at Rome. Among his works that influenced the visual arts, were, in ascending order of importance, the poem *Africa*, for its descriptions of the Roman gods, *On Famous Men*, which produced a cycle of wall-paintings at Padua, and the *Triumphs*, which popularized the idea of allegorical triumphal processions that appear on Gothic tapestries and pervade Italian Renaissance painting.

THE MARRIAGE OF FORM AND CONTENT: At the beginning of the fifteenth century mythological paintings still depicted the gods and goddesses in present-day attire; the use of classical forms (as in Donatello's sculpture) was as yet mostly confined to sacred figures. The pagan divinities had just occasionally preserved their ancient lineaments in astronomical treatises where they represented the planets and constellations. The aim of painters in the first half of the fifteenth century was the imitation of nature, rather than the pursuit of classical ideals for their own sake. It was not until the second half of the century that painters and sculptors were caught up in the humanist movement. One influence was Alberti's *De Pictura* which encouraged artists to become men of letters themselves and to look for illustrative subject-matter in classical writers, especially in descriptions (*ekphrases*) of ancient works of art. The earliest expression of humanist ideas among artists is seen at Padua, in particular in the work of Mantegna who was there until 1460.

THE PRINCE, ARTISTS AND ASTROLOGERS: It was exceptional that the ruler of an Italian city state was a man of culture who patronized art for its own sake. Mostly they used artists to enhance their public and private reputations. A regular member of the prince's court was the astrologer who chose the timing of his master's actions. Astrology was almost universally held to be true and was not incompatible with Christian belief. Yet after a

successful venture it was to God or the Virgin that thanks were given, often in the form of a votive painting depicting the Virgin, saints and donor. Astrological cycles, featuring the pagan divinities are commonplace in private apartments and chapels in the Renaissance, the configuration of the heavenly bodies usually denoting the date of some event that was being commemorated. A person's birth date, represented in this way, as in Chigi's Villa Farnesina at Rome, indicates a belief in the horoscope, that is, that one's future destiny lay in the stars.

THE GREEK REVIVAL: Greek studies flourished in Italy, especially Florence, after the fall of Constantinople in 1453. Cosimo de' Medici set up a kind of academy whose leading light was the Platonist Marsilio Ficino. Ficino created an original philosophical system which combined late antique Neoplatonism with a rather watered down Christianity, and embraced the Greek myths and much else. He appears to have shared the view of the early Neoplatonists, though denied by Plato himself, that the artist was capable of apprehending Plato's realm of Ideal Forms and not merely their particular earthly manifestations. High Renaissance artists, Raphael and Michelangelo in particular, strove to realize those ideal forms in their art. According to the Florentine Neoplatonists the Greek myths were allegories concealing an ancient universal wisdom. Venus in particular occupied their attention. She stood for two aspects of love, corresponding to Plato's two realms, the eternal Ideal and the earthly manifestation. They appear side by side in a well known allegorical painting by Titian. Venus had already appeared, along with other mythological figures, in Botticelli's two famous allegories, which show signs of having been devised by someone with Neoplatonist leanings, possibly Ficino himself. Their meaning has not yet been entirely revealed. From now on the myths became popular subjects in painting and sculpture not only as allegory but to celebrate antiquity and show the artist's mastery of the nude figure. Contemporary humanist poets provided the themes, as did classical authors like Ovid. A type of allegory once familiar in religious sculpture reappeared in a new guise. The medieval contest of the virtues and vices now became a battle between Love and Chastity (Venus and Diana) or Love overcoming Strife (Venus and Mars), and so on. Venus and Mars were favourite subjects for portraying the Renaissance courtier soldier and his mistress.

THE RENAISSANCE LANGUAGE OF SYMBOLS: The Neoplatonists believed in the existence of an ancient, occult language of symbols. It gained strength through the discovery of a late antique manuscript, the *Hieroglyphica*, purporting to decipher Egyptian inscriptional writing in this sense. From the early sixteenth century there developed a fashionable craze for emblem books, rebuses and similar riddles. The *impresa*, the personal emblem with a motto,

having some private significance for its owner, was another use of symbol-language. During the sixteenth century a number of dictionaries of myths and symbols were published.

THE CHURCH AND HUMANISM: During the fifteenth century the papacy recovered its strength and influence after the return from Avignon. From mid-century it had become a wealthy patron of the arts, though the rebuilding of Rome was not done without cost to her ancient monuments which were sometimes used for building materials. The early sixteenth century was a short but brilliant age for artists in Rome, ending with the sack of the city in 1527. The artist himself had by now achieved personal recognition in society. Two outstanding works of this period were Michelangelo's ceiling frescoes in the Sistine Chapel and Raphael's decoration of the papal apartments of the Vatican, each of which combined a theological programme with classical-humanist features.

DECORUM IN ART: Treatises on art theory in the sixteenth century advised artists to attend to decorum, that is, the fitness of all the elements of a work to their purpose. Michelangelo was accused of lacking decorum by painting sacred figures in the nude. Lomazzo, painter and critic, regarded subject-matter as an aspect of decorum; for him, the fitness of a subject was a question of its location; hall, bedchamber, or cemetery, for each the correct choice of subject was determined by the principles of decorum. In the private residences of prelates, such as the Farnese palaces at Caprarola and Rome, the classical myths are prominently depicted. They reflect decorum (the House of Sleep in a bedchamber at Caprarola) or are intended as allegory (as in the Roman palace). The splendid nudity of the Carraccis' figures at Rome appears strikingly at odds with the prevailing spirit of the Counter-Reformation and the directives to artists which had been laid down by the Church.

The Counter-Reformation
and the Baroque Age

THE INTELLECTUAL FREEDOM of the Renaissance had meant that artists who served the Church were not bound by questions of strict dogma. It was an age when the individual was pre-eminent and sacred works reflected the sentiments of the artist or his adviser as much as any official doctrine prescribed by the Christian religion. Painting and sculpture conveyed a sense of the intimacy of human relations, in devotional images no less than in narrative scenes. The godhead was represented not as a remote impersonal divinity but as a human being, one of a family, always cherished by a loving mother whether in infancy or in death. Scenes from the life of Christ were depicted with down-to-earth realism as in Tintoretto's great cycle in the Scuola di San Rocco at Venice. A more formal type of devotional subject was the so-called Sacra Conversazione, or Holy Conversation which evolved in the second half of the fifteenth century. Mantegna's Madonna of Victories [7.11] was an early example. It became popular in High Renaissance art especially among Venetian painters, one more testimony to the undiminished fervour with which the Virgin was regarded.

The Sacra Conversazione followed the pattern of Gothic altarpieces, only now the separate compartments disappeared and the figures formerly within them were united with the central image in a single composition. The Virgin is usually enthroned, holding the Infant, with saints in attendance on both sides. The latter generally include the patron of the city, church, monastic Order or other body which commissioned the work. The personal tutelary saint of the donor may be seen presenting his kneeling charge – who will often be his namesake – to the Virgin. Votive paintings, as we saw, may include the warrior saints, the guardians of men in battle, or the ones who ward off disease. In the sixteenth century an aura of magic still surrounded much religious art, as it had done since very early times. Pictures of the Virgin in particular were believed to have miraculous properties. A panel painting of the Madonna in the church at Impruneta, not far from Florence, was regarded as a kind of Palladium. The diarist Luca Landucci, writing between 1450 and 1516, tells how the Florentine authorities on many

8.1 Religious sculpture with an underlying paganism. (*Left*) The
Virgin and Child, and (*centre* and *right*) angels. Donatello, 1445–50.
From the former high altar of Sant'Antonio, Padua. (Not in proportion.)

occasions had the picture brought into the city with great ceremony, when its
powers were invoked against drought, flood, or outbreaks of disease.[1]

Religious art and the antique

There was bound to be a profane element in the Renaissance treatment of the
traditional sacred themes. The influence of antiquity can be seen in the use of
classical forms and, more clearly, by the introduction of classical motifs. It
was present from the first in much of Donatello's work, besides his celebrated
rendering of David. The series of bronze reliefs and free-standing sculptures
made for the altar of Sant'Antonio, Padua, also reveal this aspect of his
genius. In the centre is the Madonna and Child [8.1] flanked on either side
by saints. The latter are depicted with a naturalism that seems to be in
deliberate contrast to the figure of the Virgin who is proportionately larger,

befitting her greater sanctity. She stands in a solemn, hieratic attitude, apparently derived from a Byzantine type. At the same time a feeling of archaism is conveyed by other features: the sphinxes which form the sides of her throne, the curiously shaped crown, and the classically-parted hair. They recall antique sculptures of another mother goddess, the pagan Cybele, whose cult was introduced into Rome in 204 BC.[2] Donatello's reliefs of pipe-playing angels on the same altar are likewise derived from classical reliefs of the followers of Bacchus and are strongly suggestive of pagan antiquity [8.1].

It was the fate of the Mother of God in particular to become involved with Renaissance paganism in poetry as well as in art. In 1526 the humanist poet Jacopo Sannazaro (1458–1530) published a long work in three books entitled De Partu Virginis, 'The Virgin Birth', which related, in Latin hexameters closely modelled on Virgil, the story of Christ's Nativity. In it the biblical narrative is interwoven with figures and episodes from classical mythology. Other poets compared Mary to Diana, the virgin goddess of the Romans, while in painting, the Madonna sometimes had an unmistakable likeness to Venus. The Mannerist painter Parmigianino who habitually introduced antique motifs into his religious pictures painted about 1530 a Virgin and Child so ambiguous that it was believed at the time to have been originally conceived as a Venus and Cupid [8.2]. The pose of the Virgin is yet another rendering of the often-repeated classical type of the Medici Venus [7.9], while her barely-concealed nudity and the treatment of the Child strike a clearly-intended note of pagan sensuality. The red rose held by the Christ-Cupid was always a symbol of Venus no less than the Virgin Mary.

Parmigianino's Madonna of the Rose was acquired by Pope Clement VII (1523–34), one of the Medici family and a noted patron of scholars and artists. It was he who, shortly before his death, proposed to Michelangelo the idea of a Last Judgement for the Sistine Chapel. This work, so different in feeling from the ceiling frescoes of the Creation painted some thirty years earlier, reflects the spiritual crisis which the artist underwent in his old age. His nude figures no longer express the humanist concept of ideal Beauty, but a profound and tragic pessimism. Christ the Judge threatens the damned with a gesture reminiscent of Traini's Judge in the Camposanto at Pisa [6.11], which Michelangelo would have known. But equally he reminds us of an avenging Jupiter casting his thunderbolts – Dante after all had compared Christ to 'almighty Jove.'[3] Dante's influence can be seen too in the pagan images of hell, such as Charon, the ferryman, and Minos, the judge of the underworld girded with his serpent's tail.

When it was unveiled in 1541 the work aroused extremes of admiration and condemnation. By now the new current of reform was flowing strongly through the Church of Rome: one group of cardinals immediately protested that it was improper to decorate the house of God with nude figures, that the

8.2 The Madonna of the Rose, or perhaps Venus and
Cupid. Parmigianino, *c.* 1530. Dresden Gallery.

person of Christ was wanting in majesty, was too youthful and lacked the
customary beard. Aretino's accusations four years later, though falsely based,
echoed what was becoming the dominant opinion. The subsequent
alterations carried out by Daniele da Volterra, the 'breeches-maker', were
only the first of a number of such tamperings.[4] From now on the mood of
austerity in Church affairs, fostered by the rise of Protestantism in the north,
made itself felt increasingly in religious art.

PROTESTANT AND CATHOLIC REFORMS

The Protestant reformers and art

The movement towards religious reform which spread through northern
Europe from the 1520s was not the first to come to grips with the problem of

abuses within the Church. It was, however, the first to have such far-reaching consequences, not least in its impact on religious art in the north and, indirectly, in Italy. The reformers aimed their attacks not only at the widespread corruption among the priesthood but towards certain aspects of the Church's teaching which they regarded as false. One of the factors that helped bring about this new attitude was the spread of Italian humanism to the countries beyond the Alps.

Humanist study of Greek and Latin texts was by no means confined to pagan authors. The northern humanists, among whom Erasmus of Rotterdam (c. 1469–1536) was the most eminent, applied themselves to early Christian literature, making critical revaluations of the Greek New Testament and the writings of the Church Fathers. They explicitly rejected the theology of the medieval schoolmen which they saw as distorting the sources of Christian knowledge.[5] Their work helped to foster a change of religious outlook in the Low Countries and Germany. There was now a growing conviction that the individual might receive God's grace and achieve a higher degree of spirituality without the mediation of a priest or the sacraments. Christian humanists in the north thus played a part in forming the attitudes that gave birth to the Reformation.

One of the reformers' principal targets was what they saw as the growth of idolatry in Christian worship. Their attacks, in sermons and pamphlets, aroused the more fanatical of their followers to the wholesale destruction of religious images which in many communities was as severe as the iconoclasm suffered in the Byzantine Empire in the eighth century. The leaders of the Reformation in fact took a rather more tolerant view. Luther (1483–1546) approved the painting of biblical scenes on the walls of churches and private mansions. The law of Moses, he observed, forbade only the image of God – though he allowed the crucifix. The French reformer John Calvin (1504–64) was more thorough-going, yet even he conceded 'I am not so scrupulous as to think that no images ought ever to be permitted,' since art was one of God's gifts to man. It must be kept out of churches, though, for fear of idolatry. Moreover 'men should not paint nor carve anything except such as can be seen with the eye, so that God's majesty which is too exalted for human sight may not be corrupted by fantasies which have no true agreement therewith.'[6]

Idolatry meant much more to the reformers than just the adoration of images. For Calvin it included, besides the making of images of God, the veneration accorded to the Virgin and saints especially in their role as intercessors, and hence painting and sculpture associated with them were likewise condemned. He objected to the celebration of Mass because it 'substituted for God an execrable idol', and he devoted a treatise to ridiculing the cult of holy relics. Luther's approach had been different. He set out to question rather than challenge the traditional teaching of the Church yet his

basic doctrine of 'justification by faith' struck at its very roots as much as the later onslaughts of Calvin. According to Luther, faith alone was needed to obtain God's mercy and for this one had only to turn to the Bible. If faith were sufficient to acquit man from punishment for his sins then the regular means of obtaining forgiveness and grace – penance of various kinds, good works, the sacrament of the eucharist – were of only secondary importance.

It was in response to challenges of this kind against her fundamental doctrines that the Church of Rome, seeking every possible means of asserting her spiritual authority, eventually turned to artists. After the lapse of half a century or more, towards the end of the sixteenth century, religious art in Catholic countries began to lay emphasis on those very subjects that upheld the disputed dogmas, and new ones were invented for the same purpose. Thus we shall find the Virgin glorified anew, especially as the Immaculate Conception; the honouring of modern saints such as Charles Borromeo (1538–84) who were noted for their charitable works; and themes such as the Last Communion of a saint or the Triumph of the Eucharist (depicting the chalice and wafer or a monstrance borne on a triumphal car), which proclaimed the doctrine of transubstantiation. And, as we shall see, the reason for the appearance of the theme of Purgatory, in its various versions, in Counter-Reformation art can be traced back to the day in 1517 when Luther posted his ninety-five theses on the door of Wittenberg church.

The reform of the Catholic Church

The movement for reform which was under way in the Church of Rome in the first half of the sixteenth century was only partly a reaction against the rise of Protestantism. It was also a rejection of much that the Renaissance stood for. The reformist Popes, unlike their more worldly predecessors, regarded humanism as a threat to the Church's teaching on spiritual matters, while her political influence seemed to be challenged by ideas such as Machiavelli's which taught secular princes how to seize and hold on to power. *The Prince* was one of the first works to be placed on the new Index of prohibited books, in 1559. The papacy's efforts to overcome the all-too-prevalent moral failings of the clergy recall the attempts of Savonarola to reform the Florentines of his day. The kind of books and paintings that the Dominican preacher had denounced as an 'incitement to sin' were still blamed as a cause of corruption. Much Renaissance poetry, especially the more erotic, was now either banned or bowdlerized, and even the greatest names were not immune. A 'spiritualized Petrarch' was published in 1536 and Ariosto's romantic epic *Orlando Furioso* reappeared in 1589 in a version 'transported into spiritual argument'.[7] Religious art in the second half of the century was subjected to a similar process of purging.

The main objectives of the Catholic Reformation were to reassert traditional theology, defending it from whatever quarter it was threatened,

Protestant or humanist, and to create a revitalized and disciplined priesthood to carry this out. Even before official policy was formulated, laymen and clergy had begun spontaneously to dedicate themselves by teaching and example to the cure of abuses within the Church. New, idealistic religious Orders sprang up in Italy from the 1520s and quickly received papal approval. As they grew in strength and influence one in particular became identified with the aims of the Church and turned into a powerful instrument for propagating them. This was the Jesuit Order, founded in 1534 by Ignatius of Loyola (1491 or 1495–1556). By the seventeenth century the new Orders, in particular the Jesuits and the Oratorians, were acquiring patrons who had the resources to build churches and commission artists to decorate them. The Oratorians were a congregation formed in 1575 by Philip Neri (1515–95) who loved music and painting. Oratorian services were noted for their singing (hence 'oratorio') and their churches contain some of the most lavish decoration of the Baroque age. Both Ignatius and Philip Neri were canonized soon after their deaths and feature in the art of their Orders.

The first Pope to tackle reform within the Church was Paul III, Alessandro Farnese (reigned 1534–49). There were two sides to his character. Having had a humanist education he was a Renaissance man at heart and was the lifelong friend and patron of artists, poets and other men of letters. At the same time, on becoming Pope, he encouraged the new Orders, revived the Inquisition and managed, in spite of opposition, to set up the Church Council which first met at Trent in 1545. His efforts to restore the authority of Rome in the churches of northern Europe were less successful. A papal bull published in 1538 against Henry VIII of England, listing his offences against the papacy, had no effect. A painting by Taddeo Zuccaro of the king kneeling penitently before Paul III represents a purely imaginary situation, symbolic only in meaning [8.3]. The little scene in the background, across the water, of the beheading by the English of a group of figures in religious habits was, however, certainly based on fact. Vasari incorrectly calls the picture the Excommunication of Henry VIII. While it served its purpose as part of a cycle of paintings honouring the Farnese Pope, excommunication had already been pronounced a few years earlier by Clement VII.

The sternly anti-Protestant Paul IV (1555–9), though also a classical scholar, was less in sympathy with Renaissance ideals. He surveyed critically the religious art in churches and had much removed that he regarded as unsuitable. A medal was struck for him depicting Christ cleansing the Temple, in reference to this activity. Nor did Rome's ancient remains escape the attentions of more zealous Popes. Antique statuary, especially the nude, was removed and sometimes destroyed. Part of the Vatican's collection of classical sculpture that had been put together at such a cost by Renaissance

8.3 The 'Excommunication' of Henry VIII by Pope Paul III. Taddeo
Zuccaro, 1561. Villa Farnese, Caprarola.

Popes was given away by Pius V (1566–72) who thought it unfitting for a
papal residence. It was set up again on the Capitol by the grateful civic
authorities of Rome. Pius V also emptied the villas of earlier Popes of many
of their pagan treasures which were eagerly acquired by princes and nobles in
Italy and abroad.[8] Sixtus V (1585–90), though a patron of artists and
scholars, had little respect for Rome's antiquities and is remembered for,
among other things, having the columns of Trajan and Marcus Aurelius
crowned with the figures of St Peter and St Paul.

The Council of Trent and its influence on art

The Council of Trent, which met on and off for nearly twenty years from
1545, reaffirmed the basic doctrines that were under attack from Protestants
and laid down broad guidelines for sacred art. On theological matters it
declared that Tradition had the same validity as Scripture. Tradition, in the
ecclesiastical sense, was the accumulation of religious truths that had been
received from sources other than the Bible. In other words, a blow was struck
against Luther's doctrine of the sufficiency of the Bible in matters of faith. At
the same time this had the effect of giving official sanction to the varied
iconography of the Virgin, little of which is derived from the gospels. The
Council confirmed that there were seven sacraments and that all were
necessary for salvation, thereby providing another source of themes for art in
the future. Its declaration concerning images, made at the final session in
1563, was carefully framed to prevent any accusation of idolatry. They were

to be given 'due honour and veneration', not however that 'any divinity or virtue is believed to be in them ... or that something is to be asked of them, or that trust is to be placed in images as was done of old by the Gentiles.' Honour shown to images referred only to the 'prototypes which they represent'. Images were also for instruction in the faith and must therefore be doctrinally correct. Superstitious elements must be removed, lasciviousness or any other indecorousness avoided. 'Nothing new, nor anything that has not hitherto been in use in the Church' was to be allowed without the local bishop or, as a last resort, the Pope himself being consulted.[9]

Statements of this kind, defining the proper use of images in religion, had already been made in a number of treatises by Catholic reformers which began appearing in the two decades before the Council's declaration. The next half century saw a spate of books which set out to interpret the Council's broad guidelines. Some went into great detail in instructing artists on the correct choice of subject-matter and the way it should be represented.[10] Their purpose was to ensure that religious art was free from idolatry and superstition and therefore safe from Protestant criticism. There was, for a start, a great weeding-out of old themes if their origin was suspect. A Flemish ecclesiastic, John Ver Meulen, in a book published in 1570 that had a wide influence throughout Catholic Europe, declared that the *Golden Legend* was a legend of lead.[11] He also condemned the early non-canonical texts, the so-called apocryphal gospels, which contained the stories of the infancy and childhood of the Virgin. In practice, however, a distinction seems to have been made between the popular fictions invented by medieval monks, of the kind found in the *Golden Legend*, and the much more ancient non-biblical sources that had become, in effect, part of the Tradition of the Church. Thus saints like Wilgefortis (p. 172) and the giant Christopher and subjects such as St Nicholas rescuing the children from the pickling tub were no longer represented, or only rarely. On the other hand the stories from the New Testament Apocrypha like Joachim and Anne and the Education of the Virgin in the Temple continued to appear. Even so, the iconography of the Virgin was affected by this negative, destructive attitude to the reform of sacred art. The Madonna of Mercy [6.14], derided by Luther because it reminded him of a hen with her chicks, fell out of favour as did the various allegories of the Virgin with the unicorn which had been specially popular with artists of northern Europe. The general proscribing of unnecessary nudity brought an end to one of the most ancient of all images of the Virgin and Child, the *Virgo Lactans*, depicting the mother suckling her Infant. The price paid for this drastic reappraisal was the disappearance of some of the most appealing features of Christian iconography.

Cardinal Paleotti, in his treatise of 1584 (p. 284), repeated the objections of the Council of Trent to anything profane, superstitious or immodest, or that savoured of innovation. Like Ver Meulen he condemned the custom,

widespread in the Renaissance, of introducing portraits of the living into the features of sacred persons. Like Pope Paul IV he demanded that pictures in churches be inspected and if offensive to be retouched, altered, or, as a last resort, removed. The importance of fidelity to textual sources was often mentioned by reformers, meaning that artists must not introduce irrelevant and superfluous detail simply for the sake of embellishment. The Inquisition, revived by Pope Paul III in 1542 to deal with Protestant heresy, concerned itself on one famous occasion with this aspect of religious art. In 1573 Paolo Veronese was called before the tribunal of the Holy Office in Venice to explain his treatment of a picture painted for the convent of SS Giovanni e Paolo in that city. According to the account of the hearing, which has fortunately been preserved, Veronese entitled the work 'The Last Supper that Jesus Christ took with his apostles in the house of Simon'. This incidentally was a confusion in the artist's mind of two quite separate biblical events which, strangely, the judges appeared not to notice.[12] Their complaint concerned the accessories introduced by the painter. The picture was one of several large-scale canvases by Veronese, done in his customary grand manner, depicting various gospel episodes of Christ at table. It shows the Saviour sitting down with the disciples to a great Venetian banquet under a palatial portico with servants and others in attendance. Questioned about the figures Veronese said, 'There is the owner of the inn, Simon; besides this figure I have made a steward who, I imagined, had come there for his own pleasure to see how the things were going at the table. There are many figures there which I cannot recall, as I painted the picture some time ago.' He was asked to explain the presence of a servant with a bleeding nose, armed men dressed in the German fashion holding halberds, and a buffoon with a parrot on his wrist. In reply Veronese claimed the right of an artist to decorate and enrich a picture as he saw fit. But he was not allowed to evade the doctrinal issue. 'Do you not know,' his judges asked, 'that in Germany and in other places infected with heresy it is customary with various pictures full of scurrilousness and similar inventions to mock, vituperate and scorn the things of the Holy Catholic Church in order to teach bad doctrines to foolish and ignorant people?' Veronese was finally forced to admit his errors and ordered to make certain alterations. In the event, all he changed was the title of the picture to 'The Feast in the House of Levi', which was the occasion when Christ and the disciples sat down with tax-gatherers and sinners.[13] This apparently satisfied the tribunal. Their leniency, and indeed the whole tenor of Veronese's answers at the trial, illustrate how Venetian artists remained comparatively free to continue in their own essentially Renaissance manner during the repressive phase of the Counter-Reformation following the Council of Trent. The Venetian authorities in fact retained the right to veto the sentence of the Inquisition whenever it concerned their own citizens.[14]

ART AS PROPAGANDA

Towards the end of the sixteenth century the restrictions and austerities that had hitherto set the tone of the Catholic Reformation began to relax. They were replaced by a more positive, confident outlook and also a growing mood of religious fervour. There were several reasons for this change. The threat of heresy was receding. Many of the formerly Protestant areas of Europe had been won back to Rome thanks to the labours of men like the Jesuit Peter Canisius (1521–97). It was increasingly recognized that richness and splendour in church services gave them an emotional appeal that was missing from Protestant forms of worship. The new Orders were awakening a spirit of revivalism. At the Oratory of Philip Neri priests and laymen were given to delivering spontaneous utterances during the service and it became one of the most popular religious congregations in Rome. The personal influence of Ignatius of Loyola continued after his death through his widely-used devotional book, the *Spiritual Exercises*. It was a course of moral instruction and meditation which led a person to feel and, as it were, relive through all his faculties and senses the sufferings of sinners in hell, the Passion of Christ and his Resurrection and the glory of his Ascension. A climate of emotionalism and spiritual ecstasy was being generated which would translate itself in the seventeenth century into a triumphant religious imagery, all the more understandable since many artists were themselves members of the Orders. Christian art was reverting to its original function of serving the Church, and Renaissance theories of ideal Beauty were being replaced by rules of religious decorum. The last revolution of sacred art took place in the Baroque age and thereafter Christian iconography in Catholic Europe settled into a stereotyped mould.

New churches: their design and decoration

This second, positive phase of the Counter-Reformation aimed at glorifying the Catholic Church and expressed itself in a new style of ecclesiastical architecture as well as in painting and sculpture. An early lead had been given about 1572 in a book by Charles Borromeo (1538–84), the Archbishop of Milan, on the design and furnishing of churches.[15] Borromeo had been an active member of the Council of Trent and had introduced thorough-going and often unpopular reforms among his own clergy. He gave his wealth to the poor and worked tirelessly among the sick of Milan during the plague of 1576. He was canonized in 1610 and is very widely represented in Italian seventeenth-century painting. Like other writers of the time, Borromeo recommended that church buildings should revert to the cruciform plan that had been the custom in the medieval West. He rejected plans based on the circle. In the Renaissance the circle and the sphere had been favoured because they were classical forms and, equally,

because they reflected the shape of the cosmos and hence the mind of the Creator. To Borromeo the circle smacked of paganism while the cross symbolized Christ's redemptive act. He wanted the high altar set in a spacious area and approached by steps in order to add dignity to the ritual. For the same reason the priest's vestments should be sumptuous to the eye. Windows should be of clear glass so that nothing taking place within the church was obscured.[16]

Some of Borromeo's ideas were probably inspired by the design of the Gesù, the mother church of the Jesuits in Rome. The building was begun in 1568, thanks to the munificence of Cardinal Alessandro Farnese, the grandson of Pope Paul III. The architect was Giacomo Vignola who was also responsible for the Farnese residence at Caprarola. The church is cross-shaped and has a wide nave with side-chapels in place of aisles. Above the crossing is a cupola on pendentives. The high altar stands in a wide apse and there is an imposing altar at the end of each transept, a feature recommended by Borromeo. The altar in the north transept forms the tomb of St Ignatius. The Gesù became the model for many Catholic churches over the next century and a half, not only Jesuit: the first church of the Theatine Order, S. Andrea della Valle, begun in 1591, follows a similar plan. This vast, ornate edifice was erected for a body that was remarkable for its rigorously ascetic way of life.

The decoration of the Gesù came to a halt before it had hardly begun, with the death of Cardinal Alessandro in 1589, His immediate heirs took no interest in it and it was not until some seventy-five years later, in the High Baroque period, that the Jesuits were able to persuade the cardinal's descendants to provide money so that work could be resumed. Typical of church decoration of this time is the frescoed vault above the nave of the Gesù which creates an illusion of the open heavens, and the elaborately sculptured tomb of the saint where a dramatic conflict of Catholic virtues and vices is being enacted. Protestantism is condemned in no uncertain terms by the angels who tear to pieces the works of Luther and Calvin [8.4]. This group was executed by the French sculptor Pierre Legros (1666–1719) at the very end of the seventeenth century and illustrates how art could still convey strong anti-Protestant sentiments some hundred and fifty years after the death of Luther.

Other images in the Gesù have a special meaning for Jesuits. Over the high altar is a painting of the Circumcision of Christ, a subject found repeatedly in Jesuit churches throughout Catholic Europe.[17] The Feast of Circumcision is observed with special solemnity by the Society of Jesus because it also commemorates the name that Ignatius gave to his movement: 'Eight days later the time came to circumcise him, and he was given the name Jesus.'[18] In the fresco on the ceiling of the Gesù, painted by Baciccia between 1668 and 1683, the name appears in the form of a monogram, IHS,

8.4 Protestant books destroyed.
Detail of an allegorical sculpture,
Faith overcoming Heresy. Pierre
Legros, begun 1695. Tomb of St
Ignatius, the Gesù, Rome.

which sheds its heavenly radiance on the surrounding angels, adoring saints, the three kings of the Nativity, and not least a representative of the house of Farnese who holds a model of the church. The rays also strike Satan and his band of heretics who tumble out of the sky. On each side of the nave, above the cornice, are sixteen figures in gilt stucco gazing up at the vision of heaven. They personify the remoter regions of the world where Jesuit missionaries penetrated to preach Christianity. The greatest of these missionaries was Francis Xavier, a Spanish nobleman and a friend of Ignatius from his youth. He became known as the Apostle of the Indies and of Japan, and the altar in the south transept, opposite the founder's tomb, is dedicated to him. Among the many scenes and cycles of the lives of Jesuit saints is a painting by the Jesuit artist Andrea Pozzo in the apse of Sant'Ignazio at Rome which depicts St Francis Xavier kneeling before St Ignatius to receive his blessing before departing for the East.

ART AGAINST PROTESTANTISM

In Naples cathedral, in the chapel dedicated to the city's guardian saint, San Gennaro, there is a fresco by Domenichino painted between 1630 and 1641. It is crowded with figures. At the foot lie Luther and Calvin, trampled upon by a youth holding a banner. The fresco represents the triumph of the Catholic Church over Protestant heresy and the artist has managed to introduce into the small area of the pendentive a surprising number of references to official dogma [8.5]. At the top the Virgin kneels before Christ who is enthroned on a cloud. He receives the sword of judgement from the

8.5 The Triumph of the Catholic Church. Bottom right, Luther and
Calvin are trampled underfoot by the Virgin's standard-bearer.
Domenichino, 1630–41. Chapel of San Gennaro, Naples cathedral.

hands of angels. The Virgin's gesture signifies that she is interceding with
him for the woman below who holds a rosary. The latter personifies the
prayers of those on earth which are carried up to heaven by angels. The
banner proclaims three Marian doctrines, that she was eternally virgin
(*Semper Virgo*), was the Mother of God (*Dei Genitrix*), and was herself
conceived 'without sin' (*Immaculata*). To the left of the figure of Prayer is a
flagellant scourging himself who personifies Penance, one of the Seven
Sacraments. Below him a priest holds a reliquary to which he is pointing.
The mitred and disembodied head beside him belongs to St Gennaro.

Relics of saints

The head of St Gennaro, or Januarius, is preserved in the cathedral treasury
along with two phials said to contain his blood. If these relics are authentic
they are of great antiquity since the saint is believed to have been a bishop of
Benevento who was executed early in the fourth century during the
persecutions of the Emperor Diocletian. To this day a ceremony is regularly

performed in the cathedral, usually before a packed congregation, when the saint's blood, normally congealed, appears as if by a miracle to liquefy.[19] A phenomenon of a somewhat similar kind is recorded about a crucifix in the Carmelite church in the same city on which the hair of the Saviour apparently grew and was ceremoniously cut off every year. It is easy to see how Protestants came to regard the veneration of relics and other devotional objects as mere superstition abetted by the clergy. The Council of Trent in its session on images gave general approval to relics provided they were genuine and took care to warn lest 'the celebration of saints and the visitation of relics be perverted by the people into boisterous festivities and drunkenness'.

The cult of saints and martyrs, fostered by the papacy during the Counter-Reformation, was accompanied by a growing reverence for their remains. Pope Urban VIII (1623–44), whose enthusiasm for the arts gave a great stimulus to the design and decoration of Roman churches, provided the relics in St Peter's with a new and grander setting. These four precious objects – the *sudarium* of St Veronica, a piece of the True Cross, the lance which pierced the side of Christ and the head of St Andrew – were now installed each in its own small chapel in each of the four great piers that support the central cupola.[20] Bernini, who was employed by the Pope as architect to St Peter's, designed a niche for each of the piers in which were placed larger-than-lifesize statues of the persons associated with the relics: St Veronica, St Helena (the mother of Constantine the Great who was said to have discovered the cross), St Longinus (the lance-bearer) and St Andrew. Only the statue of Longinus is by Bernini.

Intercession

According to the Church's traditional teaching the saints and the Virgin Mary were able to intercede with God, therefore they could be invoked to pray on one's behalf. Protestants denied this, holding that there was only one who could act as Mediator and that was Christ. They rejected the invocation of the Virgin and saints for the same reason that they rejected the veneration of relics, because there was no biblical authority for it.[21] Domenichino's Virgin is clearly meant to denote Intercession though this was far from being the first example of her in this role. An early Florentine painting done two centuries previously [8.6] shows Mary baring her breast to her Son who in turn is conveying her prayers to the Father. Her gesture, symbolizing mercy, is made on behalf of the figures kneeling at her feet.

The rosary

When Calvin wrote of 'papists who vainly consume the time by reiterating the same orisons',[22] he was referring to prayer-cycles like the Mysteries of the Rosary. To recite this is to repeat the Ave Maria ten times preceded by a Paternoster and followed by a Gloria Patri, the whole being repeated fifteen

8.6 Prayers of Intercession [cf.
8.8]. The inscriptions read: (Virgin)
'Dearest Son, because of the milk I
gave you have mercy on them.'
(Christ) 'My Father, let those be
saved for whom you wished that I
suffer the Passion.' Florentine,
c. 1402. Metropolitan Museum of
Art, Cloisters Collection.

times to form one complete rosary. It includes an invocation to the Virgin to
intercede: 'Pray for us sinners now and at the hour of our death.' The cycle
gradually took shape during the Middle Ages and was officially recognized
in its present form by Pope Pius V in 1568. The string of beads, named after
the devotion and used for counting while praying, is seen in Domenichino's
fresco in the hand of the woman who personifies Prayer. Its origin is wrapped
in legend but it appears that the practice of using beads as an aid to devotion
was brought back by crusaders from the East. However, the Dominican
Order believed otherwise. According to them the Virgin had appeared one
day to their founder and handed him a chaplet of beads that he called 'Our
Lady's crown of roses' [8.7]. It was claimed that the rosary's miraculous
powers helped him overcome the Albigensian heretics. Dominic's vision of
the Virgin is widely represented in churches of the Order. The paintings date
from the end of the fifteenth century when Dominicans began actively to
promote the cult of the rosary as a means of obtaining the Virgin's protection.
As a talisman it appeared to be especially effective against heresy and was
therefore invoked against Protestants. But it was against the forces of Islam
that the rosary scored its most notable success. The victory of the Venetian

8.7 The Madonna of the Rosary. The Virgin
hands a rosary to St Dominic while the Infant offers
another to St Catherine of Siena, and places a
crown of thorns on her head. At the foot, lilies, the
attribute of both saints as well as the Virgin, and a
garland of roses, alluding to the legend. Sassoferrato,
1643. S. Sabina, Rome.

fleet against the Turks at Lepanto in 1571 was attributed to the power of the
rosary by Pope Paul V. In 1573 he instituted the Feast of the Rosary to be
kept on the anniversary of the victory. The scene of the battle appears
frequently in Dominican art from this time and may include Dominic's
vision of the Virgin.

The Seven Sacraments

To mortify one's flesh with a scourge, as in the Naples fresco, may denote
repentance though it is not immediately apparent why Penance is regarded as
a sacrament. To early Christians a sacrament was a specially sacred rite, a
'mystery' in the sense of a ceremony in which only initiates took part. From

the first the chief sacraments were Baptism and the Eucharist and in time other acts of worship acquired the same status. From the twelfth century schoolmen developed the idea that the sacrament was a sign or token through which a priest conferred divine grace. At the same time the number of sacraments was established as seven with the addition of Confirmation, Penance, Extreme Unction, Holy Orders and Matrimony. These seven were confirmed by the Council of Trent which also decreed that they were all instituted by Christ. This was in answer to Protestants who disagreed both as to their number and the manner in which they operated. Protestants maintained that there were only two sacraments, Baptism and the Eucharist (which they called the Lord's Supper), and that the gospels sanctioned no others, though Luther had, with reservations, also admitted Penance.[23] Calvin published a refutation of the Council's decrees, recognizing only two. 'If a sacrament consists of spiritual grace and an external sign, where will they find anything of the kind in Penance?'[24]

The Seven Sacraments appear in the fourteenth-century reliefs on Giotto's campanile at Florence but, surprisingly, they have only rarely been represented as a group in Italian painting. There is a fresco attributed to Roberto Oderisi (active between 1350 and 1382) in the church of S. Maria Incoronata in Naples. Poussin who spent a great part of his working life in Rome painted the series twice, once between 1639 and 1640 and again between 1644 and 1648, though neither was done for a clerical patron. The first series was commissioned by an Italian art collector and member of the Barberini circle, Cassiano del Pozzo, and it is likely that he briefed the artist in some detail. But Cassiano's interests leaned towards antiquarianism and he was inspired by no anti-Protestant fervour. The second series was painted for a Parisian patron, Fréart du Chantalou, at a time when Roman patronage was beginning to decline after the death of Pope Urban VIII.[25]

As for individual sacraments, two in particular, the Eucharist and Penance, feature prominently in seventeenth-century painting because they had become the focus of debate. The doctrine that the eucharistic bread and wine change into the body and blood of Christ was generally accepted from early times but Protestants rejected it as being, at the very least, unprovable. It was accordingly reaffirmed at Trent. In painting, the sacrament was normally represented by the scene of the Last Supper. Until the second half of the sixteenth century artists usually depicted the moment that Christ uttered the words 'One of you will betray me', showing the apostles turning to one another in surprise and mystification. Leonardo's wall-painting at Milan is perhaps the best-known of many that treat the subject in this way. The later, doctrinal version turned it into a Communion of the Apostles, showing Christ in the act of consecrating the bread and wine or administering the sacrament. It now illustrated the words 'Take this and eat; this is my body ...' making the scene a visual rendering of the doctrine of

transubstantiation. Other variations of the theme of communion occur widely in seventeenth-century art, inspired by the same motive. Especially popular was the last communion of a saint. He or she is often the founder or other revered member of a religious Order who is seen receiving the sacrament for the last time, sometimes from the hands of Christ himself.

Penance

Penance, that is, making atonement for past sins, was demanded by the Church from its members at least as early as the third century. In the course of time it came to have three separate elements: repentance, confession and the act of penance itself, known as 'satisfaction'. The outward sacramental sign is the granting of absolution by the priest after confession. Nevertheless it was the image of the penitent and not the rite itself that the Church used to support its teaching, favouring above all the apostle Peter, his tear-stained face turned pitifully to heaven after he had denied Christ three times. Peter's repentance became the subject of sermons, meditations and poems besides being a popular theme in devotional painting. The chief source of inspiration for this imagery was a book by a Jesuit theologian, Roberto Bellarmino (1542–1621), who was an eloquent opponent of Protestantism. Besides St Peter, Bellarmino took as examples of Penance Mary Magdalene whose tears wetted the feet of Christ and, by way of an Old Testament prefigurement, King David who begged the Lord's forgiveness with fasting and weeping when his son, the first child of Bathsheba, was mortally ill.[26]

In the seventeenth century, pictures of the repentant apostle multiplied in Catholic churches in Italy, France and Spain, and sometimes form a pendant to the Magdalene. She is usually depicted at prayer in the desert, perhaps outside a cave, often weeping and sometimes gazing up at a cross round which angels hover. The setting is meant to represent the countryside near Ste Baume in Provence where, according to a medieval legend, the Magdalene ended her days as a hermit. David playing the harp, the return of the Prodigal Son and the good thief who was crucified beside Christ all found a place in the theme of repentance. They are sometimes represented all together in a group around the figure of the Saviour.

Indulgences and Purgatory

Penance in the Middle Ages was made in public and could be of great severity, consisting of fasting, flogging and imprisonment. Total abstention from sex might also be required. Absolution was only granted after the penance had been completed. Florentine and Sienese paintings of the fourteenth century occasionally depict the Flagellants who wandered in bands from city to city after the Black Death, chastising themselves in the manner of Domenichino's penitent. By the time of the Reformation conditions were much relaxed and 'acts of satisfaction' typically consisted of

prayer, almsgiving or a modest fast. A penitent was even allowed to elect a surrogate to carry out the penance in his place; indeed, the story is told of servants who were obliged to fast on behalf of their contrite mistresses. The clergy had the power to substitute a lighter penalty for a heavier or remit a punishment altogether, that is, to grant an indulgence, in return for which the penitent was expected to give money to charity.[27] The practice grew up of offering indulgences for sale, often by professional pardoners, in order to raise money for specific purposes such as building a church or paying off the debts of the papacy. It was this 'traffic in sins' which so offended Luther and precipitated the Reformation. At the same time it was maintained that the good works accomplished by the saints on earth, which far outweighed their sins, had accumulated in heaven in a so-called Treasury of Merits and that the Pope could draw on this whenever he granted an indulgence, thereby, as it were, balancing the account with God.

In the case of ordinary mortals atonement for sin could only partially be achieved through acts of penance on earth – the rest was paid for after death in the fires of Purgatory. There were two ways of shortening that stay: by buying an indulgence or, after one's death, through the intercessory prayers of others. This concept of the soul's purification was widely propagated in the Counter-Reformation in response to Luther's arguments that 'there is no divine authority for preaching that the soul flies out of Purgatory immediately the money clinks in the bottom of the chest,' nor that the Pope could 'remit to souls in Purgatory any penalty which canon law declares should be suffered in the present life'.[28] Later, Protestants went further and denied the very existence of Purgatory.

Images of Purgatory appeared widely in the art of Catholic countries from the end of the sixteenth century. The doctrine of Purgatory was developed in the sixth century by Gregory the Great who taught that prayer would shorten the soul's torments. He is therefore sometimes present, recognizable by his attribute, a dove [8.8]. Paintings done for the religious Orders similarly depict their founders interceding for the sufferers.

MAGIC, DEATH AND ECSTASY

When the seventeenth century opened Italy was divided into small kingdoms mostly under the domination of the Spanish Hapsburgs. The papacy, as a result of the policies of Sixtus V (1585–90) and Clement VIII (1592–1605), had managed to free itself from Spanish influence and taken up a neutral position in European affairs. At the same time a *modus vivendi* had been reached in papal relations with Protestant countries. So, while the rest of Europe for the next half century was involved in war, civil unrest and economic crisis, the papacy enjoyed a period of stability. Rome was the centre of Catholic Europe and the wealth and power of the Popes was

8.8 (*Left*) St Gregory the Great delivering souls from Purgatory. The
Virgin intercedes for them in heaven. Guercino, 1647. S. Paolo,
Bologna. (*Right*) Souls in Purgatory supplicating the Madonna. The
Madonna was copied by the artist from an ancient statue, no longer extant,
in the Santa Casa, Loreto. Drawing. Guercino, before 1621. National
gallery of Canada, Ottawa.

growing. The outward expression of their greatness, like that of the
Renaissance princes two centuries earlier, was lavish patronage of the arts.
The Popes, together with their families and entourage, provided on a grand
scale for new churches and palaces and for painting and sculpture to adorn
them. The high point of that brilliant age, the High Baroque, was the
pontificate of Urban VIII which lasted from 1623 to 1644. The Pope,
Maffeo Barberini, and his circle furnished opportunities for men like
Bernini, Pietro da Cortona and Borromini to create an international style
that embraced architecture, sculpture and painting. Baroque was a complete
contrast to the courtly art of the Renaissance and to the involved ambiguities
of the later Mannerists. It was intended for the many, not the few, and so had
to be easily understood. It was designed for the masses of the faithful, to
arouse emotions of ecstasy and piety. While it expressed the spirit of Catholic

orthodoxy it was by no means only concerned to denounce Protestantism. Unlike Renaissance art it drew a clear line between Christian and pagan. It established new formulas for sacred subjects, many of which have lasted to the present day.

The cult of images

It is not surprising that images intended to have a popular appeal and to inspire a more intense religious ardour should acquire supernatural properties themselves. The tendency to turn images of sacred persons into objects of worship was deep-rooted and had been at the centre of every argument about iconoclasm. The Council of Trent, in defining the limits of the veneration of images, was only echoing the decree of the Council of Nicaea in 787. But however much Church Councils might insist that honour paid to an image was passed on to its prototype or that there was no virtue in the object itself, the ordinary worshipper, and indeed many of the clergy, all too often believed otherwise. Stories circulated among Catholics during the Reformation, of statues and paintings that shed blood or wept tears when they were destroyed. St Philip Neri, who well understood human credulousness, warned his followers of the danger of gazing too fixedly upon sacred works of art. Belief in the power of images, especially those of the Virgin, to work miracles became ever more widespread from the beginning of the seventeenth century. Books were written cataloguing such Palladia and describing their manifold virtues, and churches and chapels were built to enshrine them. The church of S. Maria in Campitelli in Rome was rebuilt (1662–67) expressly to house a mosaic of the Madonna which was said to have prevented an outbreak of the plague. The help of the Virgin in overcoming heresy was even more widely recognized. Her image, carried by a Carmelite friar at the Battle of the White Mountain near Prague in 1620, was believed to have brought about the victory of the Catholic army over the Protestants. The Roman church of S. Maria della Vittoria was rebuilt the same year to celebrate the victory and provide a shrine for the image.

The most venerated of all such guardian images was a Madonna and Child known as the *Salus populi romani*, the Salvation of the Roman People, in S. Maria Maggiore. It forms the centrepiece of the Borghese Chapel, named after Camillo Borghese who became Pope Paul V (1605–21) and who had the chapel built and decorated in order to provide a suitable setting for it. The work is a fine example of a Byzantine icon, originally thought to be of the twelfth or thirteenth century but now considered to date from the ninth or earlier. Its fame however rested on the belief that it was painted by St Luke and thus it provided the ultimate argument against iconoclasts and justified the presence of religious images in churches. By way of underlining this the Pope commissioned frescoes for the chapel which include scenes of the violent deaths of Byzantine iconoclast emperors in the eighth and ninth

centuries. It was during that time that the second Council of Nicaea had met to declare in favour of sacred art. It is probable that the icon was one of those, like the Volto Santo at Lucca (p. 172), which were secretly brought to the West to save them from destruction during the controversies about images in the Byzantine Church.[29].

The subject of St Luke painting the Virgin was not at all widely represented until the seventeenth century. From that time it became part of a growing Marian cult that was the reaction to Protestant criticism of her role in Christian worship. The Marian dogmas were proclaimed by the new religious Orders, above all by the Jesuits, and confraternities were established to do her honour. Of the doctrines set forth on Domenichino's banner, one in particular, the Virgin's Immaculate Conception, featured prominently in Catholic teaching and in art from now on.

The Immaculate Conception

The belief that the Virgin Mary had been conceived solely by the miraculous intervention of God, her origin untainted by human lust, had become more generally accepted since the time when Franciscans and Dominicans had taken opposite sides on the issue (p. 221). In 1476 Pope Sixtus IV had instituted the Feast of the Immaculate Conception and the Council of Trent, while not explicitly confirming the doctrine, had declared that the Virgin was exempt from Original Sin.

There was no handy visual formula for representing an idea so abstract as Mary's conception. The homely scene of the embrace of her parents, Joachim and Anne, at the Golden Gate, which had once served the Franciscans well had fallen out of favour since the Counter-Reformation because it came from the apocryphal gospels and they were now dismissed by many as mere fables. A different kind of image was needed, one that would reflect the theological basis of the doctrine. It was claimed that Mary's role in the divine plan began not with her conception but had existed in the mind of the Creator since the beginning of time. Various Old Testament passages were cited as evidence of his intentions regarding the future Mother of God who would be immaculately conceived and remain for ever a virgin. Thus an image gradually took shape during the sixteenth century of a young woman floating between heaven and earth and surrounded by a variety of pictorial motifs, mostly from the Old Testament. This is not meant to be the 'historical' Mary of the gospels or the apocryphal books but a timeless being, uniquely wise, spotless and of perfect grace, whose existence was adumbrated in the earliest books of the Bible. An historical element was sometimes introduced by including the Fathers of the Church consulting their books below, to imply that the doctrine was backed by their authority. This idealized vision of the Virgin is sometimes combined with the scene of the combat of St Michael with Lucifer or the rebel angels tumbling out of heaven. Since those events

occurred before the Fall of Man, to have been present at them was proof that she was free from Original Sin.

The Virgin's triumph over evil was also conveyed by depicting a serpent trodden beneath her foot. God's curse upon the serpent in the Garden of Eden, 'I will put enmity between thee and the woman and between thy seed and her seed . . .,' was regarded as an allusion to the Virgin since the days of the early Church. She thus became known as the Second Eve whose coming had been foretold in the book of Genesis and who, by giving birth to the Saviour, had made possible man's redemption from the sin of the first parents. Protestants had not been slow to point out a mistranslation in the Latin Vulgate, that it was Christ and not the Virgin who was destined to crush the serpent's head. Nevertheless the motif of the serpent which had for long been a symbol of evil in Christian art, was very often introduced into pictures of the Immaculate Conception in the sixteenth century. It signified the Virgin's victory over sin in general and also over the heresy of Protestantism [8.9].

References to the Virgin seemed to be scattered throughout the Bible for those who took the trouble to look for them. There was not only Isaiah's famous prophecy of a virgin giving birth (another disputed translation) and a metaphorical allusion to her virginity in Ezekiel. She was identified with the figure of Wisdom in the books of Ecclesiasticus and the Wisdom of Solomon, hence her title 'Sapientissima'. Her attribute of a mirror, the symbol of purity, was also connected with Wisdom who was 'the flawless mirror [*speculum sine macula*] of the active power of God'.[30] In the book of Proverbs Wisdom says 'The Lord created me the beginning of his works, before all else that he made, long ago. Alone I was fashioned in times long past, at the beginning, long before the earth itself.'[31] Here was more evidence that the Virgin had existed for all time.

The most abundant source of images of the Virgin was the *Song of Songs* which had been treated as a Christian allegory of one kind or another since the third century; she was identified with the Shulammite maiden who, in the Song, was compared with the flowers of the field, the asphodel, a lily among thorns, a fountain, a spring of running water, a garden close locked, and much else besides. These poetic similes found their way into various litanies addressed to the Virgin which first appeared in the twelfth century. This form of prayer invoked the Virgin under various titles, 'Most wise', 'Queen of angels' and so on, in which the congregation joined with the responses. Thus, when the motifs were introduced into pictures of the Immaculate Conception in the sixteenth century they were immediately familiar to the average spectator.

Later, in the Baroque age, the Virgin shed most of these attributes but at the same time acquired a few new ones. Artists now treated the theme more simply, depicting an ethereal woman, the divine ideal, surrounded by angels

8.9 The Immaculate Conception. Carlo Maratta, between 1665 and 1671. Sant' Agostino, Siena.

who, like her, were the first beings conceived by God. She was sometimes contemplated by the Father on high. A new formula derived from the Book of Revelation became widely established in the seventeenth century and was used by Spanish painters and sculptors, even more than Italian. This was the pregnant Woman of the Apocalypse who had first been linked with the Virgin by St Bonaventura in the thirteenth century. She appeared in heaven, just before the combat took place between St Michael and the Devil, 'robed with the sun, beneath her feet the moon, and on her head a crown of twelve stars'.[32] Carlo Maratta painted an Immaculate Conception, between 1665 and 1671, for the church of the Augustinian Friars, Sant'Agostino, in Siena [8.9]. The Virgin is bathed in a heavenly radiance, her head surrounded by a halo of stars. Below the globe of the earth is a crescent moon. The serpent of

heresy is coiled over the earth. It is significant that it is trodden underfoot by the Virgin and Christ-child together. Catholic orthodoxy had resolved the argument about whose foot would crush the Serpent by declaring that the Virgin had been aided by her Son, and this had been confirmed by Pope Paul V in his bull on the rosary. A picture by Caravaggio of the Virgin, Child and St Anne, now in the Borghese Gallery at Rome, depicts exactly the same motif.[33] At the foot of Maratta's painting on the left is St Augustine, patron of the church and author of the Rule followed by the friars, who had expressed the view, though not very explicitly, that the Virgin was exempt from the sin of Adam.

Martyrs and other saints

The saints always had a place at the centre of Christian devotions since the days of the early Church, though after the Reformation Protestants excluded them on the grounds that they were tainted with paganism and superstition. The Counter-Reformation movement encouraged the veneration of saints because, like the Virgin, they were effective intercessors with God and because their lives were shining examples of the good works that must be performed by ordinary men and women to earn salvation. New books appeared, supposedly more factual, to replace the *Golden Legend*. The definitive version of the lives of the saints, the *Acta Sanctorum* by the body of Jesuit scholars called Bollandists, began publication in 1643 and is today nearly complete. The growing popularity of the saints after the Counter-Reformation reached a sort of climax in 1622 when on 12 March, amid scenes of great pomp in St Peter's, Pope Gregory XV canonized five of them together. They were a twelfth-century Spanish peasant called Isidore the Ploughman, Teresa of Avila, Philip Neri, founder of the Oratorians, and the Jesuits Ignatius Loyola and Francis Xavier. Shortly afterwards Van Dyck, one of many foreign painters working in Rome at that time, was commissioned to paint portraits of the two Jesuits. Thereafter images of saints multiplied at a great rate. Bernini's piazza in front of St Peter's is framed by two curved porticoes surmounted by a row of larger-than-lifesize statues of saints, one hundred and forty in all.

The early saints all died at the hands of the Roman emperors so until the fourth century the terms saint and martyr are synonymous. The martyr always ranked first among the saints and his intercessions were believed to be the most effective of all. It was therefore a cause of great wonder when the Roman catacombs were rediscovered. The existence of virtually all of them had been forgotten in the Middle Ages and it was only an accidental subsidence in 1578 which revealed the catacomb of Priscilla which at that date still contained the bones of many supposed martyrs. Its wall-paintings were satisfying proof to Catholic reformers that primitive Christians had made use of images in their devotions. The first *Roman Martyrology* was

published in 1584 and soon afterwards, in 1588, there began to appear the early volumes of what was to become a vast history of the Church, the *Annales Ecclesiastici*, by a member of the Oratory, Cesare Baronius. The latter was a reply to a recently published Lutheran history[34] and its early chapters dealt fully with the trials of the martyrs.

This spreading of knowledge about the primitive Church came at a time when numbers of Christians were once more facing death for their beliefs. The victims now were the missionaries sent abroad by the Orders, especially the Jesuits, to preach to heathens and heretics. Many died in a wave of persecution in Japan and in 1597 a mass crucifixion of Japanese converts took place. Missionaries to Protestant countries, England in particular, were put to death by torture. The concept of martyrdom made a powerful appeal to more ardent spirits, and artists were brought in to help strengthen their idealism. Jesuit seminaries in Rome and the churches attached to them were decorated with scenes of the deaths of the early saints in order to inspire young novices during their training. The frescoes in S. Stefano Rotondo are a vivid example. The church dates from the pontificate of Simplicius (468–83) and once embodied the form of a Greek cross within its circular plan, like many of the early martyrs' churches in the Holy Land. The fact that it was dedicated at its foundation to Christianity's protomartyr[35] and the discovery of a great quantity of human bones during the present restorations suggest that it was originally built as a *martyrium*. In the sixteenth century the church belonged to Jesuit novices and the walls were then decorated (*c.* 1610) by Pomarancio with scenes of the trials of early Christians. The Counter-Reformation had demanded realism from its artists, a quality certainly not lacking in Pomarancio's renderings of mutilation and dismemberment. But it takes a greater master than him to prevent the present-day spectator from feeling merely amusement of distaste. We can however still be moved by Domenichino's fresco of the Scourging of St Andrew (1608) in the church of S. Gregorio Magno at Rome; and Rubens, who had spent his formative years in Italy and later produced works for Jesuit churches in Antwerp and Ghent, compels our reluctant admiration with his picture of the sufferings of St Lieven, said to have been a bishop of Ghent, martyred in 657, whose tongue, having been cut out, is thrown to a dog by one of his executioners (*c.* 1635).[36] It is interesting to notice how St Sebastian, whose image had magically protective powers in the middle Ages and, in the Renaissance, was more often just a vehicle for depicting the male nude, reverted in the seventeenth century to his historical role of martyr [8.10]. The painting by Bernardo Strozzi reminds us of the legend that Sebastian, who was said to be a Roman soldier in the reign of Diocletian and who became a convert to Christianity, survived the executioner's arrows thanks to the devoted nursing of a Roman widow, Irene, and her maid. (He later returned to confront the emperor and was clubbed to death and thrown into the Cloaca Maxima.)

8.10 Two aspects of the martyrdom of St Sebastian. (*Left*) Renaissance
figure-painting inspired by antique sculpture. Mantegna, 1459–60.
Louvre. (*Right*) Baroque pathos, and a stronger narrative element. Bottom
right, Sebastian's armour. Bernardo Strozzi, between 1631 and 1644.
S. Benedetto, Venice. In neither case do arrows pierce his heart, a custom
usually observed by artists.

Death and entombment

To meditate upon death was a spiritual exercise recommended by Ignatius
and by others after him. It led to tranquillity of mind and stilled the physical
passions. In the mid-seventeenth century a doctrine known as Quietism
emerged which sought by means of prayer to achieve total annihilation of the
will and a state of 'mystic death'. The chief advocate of Quietism was a
Spanish priest, Miguel de Molinos (*c.* 1640–97), who went to Rome in 1663
where he became well known as a spiritual adviser. In 1675 he published his
Spiritual Guide, in Italian, which for a time enjoyed a great vogue though later
it was officially condemned. It had been the custom, more often among

conventuals, to use a human skull as an aid to this kind of devotion, to be gazed upon while at prayer. From the later sixteenth century the saints, in particular Francis of Assisi, were frequently depicted either holding or looking upon a death's head while they prayed. It became a common theme with Spanish, French and Italian artists. They were also called upon to produce pictures on the subject of death to serve as objects of contemplation, introducing a skull, skeleton or some other reminder of the brevity of life. It seems inevitable that such motifs should be used in the sculptured decoration of tombs yet until the Baroque age they had been fairly rare.

The original purpose of a tomb, to provide a kind of house for the spirit of the dead person and his belongings, gave way in time to the monument designed to honour his memory. The architectural features of medieval tombs with their miniature columns, entablature and perhaps pediment, are a distant echo of their ancient function. Some of the grandest monuments were planned not after death but during the lifetime of those they would eventually commemorate, for example the mausoleum of Hadrian at Rome (now the Castel Sant'Angelo), the fourteenth-century tombs of the later Scaligers at Verona with their equestrian statues of the deceased and, in the seventeenth century, the tomb of Urban VIII in St Peter's which was designed by Bernini in consultation with the Pope. The Pope is majestically enthroned, his right arm raised in a gesture of absolution. To show the dead in any such lifelike manner was rare before the end of the Middle Ages; until then they generally lay supine in sleep or death. Michelangelo had made his figures alive and upright on the Medici tombs in the new sacristy of S. Lorenzo, Florence, a monument which probably influenced Bernini. The Medici princes, Giuliano of Nemours and Lorenzo, Duke of Urbino, are seated each within his own niche, his head turned towards the altar, looking at the image of the Virgin at the centre of a Sacra Conversazione. Below them, reclining on the two sarcophagi, are the allegorical figures of Day and Night, and Dawn and Evening, symbols of the passing of time and the decay it brings.[37] In Baroque funerary sculpture, on papal tombs in particular, the deceased usually turns to the altar, as he would have in life. He is regularly accompanied by female personifications. Generally they do not hold the layers of meaning hidden in Michelangelo's figures, but allude simply to the virtues of the deceased. Below Urban VIII, on either side of his sarcophagus, are Charity, nursing her infants, and Justice, holding a sword. Beside the latter is a *putto* bearing the lictor's *fasces*. She herself seems somnolent, her eyes closed and her head resting on one arm, as if to remind us that, at least in one respect, the Pope had failed to uphold justice. His nepotism, which was notorious, led to the downfall of the Barberini family a few years after his death, perhaps significantly at the very time when Bernini was working on this last figure [8.11]. Later in the century, personifications tended to become involved in some activity. On the tomb of Ignatius in the Gesù, Faith wields

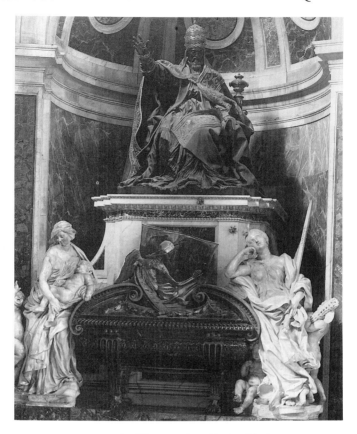

8.11 Tomb of Pope Urban VIII with the
figures of Charity and Justice. Between them
Death, a winged and hooded skeleton, inscribes
the Pope's name on a tablet. Bernini, 1628–47.
St Peter's, Rome.

a burning brand at Heresy who is struck to the ground tearing her hair
(Pierre Legros, the Younger, 1695–99). Fortitude lifts the pall that covers the
sarcophagus of Gregory XIII to reveal a scene of the Pope demonstrating,
with the aid of a globe, his reform of the calendar to a group of onlookers
(Camillo Rusconi, 1719–25, St Peter's).

But amid all this lively activity reminders of death were not absent. The
skull, seen only rarely on Renaissance funerary sculpture, began to reappear
on tombs in the second half of the sixteenth century and Bernini sometimes
added wings to it. The skeleton, often carrying an hour-glass and scythe,
decorated catafalques and was introduced on Baroque tombs. This familiar
personification of Death which had flourished in the funerary sculpture of

northern Europe as the Gothic age declined now found favour in Italy.[38] It is seen recording the name of Urban VIII on a scroll for posterity; on the tomb of Alexander VII (d. 1667), one of Bernini's most splendid works in this field, a winged skeleton holding an hour-glass seems to threaten from below the devoutly kneeling figure of the Pope (St Peter's, 1671–8).

No trace of an architectural framework remained on the typical Baroque tomb so that it was no longer a shrine for the dead but a monument intended for the eye of the living spectator. Bernini catches this feeling exactly in the mortuary chapel which he designed between 1644 and 1651 for the Venetian family, the Cornaro, in the church of S. Maria della Vittoria. Here he has created an elaborate edifice which forms the centrepiece of the chapel yet it holds not a sarcophagus, for none is visible, but the image of St Teresa experiencing her rapturous union with God. From each of the lateral walls, as it were in a box at the theatre, members of the Cornaro family look upon the scene. We are thus invited to share with them in the mystic vision.[39]

Images of heaven

There was nothing new about a religious theme which made the spectator feel he was sharing a mystical vision with the men and women who formed part of the picture. The scene of the Assumption showed the apostles standing round an empty tomb gazing up at the Virgin who floats above their heads surrounded by the heavenly host. Some versions of the Ascension were treated in a similar way, like Giotto's fresco in the Arena Chapel at Padua. It is divided into two zones. The upper depicts Christ rising to heaven accompanied by those he has rescued from limbo, their lower parts fading away into clouds. Below on earth the Virgin and apostles kneel, some of them raising a hand to shield their eyes from the brightness of the glorious spectacle, a gesture which neatly underlines their earthbound condition at that moment. In Baroque painting the Virgin is removed from the earth whenever the context allows. Gone is the Madonna of Humility seated on the ground, the Virgin of the Rose Garden and similar themes popular in the later Middle Ages. The Renaissance Sacra Conversazione, in which the bearing of the saints was often stiffly formal like courtiers round a throne, gradually gave way in the sixteenth century to a more mystical treatment. Raphael's Madonna of Foligno, painted about 1512–13, shows clearly the separateness of earth from heaven with the Virgin and Child resting on a bank of clouds and framed in a golden disk, while below saints and a donor behold her in adoration.[40] The landscape in the background shows the city of Foligno framed in a rainbow, symbol of the throne of God which thus creates a link between the two halves of the picture. An early example of a more rhetorical treatment of the vision of heaven is seen in a painting by Annibale Carracci of the Madonna and Saints, dating from about 1588,

which foreshadows the typical handling of such themes in the Baroque age [8.12].

The Virgin played an important part in the spiritual life of visionaries like Philip Neri, Ignatius and Teresa of Avila, and after their canonization in the seventeenth century their mystical experiences, which had been fully recorded and were well-known, were reproduced by artists in a manner which was calculated to involve the emotions of the spectator to the full. But that is not enough to account for the supernatural element in Baroque art. The Christian religion had always had its mystics but, apart from adding to the repertory of Christian themes, they had not in the past noticeably influenced the character of painting or sculpture. The fact was that artists themselves were caught up in the revivalist spirit of the age and many had joined the religious Orders. Bernini practised Ignatius' *Spiritual Exercises* and applied himself regularly to another famous manual of devotional instruction, the *Imitation of Christ* by Thomas à Kempis. The influence of the Spanish temperament on Italian religious thought was not insignificant. The papacy might have prevented the domination of Spain over her political affairs, yet the spiritual life of the Italian people in the seventeenth century was permeated with the fervent mysticism of Ignatius, Teresa and the Quietist Molinos. It was a Spanish painter and writer, Francisco Pacheco, the father-in-law of Velasquez and art-censor for the Inquisition who laid down the orthodox iconography for the Immaculate Conception in his *Arte de la Pintura*, published in 1694, which influenced later treatment of the theme throughout Catholic Europe. 'In this most lovely mystery the Lady should be painted in the flower of her youth ... with a white tunic and blue mantle ... She is clothed in the sun ... crowned by stars ... An imperial crown should adorn her head which should not hide the stars. Under her feet is the moon, light and transparent above the landscape as a half-moon with the points turned downward.' Pacheco dealt with other sacred themes in the same manner.

PAINTED CEILINGS

Heaven and apotheosis

The ceiling often had a special function in a decorated interior. In the sacred topography of the Byzantine church it was the zone of heaven and the top of the dome was reserved for the image of God. In medieval wall-painting it is often the case that themes increase in sanctity the higher the spectator raises his eyes. Stained-glass windows are usually 'read' from the bottom to top so that, as in a Tree of Jesse, the most sacred figures are the highest. Renaissance painters, exploring the possibilities of perspective, developed a new treatment of walls and ceilings. Peruzzi, the architect of the Villa Farnesina who was also a stage-designer, created in the Sala delle Colonne of the villa striking

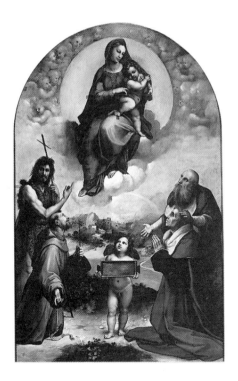

8.12 The Virgin and Child
with saints: the evolution of the
Sacra Conversazione [cf. 7.11].
(*Left*) The Madonna of Foligno.
Raphael, 1512–13. Vatican
Picture Gallery. (*Below*) The
Assumption. Annibale Carracci,
c. 1588. Bologna Gallery.

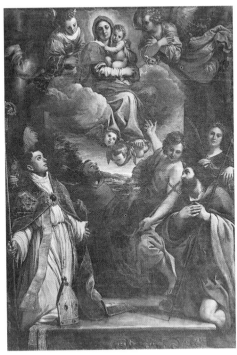

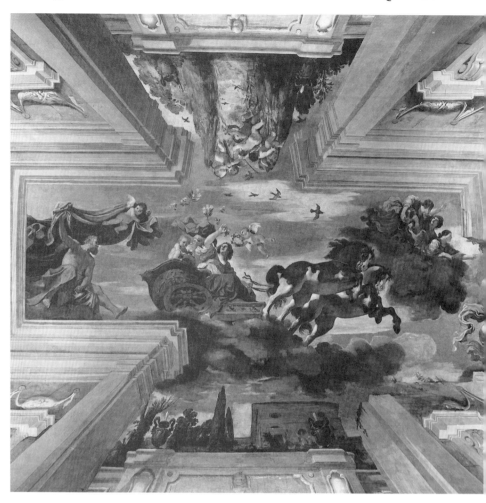

8.13 Aurora, the goddess of dawn, drives her chariot across the heavens. The Horae (the Hours) go before her. Tithonus, her aged husband, just awakened, is left behind. Guercino, 1621–3. Ceiling of the entrance hall of the Casino Ludovisi, Rome.

trompe l'œil effects by blending real architectural features with painted perspectives of columns and façades. This illusionistic device, known as *quadratura*, was popularized by Annibale Carracci and other Bolognese painters working in Rome at the end of the sixteenth century. It was therefore already well-established when Baroque artists began to create their vertiginous prospects of the heavens [8.13]. The vista of open skies peopled with far-off figures floating among the clouds which we meet in many

8.14 Ceiling painting giving the illusion of open sky. A forerunner of
the Baroque painted ceiling. Mantegna, completed 1474. Camera degli
Sposi, Ducal Palace, Mantua.

seventeenth and eighteenth century churches and palaces owes its original
inspiration to a fresco by Correggio in the dome of Parma cathedral. Here,
between 1526 and 1530, he painted the Assumption of the Virgin, a work
thronging with figures but principally depicting the Madonna ascending to
heaven watched by the apostles. The figures are boldly foreshortened, an
aspect of perspective which seventeenth-century artists were to develop with
great skill in ceiling paintings, At the base of the dome, round its
circumference, Correggio has painted a balustrade which forms a dividing-
line between the real interior of the building and the imaginary heavens
beyond but which also serves to unite the two. This feature had already been
used by Mantegna, together with foreshortened figures, on the ceiling of the
Camera degli Sposi at Mantua, a work which Correggio is sure to have
known [8.14].

The earliest example by a Baroque painter of a ceiling inspired by the
Parma dome was produced (1625–7) by Lanfranco for the dome of S.
Andrea della Valle, the mother church of the Theatine Order at Rome.
Lanfranco was born at Parma, received his training there and was much
influenced by Correggio's work. He depicts a different version of the
Assumption of the Virgin, showing her seated among the clouds in the
lowest circle of the heavens. Her arms are extended in a gesture of intercession

towards the half-length figure of Christ at the top. Kneeling on either side of her, as in a Sacra Conversazione, are St Gaetano, one of the founders of the Order who is being presented by St Andrew, and another revered member of the Theatines, St Andrew Avellino, who is introduced by St Peter. The natural daylight shed by the lantern, which contains the image of Christ, acquires a symbolic meaning as it illuminates the surface of the dome with its descending circles of angels, apostles, saints and martyrs. Their arrangement recalls the medieval hierarchy of angels that Dante described as a series of concentric rings all lit by the fiery point at their centre which is God.[41] Indeed, other images in the closing cantos of the *Paradiso*, when St Bernard, on Dante's behalf, addresses a prayer of intercession to the Virgin at the edge of the mystic rose, bear a curious resemblance to Lanfranco's conception.

The Baroque heavens contain a wide variety of images, sacred and secular. A recurrent theme in churches of the Orders from the later seventeenth century and one that was completely in harmony with prevailing sentiment, was the 'apotheosis' of its founder. The image of the saint being received into heaven was an unorthodox adaptation of the ancient pagan belief in deification (pp. 47–8), when the soul of an emperor or hero was carried up after death on the back of an eagle to join the company of the gods. St Dominic is seen entering the realm of the immortals in the Roman church of SS. Domenico e Sisto (painted by Canuti and Haffner, 1674–5) and St Ignatius does likewise amid towering *quadratura* columns and cornices on the ceiling of the nave of S. Ignazio (Andrea Pozzo, 1691–4). Kings and princes, when commemorated in this fashion in their palaces, are as likely to be received into Olympus where Jupiter reigns. Luca Giordano's fresco cycle in the Palazzo Medici-Riccardi in Florence (painted 1682–3) shows the Medici Grand Dukes Ferdinando II and Cosimo III, together with Cosimo's two young sons who are on horseback, borne upwards towards Jove who is enthroned majestically among the clouds.

Between the extremes of sacred and profane subject-matter was a broad region inhabited by the figures of moral allegory. They are found more frequently in ceiling painting than in sculpture. One reason for their growing popularity was the appearance in 1593 of Ripa's *Iconologia*, a comprehensive dictionary of personifications which rapidly became a working tool for artists. At the same time there was a renewed enthusiasm in the seventeenth century for elaborate iconographical programmes. This may have been partly due to the influence of the *Iconologia* but was also the result of the encouragement given to letters as well as the visual arts by Urban VIII and his circle. Moral allegory came into its own nowhere more triumphantly than in Cortona's vast fresco in the Barberini Palace known as the Triumph of Divine Providence or, more explicitly, the Glorification of the Reign of Urban VIII. It was painted between 1633 and 1639 and fills the ceiling of the Gran Salone, the main reception-room of the Pope's Roman residence.

The elaborate programme was devised by a member of the papal entourage, Francesco Bracciolini, at one time secretary to Maffeo Barberini but who later fell from favour. What was conceived as a rather fulsome exercise in flattery was transformed by Cortona into a major work of art [8.15].

The principal figure is a woman enthroned on a cloud, distinguished only by a radiant light shining behind her head and a sceptre in her left hand. She is Divine Providence, that is, she personifies the idea of God's benevolent intervention towards mankind. Since she is gesturing towards a group of figures bearing the emblems of the papacy and the Barberini family we infer that Urban VIII was looked on with especial favour from on high. Her gesture also directs another nearby figure, Immortality, to place a circlet of stars among the group. This freely-arranged Barberini escutcheon shows, at the top, the personifications of Religion holding the papal keys, and Rome who holds a tiara. Below them are Faith, Hope and Charity bearing branches of laurel, all five figures forming a ring which encloses three bees. The laurel and bees were both Barberini insignia. The latter, popular heraldic creatures symbolizing the sweet rewards to be earned from industriousness in a well-organized society, featured in the coat of arms of the French monarchy and were granted to Maffeo Barberini by Henri IV at the end of a term of office as Papal Nuncio in Paris. A laurel crown is borne towards the group from one corner by a *putto*, a reminder of the Pope's literary accomplishments. The bearers of the laurel branches, the Theological Virtues, are complemented by the four Cardinal Virtues, Justice, Temperance, Fortitude and Prudence, which together make up the medieval canon of seven. The latter are seen (clockwise from the top) in the four compartments adjacent to each side of the central section, engaged in combat with the Vices. In the octagonal medallions in the four corners of the central frame are 'historical representatives' of the Cardinal Virtues, all famous men of ancient Rome to whom the Pope, we are meant to understand, made a worthy successor. A host of minor Virtues, several unidentifiable, surround the central figure of Providence.

Bracciolini's programme has a number of features in common with religious allegory in the Middle Ages, for example the psychomachy, or combat between Virtues and Vices, the seven principal Virtues and the historical representatives. Yet Cortona's painting was for long regarded as essentially non-religious. Domenichino wrote from Naples in 1640, the year after the fresco was completed, that he had heard the work was more suitable for a secular prince. Misunderstanding arose because no written programme is known to have survived, indeed may not have existed in any detail since Bracciolini and Cortona collaborated closely during the work's execution. But there was another reason for its partial failure to communicate. In the seventeenth century there was no longer a common language of attributes and symbols such as existed in the Middle Ages and Renaissance. Thus it was

8.15 Allegory glorifying the reign of Maffeo Barberini, Pope Urban
VIII. Pietro da Cortona, 1633–9. Central section of the ceiling of the
Gran Salone, Barberini Palace, Rome.

possible for a contemporary biographer of artists, G. B. Passeri (1610–79), to mistake Faith, Hope and Charity for the Muses Urania, Calliope and Clio celebrating the Pope's gifts as a poet.[42] The misreading survived to the present day and partly explains why it was looked on as secular and not religious allegory.

THE DECAY OF ALLEGORY

Many programmes of a similar kind were produced in the seventeenth and eighteenth centuries. Though often complex, they are not the same as the metaphysical conundrums devised by Renaissance Neoplatonists. The objective is straightforward, the praise of a great man, even though it is couched in the language of symbol and allegory. The obscurity lies not so much in complexity of thought as in the failure of the symbolic language to make its meaning clear. This was not due to a deliberate intention to mystify. The fault lay with the mythographical manuals used by seventeenth-century artists. There were principally two, the *Hieroglyphica*, a dictionary of symbols by Pietro Valeriano, published in 1556, and, even more widely followed, Ripa's *Iconologia*, a catalogue of abstract concepts which, in the enlarged and illustrated edition of 1603, amount to some eight hundred. It was the efforts of their authors to be all-embracing which led to the confusion. Ripa derives much from the gods of classical antiquity but he also borrows from the medieval mythographers, images on medals and coins, and from the books of so-called hieroglyphics of which Horapollo's was the original. Hence, the splendid family of allegorical figures which the Renaissance created out of the classical gods and goddesses have degenerated in the pages of Ripa into a bastard progeny. A women in armour once clearly denoted Pallas-Minerva-Wisdom but in the *Iconologia* may stand for Fortitude, or Reason, or a number of other concepts. The thunderbolt, once the property of all-mighty Jupiter because he controlled the weather, turns into a Christian symbol, appearing in the hand of a figure rather like the Ancient of Days who is called 'Flagello di Dio', the Scourge of God [8.16]. In the introduction to the *Iconologia* Ripa acknowledges the difficulty: 'I think the rule of writing the names underneath should be always observed except when a King of Enigma is intended, for without knowing the name it is impossible to penetrate to the knowledge of the signification except in the case of trivial images which will be recognized by everyone thanks to usage.'[43]

The want of an unambiguous language is felt in another painted ceiling in the Barberini Palace, the allegory of Divine Wisdom by Andrea Sacchi. It was completed about 1633, the year that Cortona began the ceiling in the Gran Salone. Sacchi's fresco has echoes of Raphael's Parnassus. It has no narrative content to speak of, being composed almost entirely of groups of graceful female figures distinguished from one another chiefly by the objects

8.16 Personification of the Scourge of God, 'Flagello di Dio'. In his right hand, a scourge, in his left, a thunderbolt. On the ground, locusts. The name was once applied to Attila the Hun, who was regarded in Christian legend as a minister of divine vengeance. Cesare Ripa, *Iconologia*, 1603 edition.

they hold. No written programme exists and the author is unknown though he is likely to have been a cleric. Fortunately, however, there are contemporary descriptions which help us. The principal figure, enthroned above the earth, is Divine Wisdom. She is crowned and sceptred like any monarch but, in addition, a sun shines from the middle of her breast. The sun, like the bees and laurel, was a Barberini emblem and also an attribute of several abstract concepts which, luckily for the inventor of the programme, included Wisdom. Wisdom's sceptre has an eye at its tip, a 'hieroglyph' known to the Renaissance as a symbol of the sun and thus another reference to the papal family. Wisdom herself is more than just the everyday virtue. She represents the divine ideal described in the Old Testament Wisdom of Solomon whom princes of the earth must honour that they may reign forever. It was she also with whom the Virgin was identified and here she holds the same flawless mirror that is the attribute of the *Immacolata*. Among the attendants of Wisdom, ranged around her, we recognize Justice with her scales and Fortitude with Hercules' club. The person holding a serpent, circular and biting its tail, would according to Horapollo be Eternity or the Universe. In this case the former seems to be intended. Thereafter, our difficulties would increase without the help of an interpreter. The swan in the arms of the woman standing on the right of the throne belongs to several personifications, as does the eagle just below, likewise the lyre resting in the

8.17 The personification of Divine Wisdom and her attendant Virtues.
They represent qualities supposedly possessed by the Barberini family.
Andrea Sacchi, 1629–33. (Ceiling, detail.) Barberini Palace, Rome.

lap of one of the group on the left. According to Passeri who describes the
fresco in some detail the owner of the swan is Purity, the eagle because of its
sharp eyesight Perspicacity, the lyre, Harmony. The figure with flowing hair
and holding a triangle is identified by Passeri as Nobility though both
Valeriano and Ripa are silent about it [8.17].

The connection between a symbolic idea and its realization in art is
weakened when the pictorial language through which it is expressed is an
arbitrary one. Allegory based on the figures of classical mythology had been
able to preserve this unity more easily. Ripa's figures on the other hand were
derived from a variety of sources, classical, biblical and medieval and, in the
case of hieroglyphs, were based on a complete misunderstanding of the nature
of ancient Egyptian writing. Thus there is seldom any necessary link between
the idea and its image in Ripa. The elephant, he tells us, makes a fitting
companion for Temperance because of its moderate eating habits. [8.18]. It
is here that Baroque allegory, however ambitiously conceived, so often seems
to fail.

Their lack of intrinsic meaning made the figures in the *Iconologia* equally at
home among pagan gods as among sacred persons. Emile Mâle has shown

us[44] how artists like Bernini and Domenichino consulted the book extensively in the decoration of churches in Rome and Naples. Carlo Maratta, too, made considerable use of it in his religious paintings. At the same time, one of the most successful of large-scale allegories, Luca Giordano's ceiling in the main gallery of the Medici-Riccardi Palace in Florence, is wholly secular and yet also relies heavily on Ripa, combining his abstract figures with the gods of classical myth. The programme was devised by a Florentine senator and man of letters, Alessandro Segni. It seems with its multiplicity of parallel, interwoven themes, almost as if it were deliberately designed to exploit the wealth of material contained in the *Iconologia*. The underlying idea is the progress of a human life, guided by the Virtues from birth to manhood and thence to death and final apotheosis [8.18]. The last act of the drama portrays not allegorical figures but actual members of the Medici family rising to heaven. Simultaneously Giordano depicts the changing seasons from spring to winter, the movement of time from dawn to night and the sequence of the four elements, themes that are related symbolically to the span of man's life on earth and his place in the universe. Even this elaborate programme is subsidiary to an overall plan which links the gallery frescoes to another cycle in the library. The latter depicts the world of the intellect and the spirit ruled over by Divine Wisdom. It is she who guides the destiny of Urban VIII in the Barberini Palace. Here she is attended by Theology, Philosophy and Mathematics. *Putti* are playing with scientific instruments (including a retort which no doubt denotes Alchemy). The two rooms together symbolize the Active and Contemplative Life, a concept which often featured in the allegories of the Florentine humanists two centuries earlier.[45]

SUMMARY

The treatment of sacred themes in the Renaissance was undogmatic and tended to reflect the personality of the artist. Echoes of pagan antiquity were often present. By the mid-1500s all that was changing, reform of the arts in Italy was under way and Renaissance attitudes were out of favour. The reason was the rise of Protestantism. The Catholic Church, in defending itself, also laid blame on humanism and other aspects of Renaissance thought for the growth of unorthodox belief. One of the targets of the Protestants was what they saw as the encouragement of idolatry by the papacy, by which they meant not just the use of images in churches but the veneration of the Virgin, the rite of the Mass, and the cult of relics. The Catholic Church's response was to reassert traditional theology and, to help it to do so, to revitalize the priesthood. Art was to be purged of unsuitable subject-matter; later it became an instrument for propagating dogma. The main objectives were

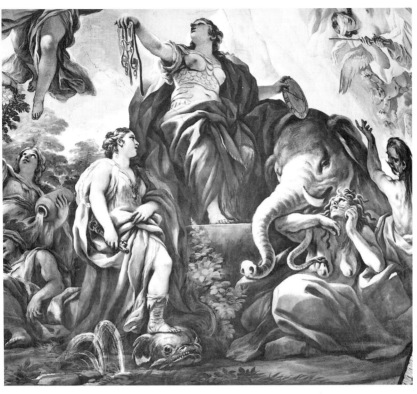

8.18 Temperance personified.
(*Above*) The bridle symbolizes
her restraining influence; the
clock-face, that all should be
done with due measure. Luca
Giordano, 1682–3. Palazzo
Medici-Riccardi, Florence.
(*Right*) The elephant has divided
his four barley-cakes into two
parts, leaving one part for later.
Ripa, *Iconologia*, 1603 edition.

codified by the Council of Trent (1545–63). The formation of an active religious Order like the Jesuits in 1534 came at an opportune time.

Towards the end of the sixteenth century many new themes appeared in Italian art and others were given new prominence in order to underline various aspects of Catholic dogma: devotional images of the Virgin (Immaculate Conception, and Assumption); examples of the Sacraments (Last Communion of a saint, Triumph of the Eucharist; Penitence of St Peter and the Magdalene); and the miracles of the Rosary. The scene of souls in Purgatory was a reminder of the argument with Protestants over the effectiveness of indulgences. Scenes of the death of early martyrs and episodes from the lives of more recent saints, especially the founders of the new Orders, served to inspire novices and those about to face the dangers of missionary work abroad. The emphasis on images as a part of the religious life revived the always latent impulse to revere them as magical objects. Pictures of the Virgin in particular were believed to have miraculous powers.

From the beginning of the seventeenth century a period of peace and prosperity opened for the papacy. Architecture, sculpture and painting thrived under the patronage of the Popes and their court. This was the age of High Baroque which reached its climax in the pontificate of Urban VIII (1623–44). Art was by no means solely concerned with propagating dogma. After death the Popes were honoured with magnificent tombs on which allegorical figures and narrative reliefs commemorated their achievements. The figure of Death (as a skeleton or skull), absent from Renaissance funerary art, reappeared on tombs and in pictures of saints at prayer, reflecting the influence of works like Loyola's *Spiritual Exercises* on religious attitudes of the time.

The new treatment of painted ceilings typified the Baroque spirit. The illusion of open heavens in which figures floated upwards was used at first for sacred themes like the Assumption of the Virgin, but later would depict allegories or the 'apotheosis' of a saint. Secular princes might be received among the gods of Olympus. Allegorical figures were very numerous in seventeenth-century painting and sculpture, largely owing to the popularity of Ripa's dictionary, the *Iconologia*. But the very multiplicity of figures and attributes led to a blurring, and therefore a weakening, of the language of symbols. An example of a large-scale programme that successfully uses Ripa is Giordano's Allegory of Human Life in the Palazzo Medici-Riccardi in Florence.

Art in Decline

I TALIAN ART, having led the way in Europe for so long, was already showing signs of a decline in the second half of the seventeenth century and by the end of the eighteenth dwindled almost into insignificance. Artists no longer responded to new ideas as they had in the past. The Neo-classical revival in the mid-eighteenth century failed to stimulate them in the way that the discovery of antiquity had once inspired Renaissance artists. Although Rome played an important part in arousing this renewed interest in the ancient world, it was French painters who were foremost in creating a new style and a new repertory of classical images. Still less were Italian artists influenced by political events. While the French drew inspiration from the ideals of the Revolution and the career of Napoleon, in Italy the movement for national unity in the nineteenth century made no comparable impact even though its effect on Italian literature was not inconsiderable.

The decline of painting and sculpture in Italy had much to do with the changing pattern of patronage in Europe. After the death of Urban VIII in 1644 spending by the papacy on the arts was greatly curtailed. Only the Chigi Pope, Alexander VII (1655–67), a descendant of the wealthy banker who built the Villa Farnesina (p. 255), lavished his personal fortune and the resources of the papacy on the embellishment of Rome on anything like the scale of the Barberini family. At the same time, the economic decline of the Italian city states was hastened by the growing strength of trading countries like England and Holland so that the merchant classes in Italy were now less able to support the arts. Luckily for Italian artists there was no lack of demand for their services from abroad. In France, Cardinal Mazarin (1602–61), who was Italian born, used his position at the court of Louis XIV to provide commissions for his compatriots. From the later seventeenth century they were continually called upon by the rulers of the many German states, Catholic and Protestant, and, equally, by the English nobility.[1]

There was still a number of individual collectors with the means to keep patronage alive in Italy. Mostly they did not live in Rome but were scattered in provincial towns and cities and so had no unifying influence on the course of art. The works they commissioned reflected personal tastes, though their choice of subject-matter was on the whole unoriginal. There was a preference for 'history pictures', that is, themes from ancient history, legend and the myths, and from the romantic epics of Ariosto and Tasso, treated in the

monumental style that was characteristic of Roman painting. Meanwhile pictures of a humbler sort had slowly been establishing themselves in popular favour, especially among collectors of smaller means. This was genre painting, introduced into Rome by the Dutch artist Pieter van Laer who worked there between 1625 and 1627. His scenes of everyday life in the streets of Rome were regarded in academic circles, however, as worthless and labelled *bambocciate*, things that were clumsily childlike – perhaps a slighting reference to van Laer himself who was apparently deformed. Nevertheless by the eighteenth century painters of various categories of genre were busy in Bologna, Naples, Venice and other cities besides Rome. The depicting of beggars and vagabonds, peasants in taverns and the life of the poor in general was seldom, if ever, meant to be social comment. It tended, rather, to give a sentimental gloss to poverty, concealing the truth. Another popular genre represented the middle classes in scenes of typical domestic activities. These themes, which eventually became stereotyped through constant repetition, were mostly adapted from literary sources, sometimes from the figures of medieval allegory and even from religious images.[2]

Venice and Rome

It was in the republic of Venice that Italian painting had its final flowering in the eighteenth century. Here the Church and the religious Orders still had the support of wealthy aristocratic families and commissions for sacred subjects were plentiful. The spirit of the Counter-Reformation lived on. The church of S. Maria del Rosario, for example, built between 1726 and 1743 for the Gesuati, a branch of the Dominicans, has a ceiling fresco by Tiepolo depicting St Dominic instituting the Rosary, besides altarpieces glorifying other leading saints of the Order. The Carmelites, too, were generous patrons in Venice at this period and commissioned Tiepolo and others to decorate their churches. The nuns of the Order devoted themselves particularly to penance and prayers of intercession addressed to Our Lady of Mount Carmel. The Madonna, in Carmelite churches, is depicted interceding on behalf of souls in Purgatory (especially those of Carmelite priests) though scenes of torment are more often avoided. Elijah, the traditional founder of the Order who was said to have lived as a hermit on Mount Carmel, features prominently in Carmelite art. He may be dressed in the Carmelite habit and be accompanied by his disciple Elisha. In the Scuola dei Carmini at Venice Tiepolo shows them both attending the Virgin as she hands a scapular to Simon Stock, an English General of the Order (d. 1265). This miraculous garment protected the wearer from the fires of Purgatory.

The picture of Venice herself that was presented by eighteenth-century painters was still one of a great maritime power yet, in reality, those days were past. The ceremony performed annually by the Doge on Ascension Day, the Wedding of the Sea, was once the symbol of the city's might but by the time

9.1 Homage to Venice. Justice (left) and Peace (right) hand over
their emblems to the personification of the city. Beneath the throne is
the lion of St Mark, the city's emblem. Veronese, *c.* 1577. Sala del
Collegio, Ducal Palace, Venice.

of Canaletto (1697–1768) renderings of the scene were no more than an
exercise in nostalgia. The Doge's Palace contains many works by sixteenth-
century painters celebrating the greatness of Venice before economic decline
had taken hold. Veronese shows the figures of Justice and Peace handing
over their symbols, the sword, scales and olive branch, to the triumphant city
(Sala del Collegio) [9.1]. On the other hand, Tiepolo's painting of Neptune

9.2 Neptune's offering to Venice, a cornucopia overflowing with gold.
The origin of Neptune's trident (top left) may have been the attempt by
artists in antiquity to represent a thunderbolt [cf. 8.16]. On the right, the
lion of St Mark. Tiepolo, c. 1745. Ducal Palace, Venice.

pouring golden coins from a cornucopia at her feet (Sala delle Quattro Porte,
1745–50) dates from the time when Venice had lost the greater part of her
sea-borne trade and was vainly trying to preserve an image of splendour and
prosperity that had long ceased to exist [9.2].

 In Rome, by the end of the seventeenth century, monumental painting
and sculpture were losing their originality and relying increasingly on
stereotyped formulas that were no more than echoes of the High Baroque.
The typically Roman grand manner, looked on in offical circles as the true
classical style, had become more often merely grandiose. The design of papal
tombs, however, still seemed able to stimulate the artists' imagination and in
the tombs of the laity and lesser clerics even more originality was achieved.
Instead of the traditional effigy sculptured in the round, a medallion portrait
of the deceased might be substituted, recalling the type of image that appears
on ancient Roman sarcophagi (p. 53). The typically Baroque arrangement
of the figures in pyramidal form with the deceased at the apex gave way to
altogether freer compositions in which the personified Virtues sometimes
adopted the pose of mourners or were involved in some other activity. A
pyramid itself, in relief, often became the principal feature of the tomb.
Besides being the most ancient of all forms of funerary monument it was also
a symbol of Eternity. It is used in this sense on the tomb of Cardinal
Calcagnini (1746) by Pietro Bracci in S. Andrea delle Fratte in Rome where
a medallion portrait is set into a pyramd while the figure of Fame writes an
inscription at its foot. Canova, half a century later, introduced similar

features on the monument to Maria Christina of Austria (1799–1805).[3]
Here a medallion on a pyramid is framed by a snake biting its tail, another
symbol of Eternity. The portrait is supported by a flying figure representing
Felicity who is balanced by a *putto* opposite, reminiscent of the pairs of
winged Genii which uphold the medallion on antique sarcophagi.

If Rome was no longer the artistic centre of Europe in the eighteenth
century, her position as the focus of antiquarian and archaeological studies
was unique.[4] Academies were set up (the first had been established by the
French in 1666) devoted to the study and copying of classical remains. Many
artists came from abroad with the same objectives, as well as to observe at first
hand masterpieces of the Renaissance. The Grand Tour, the cultural
pilgrimage of the English gentleman, took him to Rome where, often
accompanied by a knowledgeable guide, he learned to admire the most
famous monuments. Throughout Europe the upper classes, if they had a taste
for the arts, followed in the same footsteps. Portrait painters like Pompeo
Batoni (1708–87) were always ready to depict them, posed near some well-
known classical sculpture like the Apollo Belvedere or the Laocoön to
provide a lasting memento of their visit.

Also catering for the tourist of that day with his enthusiasm for antiquity
were painters and etchers who produced townscapes, in particular, views (or
vedute) of the ruins of ancient buildings. Rome's only antique pyramid tomb,
inscribed to Gaius Cestius, a Roman official who died in 43 BC, appears
repeatedly in this kind of work and helped to generate its typically elegiac
mood. The greatest of the creators of *vedute* was Giovanni Battista Piranesi
(1720–78), a Venetian by birth who spent most of his working life in Rome.
Not content with representing the city as it stood in his day he produced also,
in a series of large-scale etchings, reconstructions of ancient Rome. These
were buildings not as they might have appeared in reality but architectural
fantasies in which the human figure was often deliberately drawn to a smaller
scale in order to increase the illusion of vast dimensions.[5] Copies of Piranesi's
etchings were widely sought and helped to disseminate an image of Rome as
a city of romantic antiquities.

The Neo-classical movement

The German art historian and archaeologist, Johann Winckelmann
(1717–68), settled in Rome in 1755. As a young man he developed a
passionate love for ancient art and in later life his writings, which had a wide
readership, helped to create a new outlook on the antique. For
Winckelmann the forms of classical Greek sculpture were the ultimate ideal
towards which all art should strive. Roman copies of Greek originals were a
step away from that perfection. This view was not shared by all art theorists
in the eighteenth century: in the field of architecture in particular, Piranesi
among others made strong claims for the primacy of Rome. Winckelmann

saw that works of art were not simply the expression of individual genius but were also a reflection of the civilization into which the artist was born. The Neo-classical movement owed much to Winckelmann's writings and in its later stages testified to the truth of this latter thesis.

The movement began as a reform of style. It was a reaction against extravagantly ornate art of the kind produced at the French court of Louis XV, known as Rococo, with its endless scrolls, swags and shell-work and its preference for mythological themes that lent themselves to tastefully erotic interpretation. Reform was also partly due to a new climate of thought spreading over Europe, the Enlightenment, which replaced the habits of tradition with an attitude of rational and scientific inquiry, and which, in its moral seriousness, was the very antithesis of the Rococo spirit.

The positive aspect of the Neo-classical revival in its early period can be seen in the work of the German painter Anton Mengs (1728–79). Mengs spent most of his working life in Italy and became a friend and protégé of Winckelmann. As a young man he painted in a Rococo style which he never entirely succeeded in shaking off. His conversion to the classical ideal was partly the influence of his mentor and partly due to the study of volumes of engravings which began to appear from 1757 of the ancient remains, mostly wall-paintings and bronzes, of Herculaneum and Pompeii, first excavated during the two previous decades.

In 1760–61 Mengs painted Apollo and the Muses on Parnassus for a ceiling in the Roman villa of Cardinal Alessandro Albani, newly built to house his fine collection of classical sculpture.[6] The cardinal, who employed Winckelmann as his librarian, was the nephew of Pope Clement XI, himself a generous patron of the arts. The content of the Parnassus is conventional: Apollo stands among a grove of trees holding a lyre and a laurel wreath. The Muses are grouped around him, identifiable by their customary attributes. The god's pose strongly recalls the Apollo Belvedere, a Hellenistic sculpture passionately admired by Winckelmann and we may assume his influence here. The work is remarkable for its total rejection of the usual features of Baroque ceiling painting. Gone are the illusionistic columns and cornices, the dramatic foreshortenings and the swirling figures in the heavens. Mengs conceived the subject wholly in terms of an easel painting, the figures assuming classical postures, some of which the artist certainly derived from Pompeian engravings. Over all dwells a quietness and serenity which was felt to be essentially Greek.

For the leaders of the Enlightenment in France the pagan gods served only to illustrate the depths of superstition to which even the most civilized peoples could descend. Antiquity deserved to be commemorated by worthier exemplars. The history of Greece and republican Rome offered countless instances of heroic deeds by men and women of courage, honour and integrity. The war-leaders, statesmen, judges and philosophers of the ancient

world were the models that inspired the revolutionary idealists of eighteenth-century France. The mood of patriotic heroism was summed up in the picture of the Oath of the Horatii by Jacques-Louis David, a legendary episode from the war between Rome and Alba related by Livy.[7] In fact the artist anticipated political events by a few years, exhibiting the picture first in 1785. Homer too enjoyed a considerable revival. Heroic themes from the *Iliad* and, to a lesser extent, the *Odyssey* attracted artists such as the Italian Batoni. Foreigners like the Englishman John Flaxman and the Scot Gavin Hamilton who gravitated to Rome under the spell of the classical revival produced whole series of Homeric themes while there.

The cult of the hero in Neo-classical art took an unexpected turn with Napoleon's rise to power. One incidental result was the emptying of Rome, after occupation by the French in 1798, of her finest antique treasures, including nearly three hundred from the Villa Albani alone, which were taken to France. The man who liked to compare himself to Alexander the Great and Julius Caesar found his ideal painter in David who set out to portray him as a superhuman figure surrounded by all the panoply of majesty. On the other hand Canova, who was also a favourite of the Bonaparte family, surprised the emperor by representing him in the nude (1803–6), after the model of the Greek gods and Roman emperors. Though the work prompted David to write to the sculptor 'You have done for posterity all that mortal man could do', Napoleon, having seen it for the first time in 1811, thought otherwise and forbade any further showing in public.[8]

Canova

Antonio Canova, lonely standard-bearer of Neo-classicism among Italians, had, unlike the French, no misgivings about mythology. His large output includes many renderings of the gods and goddesses in familiar guise, often echoing stylistically some Greek or, more usually, Roman original. The figure of Perseus in the famous sculpture of the god holding the severed head of Medusa (1797–1801)[9] resembles in several points the Apollo Belvedere. The work was in fact commissioned as a replacement for the Apollo, which had been looted by Napoleon. Political overtones were generally absent from Canova's mythological figures. It was once suggested that the huge carving of Hercules and Lichas (1795–1815),[10] showing the hero, with a mighty effort, about to hurl the unfortunate messenger into the sea, symbolized the fate of the French monarchy at the hands of the people, but this was denied by Canova.

Between 1787 and 1792 Canova produced several series of plaster reliefs on historical themes of the kind favoured by the Neo-classical movement: episodes from the Trojan War from the *Iliad* and *Aeneid*, and scenes of the trial and death of Socrates. In terms of composition he comes nearest to painting in these works, and indeed the influence of Gavin Hamilton's

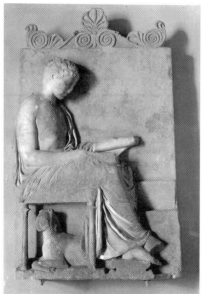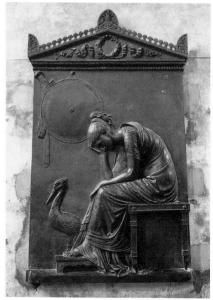

9.3 (*Left*) Attic Greek *stela*. The figure represents the deceased's soul.
The dog under his chair is not a pet but the underworld guardian of his
soul. 5th cent. BC. Abbey Museum, Grottaferrata. (*Right*) The revival of
the classical *stela* two thousand years later: a monument to Prince William
of Orange who died at Padua in 1799. The figure personifies Piety. The
pelican was a heraldic device of the House of Orange and was also
associated with piety in Christian symbolism. Bronze copy of a marble by
Canova, 1806. Eremitani, Padua.

pictures has been noted.[11] But sculpture provides some opportunities not
open to the painter, particularly in the field of monumental art. Canova
received many commissions for funerary sculpture in Italy and from abroad.
He evolved a great variety of designs, generally adapting Greek and Roman
types. He revived the *stela*, the rectangular slab tombstone having a classical
pediment and a figurative relief panel. Whereas the antique *stela* originally
represented a house for the deceased and the figure in the panel denoted his
spirit surviving within it, Canova's figures are merely commemorative, in
keeping with later attitudes about funeral monuments [9.3]. A favourite
motif was a mourning woman seated in front of a bust of the deceased, both
of whom the artist often helpfully identifies with an inscription. She may
stand for some generally benevolent idea which the spectator would share
such as Gratitude or Friendship. If the deceased was a well-known public
figure she may personify his city (wearing a castellated crown like
Tyche, protectress of cities) or, if he was more widely famed, Italy herself.

As for the figure of Death, Canova, with a stroke of originality, made a complete break with the customary skeletons, skulls and cadavers that had lasted, with few breaks, from the Middle Ages down to Bernini. On the tomb of Pope Clement XIII in St Peter's (made between 1783–92) he portrays Death as a handsome nude youth, as it were an 'angel of death', winged and reclining on an inverted torch. A torch thus extinguished was placed in the hands of Cupid by Renaissance artists to denote love that was unrequited or dead, but the image was much older than that. Roman sepulchral art, copying Mithraic monuments, shows two genii holding torches, one upright, one inverted, symbolizing respectively life and death, and Winckelmann refers to an antique relief of two youths with down-turned torches whom he identifies as Sleep and Death, the children of Night (p. 288).[12] Canova used the motif again on the cenotaph (1817–19) in St Peter's dedicated to the last members of the Scottish Stuart family,[13] where winged *epheboi* stand on either side of a door, heads bowed and resting on their dead torches.

We have seen how an image can change its meaning from one age to another while still retaining its essential form. Canova was not averse to adapting his own works in this way to suit the requirements of different patrons. About 1813 he conceived a plan for a colossal marble statue, over twenty-five feet high, personifying the Catholic Faith, to be placed in St Peter's and to be produced entirely at his own expense. A plaster model, offered to Pope Pius VII for his approval, portrays a majestic woman, a papal tiara on her head, over it a veil turned back, and wearing a stole in the manner of a Catholic priest. One hand rests on a medallion showing the Pope praying before a crucifix. A second, larger, but still only half-size model[14] had been completed when the canons of St Peter's turned down the project. Canova, greatly embittered, had meanwhile started work on a marble figure personifying the Protestant Religion for a group of English patrons. At the news of the rejection of the St Peter's statue he decided simply to modify his original conception by removing the tiara and stole and making a few other changes. The completed work stands in the parish church of Belton in Lincolnshire beside the tomb of Sophia Brownlow whose portrait replaces that of the Pope in the medallion. Thus the meaning of images remained adaptable to the last.

SUMMARY

The quality of Italian art began to decline in the second half of the seventeenth century and by the end of the eighteenth it had nothing fresh to show. Wealthy patrons, lay or ecclesiastical, were fewer and artists were looking for commissions abroad. In Rome genre painting (*Bambocciata*) flourished, introduced from Holland in 1625, but Roman monumental art

in the grand manner gradually lost its originality and interest. The final flowering of Italian art took place in Venice in the eighteenth century. Though the great days of the city's power and prosperity were over, painters like Tiepolo continued to celebrate her past. In Venetian religious painting the influence of the Counter-Reformation was still present.

Rome in the eighteenth century was a place of cultural pilgrimage. This provided opportunities for Roman portrait painters and created a demand for the romantically-treated townscapes and views of classical ruins, called *vedute*, of which Piranesi was the master. The city's importance in the eighteenth century was as a centre of antiquarian and archaeological studies for the rest of Europe. The German art historian Winckelmann worked there from 1755. His writings on classical Greek sculpture contributed to the Neo-classical revival. This movement was international and began in France as a reaction to the excesses of Baroque and Rococo styles. In Italy its principal exponents were the German painter Mengs and the sculptor Canova. As to subjects, Neo-classical artists preferred the heroes of ancient Greece and Rome to the myths. Scenes from the Trojan war were popular. Canova was wide-ranging in his choice of subjects, his works based on mythology being among his most successful. His output included monumental tombs where classical inspiration is also evident. But whereas in France the Revolution and the rise of Napoleon strongly influenced artists, nothing comparable occured in Italy in spite of her political struggles in the nineteenth century.

Notes and References

INTRODUCTION

1 H. Foçillon, *The Art of the West*, transl. Donald King, London 1963.
2 Clement of Alexandria, *Exhortation to the Greeks*. 4:45. Transl. G. W. Butterworth, London 1919.
3 *Ibid.* 4:51.
4 Gregory the Great, *Epist.* 9:9.
5 C. Mango, *Sources and Documents: The Art of the Byzantine Empire*, New Jersey 1972.
6 Luke 15:3–7; also John 10:7–18.
7 M. P. Perry, 'On the Psychostasis in Christian Art', *Burlington Magazine*, XXII, 1912–13, pp. 94ff and 208ff; also L. F. A. Maury, 'Recherches sur l'origine des représentations figurées de la psychostasie', *Revue Archaeologique*, 1844.
8 *Vita Constantini*, III:3. Authorship doubtful, attributed to Eusebius, Bishop of Caesarea (*c.* 256–340).
9 Gen. 22:1–19.
10 Mark 14:66–72.
11 E. Mâle, *L'art réligieux du XVIIᵉ siècle*, 2:6, Paris 1932.

CHAPTER ONE

1 The name Italia was already applied to the south-west of the peninsula in the fifth century BC. By the beginning of the Roman Empire it was used for the whole region south of the Alps including Cisalpine Gaul.
2 Herodotus, *Histories*, 1:94.
3 M. Pallottino, *The Etruscans*, 1942, revised English transl. 1975.
4 Gen. 40; 41:1–45.
5 I Sam. 28.
6 From the Latin, *hira*, intestines, and *specio*, to look at.
7 From the Greek, under the earth.
8 Homer, *Iliad*, 23:200–225.
9 See further, Frederik Poulsen, *Etruscan Tomb Paintings, their Subjects and Significance*, transl. Ingeborg Andersen, Oxford 1922.
10 Virgil, *Aeneid*, 5.
11 From the French, *gésir*, to repose; hence, *ci-gît*, here lies . . .
12 Called the *pompa circensis. Pompa*, a solemn procession.
13 Livy, *History of Rome*, 5:22. Transl. Aubrey de Sélincourt.
14 Homer, *op. cit.* (note 8), 1:524–30. Transl. E. V. Rieu.

CHAPTER TWO

1 Livy. *op. cit.* (ch. 1, note 13), 5:47.
2 Pliny, *Natural History*, 35:154.
3 *Ibid.* 34:26.
4 Cicero, *The Verrine Orations*, Part II, 4:33–38. Transl. L. H. G. Greenwood, London 1935.
5 Pliny, *op. cit.* (note 2), 35:6.
6 Polybius, 6:53.
7 Pliny, *op. cit.* (note 2), 34:30–31.
8 Virgil, *op. cit.* (ch. 1, note 10), 1:6.
9 Livy, *op. cit.* (ch. 1, note 13), 1:3.
10 I. S. Ryberg, *Rites of the State Religion in Roman Art*, Rome 1955.

11 Virgil, *op. cit.* (ch. 1, note 10), 8: 42–8 and 81–5.

12 A useful, well-illustrated booklet on the Altar of Peace is *The Ara Pacis Augustae* by G. Moretti, Istituto Poligrafico dello Stato, Rome 1975. On the identity of the figures on the Tellus Mater slab, see Arnaldo Momigliano, 'The "Peace" of the Ara Pacis', *Journal of the Warburg and Courtauld Institutes*, V, 1942, pp. 228ff; also E. Strong in the *Journal of the Royal Society*, vol. 27, 1937, p. 114.

13 Now in the Philadelphia Museum of Art.

14 Livy, *op. cit.* (ch. 1, note 13), 5: 21.

15 For a detailed account of a Roman triumph see Plutarch, 'Life of Aemilius Paullus', 32–3.

16 Not a candlestick though often so depicted. See Exod. 25: 31–40.

17 Described in Exod. 25: 23–30.

18 Juvenal, *Satires*, 10: 36ff.

19 See Livy, *op. cit.* (ch. 1, note 13), 30: 15, for the accoutrements of the triumphator; also Pliny, *op. cit.* (note 2), 33: 111–12, on the use of cinnabar on statues of the gods and in triumphal processions.

20 See J. A. Philip, *Pythagoras and early Pythagoreanism*, Toronto, 1966, for an account of the Harmony of the Spheres and its cosmology.

21 F. Cumont, 'L'aigle funéraire des Syriens et l'apothéose des Empereurs', in *Revue de l'histoire des Religions*, vol. 62, 1910, pp. 119ff.

22 If the triumphal arch is thought of schematically as two uprights and a cross-piece, then the uprights are called pylons and the cross-piece is the attic.

23 See Mrs Arthur Strong, *Apotheosis and Afterlife*, London 1915, pp. 31ff.

24 Augustine, *City of God*, 22: 15.

25 Homer, *Odyssey*, 8: 266–365.

26 Lucretius, *De Rerum Naturae*, 1: 32ff. Transl. Charles E. Bennett, New York 1946.

27 Hyginus, *Fabulae*, 52, 152, 154. Ovid, *Metamorphoses*, 2: 150–327.

28 Hyginus, *op. cit.*, 153. Ovid, *op. cit.*, 1: 348–415.

29 The paintings are described by Pausanias, *Description of Greece*, 1, 15: 1–5.

30 Cicero, *De Natura Deorum*, 2: 32. Transl. H. C. P. McGregor.

31 Virgil, *op. cit.* (ch. 1, note 10), 6: 740ff. Transl. W. F. Jackson Knight.

32 Diodorus Siculus, 3: 58–9.

33 See F. Wickhoff, *Roman Art*, London 1900, for an account of the 'continuous' pictorial method.

34 Plato, *Republic*, 3: 399E. Transl. A. D. Lindsay.

35 Cicero, *Dream of Scipio* (*Somnium Scipionis*), 5: 3. Transl. Michael Grant.

36 Virgil, *op. cit.* (ch. 1, note 10), 6: *passim*.

37 Homer, *op. cit.* (note 25), 4: 563ff. Transl. E. V. Rieu.

38 St Ambrose, *De Bono Mortis*, 12: 53.

39 Plato, *Ion*, 534. Shelley's translation.

40 See F. Cumont, *Recherches sur le Symbolisme Funéraire des Romains*, Paris, 1942.

CHAPTER THREE

1 Eusebius, *History of the Church*, 2: 25. Transl. G. A. Williamson, 1965. The Vatican at that time was the name of a hill beside the Tiber and was the site of a pagan cemetery.

2 Exod. 20: 4.

3 Clement of Alexandria, *Paedagogia*, 3: 11.

4 Heb. 6: 19.

5 Tertullian, *On Chastity*, 7.

6 Gregory the Great, *Epistles*, 9: 105 and 11: 13.

7 See H. Stern, 'Orphée dans l'art paléochrétien', in *Cahiers Archéologiques*, vol. XXIII, 1974, p. 1ff.; also vol. XXVI, 1977, p. 19ff.

8 Latin *orans*, praying.

9 Tertullian, *On Prayer*, 14.

10 See F. Cabrol, *Liturgical Prayer*, London 1922.

11 Matt. 12: 39–41.

12 Luke 1: 26–38.

13 Matt. 2: 1ff.

14 Mark 2: 3–12.

15 John 11: 1–44.

16 Greek *eucharistia*, a giving of thanks, see Mark 14: 23 etc; hence also to consecrate.

17 Greek *agape*, love, charity.

18 See I Cor. 11: 17–22.

19 Justin Martyr, *Apologies for the Christians*, 1: 66.

20 Tertullian, *Prescription against Heretics*, 40.

21 The earliest account of the Last Supper is found not in the gospels but in St Paul, I Cor. 11: 23–27. For the possible significance of this, see F. R. Conybeare, *Myth, Magic and Morals*, ch. 14. London 1909.

22 Mark 8: 1–10.

23 Lev. 24: 5–9.

24 Lev. 23: 4–14.

25 The letters of the word *ichthys*, fish, from the initials of *Iesous Christos Theou Yios Soter*, Jesus Christ, of God the Son, Saviour.

26 Tertullian, *On Baptism*, 1.

27 Catacomb of St Peter and St Marcellinus, Rome.

28 See E. R. Goodenough, *Jewish Symbols in the Greco-Roman Period*, New York 1956 (Bollingen Series, xxxvii) for a discussion of the sacred meal in all its aspects.

29 Petronilla was a first-century convert of the Flavian family, descended from the Emperor Vespasian's grandfather. A sixth-century legend made her the daughter of the apostle Peter. Originally buried in the catacomb of Domitilla (another convert of the same imperial family) Petronilla's remains were transferred to St Peters in the eighth century. She became the patron saint of the French kings. See E. Mâle, *The Early Churches of Rome*, London 1960.

30 See A. Grabar, *Martyrium: Recherches sur le culte des reliques et l'art chrétien antique*, Paris, 1946.

31 Pliny, *op. cit.* (ch. 2, note 2), 35: 12.

32 The 'New Law', that is, the gospels in contrast to the Old, or Mosaic law.

33 See A. Grabar, *Christian Iconography, a Study of its Origins* (A. W. Mellon Lectures in the Fine Arts) Princeton, 1968.

34 See further, Gibbon's *Decline and Fall of the Roman Empire*, chap. 20; G. Pitt-Rivers, *The Riddle of the 'Labarum' and the Origin of Christian Symbols*, London 1966.

35 Rev. 22: 13 and elsewhere.

36 Augustine, *op cit.* (ch. 2, note 24), 21: 4.

37 Augustine, *Retractations*, 2: 43.

38 Tertullian, *On Idolatry*, 24.

39 Hippolytus, *Elenchus*, 9. 12: 23.

40 *Apostolic Constitutions*, Bk 2: 57; Bk 8.

41 Mark 4: 35–41.

42 *Ibid.* 6: 47–52.

43 John, chap. 1.

44 By a monk named Rabula in the monastery of Zagba, northern Mesopotamia, now in the Laurentian Library, Florence.

45 See chap. 4, note 30.

46 John 1: 32.

47 Gen. 18: 1–19.

48 Formerly thought to have been a converted pagan basilica of the second century. See E. Mâle, *The Early Churches of Rome*, p. 60ff.

49 Not all agree that the mosaics were directly inspired by the decisions of the Council.

50 See M. R. James, *The Apocryphal New Testament*, Oxford 1924.

51 See C. Bertelli, ' La Madonna del Pantheon', *Bolletino d'Arte*. 1961, p. 24ff.

52 *Demonstration of the Gospel*, 3. 7: 32, quoted by D. S. Wallace-Hadrill in *Eusebius of Caesarea*, Toronto 1960.

53 Rubens, Liechtenstein Gallery, Vienna. There is a copy by Van Dyck in the National Gallery, London.

54 The river of life flowed through the New Jerusalem, the celestial city. Because the river was 'God's free gift to the thirsty' it was taken to symbolize

the gospels and was represented as four separate streams. See Rev. 21; also 7:9–17.

55 Rev. 4:2ff; 5:1.

56 *Ibid.* 5:1.

57 *Ibid.* 4:6–8.

58 See 'Le trône vide d'Alexandre et le culte du trône vide' by Charles Picard, *Cahiers Archéologiques*, vol. 7, Paris 1954.

59 Greek, an unveiling.

60 'Modestina AW' – Catacomb of Priscilla.

61 Rev. 22:12–13.

62 John 1:36.

63 S. Maria Maggiore, S. Maria in Trastevere, S. Prassede, S. Cecilia, S. Clemente.

64 Rev. 14:1.

65 Gen. 2:10–14.

66 See further, *The Apocalypse in Art* (The Schweich lectures of the British Academy 1927), by M. R. James, London 1931.

67 Augustine, *Quaestiones in Heptateuchum*, 2:83; see also *City of God*, 4:33, 5:18, etc.

68 Nilus, *Epistle*, 1.4:61, 'To the Eparch Olympiodorus.'

69 Paulinus (Bp of Nola), *Carmen*, 27:511ff.

70 E. Mâle, *op. cit.* (note 48), p. 56ff.

71 For an account of early Christian worship of images, see Ernst Kitzinger, 'The Cult of Images in the Age before Iconoclasm', *Dumbarton Oaks Papers*, no. 8, 1954, Cambridge, Mass.

72 See further Grabar, *op. cit.* (note 30).

CHAPTER FOUR

1 On Byzantine bronze doors in Italy, see O. M. Dalton, *Byzantine Art and Archaeology*, Oxford 1911, p. 618ff. On their iconography, see Margaret English Frazer, 'Church doors and the Gates of Paradise: Byzantine bronze doors in Italy', *Dumbarton Oaks Papers*, no. 27, 1973, p. 145ff.

2 On Byzantine art in Italy, see in particular, besides Dalton, *op cit.* (note 1), A. L. Frothingham, 'Byzantine Art and Culture in Italy and especially in Rome', *American Journal of Archeology*, vol. x, 1895, p. 152ff; Ch. Diehl, *L'art Byzantin dans l'Italie méridionale*, Paris 1894; Ch. Diehl, *Manuel d'art Byzantin*, Paris 1925, in particular vol. 2, ch. xi, p. 712ff; O. Demus *Byzantine Art and the West*, London 1970 (The Wrightsman Lectures, vol. 3); Ernst Kitzinger, *The Art of Byzantium and the Medieval West: Selected Studies*, Indiana 1976.

3 Named after the Christian convert mentioned in Acts 17:34. Pseudo-Dionysius was the author of *De Hierarchia Celesti* which includes a description of nine choirs of angels, thereby furnishing an important part of

their iconography in medieval art, Byzantine and Western.

4 St Basil the Great, 329–79; St Gregory Nazianzen, c. 329–90; St Gregory of Nyssa, died c. 395.

5 M. Rostovtzeff, *Dura-Europos and its Art*, Oxford 1938.

6 For a discussion of the date, see Ann Perkins, *The Art of Dura-Europos*, Oxford 1973, pp. 40–1.

7 See J. H. Breasted, *Oriental Forerunners of Byzantine Painting*. Chicago 1924.

8 From the *Vita S. Stephani iunioris*, quoted by Mango in *Sources and Documents: The Art of the Byzantine Empire 312–1453*, New Jersey 1972, pp. 152–3.

9 See C. R. Morey, *Medieval Art*, New York 1942, pp. 102–3. Belief in the divine origin of works of art was also widely held in antiquity. Pliny mentions that bronzes of outstanding craftsmanship were attributed to the gods, i.e., Hephaestus, or Vulcan. Pliny, *op. cit.* (ch. 2, note 2), 34:5.

10 Gregory Palamas (c. 1296–1359), *Homilies*, 20.

11 See G. Millet, *L'iconographie de l'Évangile*, Paris 1916, p. 25ff.

12 The original building has been altered, the main apse having been replaced by a chapel with the consequent loss of the mosaics. For a list of cross-in-square churches in southern Italy and Sicily, see O. Demus, *The Mosaics of Norman Sicily*, London 1950, p. 86, note 29.

13 Photius, *Homilies*, X, 4ff., quoted by Mango, *op. cit.* (note 8), p. 186.

14 Acts 1:9–12.

15 *Ibid.* 2:1–13.

16 Isa. 66:1.

17 From Isa. 7:14, and quoted in Matt. 1:23.

18 Isaiah 7:14.

19 See G. Millet, *op. cit.* (note 11), Bk. I, ch. 2 & 3.

20 Annunciation, Luke 1:26–38; Nativity, Luke 2:1–20; Presentation, Luke 2:22–39; Baptism, Matt. 3:13–17; Mark 1:9–11, Luke 3:21–22, John 1:29–34; Transfiguration, Matt. 17:1–13, Mark 9:2–13, Luke 9:28–36; Lazarus, John 11:1–44; Entry into Jerusalem, Matt. 21:1–11, Mark 11:1–10, Luke 19:29–38, John 12:12–15; Crucifixion, Matt. 27:33–56, Mark 15:22–41, Luke 23:33–49, John 19:17–37; Harrowing of Hell, apocryphal Gospel of Nicodemus; Ascension, Acts 1:9–12; Pentecost, Acts 2:1–4; Dormition, apocryphal, see M. R. James, *op. cit.* (ch. 3, note 50), p. 194ff.

21 Matt. 2:13–15.

22 Luke 1:5–22.

23 John 1:1–22.

24 Last Supper, Matt. 26:17–29, Mark 14:12–25, Luke 22:7–23, John 13:21–30; Agony in the Garden, Matt. 26:36–46, Mark 14:32–42, Luke 22:39–46; Betrayal, Matt. 26:47–56, Mark 14:43–52, Luke 22:47–53, John 18:1–12; Entombment, Matt. 27:57–61, Mark 15:42–47, Luke 23:50–55, John 19:38–42; Emmaus, Luke 24:28–32.

25 See Tancred Borenius, *St Thomas Becket in Art*, London 1932, pp. 13–14 and plate I; also O. Demus, *op. cit.* (note 12), pp. 128ff.

26 On the general theory of the icon in middle-Byzantine church decoration, see O. Demus *Byzantine Mosaic Decoration*, London, 1948.

27 Gen. 22:1–19.

28 *Ibid.* 18:1–19.

29 See C. Cecchelli, *La Cattedra di Massimiano ed altri avori romano-orientali*, Rome 1936.

30 In the Cottonian Library, British Museum, London. It was badly damaged by fire in 1731.

31 Gen. 1:14.

32 Matt. 25:31–46.

33 Isa. 66:1.

34 Dan. 7:9–10.

35 Rev. 20:13.

36 Luke 23:43.

CHAPTER FIVE

1 From the Greek *barbaroi* meaning, not uncivilized, but all those peoples who did not speak Greek, just as the Jews called all but themselves Gentiles. The Greeks sometimes called the Romans barbarians.

2 Or *Longobardi*, the long-bearded. Like another Teutonic people, the Goths, they adopted the Arian form of Christianity. They were converted to orthodoxy about 600.

3 E. W. Anthony, *Romanesque Frescoes*, Princeton 1951, pp. 23ff.

4 G. H. Crichton, *Romanesque Sculpture in Italy*, London 1954, pp. 44ff.

5 In classical and Hellenistic Greek architecture, supporting columns are sometimes carved in the figure of a man with hands upraised as if bearing the weight of the architrave, called a Telamon, or Atlas (plural Atlantes). The corresponding female figure is the Caryatid. There is a fine example of a Telamon in the Archaeological Museum, Agrigento, from the nearby Temple of Zeus.

6 The Evangeliary (c. 1002–35) of Abbess Uota of Niedermunster, Staatsbibliothek, Munich.

7 See H. Foçillon, *The Art of The West*, Vol. I, p. 25, note 1, for a short bibliography concerning the end of the world in the year 1000.

8 See E. W. Anthony, *op. cit.* (note 3), also O. Demus, *Romanesque Mural Painting*, London, 1970 (transl. by Mary Whittall from *Romanische Wandmalerei*, Munich, 1968).

9 S. Giacomo, Termeno.

10 S. Michele, Lucca.

11 Modena cathedral; Pisa baptistery; Lucca, cathedral of S. Martino; Arezzo, Pieve di Santa Maria. There is also a fine series at St Mark's, Venice.

12 Called the Spinario, the 'thorn-puller'. The prototype is an antique bronze statue (Pal. dei Conservatori, Rome) representing a naked youth, seated, one foot resting on the other knee, drawing a thorn from the sole. It was much copied by 15th and 16th century Italian sculptors.

13 In Pompeian and Roman wall-painting and pavement mosaics Spring is personified by a young woman holding flowers.

14 See J. C. Webster, *The Labors of the Months*, Princeton Monographs in Art and Archaeology, 1938.

15 See J. Seznec, *The Survival of the Pagan Gods*, Bollingen Foundation Series, New York, 1953, p. 149ff.

16 Pliny, *op. cit.* (ch. 2, note 2), 7: 2.

17 Augustine, *op. cit.* (ch. 2, note 24), 16: 8.

18 Isidore of Seville, *Etymologiae*, XI, 3, 'De Portentis', 'On monsters'. Rabanus Maurus (776–856), Archbishop of Mainz, rewrote the *Etymologiae*, adding allegorical explanations. The work, *De Universo*, exists in an illustrated Italian copy made at Monte Cassino, 1022–23. See F. Saxl, 'Illustrated Medieval Encyclopaedias, I' (Warburg Institute Lecture, 1939), *Lectures*, 1957.

19 On the history of monsters of this kind, see R. Wittkower, 'Marvels of the East', *Journal of the Warburg and Courtauld Institute*, Vol. V, 1942, pp. 159ff.

20 From a letter to the Abbot of St Thierry, quoted in *Life in the Middle Ages* by G. G. Coulton, Cambridge, 1930, pp. 72–76.

21 The paintings are illustrated and discussed in R. van Marle, *The Development of the Italian Schools of Painting*, Vol. I, and E. W. Anthony, *op. cit.* (note 3), which includes a bibliography.

22 See Odell Shepard, *The Lore of the Unicorn*, London 1930.

23 Homer, *op. cit.* (ch. 2, note 25), Bk 12.

24 Jerome, *In Esaiam*, 6: 14.

25 See E. Mâle, *L'art religieux du XII^e Siècle*, p. 39ff. on animal-based columns in canon tables. See Crichton, *op. cit.* (note 4), p. 151 on such columns in sculpture. On the elephant in Hindu mythology, see H. Zimmer, *Mythes et Symboles dans l'art et la civilisation de l'Inde*, p. 101ff., Paris 1951. Originally published in English, New York, 1945.

26 Fidenza was for long known as Borgo San Donnino after the legendary Christian martyr to whom the cathedral is dedicated.

27 The tomb, purporting to be that of the apostle, was discovered about 830.

28 Peter, Abbot of Josselin, quoted by Joan Evans, *Life in Medieval France*, Oxford, 1925, p. 102.

29 Chaucer, *Canterbury Tales*, Prologue, l. 685.

30 A. Kingsley Porter, in *Romanesque Sculpture of the Pilgrimage Roads*, (Boston, 1923), questions whether French equestrian statues of Constantine are derived from the Marcus Aurelius, which was the opinion of Mâle *op. cit.* (note 25). According to Porter there are equal grounds for its derivation from Byzantine or Egyptian equestrian figures.

31 A relief of the Volto Santo appears on

the outside of Langford church, near Oxford.

32 Images of jongleurs are found on the portals of French churches, e.g., Amboise, Ferrières, Bourbon-l'Archambault, Souvigny, St Martin of Tours, indicating a well-established tradition.

33 See Rita Lejeune and Jacques Stiennon, *La légende de Roland dans l'art du moyen age*, Brussels, 1966, 2 vols.

34 Dante, *Paradiso*, XVIII: 43–5.

35 Dante, *Inferno*, V: 73–142.

36 From the *Historia de Proeliis*, 'A History of Warriors', (951–969) by Archpresbyter Leo of Naples, quoted by R. S. Loomis in 'Alexander the Great's Celestial Journey', *Burlington Magazine*, vol. 32, 1918, p. 136ff., to which I am indebted for much else concerning this subject.

37 R. S. Loomis *op cit.* (note 36), mentions the following: Tympanum: Charney Bassett, Berks (second half of twelfth century). Misericords: Wells cathedral (1330); Gloucester (two examples, *c.* 1345); Lincoln (*c.* 1370); Chester (*c.* 1390); Cartmel priory church (end of fourteenth century); Darlington (*c.* 1430); Whalley, Lancs (slightly later); St Marys, Beverley, Yorks (*c.* 1445).

38 See E. W. Anthony *op. cit.* (note 3), page 105ff., for a discussion and bibliography.

39 I Kings 10: 1–13.

40 See O. M. Dalton, *op. cit.* (ch. 4, note 1), p. 344ff.

41 Isa. 11: 1–2.

42 Matt. 1: 1–17.

43 Isa.: *loc. cit.*

44 See A. Katzenellenbogen, *The Sculptural Programs of Chartres Cathedral*, Baltimore, 1959.

45 The first account is in apocryphal literature, probably fourth-century (see M. R. James, *op. cit.* (ch. 3, note 50). A much extended version is found in the thirteenth-century *Golden Legend*. The theme appeared first in Byzantine art after the iconoclast era and formed the last of the cycle of Twelve Feasts (p. 127).

46 'Leva eius sub capite meo et dextera illius amplexabit me.' – Song of Songs. 8: 3.

47 'Veni electa mea, et ponam in te tronam meam', an extract from the antiphon sung at the feast of the Assumption, probably inspired in part by Psalm 45, especially verses 6–9.

48 Matt. 25: 31–46.

49 M. G. Zimmermann, *Oberitalische Plastik*, Leipzig 1897.

50 Matt. 20: 1–16.

51 From the Life of St Barlaam, in the *Golden Legend*, a collection of lives, chiefly of the saints, by Jacob of Voragine, Archbishop of Genoa, published about 1275. The decoration of the south portal of the baptistery is thought by some to be some sixty years later than the others which have been dated about 1216.

52 Psalm 144, verse 4. See O. M. Dalton, *op. cit.* (ch. 4, note 1), p. 664 and C. H. Crichton, *op. cit.* (ch. 5, note 4), p. 66ff., for discussion and bibliographies.

53 I. Cor. 13: 13.

54 See H. Woodruff, *The Illustrated MSS of Prudentius*, Cambridge, Mass. 1930.

55 Plato, *op. cit.* (ch. 2, note 34), 4: 427ff.

56 See O. Demus, *Die Mosaiken von San Marco in Venedig 1100–1300*, Baden 1935; also A. Katzenellenbogen, *Allegories of the Virtues and Vices in medieval Art*, London 1939.

CHAPTER SIX

1 See G. G. Coulton, *The Medieval Scene*, Cambridge 1960, for a summary of the 'scholastic method' derived from Abelard.

2 The bull *Cum inter nonnullos* issued by John XXII.

3 See further on the background to this period, Frederick Antal, *Florentine*

painting and its Social Background, London 1948.

4 I Sam. 16:1–13.

5 Judges 6:36–40.

6 Isidore of Seville, *op. cit.* (ch. 5, note 18), 8:8.

7 The earliest discussion of the Sibyls by a Christian writer is in the *Divinarum Institutionum* of Lactantius (*c.* 250–317).

8 Augustine, *op. cit.* (ch. 2, note 24), 18:23.

9 *Ibid.* 10:27.

10 Mayor, Warde Fowler and Conway, *Virgil's Messianic Eclogue*, 1907; T. F. Royds, *Virgil and Isaiah, a Study of the Pollio*, 1918.

11 See also Elizabeth A. Rose, 'The Meaning of the Reliefs on the Second Pier of the Orvieto Façade', *Art Bulletin*, vol. 14, 1932.

12 See J. Schlosser, 'Giustos Fresken in Padua', *Jahrbuch der Künsthistorischen Sammlungen in Wien*, vol. 17, 1896, for a detailed description copiously illustrated with sketches.

13 The Seven Sacraments, in the order in which they appear on the campanile (north side) are: Baptism, Penance, Matrimony, Ordination, Confirmation, Eucharist and Extreme Unction.

14 Vincent of Beauvais, 'Speculum Historiae' (the third part of the *Speculum Majus*) 1:57; Isidore of Seville, *op. cit.* (ch. 5, note 18), 19:20–33.

15 Dante, *Convito*, 2:5.

16 *Ibid.* 2:14–15. For a discussion see, e.g. T. G. Bergin, *An Approach to Dante*, London 1965.

17 See P. d'Ancona, 'Le Rappresentazioni allegoriche delle Arti Liberali nel Medio Evo e nel Rinascimento', *L'Arte*, vol. 5, 1902.

18 See *The Canticle of Brother Sun*, a hymn of praise by St Francis. A translation is given in G. Kaftal, *St Francis in Italian Painting*, London 1950.

19 Bonaventura, *Legenda Major*, 7:6.

20 Musée Condé, Chantilly. One of a series of eight painted for the church of San Francesco at Sansepolcro. The other seven are in the Nat. Gall., London.

21 Gen. 2:9; 3:22.

22 See ch. 5, note 51.

23 See P. Mazzoni *La Legenda della Croce nell'Arte italiana*, Florence, 1914.

24 Rev. 7:2

25 National Museum, Pisa.

26 The Louvre, and the Diocesan Museum, Cortona.

27 *De Vita et miraculis S. Dominici et de Ordine Praedicatorum quem instituit* – On the life and miracles of St Dominic and the order of Preachers which he founded.

28 'Veritatem meditabitur guttur meum et labia mea detestabuntur impium' – 'For my mouth shall speak truth; and wickedness is an abomination to my lips'. Prov. 8:7.

29 Dante, *op. cit.* (ch. 5, note 35), IV:144.

30 Matt. 14:22–34.

31 Often treated as a subject in its own right, called 'Noli me tangere' – 'Touch me not,' from John 20:10–18.

32 A. Venturi, *Storia dell'Arte Italiana* (Milan, 1907) gives other examples of images he considers are derived from Passavanti (vol. V, p. 778ff).

33 A third-century African bishop who, like Arius, held heretical opinions about the Trinity.

34 A full analysis with identifications is given by J. Schlosser, *op. cit.* (note 12).

35 Isa. 11:2. Isaiah gives only six: Piety (Pietas) was added in the Middle Ages to round off the number.

36 See discussions, with references to others, in F. Antal, *op. cit.* (note 3) p. 259, n. 51, and M. Meiss, *Painting in Florence and Siena after the Black Death*, Princeton, 1951, p. 98, n. 9. Both describe the iconography of the Spanish Chapel.

37 Dante, *op. cit.* (ch. 5, note 34), XII:100–105.

38 The Assumption of the Virgin was based on an account attributed to Melito, bishop of Sardis (*c.* fourth century). See M. R. James, *op. cit.* (ch.

3, note 50).(See also ch. 5, note 51.)

39 A modern edition of Giovanni de Caulibus' *Meditations on the Life of Christ*, with illustrations from a fourteenth-century Italian version, has been translated by Isa Ragusa and Rosalie B. Green, Princeton, 1961.

40 Bridget of Sweden, *Revelationes Celestes*, VII.

41 See M. Meiss, *op. cit.* (note 36), p. 106, n. 6, and p. 149, n. 73. Also E. Panofsky, *Early Netherlandish Painting*, p. 46, etc.

42 Matt. 25:41.

43 Rev. 20:1-3, 7-10.

44 Job. 41.

45 Museo di S. Marco, Florence.

46 Virgil, *op. cit.* (ch. 1, note 10), 6.

47 *Ibid.* 3:225ff.

48 Dante, *op. cit.* (ch. 5, note 35), XVII:64. Dante does not name the usurer but identifies him by his coat of arms which was a blue sow in farrow.

49 Rev. 12:1.

50 See M. Meiss, *op. cit.* (note 36), ch. 6, for a discussion of the Madonna of Humility.

51 Giovanni de Caulibus, *op. cit.* (note 39), p. 82.

CHAPTER SEVEN

1 Jerome, *Epistle* 22.

2 Augustine, *op. cit.* (ch. 2, note 24), 8:5.

3 Augustine, *De Vera Religione*, 7.

4 For references see *City of God*, transl. H. Bettenson, Penguin Books, 1972, p. 314, note 23.

5 From *Fulgentius the Mythographer*, a translation by L. G. Whitbread, Ohio 1971.

6 On the moralizing of Ovid, see J. Seznec, *op. cit.* (ch. 5, note 15), pp. 92, 109, etc; E. Panofsky, *Renaissance and Renascences in Western Art*, London 1970, pp. 78–81 (note).

7 Dante, *op. cit.* (ch. 5, note 35), IV. See p. 113 for the Harrowing of Hell in Byzantine art.

8 Dante does not ignore the problem of the virtuous pagan and his place in the Christian after-life (*Paradiso*, XIX and XX). He allows only two to enter heaven, the Emperor Trajan and a hero of the siege of Troy named Rhipeus (*Aen.* 3:426–7).

9 Dante acknowledges his debt to earlier poets of the love-lyric in the *Paradiso*, XXVI.

10 Giorgio Vasari, *Lives of the Painters, Sculptors and Architects*. Florence 1550.

11 See E. Panofsky, *Studies in Iconology*, p. 18ff., Oxford 1939.

12 Aeneas Silvius Piccolomini (1405–64).

13 Virgil, *op. cit.* (ch. 1, note 10), 1:242ff.

14 On Renaissance antiquarianism, see R. Weiss, *The Renaissance Discovery of Classical Antiquity*, Oxford 1969.

15 Dante declined the honour unless the ceremony took place in the Baptistery of his native city, Florence, where he had been baptised. He died un-crowned in exile. See *Paradiso*, XXV:7–12.

16 Dante, *Purgatorio*, XXIX to XXXI.

17 See, for example, the Triumph tapestries at Hampton Court Palace and the Victoria & Albert Museum, London. They were woven in Brussels during the first quarter of the sixteenth century. Those at Hampton Court were once part of a set of eight bought by Cardinal Wolsey about 1523.

18 For Petrarch and his influence on art, see Prince d'Essling and Eugène Müntz, *Pétrarque, ses études d'art (etc)*, Paris 1902. For the history of the Sala dei Giganti, see Theodor E. Mommsen, 'Petrarch and the dec-oration of the Sala Virorum Illustrium in Padua', *Art Bulletin*, June 1952, p. 95ff.

19 Dante, *op. cit.* (ch. 5, note 35), XX:115–7.

20 Examples of visual and literary mis-readings are given in Seznec, *op. cit.* (ch. 5, note 15), pp. 179–183. On Qazwini, see Seznec, pp. 162–3.

21 Panofsky, *op. cit.* (note 6), p. 164, note 1.

22 For two views of Masaccio's Eve, see Panofsky, *op. cit.* (note 6), p. 167, note 2, and Benjamin Rowland, *The Classical Tradition in Western Art*, Harvard 1963, pp. 161–4.

23 Alberti, *De Pictura*, III: 54, from the trans. Cecil Grayson, London 1972.

24 For the iconography of the 'Andrians' see F. Saxl, 'A Humanist Dreamland', from *Lectures*, Warburg Institute, London 1957. The 'Feast of Venus', is discussed by E. Wind, *The Feast of the Gods*, Cambridge, Mass. 1948, pp. 56–63. On *ekphrasis* as a literary form among Byzantine and Italian humanists see M. Baxandall, *Giotto and the Orators* Oxford–Warburg Studies), Oxford 1971.

25 Almost entirely destroyed by bombing in 1944, though the church was rebuilt and part of the frescoes restored.

26 See further F. Saxl, *op. cit.* (note 24), 'Jacopo Bellini and Mantegna as Antiquarians'.

27 Now in the Orangery, Hampton Court Palace, London.

28 See E. H. Gombrich, 'The early Medici as Patrons of Art', in *Italian Renaissance Studies : A Tribute to the late Cecilia M. Ady*, London 1960.

29 See F. Saxl, *op. cit.* (note 24), pp. 174–188, 'The Appartamento Borgia'.

30 Augustine, *op. cit.* (ch. 2, note 24), 5 : 2–6.

31 Aquinas, *Summa Theologica*, I.I. 115.4., quoted by T. O. Wedel in *The Medieval Attitude toward Astrology*, Oxford 1920.

32 F. Saxl, *op. cit.* (note 24), 'The Villa Farnesina', pp. 189–199.

33 Plato, *op. cit.* (ch. 2, note 34), 10 : 597–8.

34 Plotinus, *Enneads*, II, 9, 16, quoted by Bertrand Russell, *History of Western Philosophy*, p. 315.

35 See further A. Chastel, *Marsile Ficin et l'art*, Geneva/Lille 1954, especially pp. 64–68.

36 Pliny, *op. cit.* (ch. 2, note 2), 35 : 64.

37 Alberti, *op. cit.* (note 23), para. 56.

38 Quoted by Robert Klein and Henri Zerner in *Sources and Documents : Italian Art 1500–1600*, New Jersey 1966.

39 The term used by Jane E. Harrison. See *Introductory Studies in Greek Art*, London 1892, especially Chapter 5.

40 Quoted by Jane Harrison, *op. cit.* (note 39), p. 219.

41 No. LX in the edition by Karl Frey, *Die Dichtungen des Michelagniolo Buonarroti*, 1897.

42 Frey, *op. cit.* (note 41), No. CIX.

43 The evolution of the Idea in relation to art from Plato to the 17th century is fully treated by E. Panofsky in *Idea*, English translation, New York 1968.

44 Matt. 13 : 10–11.

45 See further E. Wind, *Pagan Mysteries of the Renaissance*, London 1958, especially ch. 2.

46 Plato, *Symposium*, 180e. Ficino's theory of love is set out in the *Convito*, or 'Banquet', a commentary on the *Symposium*. Its form, modelled on Plato, is that of a series of discourses given by a group of friends who have gathered to celebrate Plato's birthday. This event is known to have taken place at least once at Careggi.

47 See E. Panofsky, *op. cit.* (note 11), ch. 5. 'The Neoplatonic Movement in Florence and North Italy'.

48 See further, E. Wind, *op. cit.* (note 45), ch. 9, 'Sacred and Profane Love'. On 'mythological portraits' see the same author, *op. cit.* (note 24), pp. 36–44. On the identity of the bride and groom see Tomei, Alessandro, 'Amor sacro e profano' in *Attività educative*, published for the Borghese Gallery by the Beni Artistici e Storici di Roma, December, 1977.

49 Ovid, *Fasti*, 5 : 193ff.

50 Alberti, *op. cit.* (note 23), III: 54.

51 The extracts are from the translation by Robert Graves, 1950.

52 For a discussion of Botticelli's mythological paintings from varying standpoints see E. H. Gombrich 'Botticelli's

Mythologies', in *Symbolic Images*, London 1972; the relevant chapters in E. Wind, *op. cit.* (note 45), and L. D. and Helen S. Ettlinger, *Botticelli*, London 1976.

53 The full text is given in 'Isabelle d'Este et les artistes de son temps', by Charles Yriarte, *Gazette des Beaux-Arts*, Vol. 14, Aug. 1895, p. 123 (fourth of a series of six articles).

54 For Mantegna's representations of the Vices, see D. & E. Panofsky, *Pandora's Box*, New York 1956, p. 44ff, and further bibliography therein.

55 Pico della Mirandola, *Commento*, II, vi, quoted by E. Wind, *op. cit.* (note 45), ch. 5.

56 Fulgentius, *op. cit.* (note 5), I, 21.

57 Josephus, *Jewish Antiquities*, 2: 70–72.

58 Francesco Colonna, *Hypnerotomachia Poliphili*, dated by the author 1467, but perhaps only completed at the time of its publication.

59 Erasmus, *Adagia*, II, 1.

60 See Mario Praz, *Studies in Seventeenth Century Imagery*, London 1939.

61 Ps. 139: 1.

62 J. Cartwright, *Isabella d'Este*, London 1903, ch. 7.

63 Antonio Maria Salviati (1537–1602).

64 See G. G. Coulton, *Art and the Reformation*, Oxford 1928, ch. 22, quoting Lanciani, *The Destruction of Ancient Rome*, London 1899.

65 See further Rensselaer W. Lee, *Ut Pictura Poesis: The Humanistic Theory of Painting*, New York 1967.

66 E. Wind makes the case for a Dominican friar who was a disciple of Savonarola in 'Sante Pagnini and Michelangelo', *Gazette des Beaux-Arts*, vol. 26, July-Dec. 1944, pp. 211ff.

67 See Charles de Tolnay, *The Sistine Ceiling*, Princeton 1945, for an exposition of this view.

68 Heinrich Wölfflin, *Die Klassische Kunst*, 1899; English translation, *Classic Art*, by Peter and Linda Murray, 1952.

69 The inscriptions, in Latin, read: (Theology) *Divinar(um) rer(um) notit-*

ia; (Philosophy) *Causarum cognitio*; (Poetry) *Numine afflatur*; (Justice, partly obscured) *Ius suu(m) unicuique tribuit*.

70 The kind of viol known as a *lira da braccio*. For an analysis of the Muses' instruments in Raphael's Parnassus, see E. Winternitz, *Musical Instruments and their Symbolism in Western Art*, London 1967, ch. 14.

71 Dante, *op. cit.* (ch. 5, note 34), I: 19–21. From the translation by Dorothy L. Sayers and Barbara Reynolds, Penguin Books 1962.

72 *Discorso intorno alle imagini sacre e profane*, Bologna 1584. Two volumes only were completed, the last three being published in summary only.

73 Horace, *Ars poetica*, line 1ff.

74 Quoted by Anthony Blunt in *Artistic Theory in Italy, 1450–1600*, Oxford 1940, ch. 2.

75 See Klein and Zerner, *op. cit.* (note 38), p. 123.

76 Giovanni Paolo Lomazzo, *Trattato dell'arte della pittura, scultura et architettura*, Milan 1584, and *Idea del tempio della pittura*, Milan 1590.

77 Lomazzo, *Trattato*, 6: 22–27.

78 Now the French Embassy.

79 Ovid, *op. cit.* (note 49), 5: 111–128.

80 The letter, dated 15 May 1565, is given in Gombrich, *op. cit.* (note 52), pp. 23–5 and, in translation, in Klein and Zerner, *op. cit.* (note 38), p. 155ff.

81 Caro's letter, dated 21 November 1562, is given in Vasari in the Life of Taddeo Zuccaro.

82 Hesiod, *Theogony*, 755–59.

83 Pausanias, *Description of Greece*, V, 18: 1.

84 Ovid, *Metamorphoses*, 11: 597ff.

85 Pausanias, *op. cit.* (note 83), VI, 23: 5.

86 For a full analysis of the iconography see J. R. Martin, *The Farnese Gallery*, Princeton 1965.

87 ΘΕΟΘΕΝ ΑVΞΑΝΟΜΑΙ, Theothen auxanomai.

88 An early source is Xenophon, *Memorabilia*, 2.1: 22ff. The original painting is in the Pinacoteca

Nazionale at Naples. The version at Rome is a copy.

89 J. R. Martin, *op. cit.* (note 86), p. 24ff.

See also G. K. Galinsky, *The Heracles Theme*, London 1972.

CHAPTER EIGHT

1 Luca Landucci, *Diario fiorentino dal 1450 al 1516*, Florence, 1883 edition, pp. 44, 106, 193, 199, 209, 238, 250, 279, 291, 308, 328, 330, 337.

2 On the iconography of the Paduan Madonna, with further references, see H. W. Janson, *The Sculpture of Donatello*, vol. 2, p. 184–5, Princeton 1957.

3 Dante, *op. cit.* (ch. 7, note 16), 6: 118.

4 See Ludwig Pastor, *The History of the Popes*, vol. 12, pp. 613ff, English translation 1912.

5 See P. O. Kristeller, 'Paganism and Christianity', in *The Classics and Renaissance Thought*, Harvard 1955.

6 Calvin, *Institutes of the Christian Religion*, I, xi, 12.

7 See Charles Dejob, *L'influence du Concile de Trente sur la littérature et les beaux-arts chez les peuples catholiques*, Paris 1884, especially chap. 3.

8 Pastor, *op. cit.* (note 4), vol. 17, ch. 1.

9 Council of Trent, 25th session, 3 and 4 December 1563. Quoted in Klein and Zerner, *op. cit.* (ch. 7, note 38).

10 Dejob, *op. cit.* (note 7), pp. 243–54; Blunt, *op. cit.* (ch. 7, note 74), pp. 110ff.

11 Molanus (latinized form of Ver Meulen), *De Picturis et Imaginibus sacris*.

12 Unlike the Last Supper at Jerusalem the 'Feast in the House of Simon' took place at Bethany. It was the occasion when Mary Magdalene, or the 'penitent harlot', emptied a flask of myrrh over Christ's feet. It is related in all four gospels.

13 Luke 5: 29–32.

14 The account of the trial, though in dialogue form is not verbatim. It is given in Pietro Caliari, *Paolo Veronese*, Rome 1888, and (in French) in A. Baschet, 'Paolo Veronese', *Gazette des Beaux-Arts*, vol. XXIII, 1867, pp.

378ff. See also Blunt, *op. cit.* (ch. 7, note 74), p. 116.

15 Borromeo, *Instructiones Fabricae et Supellectilis Ecclesiasticae*.

16 Blunt, *op. cit.* (ch. 7, note 74), p. 127ff.

17 The original painting was by Girolamo Muziano but has been replaced by a more recent version by Alessandro Capalti.

18 Luke 2: 21.

19 Failure to liquefy is not unknown and may have political implications. *The Times* (5 May 1976) reported a case of this kind: 'Some of the faithful argued that the saint might have been upset by the presence of a Communist at the head of the municipal administration. But less weight is placed on this theory because Signor Maurizio Valenzi, the Communist Mayor, was heard to comment favourably on the saint's behaviour when the miracle occurred with every promptness immediately after his election.'

20 The head of St Andrew has lately been returned to the Greek Orthodox church at Patras. The others are now all kept in the pier of St Veronica and are displayed in Holy Week.

21 Acts 19: 12 is quoted as biblical support for the curative powers of relics; also Matt. 9: 20–22 and even Acts 5: 15.

22 Calvin, *op. cit.* (note 6), III, xx, 29.

23 Luther, *The Babylonian Captivity of the Church*, 1520.

24 Calvin, *Antidote to the Council of Trent*, 1547.

25 First series: Nat. Gall., Washington, and Belvoir Castle (Duke of Rutland); second series; Nat. Gall. of Scotland, Edinburgh. On Cassiano as the patron of Poussin, see Francis Haskell, *Patrons and Painters* (new edition), Hew Haven 1980.

26 Roberto Bellarmino, *Disputationes de Controversiis Christianae Fidei* (3 vols), 1586–93.

27 Manual labour was accepted instead of money. For example, indulgences were granted to help the rebuilding of St Paul's Cathedral, London, which was completed in 1287.

28 *The Ninety-five Theses*, nos. 27 and 22 from *Reformation Writings of Martin Luther*, vol. 1, by Bertram Lee Woolf, London 1952.

29 On the iconography of the Borghese Chapel see Emile Mâle, *L'art réligieux du XVIIe siècle*, Paris 1932.

30 Wisdom of Solomon, 7:26.

31 Prov. 8:22.

32 Rev. 12:1–6.

33 E. Mâle, *op. cit.* (note 29), p. 38ff.

34 *Historia Ecclesiae Christi*, known as the *Centuries of Magdeburg*, Basle, 1559–74. *Magdeburg*, Basle, 1559–74.

35 Stephen who was stoned to death (Acts. 7:57–60), rather than the supposed martyr Pope Stephen I (d. 257).

36 Brussels Museum.

37 See E. Panofsky, *op. cit.* (ch. 7, note 11), 'The Neoplatonic Movement and Michelangelo'.

38 See C. R. Morey, *Medieval Art*, p. 390ff.

39 See R. Wittkower, *Art and Architecture in Italy, 1600 to 1750*. Pelican History of Art, 1973 paperback edition, p. 157ff.

40 Vatican Picture Gallery. A votive picture. The donor, Sigismondo Conti, escaped death when a cannon-ball fell on his house during the siege of Foligno.

41 Dante, *op. cit.* (ch. 5, note 34), XXVIII. Dante's image is based on the *De Hierarchia Celesti* by pseudo-Dionysius the Areopagite (see ch. 4, note 3).

42 Giovanni Battista Passeri, *Vite dei pittori, scultori ed architetti* (etc), not published until 1772. The interpretations are discussed by W. Vitzthum in 'A comment on the iconography of Pietro da Cortona's Barberini ceiling', *Burl. Mag.*, vol. CIII (1962), p. 427ff.

43 Quoted by E. H. Gombrich in *Symbolic Images*, p. 144.

44 E. Mâle, *op. cit.* (note 29), p. 390ff.

45 For the iconography of the palace and a bibliography, see Ronald Millen, *Luca Giordano a Palazzo Medici-Riccardi*, in the series 'Forma e Colore', Florence 1965.

CHAPTER NINE

1 See further Haskell, *op. cit.* (ch. 8, note 25), pp. 179–202.

2 Wittkower, *op. cit.* (ch. 8, note 39), p. 491ff.

3 Duchess of Saxe-Teschen in the Augustiner-Kirche, Vienna.

4 L. Hautecoeur, *Rome et la renaissance de l'antiquité à la fin du XVIIIe siècle*, Paris 1912, which also deals with the earlier part of the 18th century.

5 The *Carceri d'Invenzione* (Imaginary Prisons), 1745, revised 1760–1.

6 Now the Villa Torlonia.

7 Livy, 1:23–4.

8 It was acquired by the British government after the Battle of Waterloo and presented to the Duke of Wellington. Now in Apsley House, London.

9 Vatican Galleries.

10 National Gallery of Modern Art, Rome. The story is told in Ovid, *op. cit.* (ch. 7, note 84), 9:212–220, and Sophocles, *The Women of Trachis*.

11 E. Bassi, *La Gipsoteca di Possagno*, Venice 1957.

12 J. J. Winckelmann, *Geschichte der Kunst des Altertums*, 1764.

13 The Old and Young Pretenders (d. 1766 and 1788) and Cardinal York (d. 1807).

14 Now in the Accademia di San Luca, Rome.

Greek and Latin alphabets and inscriptions

Alphabetic writing, that is to say, the use of signs to represent single sounds (as opposed to the various systems of picture-writing) seems to have developed first among peoples of the Near East who spoke Semitic languages. The inhabitants of Syria and Palestine are believed to have used an alphabetic script as early as the middle of the second millenium BC. The Greek alphabet, which the Greeks and Romans claimed was invented by one or other of the figures of myth or legend, was adapted from a northern Semitic script, probably about 1000 BC, perhaps in a Greek colony on the coast of Syria. Letters representing sounds common to both languages were taken over by the Greeks more or less unchanged, while new ones were added for vowels (absent from the Semitic alphabet) and for consonants such as 'ph' and 'ps' that were specifically Greek. Like the Semitic scripts, Greek was at first written from right to left; later the lines went in alternate directions, the style known as *boustrophedon*, that is, as the ox turns when drawing a plough. From about 500 BC Greek was written from left to right.

The Latin alphabet was an offspring of Greek. It was once thought to have descended directly from the Greek used by colonists in southern Italy, but more recently it has been shown to be adapted from Etruscan, which was itself derived from a branch of Greek. The earliest Latin inscriptions, like most Etruscan, were written from right to left or in *boustrophedon* and date from the seventh and sixth centuries BC. The Romans made changes to the Etruscan alphabet to suit the sounds of their own language, such as dropping the Greek letters *theta* (th), *phi* and *chi*, and introducing U (written V) to serve for V or U. (The letters J, U and W were added in the Middle Ages.) The splendid alphabet of Roman majuscules, or capital letters, developed by professional stone-cutters in the age of Augustus and the early Empire, set a standard which was never surpassed. In the Middle Ages monumental inscriptions in stone retained the essential character of the Roman 'square' capitals, but in more flexible mediums, such as metal, alphabets became more rounded, influenced by the styles of penmanship in manuscripts. Black-letter, or Gothic, a calligraphic style which appeared in the thirteenth century, was not favoured in Italy for monumental work. In the Renaissance, thanks to the influence of the humanists, letter-forms used for inscriptions were deliberately modelled on the classical Roman capital alphabet, which has remained in use to this day.

There were many uses for inscriptions in the ancient world. Besides commemorating the dead on tombstones, they were used to record treaties between Rome and her neighbours and for official decrees of all kinds. In the latter cases they were incised on tablets of stone or bronze and set up in a public place, usually a temple. The temple itself, the altar, vases and other consecrated objects were inscribed with dedications to the gods. When emperors and war-leaders were honoured with a monument – a triumphal arch, column, or statue – their deeds were recorded on it in the finest lettering.

Abbreviations were used extensively in all classes of inscriptions, particularly for words and phrases that were familiar through repetition. They shortened the tedium of the work and also helped economize in the use of scarce materials. A dedication to Jupiter may begin I · O · M · , *Iovi optimo maximo*, to Jupiter the best and greatest, and may be followed by some such expression as D · D · , *dono dedit*, indicating that the object is a votive gift. On a public building the letters S · P · Q · R · , *Senatus populusque Romanus*, the Roman Senate and People, at the head of an inscription denote that its erection was authorised and funded by the governing body of Rome. An emperor after death is invariably styled *divus*, but lesser men, especially senators, are C · V · or, later, V · C · , *Vir clarissimus*, a most highly renowned man. Prefects and lower ranks may be V · P · , most perfect, or V · E · , most 'egregious', i.e., excellent.

Inscriptions on Roman tombstones, pagan and Christian, had many conventions of their own. In the imperial age pagan epitaphs are often headed D · M · , or, in full, DIIS MANIBUS, To the spirits of the Underworld. The Manes were the souls of the dead who were feared for their power to do evil to the living. Manes means literally 'the kindly ones' and was hence a term of appeasement. They were originally regarded as impersonal beings but later became identified with the family ancestors and finally with the individual soul of the deceased, residing in the lower regions. 'Here lies' was expressed as HIC SITVS EST. It was not unusual to include references to living members of a family, and their names were then preceded by V (*vivus* or *viva*) to distinguish them from the dead who were given a Greek *theta*, θ (*thanon* or *thanousa*). The deceased's age was sometimes expressed very precisely, with years, months, days and even hours. It begins Q · V · A · , *qui vixit annis*, 'who lived (so many) years', followed by numbers. If known only approximately, the letters P · M · (*plus, minus*) may be added. In Roman law a tomb and the land on which it stood was sacred and inviolable. It could not be sold nor bequeathed outside the family. A variety of formulas served as a reminder of this, for example H · M · H · N · S · (*hoc monumentum heredem non sequitur*), 'this monument shall not pass to another by inheritance.' Warnings against desecration, which might include witchcraft, are given in phrases like H · L · D · M · A (*huic loco dolus malus abesto*). *Dolus malus* was a legal term for 'deliberate fraud' which must be

'absent from this place'. The classical style of inscription was revived in the Renaissance, as on the tomb of Cosimo de' Medici. He was officially proclaimed *Pater Patriae*, 'father of his country', the term used by the ancient Romans for a saviour of the nation: COSMVS MEDICES/HIC SITVS EST/DECRETO PVBLICO PATER PATRIAE/VIX · AN · LXXV · MENS · III · DIES · XX.

Ancient Roman epitaphs sometimes mention a *collegium*. This was a guild, usually named after its founder or a god, which acquired its own burial places, paid for by the members, and ensured that their funeral rites were properly carried out. It arranged memorial feasts at the tomb of the founder or other benefactors. It is very likely that the earliest Christian asssemblies were modelled on the pagan burial guilds. The funeral banquets at which pagans remembered those who had given money to the guild became, among Christians, the occasion to celebrate a martyr's anniversary. The guild kept a calendar of its regular events which was probably the origin of the Christian calendar of saints.

The earliest Christian inscriptions are found in the catacomb of Priscilla at Rome and probably date from the later second century. At this period they are brief, mostly consisting simply of the deceased's name. Occasionally a short invocation is added, such as PAX TECVM, 'Peace be upon you', or VIVAS IN DOMINO, 'May you live in the Lord', or simply IN PACE, 'in peace'. The last is also sometimes found in Greek, EN EIPHNH (*en eirene*). Greek was the language of the whole Church in the early centuries and was therefore widely used for funerary inscriptions even where Latin was the spoken language. Greek letters were sometimes even used for Latin words (for the alphabet, see below). Other Greek expressions found in the catacombs are the *chi-rho* monogram (p. 81), the sign Aω (*alpha* and *omega*) and the word fish, sometimes with points between the letters which suggest its acrostic meaning: I · X · Θ · V · C (p. 73, and ch. 3, note 25).

The word SANCTVS is often applied to the deceased in early Christian epitaphs. Though in due course it was used to denote 'saint', at first it signified no more than 'greatly revered'. In that sense it was sometimes used as a title for pagan emperors. It began to acquire a more specialized Christian meaning on being associated with the early martyrs. Thus SANCTI MARTYRES APVD DEVM ET CHRISTVM ERVNT ADVOCATI, 'The holy martyrs shall be advocates (for every man) before God and Christ.' The martyrs were very soon regarded as having the power to intercede on behalf of souls in Purgatory. The word REFRIGERIVM, a cooling off, was much used in this context, when petitioning martyrs to obtain relief for souls suffering in the fires. On the other hand, pleas to the dead on behalf of the living were expressed simply as ROGA (or PETE or ORA) PRO NOBIS, 'Ask (or plead, or pray) for us'. There were martyrs among the early bishops of Rome and inscriptions, nearly always in Greek,

have survived for several of them: thus ΘABIANOC ЄΠI (*skopos*) MP, 'Fabianus, bishop, martyr', for Pope Fabianus who died in 250; and, in Latin, CORNELIVS MARTYR EP, the Pope who died in 253. There are many epitaphs to those of lesser rank, whether martyrs or not, and here Latin is more often used: PRES(BYTERUS) or ΠPECBYTEPOC; VIRGO SACRA, the unmarried woman who consecrated her life to the Church, VIDVA, the widow; and the faithful, FIDELIS or ΠICTOC, that is, one who has been baptized and initiated into the mysteries. ALVMNVS, or ΘPEΠTOC, denotes a child of pagan parents fostered in a Christian family.

From the beginning of church building and decoration in the fourth century and, far more, in the Middle Ages, the use of inscriptions continually widened, and was no longer confined to epitaphs. Religious images of many kinds, whether in stone, mosaic, fresco or other mediums, often carry a descriptive message. Sacred figures are identified by name, as are personifications of the Virtues and Vices. The prophets hold a scroll bearing an extract from their writings. Episodes from the Bible and the early non-biblical narratives, especially those that established themselves as Feasts of the Church, carry a title or are given a longer quotation. Thus we frequently see a scroll with the words ECCE VIRGO CONCIPIET ET PARIET FILIUM ... 'Behold, a virgin shall conceive, and bear a son', which identifies the holder as Isaiah (7:14). A winged figure with a scroll reading AVE MARIA GRATIA PLENA ...' 'Hail Mary, full of grace', is Gabriel, the angel of the Annunciation (based on Luke, 1:28). On a pair of bronze doors made by Bonanno of Pisa, for Pisa cathedral, (*c.* 1190–1200), the life of Christ is depicted in twenty panels, all of them named. Among them are NATIVITAS DNI (*Domini*), the Nativity of the Lord, ACCEPIT SIMEON PUER(UM), Simeon takes the Child (Presentation in the Temple), LAVATIO PEDU(M), Washing the Feet, and CENA DNI, The Lord's Supper. The artist is often obliged to make contractions for reasons of space, for example, the Transfiguration becomes

RANSFIGURATIONI

The Eastern Church made use of inscriptions with greater consistency than the West. The figures of the saints in Byzantine churches are usually named, whereas the West relies more often on the system of attributes. Although the Eastern Church kept the Greek language, inscriptions by Byzantine artists in Italy are frequently in Latin, except in the far south. For certain abbreviations, such as Christ's name, Greek was always retained. The following notes are simply an introduction to the Greek capital alphabet as it is generally used in medieval inscriptions and, it is hoped, will open the door to understanding inscriptions in Byzantine art.

Greek inscriptional letters

The same as Latin	Unlike Latin	Digraphs (no Latin equivalent)	Note these false friends
A	Δ : D	Θ : TH	H : E
B	Γ : G	Φ : PH	P : R
E	Y or V : U	X : CH	C : S
I	H : E	Ψ : PS	Y or V : U
K	Λ : L	ȣ is a common medieval inscriptional form of OU	X : CH
M	Ξ : X		ω : O
N	Π : P		
O	P : R		
T	C : S		
Z	ω : O		

Note that E in Greek has two forms, short and long: E and H ; likewise O: O and ω.

Some familiar names

ΠΕΤΡΟC	ΜΑΤΘΑΙΟC	ΘωΜΑC
ΠΑΥΛΟC	ΜΑΡΚΟC	ΔΑΝΙΗΛ
	ΛΟΥΚΑC	ΓΡΗΓΟΡΙΟC
	ΙωΑΝΝΗC	ΝΙΚΟΛΑΟC
		CΕΡΓΙΟC

Abbreviations

A word shortened to its initial letter is followed by a point, as already noted. A contraction, that is the omission of the middle letters of a word, is generally indicated by a stroke above; thus, the commonest of all in Christian calligraphy and inscriptions is, $\overline{\text{IC}}$ $\overline{\text{XC}}$, or $\overline{\text{IHC}}$ $\overline{\text{XPC}}$, for IHCOVC XPICTOC , *Iesous Christos*. (The use of this contraction in Latin manuscripts led scribes into the habit of an incorrect spelling, Ihesus, and hence 'h' was introduced into other names such as Hieronimus, Jerome.)

Some other common contractions

MP ΘV, (or Θȣ), ΜΑΤΗΡ ΘΕΟV (or ΘΕȣ), *Mater Theou*, Mother of God.

ΘΚΟC, ΘΕΟΤΟΚΟC, *Theotokos*, Bearer (or 'Mother') of God.

ΚC, ΚVΡΙΟC, *Kyrios*, (the) Lord.

ΠΡ, or ΠΑΡ, ΠΑΤΗΡ, *Pater*, Father.

VC, VIOC, *Uios*, Son.

ΠΝΑ, ΠΝΕVΜΑ, *Pneuma*, Air, spirit; hence ΑΓΙΟΝ ΠΝΕVΜΑ, *Agion Pneuma*, Holy Ghost.

CHP, CωΤΗΡ, *Soter*, Saviour, (Besides its Christian meaning the word was used in ancient Greece as an epithet of Zeus, and other tutelary gods).

CΡΟC, CΤΡΟC, CΤΑVΡΟC, *Stauros*, a pole, hence the Cross.

ΑΝΟC, ΑΝΘΡωΠΟC, *Anthropos*, man.

Κ., ΚΑΙ, and.

Look out for shorthand forms such as Ħ (ΤΗ), Ρ̄ (ΓΡ), M̄Ρ (ΜΗΡ), Ⓐ (Ο ΑΓΙΟC).

The definite article

The word 'the' in Greek inscriptions precedes nearly all common nouns, usually with no space between. (In general, words are freely run together or arbitrarily broken at line-endings whenever necessary for reasons of space.) 'The' is inflected according to the gender of the noun: Ο (masc), Η (fem), ΤΟ (neut.). Thus, when joined to the adjective ΑΓΙΟC, *agios*, holy (= saint), which is also inflected:

ΟΑΓΙΟC ΠΕΤΡΟC,	(The) Saint Peter
ΗΑΓΙΑ ΜΑΡΙΑ,	(The) Holy Mary
ΤΟΑΓΙΟΝ ΠΝΕVΜΑ,	The Holy Ghost

similarly

ΟΠΑΝΤΟΚΡΑΤωΡ,	The Pantocrator, the Almighty.
ΟΑΡΧΑΓΓΕΛΟC,	The archangel, often shortened, as in ΟΑΡΓΑΒΡΙΕΛ, The Archangel Gabriel.
ΟΠΡΟΦΗΤΗC,	The prophet.

In the plural, the definite article goes: ΟΙ (masc.), ΑΙ (fem.), ΤΑ (neut.). The possessive case ('of the') is also often seen in the three genders: ΤΟV (or Τδ), ΤΗC, ΤΟV; and in the plural ΤωΝ (all genders). Thus: ΤΗCΘΚδ of the Theotokos (abbrev.); ΤωΝΜΑΓωΝ, of the Magi.

The twelve feasts of the Church (p. 127) and other themes

Η ΓΕΝΝΗCΙC , *Gennesis*, The creation, not of the world, but of Christ, i.e. the Nativity. Also, Η ΓΕΝΝΗCΙC ΤΗC ΘΚδ, The Nativity of the Virgin.

Η ΒΑΠΤΙCΙC, The Baptism (Ο ΒΑΠΤΙCΤΗC, (John) the Baptist).

Η ΤШΝ ΜΑΓШΝ ΠΡΟCΚVΝΗCΙC, The, of the Magi, Proskynesis: The Adoration of the Magi.

Η ΜΕΤΑΜΟΡΦШCΙC, The Metamorphosis: Transfiguration.

Ο ΝΙΠΤΗΡ, *Nipter*, The Washing of the Feet.

Η ΑΝΑCΤΑCΙC, (abbrev. ΗΑΝΑC), *Anastasis*, Resurrection (Harrowing of Hell) (see p. 114).

Η CΤΑVΡШCΙC, *Staurosis*, Crucifixion.

Ο ΧΑΙΡΕΤΙCΜΟC, *Chairetismos*, Salutation: Annunciation. Also, Ο ΕΥΑΓΓΕΛΙCΜΟC *Evangelismos*.

Η VΠΑΠΑΝΤΗ, *Hypapante*, Meeting: Presentation in the Temple.

Η ΕΓΕΡCΙC ΤΟV ΛΑΖΑΡΟV, *Egersis tou Lazarou*, The (Awakening) Raising of (the) Lazarus.

Η ΒΑΙΟΦΟΡΟC, *Baiophoros*, The Bearing of the Palms: Entry into Jerusalem.

Η ΑΝΑΛΗΠCΙC (ΤΟVΧΡΙCΤΟV), *Analepsis*, The Ascension (of Christ).

Η ΠΝΕVΜΑΤΟC ΠΑΡΟVCΙΑ, *Pneumatos parousia*, The Presence of the Spirit: Pentecost. Also, Η ΠΕΝΤΗΚΟCΤΟC

Η ΚΟΙΜΗCΙC, *Koimesis*, Repose, sleeping: Dormition of the Virgin.

Η ΔΕΗCΙC, *Deësis*, An entreating: the Virgin and St John interceding beside the cross.

A.1 One of the Twelve Feasts. Inscription from the Pala d'Oro, St Mark's, Venice. 11th–12th cent.

References

Diringer, D., *The Alphabet: a key to the History of Mankind*, London, third edition, 1968.

Sandys, J. E., *Latin Epigraphy*, Cambridge 1927.

Marucchi, O., *Christian Epigraphy*, Cambridge 1912.

Thompson, E. Maunde, *Handbook of Greek and Latin Palaeography*, London 1893. (Mainly calligraphy.)

Diehl, C. *L'Art Byzantin dans l'Italie méridionale*, Paris 1894. (With examples of Greek inscriptions.)

Sparrow, J. *Visible Words*, Cambridge 1969. (The revival of the classical inscription in Renaissance painting and sculpture.)

Glossary

acheiropoieta Image believed to be made not by human hands but created miraculously.

aditus Ceremonial procession towards the throne, at an imperial audience.

agape The common meal that preceded, or sometimes followed, the celebration of the eucharist in the early Church. (See *Caritas*.)

Albigenses Ascetic religious sect, strong in southern France in late 12th and early 13th cents. They were condemned as heretics and rigorously repressed.

ambulatory Semicircular processional aisle at the east end of a church, surrounding the sanctuary area.

ampulla Flask, usually of clay, used by pilgrims to carry home lamp-oil from martyr's churches. Often decorated with replicas of images in the church.

anargyros 'Without money'. A physician-saint, such as Cosmas and Damian. A class regularly represented in Byzantine churches.

anastasis Resurrection. In Byzantine art it denotes Christ's descent into limbo to resurrect the saints of the Old Covenant.

apotheosis Deification. Ceremony following the death of a Roman emperor, giving him divine status. Sometimes used to describe the scene of a Christian saint being received into heaven.

apotropaic Turning aside evil. Used of images, such as the Gorgon's head on pagan temples, which were intended to ward off harm.

apse Semicircular, or polygonal, extension at the east end of a church, its ceiling forming half a hemisphere, or semi-dome.

archivolt One of the concentric series of mouldings of an arch surrounding a portal, often having relief carvings.

arcosolium Recess in the wall of a catacomb, arched at the top, to hold the remains of the dead. Often decorated with paintings.

Arianism The doctrines of Arius (*c.* 250–*c.* 336), who denied that the divinity of the Son was equal to that of the Father. Pronounced a heretic by the Council of Nicaea, 325.

Atlantes (plural of Atlas). Atlas-like figures, usually several in a row, found especially in Romanesque sculpture supporting the universe.

atrium The main hall of a Roman house, unroofed at the centre and sometimes surrounded by a colonnade.

aureole In Christian art, the golden radiance surrounding the whole of a sacred figure, especially Christ and the Virgin.

Averroism The philosophy of the Mohammedan, Averroës (Ibn Roshd, 1126–98), especially his interpretation of Aristotle, which was condemned by Christian teachers.

baldaquin Canopy over an altar, throne, etc. Also type of porch with two free-standing columns, a feature of northern Italian Romanesque churches. (See *ciborium*)

bambocciate Pictures of peasant and street life, a genre introduced into Rome by the

Netherlandish painter, Pieter van Laer, *c.* 1625–7.

Baroque Style of art embracing painting, sculpture and architecture, between late 16th and early 18th cent. Its emotional appeal made it an ideal vehicle for Counter-Reformation teaching.

basilica In Roman architecture, a large public hall. The plan was adopted for Christian churches from the 4th cent.

basilisk Fabulous creature, part cock, part snake, whose glance could kill. A symbol of Satan in the Middle Ages.

Bestiary 'Menagerie'. Medieval book of natural history, describing the characteristics of animals in terms of Christian morals.

Bollandists John van Bolland (1596–1665) and his successors: Jesuit editors of the *Acta Sanctorum*, the definitive critical account of the lives of the saints.

brandeum An object having miraculous powers by virtue of a former physical contact with a holy person – a type of relic.

Byzantine Of Byzantium, renamed Constantinople when it became the capital of the East Roman Empire.

canon tables A set of tables at the beginning of a gospel book, showing parallel passages by means of references in columnar form.

Canopic jar Etruscan burial urn, the lid resembling a human head, the handles sometimes like arms. Named after Canopus in Egypt.

Caritas The Christian concept of love as a relationship between God and man (Gk, *agape*). One of the three 'Theological Virtues'. In English, 'Charity'.

Caryatids In Greek architecture, sculptured female figures serving as columns to support an entablature.

cassone A bridal chest. It was the fashion in 14th cent. Florence to decorate the front panel, also the inside lid, with scenes from the Bible and myth, often amatory.

cataclysm A universal flood which, according to Stoics, would bring to an end every alternate cycle of existence. (cf. *ekpyrosis*.)

catechumen One receiving instruction in the rudiments of Christian belief, prior to baptism.

Cathari Members of an ascetic religious sect, influential in northern Italy and southern France (where they were known as *Albigenses*, q.v.), 11th–13th cents. Repressed by the Inquisition.

cella Inner chamber of a pagan temple, containing a cult statue of the god.

Centaur In Greek mythology, a creature with the head and torso of a man and the body of a horse. In art, often a symbol of barbarism, man's animal passions, and so on.

champlevé Method of enamelling, in which the flux is run into troughs or cells in a metal base-plate. Earliest known is Celtic, 3rd cent. BC.

chansons de geste 'Songs of epic deeds'. Medieval French epic poems mostly anonymous. Earliest and best known is the *Song of Roland*, *c.* 1100.

chaplet Originally a circlet or wreath for the head. The three parts into which the prayer-cycle, the rosary, is divided; also the string of beads used for counting the prayers.

chiton One of the two principal items of ancient Greek clothing, a kind of tunic consisting of an oblong piece of cloth, wrapped round the body and pinned at each shoulder. (See *himation*.)

ciborium Chalice-like vessel with a lid, used to hold the eucharistic bread. Also a canopy, supported on pillars, above the altar: a baldaquin (q.v.).

ciompo Wool-carder, a menial grade of craftsman in the Florentine textile industry, 13th–15th cents.

clerestory Row of windows on each side of the nave of a church, above the roof-level of the side aisles.

clipeus (or *imago clipeata*) Medallion portrait representing the soul of a deceased person. Probably from the ancient Roman custom of decorating the soldier's round shield (*clipeus*) with ancestor portraits.

cloisonné Method of enamelling, in which the flux is run into cells formed of thin upright strips of metal. Earliest known is Mycenaean, 13th cent. B C. The process used for most Byzantine enamels.

codex Book formed of separate leaves unlike the scroll-book, or *volumen*. It began to supersede the latter in the 4th cent. A D.

colobium Ankle-length tunic, usually sleeveless, worn by Christ on the cross, 8th–10th cents., especially in Byzantine art.

conch (or *concha*) 'Cockle-shell'. The semi-dome, or concave ceiling of an *apse* (q.v.), from its shell-like shape.

condottiere Leader of one of the many bands of mercenary soldiers in Italy, especially 15th cent.

contrapposto A Renaissance term for the standing figure with the weight on one leg, the pelvis tilted or slightly turned. First appears in Greek sculpture, 5th cent. B C.

Counter-Reformation A movement for religious reform initiated by the papacy in the second quarter of the 16th cent., partly a reaction to Renaissance humanism and the teachings of Luther and Calvin.

cubiculum Small underground chamber in a catacomb, usually with more than one *arcosolium* (q.v.). Often decorated with wall and ceiling paintings.

cupola A dome, hemispherical or raised on a drum. Often decorated with fresco or mosaic, especially in Byzantine churches.

Cynocephalus Dog-headed man, found in Romanesque art. Probably derived originally from the animal-headed masks worn by Egyptian priests.

decorum The concept of 'fitness for purpose' and of the congruity between the different elements of a work of art. An aspect of aesthetics since antiquity.

Deësis 'Supplication'. In Byzantine art, especially from 10th cent., the scene of the Virgin and John the Baptist in suppliant attitudes on each side of Christ enthroned.

desco da parto Tray painted with scenes from myth and legend, given to a mother after childbirth. Typically 14th cent. Italian.

Divus, diva Title of Roman emperors and their wives, denoting their status as gods.

drum Cylindrical base supporting a cupola.

ekpyrosis A universal conflagration which, Stoics believed, alternated with a *cataclysm* (q.v.) to end each cycle of existence.

ekphrasis 'Description'. A literary exercise in using words to create a visual effect. Part of the classical teaching of rhetoric, kept alive by Byzantine scholars and taken up by Renaissance humanists. Works of art, real or imaginary, were a favourite subject.

emblem books Books of pictures having a symbolic meaning, each accompanied by an explanatory verse expressing some simple moral. Popular literary genre in 16th and 17th cent. Italy.

entablature In the classical orders of architecture, the part supported by the columns, viz., architrave, frieze and cornice. The frieze may be decorated with relief sculpture.

enthusiasm 'Possession by a god'. A state of religious exaltation which, in the case of the devotees of Dionysus, was brought on by wine.

ephebos In ancient Greece, a youth between eighteen and twenty years of age.

epigraphy Inscriptional lettering, usually stone-carved or, as in Byzantine art, in mosaic. Minuscule forms are rarely used.

Erinyes In Greek mythology, the Furies, female spirits that avenged crime, especially the murder of a kinsman. Represented with wings and sometimes entwined with snakes.

Etruscan Of Etruria, ancient region of Italy roughly coextensive with Tuscany, and its culture.

eucharist 'Thanksgiving'. The sacrament of Holy Communion, or Mass.

evangeliary Early liturgical book in which extracts from the gospels are arranged for reading at the eucharist. It may include *canon tables* (q.v.), portraits of the evangelists, and a scene such as the Crucifixion.

exarch Provincial governor in the Byzantine Empire, especially in Italy.

fasces Insignia of Roman magistrates, carried by lictors, consisting of a bundle of rods, tied with a red strap and, when outside Rome, enclosing an axe.

feria One of a class of Roman festivals, of moveable date. (See *ludi*.)

festival cycle The major feasts of the Church, often represented as a series, usually twelve, in Byzantine art from 11th cent.

filioque 'And the Son'. Dogma of the Western Church that the Holy Ghost 'proceeds from the Father and the Son'. Its addition to the creed was denounced by the Greek Church and was one cause of schism between East and West from the 9th cent.

flamen One of fifteen priests in ancient Rome, having special rank. Each served one of the State gods to whom he made regular sacrifice.

frontality Manner of representing the human figure so that it is forward-looking and approximately symmetrical, seen from the front. A feature of primitive *apotropaic* (q.v.) images, Roman imperial art and Byzantine sacred figures.

galerus Cap made of undressed leather, worn by a *flamen* (q.v.).

Genius In Roman religion, the spirit dwelling in the *paterfamilias* (q.v.); the source of his powers (especially procreative), and later his personal guardian. Its symbol was a snake.

genre Scenes of daily life, in well-defined categories, especially as in Dutch 17th cent. painting, popularized in Rome from 1625 (see *bambocciate*).

gisant 'Recumbent'. Reclining figure, typically on the lid of Etruscan ash-chests, also used of similar figures in Renaissance funerary sculpture.

Glossai See *Phylai and Glossai*.

Gnosticism 'Knowledge'. A religious philosophy, rival to the early Church though making use of the gospels. Gnostics held that created matter was evil, in contrast to the perfection of the divine spirit. Their ideas may have survived among the *Albigenses* (q.v.) and *Cathari* (q.v.).

Gothic Style of medieval European architecture and art between mid 12th and 15th–16th cents., originally a term of condemnation applied by Italian Renaissance critics.

griffin Fabulous beast, having the head, wings and claws of an eagle and the body of a lion.

halo See *nimbus*.

harpies 'Snatchers'. In classical myth, fabulous birds with female human faces and, latterly, repellent habits.

haruspication Method of divination by studying the entrails of animals, especially the liver, practised by the Etruscans.

hetoimasia 'Preparation of the throne'. In Byzantine art, an empty throne, symbol of God as a divine sovereign, later, as the Judge to come.

himation A man's cloak, worn over the *chiton* (q.v.), in ancient Greece.

historiated Decorated with figures, especially the reliefs on the capital of a column.

Hodegetria In Byzantine art, type of image of the Virgin and Child, with the Infant on her left arm, once believed to be based on a painting by St Luke.

homoousian 'Of the same substance'. Term used in the Nicene Creed to define the relationship between the Father and the Son, intended to counter *Arianism* (q.v.).

hypogeum Underground chamber, especially a tomb.

iconoclasm 'Breaking of images'. Opposition to image-worship, as in the Byzantine Empire, 8th and 9th cents.

iconostasis In an Orthodox church, a screen separating the sanctuary area from the main body of the building, usually decorated with images.

ignudo The male nude, as in Michelangelo's classical figures on the ceiling of the Sistine Chapel.

Index (of Prohibited Books) List of books which Roman Catholics were forbidden to read. First issued 1557, abolished 1966.

inhumation Burial of a body in the earth, or at least underground, as compared to its cremation.

impresa A personal emblem, with a motto, much favoured in Renaissance Italy and France.

jamb Vertical post forming the side of a doorway or window.

Jesuit Member of the Society of Jesus, founded by Ignatius Loyola in 1534. Jesuits were active in promoting the ideals of the Counter-Reformation.

jongleur Medieval travelling entertainer who was singer, reciter, dancer or acrobat.

kalathos In ancient Greece and Rome, a wicker basket; used for bread, manna, etc., in early Christian art, hence a symbol of the eucharist.

kantharos Type of Greek two-handled drinking vessel, associated in art with the rites of Dionysus.

kithara Ancient Greek stringed instrument, the same family as the lyre. The attribute of the Muse, Erato.

Koimesis 'Sleeping'. The title of the scene of the Death of the Virgin in Byzantine art, called Dormition in the West.

kore See *kouros*.

kouros 'Young man'. The standing male nude in Archaic Greek sculpture, used as a grave-stone, regardless of the age of the deceased. Female: *kore*.

Lares and Penates In Roman religion, guardian spirits of the household, the latter, in particular, of the store-cupboard.

liturgy The prescribed form of a service of the Church, or more particularly, of the eucharist.

Logos 'Word' or 'Reason'. The Second Person of the Trinity, in his divine aspect, especially as the agent of the creation of the universe.

ludi The public games in ancient Rome, associated with various religious festivals, and originally of a ritual character.

lunette The flat, semicircular area enclosed by the arch of a vault or over a window, often decorated with painting or mosaic.

macrocosm The universe in its true dimension, as opposed to *microcosm* (q.v.).

mandorla 'Almond'. The almond-shaped frame, or *aureole* (q.v), enclosing the figure of Christ or the Virgin, especially when ascending to, or enthroned in, heaven.

mania Divine frenzy; *enthusiasm* (q.v.).

Mannerism Style of European art between *c.* 1525 and *c.* 1600, originating in Italy. Characterized by elongated and serpentine forms, the pursuit of elegance at the expense of realism, and a taste for obscure allegory.

mappa mundi Medieval map of the world showing the earth as a flat disk with Jerusalem at the centre and with much pictorial description.

martyrium Church built to house the relics of a martyr, typically a rotunda.

Mazdaism Religion of ancient Persia which taught that fire was a divine essence, the source of life and of purification at death.

menorah Seven-branched gold lamp-stand which stood in the Temple at Jerusalem, a symbol of the Jewish religion.

metempsychosis, or transmigration of souls. Doctrine of Pythagoras, and widespread in eastern religions, that souls migrate after death to another body, gradually achieving purification.

metope Relief slab, part of the frieze of a Doric *entablature* (q.v.).

microcosm The universe in miniature, especially man as its embodiment.

minium, or cinnabar. Red pigment, having various ritual uses in ancient Rome, described by Pliny (*Nat. Hist.* 33: 111–12).

Monophysitism Doctrine denying the double aspect of Christ's nature, human and divine, and affirming that it had one only, wholly divine.

monstrance Receptacle with a glass window, used in Roman Catholic churches, for displaying the eucharistic host.

mulctra Milk pail, sometimes seen in the hand of Christ, the Good Shepherd.

naos Inner chamber of a Greek temple, in which the statue of the deity stood.

narthex Vestibule of a church, especially Byzantine, an unconsecrated area to which catechumens (q.v.) and penitents were once restricted.

Nereid In Greek mythology, sea-nymphs, the daughters of Nereus, the 'old man of the sea'.

Neo-Classicism Style of European art which emerged in the second half of the 18th cent.; a revival of antique forms and themes, a reaction against Baroque and Rococo.

Neoplatonism (Renaissance) Revival by 15th cent. Italian humanists of the teachings of Plotinus (*c.* 205–70) and his followers who had created a religious philosophy derived from Plato's metaphysical writings.

Nikopea In Byzantine art, image of the Virgin and Child, both of them frontal and central, one behind the other.

nimbus, or halo Zone of light round the head of a divine person. In pagan images, the attribute of Mithras, Apollo and Helios. It appears in Christian art from *c.* 5th cent.

numen 'A nod'. The sign of the will of a god. In Roman religion the power inherent in natural objects and cult images which could be influenced by making offerings.

oliphant 'Elephant'. Medieval ivory horn, usually decorated with carving, often used as a *reliquary* (q.v.). Traditionally associated with the legend of Roland.

orant Praying figure, standing, with hands spread and raised to each side of the body. Common in early Christian funerary art, often as a symbol of the deceased's soul.

Oratorian Member of a reformist religious community founded in Rome by Philip Neri (1515–95). Singing had an important place in their devotions.

pagan Literally, of the countryside, rustic. Hence pagan religion was associated with nature worship and came to mean non-Christian (also non-Jewish).

Palladium Image having the power to protect a city. From a legendary statue of Pallas Athene at Troy.

Panotii 'All ears'. A fabulous race of Scythia, having huge ears, mentioned by Isidore of Seville.

Pantocrator 'All-mighty'. In Byzantine art, the image of Christ as a visual expression of his dual nature, human and divine.

Paschal Lamb In early Christian art the symbolic representation of the sacrificed Christ as a lamb with a cross, from the lamb sacrificed at the Jewish Passover.

patera Libation dish, represented in Etruscan and Roman art.

paterfamilias The master of a Roman household, who was also its priest.

pediment Triangular gable-end of a Greek temple often containing figure sculpture in relief or in the round.

Penates See *Lares and Penates.*

pendentive One of four concave triangular surfaces at the corners of a tower, part of the structure supporting the dome, usually decorated.

perfecti Grade of initiates in the *Albigensian* sect (q.v.) who practised rigorous asceticism.

phylactery In medieval art, a scroll bearing words, apparently issuing from a person's mouth.

Phylai and Glossai 'Tribes and Languages'. In the scene of Pentecost, figures representing the various nations which the apostles would evangelize (Acts 2:5–13).

Pietà The scene of the lamentation of the Virgin Mary over the dead body of Christ.

Pietas 'Filial piety'. In ancient Rome, the obligations of a son to a father, or a subject to the emperor; also the virtue personified.

predella Base of an altarpiece, often decorated with small narrative scenes related to the main devotional image.

presbytery The sanctuary area of a church, the part reserved for the officiating priests.

Prima Causa 'First Cause'. In medieval cosmology, the highest heaven, or empyrean, the abode of God, surrounding the lower spheres of the universe.

Primum Mobile 'First Mover'. The ninth sphere of the heavens, next below the *Prima Causa* (q.v.), and the source of motion of the others.

proskynesis Act of prostration before the Byzantine emperor or his image, subsequently (6th cent.) before religious icons.

prothesis In the Greek rite, a table used for the preparation of the eucharist, or the chapel in which it stands.

Psychomachy 'Battle for the soul'. Title of a poem by Prudentius (b. 348), describing single combats between personified Virtues and Vices.

psychostasis 'Weighing of a soul'. One of the roles of Mercury as conductor of souls to the underworld, also of St Michael at the Last Judgement.

putti Winged infants, the attendants of Venus and Cupid, since antiquity.

quadratura Illusionistic effect, in painting, of extending architectural features into an imaginary space, as in a Baroque ceiling.

quadrivium See *trivium.*

Quietism System of contemplative prayer, aiming at total annihilation of the will.

rebus Puzzle, in which pictures are used to represent parts of a word.

Reformation 16th cent. movement for reform within the Church, led by Luther, Zwingli and Calvin, eventually causing a break with Rome.

reliquary Receptacle for holy relics, often elaborately fashioned.

rinceau Repetitive, S-shaped leaf ornament, a feature of Romanesque mouldings.

Rococo 'Shell-work'. Elaborately decorative style of 18th cent. European art, originating in France. It also influenced Venetian painting, e.g. Tiepolo.

Romanesque Style of architecture and associated arts which evolved in Europe about mid 11th cent., incorporating ancient Roman features.

rotunda Circular building (not necessarily domed), a form much used for early martyrs' churches.

Sacra conversazione Type of religious painting, which evolved in the Renaissance out of the medieval altarpiece, depicting the Virgin and Child accompanied by saints, with, perhaps, a donor.

sacred monogram Combination of Greek letters, such as *chi, rho* (first two letters of Christos) and *iota, chi* (Iesous Christos), found especially in early Christian funerary art.

Salii 'Leapers'. College of ancient Roman priests of Mars, probably of Etruscan origin, who made a solemn procession annually through Rome, with song and dance.

satisfaction In Christian theology, term denoting an act of reparation for sin, associated particularly with the Catholic sacrament of Penance.

Sciapod 'Shady foot'. Member of a fabulous race, having a single large foot which was used as a sunshade.

Septuagint 'LXX'. Translation of the Old Testament from Hebrew into Greek, 3rd or 2nd cent. BC., mostly done at Alexandria, traditionally by seventy-two translators, hence its name.

sheol For the ancient Hebrews, the abode of the dead.

Sirens In Greek mythology, those who lured sailors to death by their song, represented in antiquity as birds with women's heads; in the Middle Ages, often as women with fish-tails.

soffit Underside of an arch (or lintel), usually decorated in Byzantine churches.

Soter 'Saviour'. In ancient Greece, the title of Zeus, subsequently of Christ.

spandrel Triangular space between the curve of an arch and its adjacent wall.

speculum universale 'Mirror of the universe'. Iconographical scheme of Western churches which embraced, symbolically, the whole of knowledge, based on 13th cent. encyclopaedias.

Spirituals A body of Franciscans who continued to adhere strictly to the Order's original rule of poverty after it was gradually modified following the founder's death.

squinch Series of arches set diagonally across each corner of a tower, part of the support of the dome.

stela Type of Greek and Roman gravestone, a slab with relief carving, revived in Neo-Classical sculpture.

Stupor mundi 'Wonder of the world'. Name given to the Holy Roman Emperor, Frederick II of Hohenstaufen (1194–1250) by his biographers.

sudarium 'Sweat-cloth'. Type of *acheiropoieta* (q.v.), a piece of cloth on which the features of Christ were miraculously imprinted.

Summa Medieval compendium of knowledge or doctrine, usually presented according to the dialectical method of the schoolmen.

syncretism Process of assimilation of the gods of one nation with those of another.

tabernacle Portable shrine of the ancient Israelites. Also, the decorated receptacle for the eucharistic vessels in Catholic churches.

Tartarus In Greek myth, the deepest part of the underworld where the wicked were punished.

theophany In pagan religion, the ritual showing of a god (i.e. his image) to worshippers. In the early Christian era, synonymous with Epiphany.

Theotokos 'Bearer (i.e. Mother) of God'. Greek title of the Virgin, from the 3rd cent.

Traditio legis 'Handing over the Law'. In early Christian art, the scene of Christ, between Peter and Paul, confiding a scroll (symbolizing the Church) to the former.

Tradition (of the Church) The body of doctrine gradually formulated by the Fathers of the Church but, according to the Council of Trent, having equal authority with Scripture. The term is also used of legendary history, such as the life of the Virgin.

transubstantiation Catholic doctrine that the whole substance of the eucharistic elements is converted into the body and blood of Christ, the 'accidents' (appearances) only, remaining.

Treasury of Merits Catholic doctrine that a storehouse of good works has been accumulated by Christ and the saints, forming a 'fund' out of which indulgences can be granted to penitents.

triptych 'Three-fold'. Set of three painted panels, hinged together as in an altarpiece. Similarly, diptych (two), polyptych (more than three).

Triton Sea creature, half man, half fish; a merman.

trivium and *quadrivium* The two parts of the Seven Liberal Arts, the curriculum of secular medieval education; the more elementary *trivium* (grammar, dialectic, rhetoric), and the *quadrivium* (arithmetic, astronomy, geometry, music).

tympanum Space between arch and lintel over a doorway, often decorated with relief sculpture in medieval churches. Also, the triangular space enclosed by a classical *pediment* (q.v.).

typology Doctrine that people and events in the Old Testament foreshadow those in the New, the rationale underlying many Old Testament scenes and cycles in art.

vanitas Still-life painting, the content of which invites reflection on the evanescence of earthly things and the inevitability of death, especially Dutch 17th cent.

veduta 'View'. Townscape or scene of antique ruins, romantically treated, especially of Rome, as produced by Piranesi (1720–78).

Vesperbild The 'Lamentation of the Virgin' in German art, similar to the Italian *Pietà* (q.v.).

victimarius In Roman religion, an assistant at a sacrifice.

volumen A scroll-book.

votum 'Vow'. In Roman religion, an undertaking to make a special offering to a god, in return for a specific favour.

Illustrations

Bibliographical Note

The primary sources quoted in the text and all the main critical studies, books and articles, that I have used are given in the Notes and References, pages 351–63. Primary sources are also given in a separate index, arranged under authors. For further reading on the iconography of European art the following, not mentioned elsewhere in this book, are recommended. Most of the more recent titles contain valuable bibliographical information. Schiller, G., *Iconography of Christian Art*, 1971–2; Kirschbaum, E., *Lexikon der Christlichen Ikonographie*, 1968–72; Künstle, K., *Ikonographie der Christlichen Kunst*, 1926–8; Réau, L., *Iconographie de l'art chrétien*, 1957; Kaftal, G., *The Saints in Italian Art*, (Tuscan Painting) 1952, (central and southern Italian painting), 1965. A. N. Didron's *Christian Iconography*, first published in English in 1851, reissued in 1965, was one of the foundation stones of the subject. The various volumes by Anna Jameson, also dating from the mid-nineteenth century, are still useful. Reference books on secular iconography are fewer. A. Pigler's *Barockthemen* (revised ed., 1974) is wider in scope than its title suggests, listing examples from earlier periods of Christian and secular themes. Also to be mentioned are R. van Marle, *Iconographie de l'Art profane au moyen âge et à la Renaissance*, 1931; G. de Tervarent, *Attributs et symboles dans l'art profane, 1450–1600*, 1958; and the studies by Salomon Reinach, such as 'Essai sur la mythologie figurée et l'histoire profane dans la peinture italienne de la Renaissance,' *Revue archéologique*, s.5, vol. 1, 1915; also further, Witt, R. C., *ibid.* s. 5, vol. 9, 1919. Finally, the articles in journals published by art institutions in Europe and America are an essential source of up-to-date information on all aspects of art history. The *Art Index*, published quarterly, is the standard guide to this field.

General Index

Figures in italic refer to captions or illustrations on the page. References to notes refer to chapter and note number in the Notes and References.

Index of Primary Sources

Biblical sources are given in the Notes and References

Index of Artists and Subjects